THE WEBCOMICS HANDBOOK

THE CARTOONIST'S GUIDE
TO WORKING IN THE DIGITAL AGE

BRAD GUIGAR

GREYSTONE INN COMICS

THE WEBCOMICS HANDBOOK

ISBN-13: 978-0-9815209-6-4

First Printing.

Published by Greystone Inn Comics.

Office of publication: 4324 Tackawanna St., Studio 2C, Philadelphia, Pennsylvania 19124

PRINTED IN CHINA

For information, write to: bradguigar@gmail.com.

WEBCOMICS.COM

DEDICATIONS

To Scott Kurtz, Dave Kellett and Kris Straub, my co-authors on *How To Make Webcomics* and three of the best friends I could hope to have.

To Robert Khoo, without whose confidence and generosity neither this book nor Webcomics.com could be possible.

To my wife, Caroline, and my sons, Alex and Max, for their understanding, patience and love.

To George Rohac, for his priceless guidance on the Kickstarter campaign that funded the publishing of this book, and to everyone who pledged money and helped spread the word (some of whom are named at the end of the book).

Introduction

In 2008, Scott Kurtz, Kris Straub, Dave Kellett and I wrote *How To Make Webcomics*. We set out to write the book that we wished we had owned when we were starting out in webcomics almost 10 years earlier. And, four printings later, cartoonists across the globe have told us that we did a good job.

In 2013, having updated Webcomics.com five times a week since 2009, I realized I had the makings of the sequel to that book. And, having left my own day job to pursue full-time cartooning, I had the extra time and energy to devote to the undertaking.

I hope this book is as useful and inspiring as its predecessor.

I want to start by telling you a little bit about Webcomics.com. It's a burgeoning community of professionally minded webcartoonists. Beyond my own daily posts, there's an active private forum in which members can post discussion topics or seek help with specific problems. It's a place to get solid information, spark intelligent discussion and share meaningful insight. And the site offers several exclusive membership benefits including significant discounts from vendors.

This book is largely made up of my daily posts from Webcomics.com. If you're not a subscriber, this book is an excellent way to see some of what's going on behind the pay wall. If you are already a subscriber, it's a quick reference to some of the most relevant topics we've discussed.

Beyond that, it's a way for me to build upon what Scott, Kris, Dave and I started in 2008. Think about it: Twitter hadn't even crested in 2008. Facebook was an oddity for college students. And forget about iPads and digital downloads. There's a lot of material to be discussed that simply wasn't around when we wrote the book together in 2008.

If you bought the original *HTMW*, it's likely you'll see some familiar ground covered. It's simply impossible to write on this topic and not cover some of the basics. More importantly, you might see some of these topics presented from a slightly different viewpoint. For example, the comic-convention chapter I wrote for *HTMW* and the chapter on the subject I wrote for this book are quite different. It's not that the information in *HTMW* is incorrect. Rather, my attitude about conventions has matured. And the convention chapter in this book reflects that change in attitude.

Most importantly, this book is about continuing the sharing of information among cartoonists working on the Web. It's about keeping the discussion going and helping young cartoonists realize their dreams the same way that so many of us have done since around 1998.

THE WEBCOMICS BUSINESS MODEL

Webcomics work on a very simple model. We offer our comics on Web sites for free, building a community of readers in the process. The revenue is generated through several secondary streams, which include the advertising that is presented on the site and the selling of books, T-shirts, e-books and other merchandise licensed through the comic. Wherever possible, the Webcomics Business Model cuts out the traditional middlemen (publishers, distributors, syndicates, etc.) to maximize the profitability of cartoonists' ventures.

This is a hard model to explain to cartoonists who have spent their entire lives working for publishers and syndicates. They have a hard time believing that webcartoonists can make a living "giving their work away for free."

But as a webcartoonist, you are under absolutely no obligation to anyone — except yourself — to prove that you're able to build a sustainable business. As publishers feel the squeeze tighten, these little Print vs. Web debates seem to become more fierce. And that's a shame, because Print vs. Web doesn't have anything to do with *either*.

It's actually a debate between traditional, corporate publishing and independent self-publishing. Always has been, always will be.

Under traditional, corporate publishing, the cartoonist focuses on his craft and the publisher handles all of the business aspects — handing the cartoonist a check after the process is done. And there's really nothing wrong with that as long as the publisher is (a) entering into an equitable business arrangement with the cartoonist and (b) providing services that the cartoonist couldn't do for himself.

The Webcomics approach is much more of a do-it-yourself proposition. Largely, we're self-publishers, we handle our own distribution (on the Web), we invest in creating our own merchandise and we often sell — and ship — that merchandise personally to our readers. We tend to enter into a business relationship with an outside party (like a Web host) only when that party offers something that we can't do better ourselves.

Let's be honest, it would be infinitely easier to be a "print" cartoonist — if the market would bear it. If we weren't able to easily distribute our comics, promote them, sell merchandise, etc., ourselves, it would be so tempting to hand that over to someone else and happily cash the paychecks.

But that's not the world we're living in. The profit margins aren't wide enough to allow someone to take money for something you can do on your own. And many of the contracts floating around out there are downright frightening.

We must live in the world we're faced with. That world simply doesn't support the "print" model any longer. For the great majority of us, it's either learn webcomics or leave comics.

But don't get too smug. Inevitably, something will come along to usurp "Web" — at which point, many of us will be called upon to either adapt or die ... much like the decisions being faced by today's "print" cartoonists. Let's agree now not to make such a fuss.

10 TIPS FOR THE BEGINNER

Between co-authoring *How To Make Webcomics* and running Webcomics.com, I've seen a tremendous number of webcartoonists who are just starting out. Many of them share startling misconceptions, and several have made the same rookie mistakes that can be addressed easily. Here are 10 tips for people starting out.

1. JUST DO IT

Don't wait for the "right time." There's no such thing. The only way you're going to improve is by going out there and making mistakes. I constantly get approached by people during conventions who tell me that they're waiting to launch their comic until the time is "just right." I always tell them that while they're waiting, someone else is out there building an audience.

2. FREQUENT, CONSISTENT AND SIGNIFICANT

Update as frequently as you can, while maintaining consistency (in quality and schedule), and make every update significant. It's the best way to train and retain readers.

3. SOCIAL MEDIA

Use it. Make your social-media presence a major feature on your site — as close to the comic as possible. Make it easy for fans to use Twitter/Facebook/Google+ to spread their excitement about your work. And spend some time on the social sites yourself, letting your readers get to know you a little bit. Much of webcomics is built on the personal touch.

4. SAVE YOUR MONEY, DON'T ADVERTISE ... YET

Chances are, your work just isn't ready for prime time yet, and that's OK. Save your ad money, and rely on the many free alternatives (like #3 above). Heck, until you're able to identify a target demographic for your comic — and locate those readers on the Web — you're not really spending ad money wisely anyway.

A WORD ABOUT WEBCOMICS.COM

One of the greatest challenges in writing a book like this is deciding what content to include and how deep to delve into each concept.

It's impossible. And that's why I want to make sure you know about Webcomics.com. It exists for exactly that reason. If you find you need more information on a topic that I've covered in this book, you might find it covered at Webcomics.com.

And if it's not covered there, you can e-mail a request for more information in a particular area.

The site is subscription-only. The annual membership fee is $30 (which

5. PREPARE FOR SUCCESS

Scan in high resolution (or, if you're digital, start in high resolution) — even if you don't think you'll ever publish a book. Track your expenses — even if you don't think you'll make enough money to include your webcomic in your income taxes. Assume that you're going to succeed — so that when you do, you're not tripped up by a poor start.

6. DON'T MAKE EXCUSES

Serious medical emergencies and family crises aside, please don't post a hastily drawn sketch to update your site if you're sick. Nobody wants to be tripped up by those sketches while they're reading through your archives, and if you keep posting about how you weren't able to meet the commitment of posting a comic on time because of minor inconveniences, you're telling your readers that this isn't very important to you.

7. YOUR READERS ARE LOOKING FOR ENTERTAINMENT

This applies directly to #3 and #6. Whether you're tweeting, updating your status or posting a blog, keep in mind that your readers are looking to you for entertainment. I'm not saying that you can't pose strong political or religious views on the Web. But you *do* have to be aware that those actions have real consequences. I tend to think of my Web presence in the same frame of mind that I'd assume if I were hosting a party. I want my guests to feel welcome.

8. STOP LOOKING AT YOUR STATS

A once-a-day check-in is plenty. If you're checking your stats more than that, you're putting the cart before the horse. First you post great work, and then you get traffic surges. The time you're spending living and dying over hourly fluctuations in pageviews is time that you should be spending on becoming a better cartoonist. Some of the most important lessons you can learn from your stats are the long-term ones.

9. LETTERING

For crying out loud, pay attention to your lettering. Almost every new comic I see could be improved drastically by paying a little attention to some very basic rules of lettering. They're not hard. Learn them, and apply them.

10. LOVE IT

If you don't love it, quit now.

For now, you should be in it for the love. If you're doing this because you think it's a career choice, you're screwed. This isn't a choice, it's a calling. And the love you have for cartooning is going to be the only thing that buoys you a few years from now when you're up at 3 o'clock in the morning cranking out tomorrow's strip before sneaking in some Zs before you have to be at work.

Love is the only thing that can get you from hobbyist to part-timer to almost-full-timer to full-timer. It just gets harder from here on in. If you don't have the love now, you're not going to make it.

breaks down to less than $3 a month).

When you join, you will have access to:
• Frequent updates of news, advice, tutorials and strategies.
• Contributions by fellow webcartoonists who have established excellence.
• Feedback and guidance for your comic and your small business.
• A moderated, passionate, supportive community of webcomics creators.
• Members-only deals on merchandise and vendors.

Your subscription lasts for 12 months after your sign-up day — not the calendar year. It's worth checking out —for the information, the ability to share ideas and thoughts with fellow webcartoonists, and the member benefits.

TABLE OF CONTENTS

Note: *Throughout the book, major topics are introduced with a large gray headline (such as the one at the top of this page). Some of the material for this book was written by people who have generously allowed me to include it here. I've identified each of them at the very beginning of his or her section, and every case, his or her content runs until the next gray headline.*

"It's impossible to get worse at something you do every day."

Art

Have you ever noticed that every cartooning tutorial is crammed with drawing advice even though many wildly popular comics — like *Dilbert* and *xkcd* — have very simple art? That's because art is a fairly mechanical process — and therefore easy to describe. I can explain the concept behind drawing light and shadow, for example, but explaining how to write a funny gag or build a community of supporting readers is significantly more difficult. Nonetheless, I want to take the opportunity to cover a few art issues that might be of broad usefulness to beginning and intermediate webcartoonists. If you want more instruction in this regard, please feel free to grab a copy of *The Everything Cartooning Book,* which I wrote in 2004 for Adams Media, or any of Andrew Loomis' fabulous books on drawing.

FIGURE DRAWING

Drawing heads well is probably the most important aspect of figure drawing for cartoonists. Too many of us hide behind the excuse "I'm a cartoonist, so I don't have to draw realistically." Take some hard-earned advice: You can't break the rules before you learn them. Here are a few tips on drawing a "standard" human head.

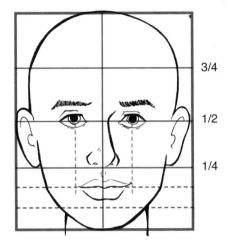 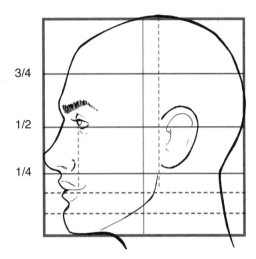

FRONT VIEW

These guidelines will help you get the features placed right:

- The eyes line right up across the center line.

- The ears rise slightly above this line and extend down to just above the one-quarter mark.

- The edges of the nose line up with the insides of the eyes.

- The mouth is about the width of the center of one eye to the center of the other.

- The mouth lines up about a third of the way down from the one-quarter mark.

- And here's another handy measurement to keep your proportions in check: The head is about the width of five eyes.

SIDE VIEW

The side view is a little harder to pin down, but here are the main guides I usually check to see if I'm staying in shape.

- Once again, if you divide the height of the head from top to chin, the eyes will line up on the center line.

- The nose extends to just above the one-quarter line.

- If you determine the center of the skull by judging the apex of the head (in other words, not counting the extra width added by the nose and chin), you can draw a line straight down. The ears line up just behind this line (again, slightly above the one-half mark and slightly above the one-quarter mark), and the jaw-line extends all the way back to this vertical guide.

BODY PROPORTIONS

Drawing a human body in the right proportions is an incredibly challenging pursuit. Even if your style is more cartoon that comic book, it's a good idea to familiarize yourself with proper proportions. The more you understand about how the body is built, the better you'll be able to break the rules and design characters that distort these proportions for all the right reasons.

Please keep in mind that the following can be applied to "standard" figure drawing. If you're drawing superheroes, for example, many of these measurements will be exaggerated.

MALE FIGURE

If you draw a line describing your character's height and divide it in half … then divide those halves in half … then divide each of those segments in half … you have a very accurate guide to a standard male figure.

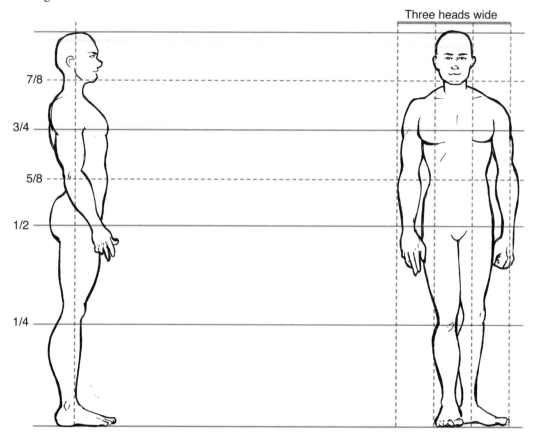

Certain features will line up on those guides. From bottom to top:

- The bottoms of the knees line up with the first quarter.
- The fingertips line up about mid-thigh.
- The wrists and the groin line up in the center.
- An eighth of the way up from the center are the elbows.
- The widest part of the chest is at the 3/4 line.
- The chin lines up with the 7/8 line.

FEMALE FIGURE

Similarly, a standard female figure lines up along these same measurements — mostly. The waist lines up slightly above the five-eighths mark, and the knees are slightly higher than the bottom quarter.

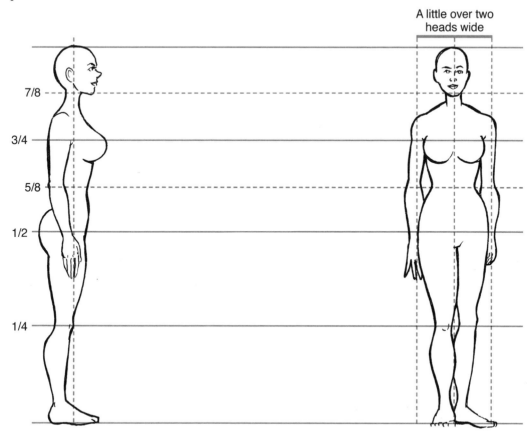

Knowing these key points, it's fairly easy to map out a guide to drawing a well-proportioned figure. For the average man, allow a width equal to three times the width of the head. For a typical woman, allow a width of two heads. Key your drawing off of the main checkpoints: chin, chest, waist, groin and knees. Keep in mind that some of these checkpoints indicate only general placement — for example, a woman's knee will line up slightly above the bottom quarter of the figure. But in general, lining your drawing up along this grid will help you keep your figures well-proportioned.

DRAWING KIDS

Drawing children involves a little understanding of human physiological development. The drawing on the next page represents a fairly typical progression from infant to adult. If you are drawing realistically, these proportions will serve you well as you try to represent believable characters at different ages. Here are a few points to remember:

• The human head doesn't really grow in size very much after birth. It starts large and grows a little bit to normal size.

• Although facial features such as the nose and ears may grow, the eyes start large and stay large.

• Across the rest of the body, the torso and legs grow rather dramatically.

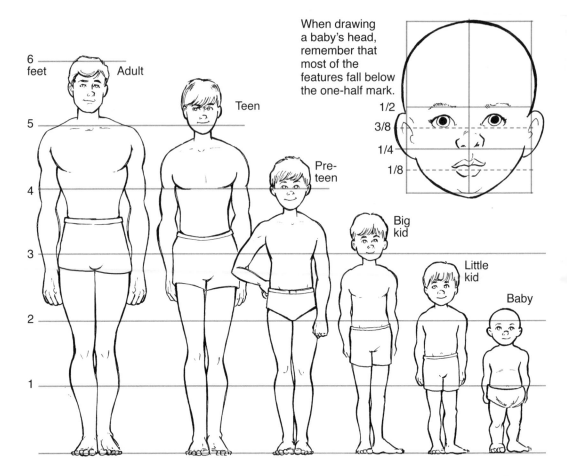

When drawing a baby's head, remember that most of the features fall below the one-half mark.

In comics, kids' proportions have to be exaggerated somewhat. Otherwise, the nuances of physiological development might be lost on a reader — leading to ambiguous interpretations of small adults or large children.

As a result, when I draw children, I try to imagine a delayed growth. Heads stay larger for longer, and torso/leg ratios remain somewhat compact right up until the teen years.

As you can see on the chart above, I try to hold the elongation of the legs back until just before the teen years. This keeps the characters small (and visually distinct from adults), while the head-to-body and eye-to-head proportions help communicate their relative ages.

In my estimation, there are four types of kids in cartooning: teens, preteens, toddlers and babies. In other words, almost-adults, big kids, little kids and babies. In my opinion, there are just not a lot of reasons to make further distinctions for most applications. Obviously, you could tweak a preteen downward to get a little more nuanced elementary-school-age kid, but unless that's crucial to your story, I think the reader is probably going to limit the identification more along the lines of big kid/ little kid.

Babies

- Two or three heads tall.

- Most of the facial features sink toward the bottom of the face.

- No neck. Head sits on shoulders.

- Eyes are large.

Toddlers (Little Kids)

- Four heads tall.

- Little-or-no neck.

- Facial features still placed low on the skull.

- Eyes aren't as exaggerated.

Preteens and Big Kids

- Five-to-six heads tall.

- The neck starts to lift the head.

- The significant difference among preteens, big kids and little kids is the length of the torso and legs.

Teens

- An adult with a proportionally larger head and slightly bigger eyes.

As a child develops, the head barely increases in size. The most pronounced growth is in the legs.

Not much growth

Significant growth

PROPORTION PROBLEMS

So, even though you've studied the guide to drawing bodies in proportion, you still look back on your finished work and see errors in your proportions. Especially this one: The head is big and the body gets progressively out of proportion the farther down the drawing goes.

This is a pretty common problem for artists, and even though I've never seen you draw, I'll bet I can diagnose the problem and offer a solution. Like many of us, most of your thought process follows a very rigid logic. You start at the top and you work your way down.

So the head starts out really well — with eyes and a nose and a mouth. But as you continue (and your concentration wanes), the proportions for the rest of the body tend to get more and more out of whack until you end at two little, atrophied feet. It's out of proportion. It's off-balance. And it's awkward as heck. And even though you've erased it and started over three times, you just can't get the hang of it.

Sound familiar?

Here's a great way to address that problem: Draw from big to little. When you're drawing a body (or anything, really), always remember to start with the biggest shapes and end with the smallest.

- Start your drawing by roughly indicating the space the figure will occupy.

- Then rough in the torso.

- Then move on to the legs.

- Now place the arms.

- Now add the head.

- Double-check the proportions using the one-quarter checkpoints we discussed.

- Only now are you ready to start adding smaller details like fingers and eyes and a nose and mouth.

This is an excellent habit to develop. And it works on anything you're drawing — from dinosaurs to airplanes. Start with the biggest shapes, get those into the proper proportion, and then move on to smaller and smaller details.

PUTTING IT INTO PERSPECTIVE

Now that you have a grid to work from, you can use it to draw a body in perspective. All you have to know is how to divide a grid in perspective. Start with a rectangle that recedes into space.

- Draw lines from the opposite corners, and where they intersect, draw a cross-bar.

- You've now divided the rectangle into two smaller rectangles. Use the same technique to divide these smaller rectangles evenly as well.

- To define a space for the head, divide that top rectangle one more time.

You now have a grid to use to guide you in building your figure. The top line will fall where the figure's chin is, the next one down lines up with his chest, then comes the groin and finally the bottom of his knee.

This can be used to help you create a body with an accurate perspective that recedes into space.

If you really want to show off, you can use vanishing points to draw a three-dimensional "box" with the corresponding grid marks and draw your figure inside that box. This is particularly useful when you're drawing a figure in an exaggerated perspective.

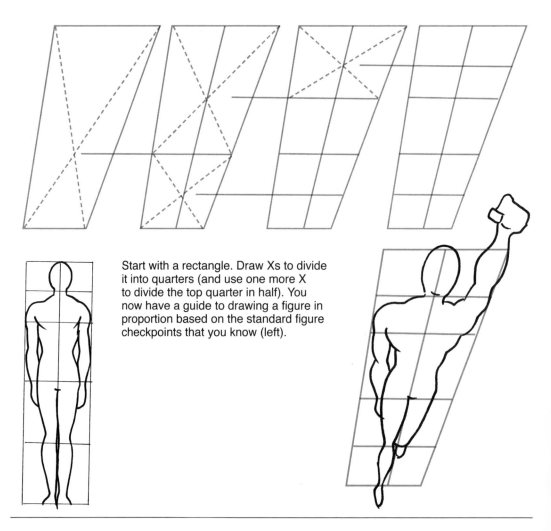

Start with a rectangle. Draw Xs to divide it into quarters (and use one more X to divide the top quarter in half). You now have a guide to drawing a figure in proportion based on the standard figure checkpoints that you know (left).

BALANCE

Here are some pointers on keeping that body balanced once you put it into motion.

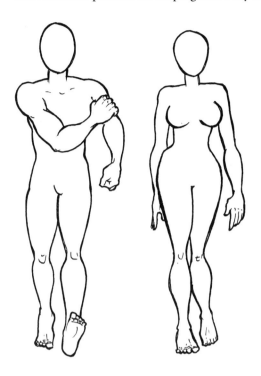

ALTERNATE SWINGERS

The first one is a relatively simple one that I see getting blown time after time: As the body walks forward, the arms and legs alternate.

In other words, as the left leg swings out, the right arm swings out.

And when the right leg is forward, it's the left arm that is out front.

GET OUT A-HEAD

As the head gets farther ahead of the weight-bearing foot, the perceived momentum increases.

GETTING HIP

If you're like me, when you're drawing a walking figure from behind, you constantly get flummoxed over which butt cheek to emphasize. Here's a simple reminder: The hip is lower above the foot that's carrying the weight. That means that the cheek over the weight-bearing foot is going to be more prominent.

MAKING HEAD LINES

When the body is at rest, the head will line up directly over the feet. At a moderate rate of forward momentum, the center of the skull will line up just a little bit in front of the foot that's carrying the weight.

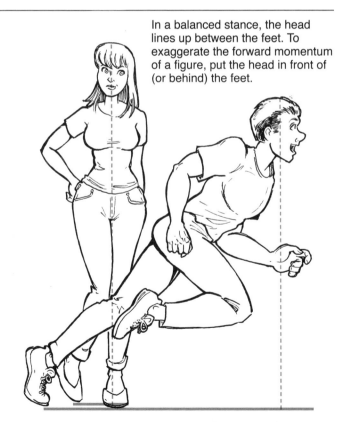

In a balanced stance, the head lines up between the feet. To exaggerate the forward momentum of a figure, put the head in front of (or behind) the feet.

WALK CYCLES

A walk cycle is the process of walking, broken down into its identifiable components. It's the process of shifting weight from one leg to another while thrusting the body forward. Animators study walks cycles closely because a poorly executed walk cycle can kill an animation.

If you're not a history buff, feel free to skip to the next subhead.

We owe much of what we know about the mechanics of human and animal locomotion to a fine, bearded photographer named Eadweard Muybridge, who, in 1872, was called in by former governor of California and race-horse owner Leland Standford to settle a hotly debated question down at the track: As horses gallop, do all four of their hooves ever leave the ground at the same time?

Muybridge set up a line of cameras along the side of the track. Threads, stretched across the track, were rigged to trigger individual cameras as they were tripped. As the horse galloped along the track, each camera, in succession, captured a portion of the horse's movement.

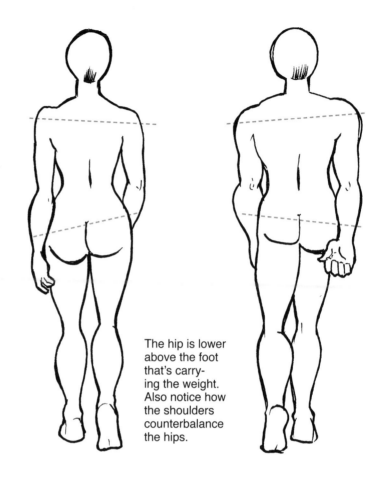

The hip is lower above the foot that's carrying the weight. Also notice how the shoulders counterbalance the hips.

Incidentally, the answer is yes, all of the hooves leave the ground at the same time right in the middle of the horse's gallop.

After killing his wife's lover, Major Harry Larkyns, with a shotgun (*"Good evening, Major, my name is Muybridge, and here is the answer to the letter you sent my wife"*), he was tried and acquitted ("justifiable homicide"), and traveled to the University of Pennsylvania, where he continued his photographic

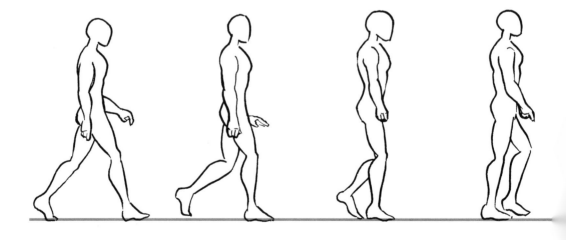

ENLARGING OR REDUCING IN PROPORTION

If you want to proportionally enlarge a rectangle, draw a diagonal line across opposing corners and extend it beyond the shape. Then lengthen each side of the rectangle so they intersect at the diagonal. The resulting shape will be a proportional enlargement of the original shape.

If you need to enlarge at a predetermined percentage, merely multiply one of the rectangle's sides by that percentage, extend that side according to the new measurement and proceed as normal, drawing a line in to intersect with the diagonal and then over to the other extension of the rectangle.

For example, if the left-hand side of the rectangle is 1 inch, and I want to enlarge it by 200%, I would multiply 1 x 2.00 = 2. I would extend the left-hand border of the rectangle to 2 inches, and draw a straight line over to the diagonal and then straight up to the top, completing the shape.

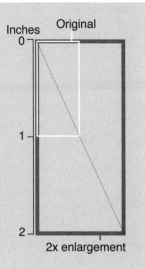

study of human and animal locomotion.

The University of Pennsylvania has a tremendous repository of these photos at its Web site (dla. library.upenn.edu). Or you can buy Muybridge's books. They're tremendously helpful.

DISSECTING THE WALK CYCLE

The illustration below is a useful image to hang above your drawing area. It's a reference you're bound to use often. Here are a few things to keep in mind when drawing a figure walking.

Counterbalance: As one leg is extended, the opposite arm extends to balance the figure.

Walking is a series of falls: The figure moves forward by swinging a leg out and leaning into the fall. As the weight distributes into the load-bearing leg, the other leg is pulled up at the hip and swung around for the next fall.

Shock absorber: As the weight is transferred to the forward leg at the beginning of a step, the front knee bends to absorb the shock.

Knee-jerk reaction: At the end of the step, as the weight is about to be fully distributed to the next foot, the lower part of the leg remains flexed below the knee until the leg is almost fully extended.

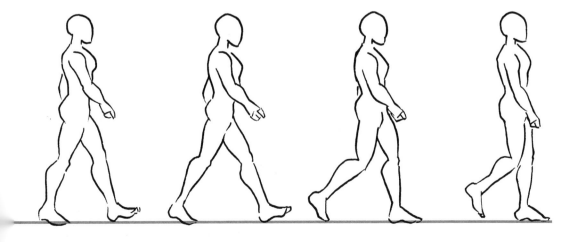

Here are some other walk cycles that might prove useful — including a few of the four-legged variety.

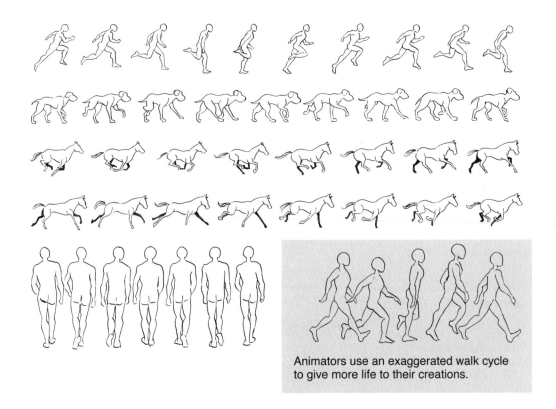

Animators use an exaggerated walk cycle to give more life to their creations.

THIS MAGIC MOMENT

Choosing the moment to illustrate in a panel is central to the success of a comic — and crucial to cartoonists working in single-panel formats like editorial cartoons and gag cartoons. You've brainstormed the who, what and where ... now don't drop the ball on the when.

BEFORE THE ACTION

Illustrating the moment before the action happens is an excellent way to increase the tension before the punchline. This is especially true if your scene include elements of visual tension (like a book teetering precariously on the edge of a shelf, seconds away from falling on the head of the person standing underneath).

In other instances, realizing what happens next is the punchline. The words provide the setup, and the reader's ability to take the scene to the next step based on the illustration provides the actual humor.

Either way, illustrating before the moment means making sure the reader is able to easily take the narrative to the next step in her imagination — based primarily on how you've composed the elements in the scene.

IN THE ACTION

This is definitely the most direct method used by cartoonists. It's logical and direct. But in terms of storytelling, it can also have such a diagramlike effect that it drains much of the life out of a scene.

Of course, sometimes there's simply no alternative. For example, in the case of dialogue between

two characters, there are really very few options in terms of choosing your moment. You're going to have to reach deeper into your bag of tricks to make that scene exciting.

I think the most important thing to keep in mind when illustrating action is to be mindful of the angle at which you're presenting the scene. You can present so much subconscious information — so much attitude — in choosing a high angle or a low angle, a long shot or a close-up. It's really a story/joke-killer to stay at that standard waist-high, medium-range scene.

AFTER THE ACTION

So few cartoonists choose to represent a scene by its aftermath, and that's a pity because you can really pull some neat tricks with this approach. For example, you can do the exact opposite of the fill-in-the-next-step approach we discussed earlier. You can show an unexpected outcome to an otherwise "normal" or ambiguous setup. Or you can show a completely normal scene that occurred as the result of a bizarre lead-in.

Almost always, this approach to presenting a scene relies on playing on the reader's expectations to deliver its drama/humor.

Let's face it. It's easy to get into the habit of illustrating the action of the scene — staying in the moment panel after panel. But as you're planning your drawing, take a moment to slide forward or backward in time. It just might be that the best way of describing a moment is to describe the moment before (or after) the moment.

LINE QUALITY

Varying the thickness of your line can improve your art in several ways. It's an incredibly powerful tool at your disposal. Using thicker and thinner lines can have three different effects.

Heavier lines indicate shading. Letting your lines get heavy in areas that are farther from the light source in the illustration (and thinner as they're closer to the light) can add instant three-dimensionality to your drawing.

Lighter lines fall into the background. You can push items into the back of the scene by drawing them with lighter lines. Drawing a heavy border around an item will bring it to the foreground.

Lines can be used as compositional tools. Lines of a heavier weight can organize the shapes into a unit. You can use similar heavier lines to tell your readers what items are important in a cluttered scene.

One popular visual method is to draw a heavy outline around all foreground characters. This look can be very striking, and the main result is that the foreground pops nicely off the background. But, like adding salt to a recipe, it's something that needs to be applied judiciously.

Notice how the line gets heavier to denote shadow (like along the boy's jawline in the second panel), and lighter to indicate highlighted areas (like the folds in his shirt in the same panel).

Q: Would it be OK to draw my comics on A4 paper? I find it hard to fill big spaces.

Drawing large helps you "shrink out" imperfections in your lines.

A: Sure you could. But if you're drawing that small, I think you're missing the benefits of drawing large and then reducing to the final size of the comic.

Reducing the art tends to make the line work look cleaner and smoother. All of the little shakes and quakes of your hand are minimized, leaving your lines looking much more confident.

For a long, long time, I understood this concept, but I never put it to adequate use. I would draw my original at 13x4", reduce it to 6x1.9" (approximately), and then add the lettering, process for print and Web, and be on my way. The reduced lines looked great, but my master files we only 6 inches wide. That left me in pretty bad shape when I needed the strips (or individual panels) to be larger. Given the way I lay out my books, this came back to bite me a lot in the first few *Evil Inc* books. It also left me in bad shape if I wanted to use the master file for any merchandising or promotional purposes.

Finally, I wised up and made my master strips 13x4". They still reduce before hitting newspapers or the Web, but when I use them at larger sizes (like when I'm designing my graphic-novelizations of the strip), I have a lot more leeway.

"... I find it hard to fill big spaces."

Everyone has a size at which they find it comfortable to draw. Some people have to draw huge with grand, sweeping strokes, and others are much more comfortable with a compact space to fill. In general, I think bigger is better. Beyond the reduction/line-quality issue, I think that drawing small can sometimes be the result of a lack of confidence. And if that applies to you, then the only way to get over it is to challenge yourself to draw larger.

How big? Again, speaking in strictly general terms, I would advise most beginning cartoonists to aim for at least 75% reduction between original art and final presentation. Once you gauge the effect that that reduction rate has on your art, you can adjust it to maximize (a) your drawing comfort and (b) the line quality you gain.

COMPOSITION

Sometimes we get so enmeshed in the routine of doing regularly updated art that we forget to pay attention to some of the small things that make a big difference in our work. One of these often-overlooked details is composition.

A well-composed panel will direct the reader's eye, in the correct order, through all of the important visual elements. For long-form cartoonists, this same concept is applied to the composition of the panels on the page.

But good composition doesn't just happen; it's planned out.

That's why almost every art class and instruction book talks about thumbnail sketches. Invariably they suggest running through dozens of possible compositions — in small, quick pencil sketches that indicate little more than general shapes — before starting to work on final art. And that's a very good idea. Except that it's kind of boring, and few people are convinced of its importance.

But you wanna take your game to the next level? Spend 10 minutes before every comic — whether it's a strip or a page — and rough out a few thumbnails. Indicate word balloons and dominant shapes. As you're considering strengths and weaknesses, consider how the word balloons flow from panel to panel. What is the dominant shape in each panel? Does the dominant shape help direct the reader to the next visual element along the way? Can you break figures or balloons out of panels to promote this flow even further?

We all get into the rut of repeating panels of mid-waist visuals with balloons floating directly overhead. Doing a few thumbnails is a great way to break out of this habit — and challenge yourself with a few more-complicated compositions at the same time.

In English, people read left to right, and top to bottom.
And, usually, the left-to-right instinct overrides the top-to-bottom one.

Because of my poor composition, many readers read a crucial word balloon
in the wrong order (or missed it entirely).

IS COPY/PASTE CHEATING?

Is it "cheating" to borrow from your own archive to copy-and-paste a character's head, background, entire body, etc.? I think the answer is yes and no — and the extent to which you're concerned with either side will determine how concerned you are about the topic of copy-and-paste cheating.

No, it's not cheating. Not really. As long as you drew it originally, it's yours to do with as you will. No one can fault you for repurposing it. And if you're having a particularly hard time getting an angle right or keeping your characters drawn "to model," this is one way to get yourself out of the hole and move on.

I still remember a week of *Greystone Inn* strips I did in which I tried to caricature Sarah Michelle Gellar from "Buffy the Vampire Slayer." Now, caricature was never my strong suit, but I wanted to try to pull this off nonetheless. I had such a rough time of it, I wound up photoshopping two heads that I thought looked sorta good and used them throughout the storyline. With a little alteration on each one, I kept it from being *too* obvious.

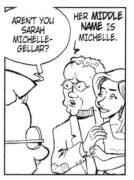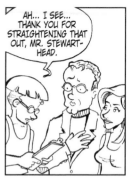

I had so much trouble doing a caricature of Sarah Michelle Gellar, I had to copy-paste her head throughout the strip with the one decent drawing I could muster. I must have been happy with the ham-handed caricature of Anthony Stewart Head, though.

However, you *are* cheating *yourself*. If I were advising an artist who was trying to improve, I would try to encourage that person to rely on copy-paste methods as little as possible. But not because I think it's cheating in an ethical sense. Rather, you're cheating your development as an artist.

Let's face it, fighting your way through a particularly tricky perspective shot is an incredible learning process that sticks with you throughout your career. Finding ways to keep your characters "on model" by using tricks like mirror proofing or character lineups will help you become a better all-around illustrator. Every time you rely on copy-and-paste, you flatten out the learning curve more and more.

HITTING THE JACKPOT
WITH A COMIC STRIP

Take a moment, if you will, to appreciate the beauty of the comic strip. It's long enough to promote character development and reader involvement, and yet it's short enough to produce on a daily basis. It seems to be the dominant webcomic format. And for good reason. The daily comic strip is a nearly perfect construct to attract and keep readers for a very simple reason: It's addictive.

Time for a little Psych 101. Positive reinforcement is when you reward a subject for a desired behavior. It's tremendously strong. You can get a mouse to press a little bar in the cage when you deliver a food pellet after the desired the action. Simple enough, right? Press bar, get food. Who wouldn't press that bar, right?

And if you keep delivering the food every time the mouse hits the bar, you'll get great results. But if you neglect to deliver the food a certain number of times, the mouse will stop pressing the bar. That's called extinction.

But what if you deliver the food pellet at a variable rate? Something interesting happens after the mouse has learned the behavior: If the pellet gets delivered inconsistently, the mouse starts pounding on that bar more than ever! And as long as the food doesn't stop entirely, that mouse is a bar-pounder for life. Because the next pellet might just be one more bar-press away. Variable-rate positive reinforcement has a very high response rate and a very low rate of extinction.

Slot machines work on this very principle.

WHAT DOES THIS MEAN TO YOU?

Your reader gets rewarded for coming to your site when that day's comic entertains them.

Naturally, your comic isn't going to be satisfying to every reader every day, but if you keep plugging away on a daily basis, your chances of hitting with a higher number of readers will go up as well.

And before you think this variable-ratio positive reinforcement is a ticket to phone-in your work and be good only sometimes, remember that there are new readers coming to your site every day. And they need to be "trained" to come back every day before they will become habitual readers.

The beauty of the daily comic strip is that, if you're giving your best effort day in and day out, the very nature of the format itself helps you to gain readers and keep them coming back for a long time.

HOW ADDICTIVE IS YOUR COMIC?

When we wrote the *How To Make Webcomics* book, we heard an outcry from folks creating long-form comics on the Web. The central complaint was that each of us did a comic strip, and, therefore, we were unqualified to comment on the unique challenges faced by people trying to do graphic novels on the Web.

I disagree for two reasons. First, from a reader's standpoint, there's really no difference between a long-form comic and a strip. They don't think in those terms the way we do. For a reader, it comes down to this: Is it an enjoyable reading experience? And when it comes to addressing that topic, long-form has to play by the same rules as strips.

Moreover, I've been working on a long-form comic for the better part of the past 13 years. It was a technique I started developing with my fist comic, *Greystone Inn*, and realized fully in *Evil Inc*. It's a long-form comic presented on the Web as a comic strip. As I said before, I think comic strips on the Web have an incredible power to retain readers. But my heart — my strength — is in telling longer stories. If you buy an *Evil Inc* book, you'll see that it's not a collection of strips; it's a graphic novel. I format the story to fit the medium it's presented in — strips for the Web and longform comics for the books.

LETTERING THEN INKING?

Yeah. Doing the lettering first allows you to do the following:

Create legible lettering without trying to cram it into predetermined balloons.

Adjust balloons to account for any lettering changes (edits, rewording, etc.) that arise.

Adjust the final composition of the panels before setting them in ink.

ASSEMBLY LINE

If you're working on multiple comics (for example, a week's worth of strips), don't work each individual strip to completion one after another. Instead, set up an assembly line.

First, do the pencilling for all of the comics. Then do the lettering. Then the inking. Then the scanning. Etc.

You'll find that you get into a natural rhythm, and the work actually goes faster as your mind eases into "lettering mode" instead of jumping from penciling to lettering to inking to scanning and back to inking.

I don't think this is the only way for a long-form comic to thrive on the Web. There are many ways to get to the same goal. But, having spent an inordinate amount of time in webcomics, I've identified three goals that have to be met — long-form or strip — that will maximize you're ability to retain readers.

THE MAGIC FORMULA

Simply put, you must make you updates **consistent, frequent and significant.**

Consistent updates: Once you've committed to an update schedule, stick to it. A huge part of retaining readers is making your comic habitual. You can't go from updating daily to a M-W-F schedule without losing or confusing a significant portion of your readers.

Frequent updates: The updates have to appear at the most frequent rate possible to ensure reader retention without sacrificing quality. If you can do your best work five days a week, that's optimum, but there's a lot to be said for two or three high-quality updates a week. (Web traffic drops so much on the weekends, it's hard to justify six or seven days.)

Significant updates: Each update has to be significant — both to your regular readers and to the reader who is arriving at your site for the first time that day. For a humor comic, that requirement is easily served by a well-written punchline. For a dramatic story, it's got to depend on a plot point — and that could be an important beat in the story, or a cliff-hanger, or any other moment that makes that reader's visit worthwhile.

Now, it's easy to see how the first two can be applied to a long-form comic, but applying that third point can become a major hang-up. For example, as one cartoonist who e-mailed me put it: "Sometimes you just need that full-page establishing shot." Or that ubiquitous full-page falling-down-a-well scene.

I still think devoting a full page to someone falling down a well is sloppy storytelling, but let's cede that point and get down to the (ahem) deeper issues.

One day I found myself complaining about a Web site run by a daily newspaper. I said:

> "Y'know the problem all of these papers make? They're trying to do a newspaper on the Web instead of doing a news-based Web site."

And as I heard the words come out of my mouth, it struck me: Maybe that's the problem with some long-form comics. They're trying to do a comic book on the Web instead of doing a graphic-novel-based Web site. In other words, maybe it's time to stop thinking about putting pages up on your site, and rather think about it in terms of updates.

Today's update might very well be a full page. But the next one might be three panels. And the update after that might be a page-and-a-half.

What's important is how each of those updates end.

I'm going to argue that each of those updates should end on a plot point of the story. Telling a story is kinda like building a wall. You introduce the concept, brick by brick, then you start unfolding the plot — in the order that will best allow your readers to follow and enjoy the narrative. If you don't establish a good foundation (or if you do it in the wrong order), the wall is going to fall down.

That doesn't mean that you have to move in chronological order, mind you. You can start in the middle and flash back. But be careful — if you don't establish some sort of narrative flooring for your audience, you're going to produce something that is very difficult to follow.

Those bricks are your plot points. And each one reveals a significant portion of your story — some-

thing that has to be developed before the next point is brought forth.

And if you're writing to maximize your updates, you'll try to end on a significant plot point every time.

If you don't reach a significant plot point, your reader will be left hanging in the narrative, with nothing to encourage her to move through the story — either forward by bookmarking/RSSing the site or backward by hitting your archives. Remember — you're not only trying to retain current readers, you're also trying to keep that reader who came to your site for the first time today.

I think long-form comics have amazing potential for the Web, but I also think it's going to mean leaving the trappings of print presentation behind.

Stop thinking pages and start thinking updates.

LIGHTBOX ALTERNATIVES

Many of us who still sling ink (in lieu of pixels) use a lightbox. It helps when drawing repeated images accurately. And it helps when you're using photographic reference.

However, lightboxes can be expensive and/or difficult to find.

Here are three possible solutions to getting a lightbox for your studio.

OLD SCANNER

An old scanner is a tailor-made lightbox. It has a sturdy base supporting a glass working surface. And certain scanners were rendered obsolete when Mac updated its operating system to Snow Leopard, so you can probably find them for incredibly low prices.

Once you get your hands on one:

- Remove the lid.
- Open the base and remove the insides.
- Install a small fluorescent light fixture that you can find in practically any hardware store. If you look around, you can find one with the on/off switch on the cord to make it easier to operate the light.
- Some folks recommend placing a reflective surface behind the light to reflect more light through the glass. Mylar, for example, would do this nicely.
- Other sources say you should affix a little parchment paper on the underside of the glass to help diffuse that light.
- Close up the base.

X-RAY ILLUMINATOR

I heard about a cartoonist who found out that his doctor was replacing all of his X-ray illuminators — those huge lightboxes that doctors use for viewing X-ray prints.

Believe it or not, you can find 'em on eBay.

Use the search term "X-ray Illuminator."

ART-SUPPLY STORES

Too much legwork? Open your wallet and buy one.

Lettering

Lettering in comics is handled in one of two ways; Either the lettering is drawn by hand or the cartoonist uses a digital font that resembles handwritten letters. Either is perfectly acceptable (unless the font in question is the despised Comic Sans), and each comes with its own strengths and weaknesses. Hand-lettering always tends to match the look of the comic much more closely than a font ever could. Additionally, if you're working in ink, it makes it much more attractive to offer for sale as original art. However, hand-lettering requires a great degree of practice, and correcting mistakes is much more difficult than lettering-by-font. Using a font has the advantages of legibility and quickness. Editing on the fly is simple when you use a font, and so is the creation of great-looking sound-effect lettering. However, many cartoonists choose a font that doesn't complement their strip, and buying a good digital hand-lettering font can be quite expensive.

HAND-LETTERING FONTS

If you're using a Windows computer, you probably have Comic Sans already loaded on your hard drive, and you're doubtlessly tempted to use it rather than invest in a hand-lettering font. Comic Sans is an awkward-looking font, and it has been overused to the point of being recognizable by even casual readers — and associated with the cheesiest of content. Don't use it.

There are two great sources for hand-lettering fonts: Comicraft and Blambot. They offer a wide array of lettering fonts — allowing you to find one that might work well with the style of your illustration. They also offer great-looking sound-effect fonts to really put the look of your comic over the top.

Hand-lettering fonts can be expensive, but Comicraft has an annual sale on January 1 of ever year. On New Year's Day, the price on each of the company's fonts is based on the year. So, on January 1, 2014, you could buy fonts from Comicraft for $20.14 apiece. That's a tremendous way to ring in the new year.

WORD BALLOONS

Want to make a small change in how you do your comics that will elevate your game overnight? Improve your word balloons. It's the single most common flaw in most beginners' work that immediately identifies them as novices in the eyes of their readers. And, amazingly, the problems are ridiculously easy to solve. Address these problems, and your work will take on an air of professionalism that is bound to be noticed by your readers.

LEAVE AN INTERIOR BORDER

This is the most common fault in novice word balloons. It's amazing to see how many cartoonists allow their text to touch the lines of their word balloons. At all times, there should be a significant, consistent border inside the word balloon that the block of text floats in.

KEEP THE INTERIOR BORDER CONSISTENT

I blame computer typography for this one. Most applications flow text into a rectangular box. But cartoonists place their text into a circle. As a result, there is often more space above and below the text than there is on the sides — which looks awkward. Luckily, if you're setting type digitally, you have a simple fix for this problem. Just move the type up and key in

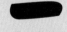

a hard return after the first word or two, forcing the rest of the copy below the first line. You can even place a strategic return near the end of the text to force one or two words into the bottom of the balloon.

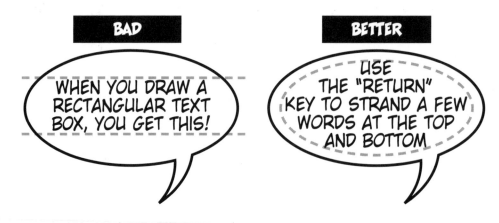

NEVER EVER CROSS TAILS

This is a cardinal sin in comics.

It is rarely, if ever, acceptable to allow the tails of your word balloons to cross. There are several ways to fix this problem. The most obvious one is the switch your speakers so their word balloons line up to be read straight across from left to right. If you're unable to switch your speakers' position, try stacking the balloons so the right-hand speaker's balloon appears above the left-hand speaker's balloon. Whenever I do this, I try to indent the bottom balloon slightly so there's no chance a reader will try to read left to right rather than top to bottom.

Finally, if you cannot change where the characters are standing, you still can use panels to break up the action, allowing the right-hand speaker to lead off in one panel, leaving the next panel for the left-hand speaker. The word balloon is the primary conduit through which your readers experience your work. A little time spent perfecting your delivery will be translated into a much better reception of your work by your readers.

Word balloons are so common — so freely accepted as a part of a cartoonist's visual syntax — that many of us haven't given the subject a whole lot of thought. Looking back at my own work, I know I didn't for the first several years. For my taste, all good word balloons share some traits:

- The body of the balloon is circular.

- The tail has a slight curve to it and points to the speaker's mouth.

- Tails never cross.

- Text is centered — vertically and horizontally — in the body of the balloon.

- The style of the balloon matches or complements the style of the illustration.

BALLOON PLACEMENT

OK, now that you know how to do an elegant-looking word balloon, what do you do with it? Well, aside from pointing the tail to the speaker's mouth, there's not much left to it, right? Wrong. There are many strategies for placing a balloon in a panel — and each has a benefit in terms of composition and text handling. So, let's get the obvious out of the way. This is a standard placement. There's a little space between the panel borders and the balloon. It's equidistant from both the top and the right-hand border.

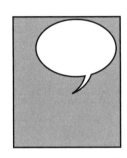

Docking

Of course, you can butt the balloon up against the panel border. I've seen this referred to as "docking." I have to admit, I'm not crazy about the look, but it eliminates dead space above the text (and to one side, if you dock it to the top and side of the panel), so it's a favorite for getting more words into a panel. Remember, docking the balloon doesn't eliminate the necessity to keep a consistent spacing between the text and the borders of the balloon.

Knockout

I remember the first time I saw this technique. It was in a *Hagar the Horrible* strip. I immediately fell in love with how it opened up the otherwise cramped confines of the newspaper-strip setup.

I use this one quite a bit in my comics. The secret to doing it well, I think, is not to get too close to the corner. See that little triangle that gets formed in the upper right of the example? If that triangle gets too small, the effect gets wonky. Of course, you could always make the body of the balloon so big that it eliminates the triangle entirely. But, again, to my taste, it's not as elegant an effect.

If you're creating word balloons in a vector-illustration application like Adobe Illustrator, draw ellipses and apply commands (such as **Object -> Pathfinder -> Subtract** and **Object -> Pathfinder -> Add**). If you're drawing them by hand, use circle templates to help keep your lines smooth.

Draw an ellipse.

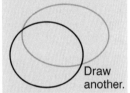

Draw another.

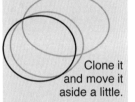

Clone it and move it aside a little.

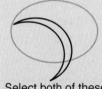

Select both of these secondary circles and use: **Object -> Pathfinder -> Subtract.**

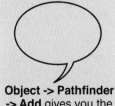

Object -> Pathfinder -> Add gives you the final word balloon.

HAND-LETTERING

When he's not working on tremendous creator-owned titles like Misery Loves Sherman *and* Cow Boy, *Chris Eliopoulos is a letterer for Marvel Comics. He has kindly provided for us this detailed guide to his hand-lettering process.*

With the advent of computer-lettering, it has become easier to letter comics quickly and with greater ability to edit. One of the skills that has slowly been pushed to the side is hand-lettering.

For years, almost all comics were hand-lettered. Two examples that are obvious exceptions were *MAD* magazine and the delightful and unique *Barnaby* by Crockett Johnson. But one of the things about hand-lettering and even the choices made by Johnson or *MAD* is that the lettering contributes to the overall look of a strip. If you look at strips like *Peanuts* or *Pogo* or even *Cerebus*, the lettering became an important part of the overall look. A font was created of Charles Schulz's lettering, and even if there were no art and you saw that lettering, you'd know who the author was.

There are many good reasons to use computer fonts, and there are equally good reasons to hand-letter; with hand-lettering, your lettering will be unique. With these readily available fonts, you see them on every strip and there is no individuality. You can also better integrate the lettering and art when it's hand-done. Sometimes it looks as if computer fonts are just pasted on top of a strip. And, of course, when hand-lettering is done, you have a whole strip on a board to frame or sell.

But how does one get good at hand-lettering? Well, it takes time and practice. Just as you practice drawing hands or using a certain pen or brush, you must also devote time to mastering hand-lettering.

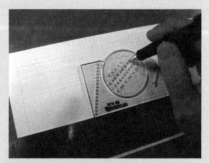

THE PROCESS

Most lettering is all uppercase because upper- and low-ercase (U&LC) lettering takes a lot more space and leaves a lot of dead space. You may want to go U&LC if you want a special look, but to save space, I suggest sticking to all up-percase. That said, what kind of tools to use is another choice that's up to you. Use a Speedball pen, brush, Rapidograph, felt-tip pen — whatever you feel comfortable with — though a marker will fade over time.

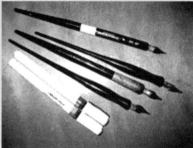

I use a T square and an Ames lettering guide* to set up guidelines. When I was young, I just assumed that the artist just did it freehand. I believe I read a story that Schulz was so good at lettering he didn't put down pencil guidelines after do-ing the strip a few years. But I have learned that I need them. The Ames guide can be bought at an art-supply store or Dick Blick online. Very simply, you rotate the wheel to the size at which you feel comfortable and just glide it along the T square with your pencil. My originals are 4x13, and I have my guide set at 5 1/2. The guides provide the area or "x-height" to letter in and also give you a smaller space or "leading" between the lines of text.

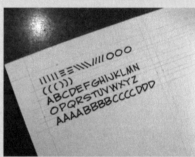

Next, I pencil in the text lightly, just to see how much can fit on each line. Then I use a No. 2 Rapidograph for regular text and a No. 3 for bolds. Bolds are usually bold and italic, and the crossbar "I" is used only on the start of words like "I'm," "I'll," "I've," "I," etc.

* *There's a detailed, step-by-step guide at the end of this chapter.*

WHERE TO START

Go down to your local copy shop, and make copies of strips you like to original size. Then take a piece of tracing paper and draw rule lines under the strip's letters to create horizontal guides. Grab a pen and copy the text. Practice tracing the lettering to get your hand accustomed to doing it. Then draw rule lines on a piece of Bristol board and try practicing that way.

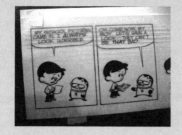

The key with lettering is remembering that each character is made with similar lines just moved around. You have a horizontal straight line, a vertical straight line, diagonal straight lines and curves. Mix those basic lines and you have all the letterforms. When I was hand-lettering comics, I would warm up by drawing those lines, not the actual letters. The difference between hand-writing and hand-lettering is consistency. And consistency of lettering looks easy, but only after the practice it takes to look effortless.

SOUND EFFECTS

Big sound effects or shouts in a balloon have a similar method of creation. I usually pencil them out first to get a consistent look, then take a pen to make the outlines and, often-times, fill them in with black. You can make them sharp and angular or wavy and scary — go look at some other strips for samples to see what you like, and imitate and adapt.

GET TO IT

So, hand-lettering may seem harder and may take more effort, but I think i's worth it. My strip has a look in its lettering that no other one does. I could never imagine this strip looking any other way, and I think you could have the same results given a little time and patience. Your strip will be complete and unique and will stand out in a crowd, so get working!

LETTERING TIPS

XFEHY

Make two guidelines for the letters' height, and one in the middle. Many letters guide off these three lines.

A You'd think "A" would fit into this category, but the crossbar drops below the middle guide.

BPRK

Some letters trap white space — like the top halves of "P," "B" and "R." Notice how those forms connect below the middle guide. The bottom half of the "B" should be somewhat bigger than the top.

S Like "B," the top curve of "S" should be slightly smaller than the bottom.

OCQ

Some letters trap lots of white space. Let these dip slightly below the bottom guide or they'll look too small.

LJT The common mistake with "L," "J" and "T" is to make their horizontal bars too long.

II Avoid using the serifs on an "I" unless it's standing alone.

MW The middle parts of "M" and "W" should reach all the way to the guide.

PUTTING IT ALL TOGETHER

Spacing letters to form a word is called "kerning." Letters that trap white space tend to push neighboring letters away a little. Letters that don't (like "I," "T" and "J") pull neighbors close. Kerning is an art, not a science.

GOOD GRIEF YOU BLOCKHEAD

"Leading" is the space between lines of type. I like mine about 20% of the height of the letters.

Overlap

Scott Kurtz uses an overlapped word balloon in *PvP* quite often.

Paired with a transparent PNG file, he gets a really cool effect on his site.

I think the key to using this technique is restraint. Floating the balloon too far away creates a disconnect between the balloon and the panel — which is counterproductive.

The two should work as a unit.

Bridge

Now, I've been reading comics since the late '70s — and working on them since the late '90s. And I'd never taken notice of this approach until a couple years back, when I was paging through an old *Batman* comic and saw this.

I gotta tell you, I think this strategy is brilliant.

I can tell you from experience that it sets up some really interesting compositions and — since some of the space that it uses comes out of the gutter — it's a good way to get more words in.

I can also tell you from experience that the key to doing this well is keeping the tail away from the gutter. If you get it too close, it looks awkward.

SPECIAL BALLOONS

Burst balloon

If you're doing this digitally, creating a starburst is pretty simple, but hand-drawing a starburst can get a little tricky.

Here's what I do: I start by penciling a standard word balloon, and then I draw a larger ellipse around the body of the balloon.

Then I draw a zigzag line between the two guides.

If I keep the angles roughly consistent, I can make it all the way around without it looking ugly.

Compound balloon (1)

You can divide the word balloon of a single speaker in the same panel.

This is useful if the speaker is interrupted by another speaker or if the speaker is delivering two separate thoughts in the same panel. Heck, it's even a darned useful way to indicate a pause.

I prefer for the connector tail to be a natural extension of the balloon tail.

Compound balloon (2)

Of course, there's nothing that says that you need a connector tail between the two parts of a compound balloon.

You might choose to mash both balloons together. But, again, in choosing where to intersect the two balloons, I try to position them so they meet in the zone indicated by the tail.

WORD-BALLOON GRAMMAR

Comic-book typography comes with its own unique set of rules. For example, there are dozens of accepted contractions — like "you betcha," "howcome" and "waitaminit" — that would make an English teacher's bespectacled eyes spin. My personal favorite is "lemme," which is used in place of "let me."

But it's not all free-form expression. There are a few DON'Ts to accompany all those DOs.

NUMBERS

Whenever possible, avoid using numerals in your word balloons; write out the word instead. For example, don't use "25", write "twenty-five" instead.

There are a couple of reasons, the most important of which is that in hand-lettering (and fonts that mimic hand-lettering), certain numbers can look an awful lot like letters. A 5 can look like an S, for example. A 1 looks like an I or a lowercase l. And then there are 0s and Os, 2s and Zs. Heck, sometimes a 3 can even read like an E.

So, you're much better off writing the word out unless it's a very complicated number.

Ten thousand is easy to write out. So is thirty-three. Heck two hundred seven is pretty doable.

5,358 would probably be better off left as numerals. And, yes, I'd use the comma — if for no other reason than it helps identify it as a number.

With complicated numbers, there are no hard-and-fast rules. Oddly enough, I'd leave 256.7 as a number, but I'd write out two-and-a-half (complete with hyphens, please).

Why? It's about enabling your reader to zip through your word balloons without being tripped up. This is especially crucial for humor comics — where so much effort is put into timing. Anything that causes your reader to pause brings him or her out of the moment. And that's bad for your comic.

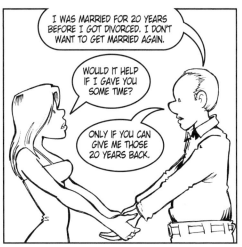

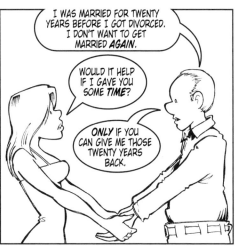

I think the bottom version — with the number written out — reads more fluidly. Anything that might cause the reader to stumble (like mistaking numbers for letters) should be avoided.

MY PERSONAL
WORD-BALLOON JOURNEY

As I was writing this book, I started thinking about word balloons in a philosophical way. Improving your word balloons is one of the simplest fixes to make in your comic that delivers the biggest return on investment. Well-done word balloons increase the professionalism of your comic, they help convey the proper tone for your comic and — most importantly — they make your comic easier to read. And smooth readability is of paramount importance when you're working in a format that bases most of its merit in being able to be consumed quickly.

Then I began to look at my own work a little more closely. And I wasn't crazy about what I was seeing.

MY CONFESSION

Since the very first days of my first comic, *Greystone Inn*, I'd done word balloons backward. I completely went against the elementary advice I gave to every novice I ever met. Instead of lettering first and drawing the balloon around the words, I drew a balloon and then later filled it with digital type.

And, to be fair, I was pretty good at it. I could guess the proper size consistently. And when I didn't, I could use Photoshop to make any adjustments.

But it lacked a great deal of finesse. And, sometimes, I painted myself into a corner. This comic was the final straw.

In Panel Two, I left way too much room, forcing me to over-enlarge the type. In the next panel, I left too much room, but didn't have a logical reason to enlarge the type. And, finally, in the last panel, I left too little room. And because of the composition of the last two panels, I didn't have the ability to enlarge the balloon.

MY ADJUSTMENT

So the next week, I made the commitment to lettering a new way. I still penciled in the word balloons, but I didn't ink them. I wanted to be sure I accounted for the balloons in my composition in some way — leaving larger balloons for wordier passages, etc. — but I didn't want to get hamstrung by those decisions.

Later, when I added the digital lettering to the final art in InDesign, I created word balloons with the ellipse tool using this method. The effect was pretty dramatic. For starters, it made it very easy to do something that I wasn't able to easily do before — break the balloon out of the panel, as I did in the third panel of the very first strip I did in the new system ...

Secondly, it made it easier to "plant" the balloon into the corner of a panel, like the upper-left-hand corner of the second panel below.

In fact, I've been able to compose my strips with a much wider variety of balloons — and that has given me not only flexibility, but also a more polished visual presentation.

Most importantly, it allowed me to mold the shape of the balloon more closely to the shape of the group of words, instead of having balloons that left awkward borders like the one directly below.

I was able to create balloons that conformed nicely to the shapes of the blocks of type they were containing, and that led to an ability to pull off much more complicated compositions.

WORDS

Here are some commonly used words and contractions used in comics — and a few that are misused.

Yeah (pronounced *yaa*) is a slang of yes. "Yeah, I agree that Larry Fine was the Forgotten Stooge." Nine chances out of 10, if you're using a slang for yes, you want to use "yeah."

Yay (pronounced *yay*) is an excited exclamation or a cheer. "Yay! Our team won!" If you're cheering, you probably want to use yay.

Yea (pronounced *yay*) is also a slang for yes, but it's not interchangeable with yeah. Because yea rhymes with hay. Unless you're quoting Biblical text about walking through the valley of death, you probably shouldn't be using yea.

Ya (pronounced *yah*) can be used as a slang for yes, but again, it's not interchangeable with yeah. It shouldn't be used unless your character is speaking with a thick German or Swedish accent (in which case, it's actually a slang for "*Ja*"): "Ya, I would like more meatballs."

Ya (pronounced *yah*), of course, can be a slang for you, as in "Get over it already, will ya?"

Uh-oh means "there's trouble brewing." I will argue that this is one of many phrases used in comics that benefit greatly from the use of a hyphen. "Uh oh" just doesn't convey the same expression.

Uh-uh means "no." Commonly misspelled as "uh uh." The hyphen makes all the difference.

Uh-huh means "yes." Again, you need that hyphen. "Uh huh" doesn't convey the idea as well.

, eh? (pronounced *A*). Used in ubiquitous Canadian-accent joke: "I'm from Canada, eh?" Commonly misspelled as ay, ai or aye. This entry is listed as ", eh?" because it singles out a specific use for "eh," which can be used in many different ways to convey a few different expressions. "Eh" can be used for "huh," or it can be used as "aw," or it can even be a simple nonverbal grunt, but when it's used after a comma to elicit agreement from the person being addressed, it should be ", eh?"

Aye (pronounced *eye*). As in "Aye-aye, Captain, setting a course for Beta Centari!" Not "Aye aye, captain" or "Aye, Aye, captain." And not "ay-ay" (or "eye-eye"). This is a phrase that is greatly helped by using the hyphen between the two words. Save the "ay" for "ay, papi" — which is a completely different kind of comic.

'course and 'cause: Shortened forms of "of course" and "because," respectively. These are perfectly fair contractions, but don't forget the apostrophe. And if you really want to impress the typophiles in your audience, make the apostrophe look like a little "9," not a "6" — same thing with abbreviating years (like '98). You'll get gushing e-mails on it if you do it right, I'm telling ya.

y'know: Contraction of "you know." This one is far from right or wrong, but I think this contraction for "you know" is far more readable than "ya know."

Kinda: Contraction of "kind of."

Whoa: As in "slow down; stop." Commonly misspelled as "woah," "wo," "woe" or "woa."

PUNCTUATION

Often in comics, punctuation marks are doubled or mixed to convey complex emotions. And that often leads to some pretty confusing situations for a cartoonist.

Which comes first?!

Sometimes a question can be asked in such amazement or excitement that it takes both forms of

punctuation to convey the emotion. But that begs the question: In what order should they appear?

Since the overall nature of the sentence is a question, I think the question mark should come first. The exclamation point is secondary, and therefore should come second, providing the emotional push.

You've been in the room the whole time?!

I can't honestly think of a situation that would merit a "!?"

Doubling up!!

There's an old adage among writers of prose: Writers are allowed three exclamation points ... in their entire lives. Obviously, we cartoonists don't live by that credo! We love our ?s and !s. But even *we* can go overboard. And that leads to a diminishing return on the emotional value of the individual punctuation mark.

So when something's really exciting, we double up — using a !! or a ?? to convey an extra charge to the sentence. Of course, here's where things go astray. Because if you use !! or ?? too often, you're going to wind up having to throw in a few !!!s and ???s. And then things really get ridiculous.

For me, I'll allow myself plenty of ?s and !s. And every once in a while — for a really good reason — I'll throw in a !! or ??.

But tripling up — like !!! and ??? or even ?!? — I'll use them three times.

In my entire life.

The pause that refreshes ...

Of course, that doesn't apply to the versatile period. Using three periods to indicate an omission in a sentence is called an ellipsis. We cartoonists use it to indicate a pause. The ellipsis is a powerful tool to control the rate at which your reader is moving through your sentence. A well-placed ellipsis can slow the reader down at a crucial point and help build suspense.

But, please, don't use an ellipsis where a simple comma will do.

There's going to be a delay ... ?

The cool thing about comics grammar is that we've developed so many innovative ways to use punctuation to convey emotion. For example, following an ellipsis with an exclamation point or a question mark indicates a delayed surprise/excitement or delayed confusion (respectively).

All alone

Compound punctuation is so adept at conveying emotions that you can actually use it alone in a word balloon — without any words. In fact, all of the mixed punctuation discussed here — including the ellipsis — can be used alone in a word balloon to communicate clearly a silent reaction.

And that's powerful stuff.

THE AMES LETTERING GUIDE

TYPOGRAPHY TERMS

Before we get started, let's cover some typography terms:

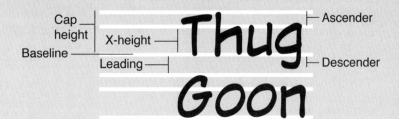

This is the Ames Lettering Guide. It is used to draw measurement guides used to do hand-lettering.

We're going to focus on the center rows of holes on the Ames guide. They're used to measure lettering at 3/5 x-height, even x-height and 2/3 x-height.

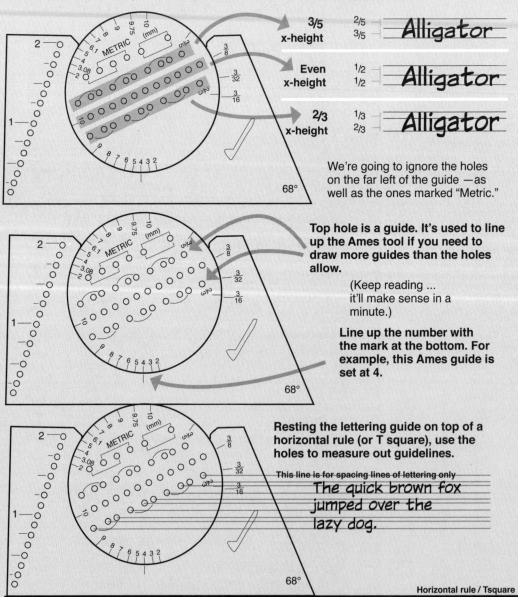

We're going to ignore the holes on the far left of the guide —as well as the ones marked "Metric."

Top hole is a guide. It's used to line up the Ames tool if you need to draw more guides than the holes allow.

(Keep reading ... it'll make sense in a minute.)

Line up the number with the mark at the bottom. For example, this Ames guide is set at 4.

Resting the lettering guide on top of a horizontal rule (or T square), use the holes to measure out guidelines.

This line is for spacing lines of lettering only

The quick brown fox jumped over the lazy dog.

Horizontal rule / Tsquare

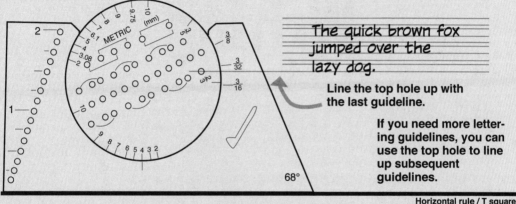

The quick brown fox jumped over the lazy dog.

Line the top hole up with the last guideline.

If you need more lettering guidelines, you can use the top hole to line up subsequent guidelines.

Horizontal rule / T square

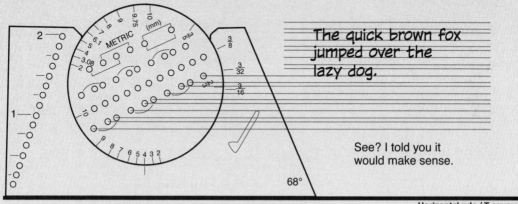

The quick brown fox jumped over the lazy dog.

See? I told you it would make sense.

Horizontal rule / T square

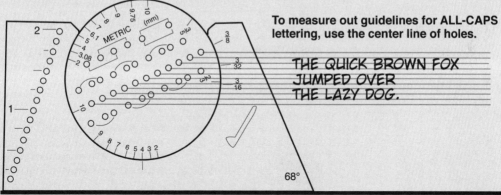

To measure out guidelines for ALL-CAPS lettering, use the center line of holes.

THE QUICK BROWN FOX JUMPED OVER THE LAZY DOG.

Horizontal rule / T square

Pro Tip: Looking at all of these lines can get confusing...

... group the lines with little " (" marks to collect them into units.

AHHH... THAT'S BETTER...

Writing

When I was approached to write *The Everything Cartooning Book* (an excellent beginner's course in general cartooning), I insisted on having a chapter on writing. Same with *How To Make Webcomics*. It infuriates me that it's not a standard topic in every cartooning tutorial.

Writing is more important — by far — than art when it comes to many kinds of cartooning (with the exception of some long-form efforts like superhero comic books). Among the most successful comics, you'll find some of the most rudimentary art.

So why isn't it in *every* cartooning book? Because teaching writing is hard! And humor writing? Forget about it! So most cartooning books focus on the mechanical aspect of the subject and try to sneak past the subject that cartoonists desperately need to be discussing: writing.

Not this book. We're going to tackle the subject head-on. I can't tell you how to write. That has to be a personal journey for you. But I can give you some strategies to use to help you find your way.

FINDING YOUR STORY

I often caution people against trying to manufacture success. They try to look at what's hot at the moment and then develop a comic that addresses its popularity. It's probably the reason the Web is overpopulated with video-game comics. The problem with that is unless you can write — really write — material for that topic, it's going to sound hollow to your readers, and you'll never get the traction you need to succeed.

I'd also caution against what I call the "demographic comic." This is a comic that is based on a strong statistical trend in hopes of attracting an audience from within that trend. An example is a strip centered on "boomerangers" — kids who have graduated from college and then have moved back home with their aging, baby-boomer parents. If you don't have a twentysomething child standing on the doorstep, pleading for his old room back, you're just not going to be able to write on that topic very well, in my opinion.

Instead, check your two most important organs: your brain and your heart. (If your answer was something else, that's an entirely different kind of comic.)

YOUR HEAD

Your best story just might be behind the thing that you know the most about — the topic in which you hold the most experience. And if that's a seemingly underwhelming topic like quilting, then that's what it is. Because you know that quilting isn't just about blankets; it's about community and relationships and traditions. You know about the culture that has developed among quilters. You know their language, and you know their shared experiences.

You're an expert in something. You have an exhaustive knowledge of a topic — even if it doesn't seem to be a particularly marketable one. And, if the past 10 years have taught us anything, it's that no topic is too mundane or too marginalized that it can't find a healthy niche readership on the Web.

So look in your head. What's in there? It might not be particularly awesome, but it's yours. It's you. Embrace it.

YOUR HEART

Conversely, your best story might lie in your heart. It might be the topic about which you are infinitely fascinated. It might be that place that your mind always wanders to — no matter where it starts out.

Maybe it's nature. Maybe it's the idea of life on other planets. It's that topic that you know — no matter what — if a movie or a book comes out with this thing as its theme, you are going to love it.

You might not know a lot about this topic, but you find it endlessly fascinating. You don't have an exhaustive knowledge about it, necessarily; but you have an inexhaustible interest.

HUH?

And that leaves you working on a comic about needlepoint naturalists from Dimension X, right?

Well, not necessarily. (Although, it *does* have possibilities ...)

You could develop a comic that is directly and literally linked to your head or your heart.

But you could also develop a comic that works off of these themes in a tangential way. For example, someone with an endless fascination of nature could easily direct that passion into an outer-space, sci-fi comic. The naturalists become explorers, and the animals become aliens.

And although a comic about quilters may or may not have much of a future on the Web, a story

"Phables" (phables.com) was a great project for me because its theme — stories about life in Philadelphia — had captured both my head (I had lived in the city for years and had a number of my own stories to share) as well as my heart (I love the city).

that uses a quilt as a metaphor throughout a larger narrative of life in a rural village could certainly have legs.

The best-case scenario, of course, is that you find a theme that applies to both your head and your heart. But I'm not going to say that it's a prerequisite. After all, if you're really passionate about something, you're going to end up with expert-level knowledge on that topic. And you can't really hold an exhaustive knowledge without a certain amount of passion. Having one is going to lead to the other if it isn't already there.

One thing I can state with conviction is that starting your story from one of these places — head or heart — will have three effects:

- Your writing will be more true. It will have authority and conviction.

- Your ideas will come more naturally — mainly because you'll be able to see this topic from perspectives and angles that "civilians" never approach.

- You will enjoy it more. And your enjoyment will infect your readers.

THEMES

I'll bet just about everybody has at least one good comic in them — a good gag, an interesting story, etc. After all, every now and then, even a blind squirrel finds an acorn. But we're not blind squirrels, are we? We're cartoonists. And that means we have to be nuts on a regular basis.

From my experience, I can tell you that it helps to have a theme to fall back on when the creativity fails to crackle.

Whether you're doing a dramatic long-form comic or a gag-a-day strip, a theme that works for you can help you iron out the bumps between moments of creative genius. A good theme contains a number of touchstones that you can count on to ignite your own personal creativity. It's the central engine of your comic. It defines the work that you do.

WHAT'S IN A THEME?

Here's what I think helps to define a good theme:

- It has an element of uniqueness to it.

- It incorporates a subject (or subjects) that you are either endlessly fascinated by or hold a great degree of expertise in.

- It touches you — and who you are deep down — personally.

You have to choose the theme that fascinates you — even if you're positive that there couldn't possibly be anyone else who could share your fascination. After all, this is the Internet. If there's one place where the ultra-small niche survives — and thrives — it's here.

A good idea is nice, but it's the excellent execution of a good idea that brings the readers to your site. If your comic's theme is something you're passionate about, that execution will come from a place of passion — not obligation.

SPACE DAD

So, for the sake of discussion, let's say you have a real passion for sci fi space-exploration stories like "Star Trek" and "Lost in Space."

And, we'll throw in some real-life influence: Your wife just had a baby. A surefire win for you would be to develop a comic that combines your love — space-based sci-fi — with all of the real-world humor you're going

to be exposed to in the years to come — being a new parent. Heck, from my experience, becoming a parent felt very much like being transported to an alien world.

We'll call the fictional strip *Space Dad*.

In our *Space Dad* example, the theme can be used to add a new twist to an old concept — coaching Little League in zero gravity, for instance, might give new meaning to the phrase "You're out!" (Waaaay out.)

Furthermore, the theme can also be used to guide the development of new characters. Again, in our example, the neighborhood bully might be cast in the guise of a hostile alien — with all of the possibilities that might imply.

You can stretch your writing muscles from there, but whenever you're feeling a little drained — creatively speaking — you have that touchstone, that theme, to fall back on ... ready to help generate new ideas on a moment's notice. (For example, if your babysitter is an alien, do you really want to encourage her to give the baby "formula"?)

When you're choosing a theme, remember that cartooning is a continuous pursuit. Once you commit to this concept, the goal is to write to that theme for an extended period of time. So give it some serious thought. Otherwise, either you're going to get bored or you're going to run out of material fast.

WRITING FROM THE SUBCONSCIOUS

I'm a firm believer in using your subconscious to boost your creativity. I try to use this in two ways: *before* and *during* my writing sessions.

BEFORE

Laugh all you want, but the night before I'm going to focus on writing, I silently chant the following in my mind (I don't recommend chanting out loud if you share a bed with someone):

I'm going to write an *Evil Inc* story line.

I'm going to write an *Evil Inc* story line.

I'm going to write an *Evil Inc* story line.

And when I wake up ... nothing.

I mean, it's not as if there's an entire story line just laid out in my brain. But when I do sit down to write later that day, I find that the connections come more readily. The ideas seem to develop more naturally.

I think this is an effect of my subconscious. My wife has said she thinks its a placebo effect.

I really don't care who's right. I win either way.

DURING

This is a somewhat dangerous technique, and I don't recommend it for everyone.

When I'm writing and the ideas aren't flowing like water, I'll make myself as comfortable as possible and I'll try to drift as close to sleep as I can without actually falling asleep. I try to hover right there in that in-between spot for as long as possible and let my mind wander around the general story lines or topics that I have in mind. I'll jot a few of them down, but I won't wake up enough to work on them fully for an hour or so.

Make sure to set an alarm. There's a real danger of falling asleep and getting nothing done. Without waiting any longer than it takes to brew a cup of coffee and/or grab a tasty sugary snack to jolt that brain back to life, start writing down ideas and concepts.

Some of them will seem stupid or incoherent. But as you wade through them, you're bound to find some material that will be the seeds of some good writing.

MEDITATION

If that doesn't sound like a good fit for the way you work, consider meditation.

Meditation is a way of clearing your consciousness and setting the subconscious free to do its magic. Turn off every last distraction — TV, Internet, radio, etc. — and simply sit alone with your thoughts. At first, your mind will go haywire — Did you leave the stove on? Did someone mention you on Twitter? Allow those thoughts to melt away. Try to go 15 minutes with your eyes closed, sitting in one spot.

Once again, an alarm clock might be useful here. The longer you sit, the deeper you'll be able to sink into a meditative state (as long as you're still not fixated on Twitter). And the more useful your meditation is apt to be.

JOURNALING

Keeping a journal is a mechanical method of meditation.

It doesn't necessarily have to be a listing of the event of that day — although that's helpful, too. Believe me, I constantly kick myself for not taking 10 minutes to write down my day. I find myself struggling to remember life events to draw from for stories, and my addled brain fails to provide the

FOURTH WALL

The term "fourth wall" comes from live theater stage-craft, in which sets have three walls. The audience looks through an imaginary fourth wall that separates them from the reality being portrayed on the stage. "Breaking the fourth wall" refers to any time that fictional characters try to either interact with the audience or indicate that they are, indeed, fictional characters in a play (or comic).

I think it should be done as seldom as possible.

It's a very simple matter of psychology. Your comic creates an illusion — an alternate reality — that your reader is trying to enter. I think breaking the fourth wall messes with that.

Before you pull the trigger on a fourth-wall breach, you have to be willing to deal with the consequences of having done so — especially if this becomes a repeated gimmick in your strip.

For me, it's just not effective enough to make it worth separating the reader from the illusion.

details. Quotes from my kids, mistakes I've made ... serious cartoon fodder. And most of it is lost.

More importantly, through journaling you write down whatever is on your mind — even if it's stupid and insignificant. Nothing's off-limits in your journal, so don't block a thought for any reason. Consider this a read-out of your subconscious. It's not for anyone to read or appreciate. Rather, it's a way to allow those free-floating thoughts to take root in the physical world, where you can sort them out and make sense of them later.

Best of all, once you've been journaling for a few years, you can look back on your old notes — with a completely fresh perspective — and discover new ideas and concept-associations that you were unable to appreciate "in the moment."

If you do this digitally, be smart and create multiple backups.

WRITER'S BLOCK

When I originally wrote about this subject for Webcomics.com, the headline was "Writer's Block is a Myth."

And people who had experienced very *real* encounters with writer's block were so furious upon reading that, that they missed the point. And the point was that writer's block is a *mental* condition that can sometimes be easily addressed by changing your *mental* state.

It's not that creative people don't face moments in which they find themselves unable to move forward in their work — because that *often* happens. (Although I will say that what many people pass off as "writer's block" is actually impatience. Writing is not a lightning-round activity.)

The problem is that we've given it this name — writer's block — that conjures up the image of some sort of obstruction that keeps the ideas from flowing out of our heads.

IT'S NOT THE IDEA, IT'S THE EXECUTION

This is doubly problematic. Not only is there no obstruction, but it also places the emphasis where it doesn't belong — on the idea.

Ideas are cheap. You have ideas in your head, flowing freely, at all times. Nothing can block this process except death. Maybe. Some ideas are good, some are mediocre and others are brilliant. But they're all nearly equal. Why? Because art — all art — isn't ideas.

Art is the execution of an idea.

FIGHT WRITER'S BLOCK WITH CONFIDENCE

Look back on any time you've experienced what others call writer's block. I'll guarantee that you had ideas in your head, yet you were unable to move forward.

You were unable to move forward because you lacked confidence in any of your ideas.

Writer's block isn't the absence of creativity; it's the lack of confidence to choose any one of those ideas and execute it to the best of your ability.

We place an almost mystical importance on ideas. How many times has someone tried to ride your creative coattails by claiming that he was going to be the "Idea Man" in your partnership (leaving the little details like actually *making* the art to you)?

The truth of the matter is that all ideas have pretty much the same value. You know what makes great art? Excellent execution of an idea.

The next time you feel blocked, call it out for what it is. It's not a stoppage in your flow of creativity. It's a lack of confidence. And there's only one way to gain that confidence. Take one of those ideas you've got rattling around in that skull of yours and execute it to the very best of your ability.

Chances are it won't be your masterpiece, but it will be something. And it will prove to you that you cannot be blocked. And if that doesn't build your confidence, nothing will. And confident writers don't spend very much time getting stalled by writer's block.

EDITING

Take it from the guy who typed out "Unshark Mask" in the first edition of the "*How To Make Webcomics*" book: It's always helpful to check your work for errors. In the best-case scenario, it's a trustworthy individual with a keen eye for spelling and grammar. But there are some methods you can use to do it yourself. One way or the other, be sure to proofread your comics before they go live on your site.

READ IT "DIFFERENT"

There are lots of approaches to this, but all of them involve slowing your brain down and making it focus on the characters that make up a word instead of the word shapes themselves:

- Read your comic backward — from the last word to the first.
- Read your comic in a mirror.
- Read your work upside down.
- Read it aloud.

Reading words out loud forces you to process the sentences differently than you do when reading them to yourself. For example, take this paragraph:

It deosn't mttaer in waht oredr the ltteers in a wrod are, the olny iprmoatnt tihng is taht the frist and lsat ltteer are in the rghit pcale. The rset can be a toatl mses and you can sitll raed it wouthit poblerm. Tihs is buseace the huamn mnid deos not raed ervey lteter by istlef, but the wrod as a wlohe.

Chances are, you could read that easily. Now, try to read it out loud. It's a little harder, isn't it?

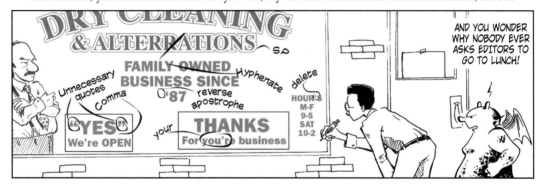

GET A SECOND SET OF EYES

You might be surprised at how eager a couple of readers might be to give your comics a good once-over in exchange for nothing more than bragging rights and the ability to see your comics before they're posted for the general public. Readers with actual backgrounds in grammar or editing would be the best option, but just having another person read the work and offer feedback would be helpful.

Perhaps you could give them access to where you upload your work before it goes live, and encourage them to alert you to any errors they catch.

GIVE IT SOME TIME

You'd be surprised how many of your own errors you catch after coming back to your work a couple of days later. Give your brain a chance to reset, and look over your work when you're fresh. You're bound to find a few things that you were "too close" to see when you were in the moment.

USE AN EDITOR

It might not be feasible for you to run every strip past an actual, accredited editor, but it certainly would be worth an investment of time and money to have an editor look over a proof of your comic before it is published. Those mistakes are easy to fix when they're pixels, but awfully pesky when they're already online.

WRITING HUMOR

Up until now, everything we've discussed could apply equally to any kind of comics writing — drama, action-adventure, humor, etc. But writing humor is, in my experience, exponentially more difficult than any other type of writing. And as such, it deserves a little extra attention.

WORD-ASSOCIATION BRAINSTORMING

Here's a method of brainstorming that I find particularly useful when I'm feeling stuck.

If I'm trying to write on a particular subject, I'll write down all the words that I can think of that relate directly to that subject. I'll write them into a long, long list down the left-hand side of a sheet of paper (or several, if the words are flowing). For example, if I'm writing about cooking, I'll be sure to include:

- People involved and their titles (chef, cook, pastry chef, baker, sous chef, waiter, etc.).
- The places they do it (kitchen, restaurant, diner, barbecue grill, etc.).
- Tools they use (spatula, butcher's knife, pots, Crock-Pot, grill, stove, pit, etc.).
- Language/terms they use (sautée, brown, flavor, broth, etc.).
- Raw materials (fruits, vegetables, chicken, wheat, etc.).

In short, I try to write down all of the words that could come up in a conversation on the topic.

Once I have my list written out, I go to the top of the list and start brainstorming words that are related to each word on the list — which I write to the right of each word. I'll write synonyms, antonyms, homonyms, word associations, and idioms or cliches involved with each word.

Synonyms are different words that mean the same thing (or are very similar in meaning). In the previous example, the word "stir" might beget the following synonyms: mix, combine, whip, whisk and blend. I like whip. It makes me wonder about the possible exchange between a chef and a dominatrix (or a chef moonlighting as a dominatrix). "Stir" can also be a word used to describe a commotion, prison or a person waking up. You could cause a stir because you stirred and found yourself in stir.

Antonyms are words that mean the opposite of one another. Some antonyms for "stir" are: calm, rest, wait and stop.

Idioms are phrases that aren't necessarily taken literally, but are readily understood. They're figures of speech. For example, "taking the plunge" doesn't really involve falling. Also in this category are clichés and common pairings. **Clichés** are phrases that are overused to the point of losing their meanings. And **common pairings** are words that always tend to get used together — like *commit* and *adultery* (a pairing I always found ironic). No one ever *does* adultery ... they always *commit* it. But adultery itself shows a *lack* of an ability to commit.

"Stir" is used in such idioms as "stir crazy," "stir the pot," "stir-fry," "causing a stir," "not a creature was stirring" and "stirring up trouble." James Bond takes his martini "shaken, not stirred."

Homonyms are words that are spelled differently but sound alike. "Star" isn't an exact homonym, but it's close enough for stir to be subbed in for familiar star idioms. For example, a wonderful cooking-school student might be called a "stir pupil." Or not. :)

There are no wrong answers in this category. And everyone will bring something different to the table when it comes to word association. The word "stir" makes me think of the 1980 movie "Stir Crazy" starring Richard Pryor and Gene Wilder — specifically the scene where they're dressed in chicken costumes. It also makes me think of "stir-fry." And "fry" takes me to "fried" as in "high." Which takes me back to Pryor.

I'll let my mind wander around the landscape a single word presents for as long as possible — writing down anything and everything that comes to mind.

You'd be surprised how often stupid, lame thoughts lead you down the path to brilliance.

If you've taken a little time with your list, you should wind up with hundreds of words — each of which should yield hundreds of offshoot words, idioms, associations and concepts for you to warp, mix, torture and otherwise humor-ize.

In other words, you now have idea soup. And it's your job to slowly work your way through it to find the morsels that are going to make the best gags.

HUMOR ME ... LEARN SOME GRAMMAR

Here's some great advice I picked up a long time ago: If you want to write better humor, learn grammar. Think about it. Behind all the talk of participles and gerunds and infinitives — all the stuff that made your eyes gloss over in grade school — lies grammar's sole purpose: clear communication. In other words, grammar is there to make sure you don't mean one thing and say another.

But ... meaning one thing and saying another is one of the purest, simplest, most common forms of humor. It's called misdirection. It's when you indicate a zig to your readers and then you zag. We'll

'CASCADING BRAINSTORMING'

When I'm working on a gag, I will write the set up in a vertical column from the top of the page to the bottom. This allows me to experiment with branching off from the set up at different junctures — or even starting in different places. It's a great way to mix-and-match different ingredients to see which combination of steps provides the best set up to the punchline. I call it "cascading brainstorming" because I can fine-tune the writing by going to the top and allowing the ideas to flow in different directions as I work my way down.

① Desi and Iron Dragon to Dr. Muskiday
That was nice... what you
did for Haynus... Now everything's
back to normal!
 Muskiday: Yes... everything=
 〈muskiday walks away sadly〉

② Desi: Oh! I almost forget! You had a delivery
This morning! A crocus!

③ Desi: Funny name for such a
pretty flower.
 CARD: Tonight at
 Six? —R

④ Six?! I barely have
time to _____ and
_____ and _____

This is how I initially approached writing this gag. I took two stabs at a punchline, and neither was funny — nor seemed to lead anywhere funny.

I realized that, as usual, I had started too early in the story. Jumping right into the action is more interesting — and it gives me one more panel to try to find the funny. So I decide to axe the first panel and try again.

✗ Desi and Iron Dragon to Dr. Muskiday
That was nice... what you
did for Haynus... Now everything's
back to normal!
 Muskiday: Yes... everything=
 〈muskiday walks away sadly〉

✗① Desi: Oh! I almost forget! You had a delivery
① This morning! A crocus!

✗② Desi: Funny name for such a
② pretty flower. 〈ill. of crocus〉
 CARD: Tonight at ~~Six?~~ Available I feel like cooking
 for dinner? tonight. Are you
 in? —R
 ④ Iron D

The crocus is a clue to the true identity of the sender (a frog ... "croak-us"). I decide not to telegraph it. Desi's line in Panel Two is a subtle clue that there's meaning in the flowers.

I try a few variations on the invitation ... still trying to find the jumping-off point to something humorous. It doesn't look promising.

Finding nothing that sparked my creativity in the card, I move on to the reaction to the card. I envisioned Iron Dragon teasing Dr. Muskiday in a "locker-room talk" kind of way.

That leads to something clever. An alternate third panel plays off a double meaning for "having plans for dessert." One is cuisine, the other is ... well ... a little sweeter...

We're getting close. "Dessert" brought me to Jell-O. Clearly, Iron Dragon prefers wrestling in it to eating it. Muskiday's rejoinder is weak-sauce, though.

Here's how the final page looks in my sketchbook. I decide it's more useful to have Desi deliver the line about "having plans for dessert." It's more endearing coming from her —and sets up Iron Dragon for his Jell-O line.

After trying out several reactions to the Jell-O line, I decide the strongest would be Desi reacting to her husband's pre-marital debauchery.

That sets Iron Dragon up for a response that's funniest when it's reduced to two words.

Here's the final comic.

discuss this concept at length a little later.

Example: Dangling modifier

Here's a good example of a rule of grammar that you can intentionally break to write humor: the dangling modifier. A dangling modifier is when a modifier is misplaced in the sentence with the effect of modifying the wrong word.

- As he humped my leg, my roommate apologized for the behavior of his dog.

That's one friendly roommate.

- Rowing the boat, the fishes sped ahead of us.

I'd say those were paddlefish, but we'll talk about puns later.

Words like *almost* and *only* get misplaced constantly.

- She told me she almost kissed all of the guys she dated.

She must have rotten aim.

And, of course, you can't talk about this subject without a nod to the master of the misplaced modifier, Groucho Marx:

- Last night I shot an elephant in my pajamas. How he got in my pajamas, I'll never know.

The point is this: If you're using correct grammar, your modifier or modifying phrase should go as close as possible to the word it modifies. But if you're writing humor, you can slide that modifier to another place in the sentence where it becomes ambiguous (in other words, it could be read as modifying the correct word as well as the incorrect one) and then spring your punchline.

- She requested a proper burial in the family mausoleum before her death.

That explains the screams I heard in the cemetery last night ...

MORE GRAMMAR-BASED HUMOR

Here's another example of how learning grammar can improve your humor-writing.

Although your eyes probably glazed over when your English teacher started discussing pronouns and antecedents, he or she was actually giving a humor lecture.

See, an antecedent is a pronoun that takes the place of a noun introduced earlier in the sentence. However, when two or more nouns are introduced, it can be confusing which noun the antecedent is standing in for.

Usually, readers assume that the antecedent matches with the closest noun — the last noun mentioned.

And that means we can write perfectly ambiguous sentences and exploit them to our heart's content because the misdirection is embedded directly into the sentence!

HYPERBOLE

Hyperbole is exaggeration. It is to humor what salt is to cooking. It's hard to find a recipe that doesn't include salt, and salt tends to improve the taste of most dishes. It's the same way with hyperbole. It's a key component in humor, and exaggeration makes almost any situation funnier. Hyperbole even works in reverse. Downplaying a situation can be as funny as exaggerating it.

PUNCHWORD

Humor follows the principles of tension and release. In the set up, tension is built — a conflict is introduced, for example, and is allowed to strengthen. Think of it as a balloon being inflated. By the time we reach the punchline, there should be a satisfying release of that tension — the popping of the balloon, if you will.

You may choose to build up tension quickly or slowly, but the humor in the comic is dependent upon your ability to build a significant amount of tension on the way to the punchline. Of course, there are as many ways to build tension as there are to write punchlines, but here's a concept that I think has helped to maximize my tension-building: the **punchword.**

The punchword is the word — or short phrase — that holds the greatest amount of surprise for your reader. It's the word with the greatest amount of charge where the joke is concerned. It's the word with all the *power*. Take a quick look at some of the effective punchlines you come across in your daily reading. Now dissect the punchline. There's one word that holds the most surprise — the one that sticks the needle into the balloon. I'll maintain that you should — *whenever possible* — hold off on that punchword until the very last moment.

Every sentence — every word you choose — on the way to the punchline should help build the tension. If you place potentially tension-building words behind the punchline, they're not doing any good, are they? Here's an example of a time when I put that reasoning into effect.

Originally, I had my punchline written like this: "If you need it, there's a little, pink cyanide tablet

in the glove compartment." And, truthfully, that's probably a more natural way to phrase it — subject/verb/object. To be sure, I could have stopped there, and I would have been pretty confident that I had written a decent gag. But I'm a big believer in this punchword concept when it comes to my own writing. As I edited the strip before finalizing it, I decided that "glove compartment" didn't hold enough humor to justify its punchword placement in the sentence.

My first revision was to run with "pink glove compartment" as the punchword: "If you need it, there's a cyanide tablet in the little, pink glove compartment." Again, you could sell me on that punchline as being workable, too.

But the idea of a "little, pink cyanide tablet" struck me as more funny, so I rearranged the sentence using an object/verb/subject format. It is less natural than the original writing of the line, but it holds back on that punchword until the very last moment. For my taste in humor, the punchline works better with the revision:

FERMENTATION

Sometimes, you work so hard trying to get to the funny, that once you even get close, you're so relieved that you immediately collapse. But getting to the funny just isn't good enough. If you want to stand out, you need to get to the funnier. Here's a thought on that ...

Write a joke to your best ability, and then let it sit for one week. Return to the joke and rewrite it with the following in the back of your mind:

- You did not conjure lightning.
- The gag you wrote, as it stands, is not funny.
- This isn't a joke; it's the framework for something better.

In rewriting this joke, you may not arrive at the same punchline (or, if you do, you may not use the same setup to that punchline).

Don't let yourself off the hook. At a certain point, you might just realize that the writing comes a little easier. That's because, as I said earlier in this chapter, your subconscious mind has been hacking away at the problem.

Your original gag really wasn't that funny. And you can see it much more clearly now. Improving the gag doesn't feel so much like tampering with something precious the way it did when you first wrote it.

This is a much slower way to write, and to be sure, you may want to establish a pattern in which you're writing first drafts on Monday and then addressing last week's drafts on Tuesday, etc. But I think you'll find that you can write much more effective, funny comics if you train yourself to let your ideas ferment.

HUMOR FRAMEWORKS

There is no formula to writing humor. However, there are some core concepts to keep in mind as you're trying to formulate a humorous situation.

MISDIRECTION

Much of humor is based on surprise. If your reader can anticipate the punchline, it's not going to be very funny.

Magicians rely on the concept to pull off illusions. If you see them stuff the item into their sleeve, you can't allow yourself to believe they made it disappear. So they have ways of directing your attention away so you don't notice their sleight of hand.

It's the same for humorists. One tried-and-true method is to write an ambiguous sentence — one that could be interpreted two different ways. The reader is going to assume the most logical interpretation. If your punchline presents the other, the misdirected reader will be surprised — and that adds strength to your humor.

For example, take this old gag:

> *A man says to his friend, "I keep seeing spots in front of my eyes."*
>
> *His friend says, "Have you seen a doctor?"*
>
> *The man responds, "Nope. Just spots."*

A good misdirection should lead readers in the wrong direction, while simultaneously setting them up for the punchline.

MISMATCHING ATTITUDE AND ACTION

Humor can also be found in allowing your characters to do something bizarre in a perfectly routine manner — or, conversely, to do an everyday task in a weird way.

The former is sometimes referred to as deadpan humor. It gets most of its energy from presenting an outrageous scene and underplaying the words and/or the attitude of the participants. In the sec-

THE 'ONE MORE PANEL' METHOD

This is another way of approaching the "fermentation" technique I explained earlier. I originally called this the "Fifth Panel" method, but realized that it has applications far beyond four-panel comic strips. When I did writing critiques of Webcomics.com members who did humor comics, I kept getting the feeling that they would have gotten to the funny if they had only gone a little further. I developed this technique to try to get them into the habit of drilling down to the really good writing.

- Once you've written your joke — refined the setup and fine-tuned the punchline — I want you to leave it for at least 24 hours. I believe this is crucial. It allows your subconscious mind to come into play, and it brings you in fresh the next day.

- Next, look at what you've written and add another panel. Your job now is to use your punchline as a setup to another punchline. Take the concept *one step further*. If an action has happened, explore the aftereffects. If a surprise was introduced, top it with a bigger one. If the punchline was wordplay, warp the words even more.

- Finally, reduce the comic to its *original* panel count. Let's say you produce a four-panel strip. Either lose the fourth panel and go straight from Panel Three to Panel Five (making any necessary wording adjustments) or incorporate any crucial parts of the fourth panel into the third panel.

And "crucial" is the operative word here. The point is *not* to write longer; it's to write *better*.

The optimum outcome should be to arrive at a sequence in which the word count is very similar to the original.

I want to thank member Oskar van Velden of *Mojo* (mojocomic.com), who graciously agreed to allow me to use one of his strips as an example. I noticed Oskar's update, and it struck me that this was a perfect subject for this conversation because, although the punchline was good, I think it could have been taken to a higher level.

This was Oskar's comic:

It's a decent punchline.

But when I saw it, I couldn't help but think about how the really *funny* stuff happened in the unseen next panel.

So, let's allow our minds to wander over to an imaginary, additional panel.

The idea of trying to stop nicotine cravings by slapping slices of turkey meat on your skin has a really nice silliness to it. And the turkey slices look enough like the nicotine patches to make the concept cross over effectively.

But now it's too long. The third panel doesn't do a thing to advance the setup. It doesn't charge the tension, and if we leave it in, it actually telegraphs the joke, draining away much of the funny. Since it's pretty much extraneous ...

I'm not even necessarily saying that this particular outcome is the best of all possible variations.

And you could definitely refine it. For example, I might have added a skinny panel between Panel Two and Panel Three in which the penguin and the cat walk away from the man, having removed their patches. It might prevent a reader from thinking that the nicotine patches are being removed in the final panel.

I feel confident in saying that it's an improvement, but I'll bet there are dozens of alternates that you could dream up that take this very good setup and push the concept to a much funnier place.

ond, familiar scenes are approached in strange and unusual ways. For example, brushing your teeth is an everyday activity (or it should be). However, if you're a vampire, it probably comes with a whole set of hurdles that most people haven't considered.

This strip gets much of its humor from the character doing something weird in a normal way.

FILL IN THE BLANK

This is a special kind of humor framework that intentionally breaks the "misdirection" rule. The humor comes from the reader filling in a missing part of the story. In this case, it's all about directing the readers to the proper conclusion — not misdirecting them. With this kind of joke, you never actually write the punchline. Rather, you set everything up and the reader fills in the appropriate words (or scene) with his imagination.

Q. *What's the difference between chopped beef and pea soup?* **A.** *Anyone can chop beef.*

The humor comes from the reader — at your direction — assembling all of the pieces on his own.

LOGIC

We live in a very illogical world. So, when simple logic is applied to our everyday lives, the outcome is often humorous.

EASTER EGGS

An Easter egg is a small, hidden gag (like the flyers on the bulletin board below) that adds an additional source of humor. Although it's possible to base a gag on an Easter egg, most cartoonists simply use them to offer their readers a little something extra.

Sometimes an Easter egg can provide a little extra something for your readers, like the "Vision screening" gag above. And sometimes, spotting the Easter egg is the punchline itself — as in the instance of the "Free-range chicken" joke.

IDIOMS

As discussed earlier, an idiom is a familiar phrase or pairing of words. It's not necessarily a cliché (which, technically, is an overused idiom), but rather is a figure of speech that may not make logical sense — but has an understood meaning. Since idioms are familiar expressions, they're very useful in writing humor that's based in wordplay (discussed earlier in the chapter). By introducing wordplay into the idiom, you can come up with some really amazing puns.

... or really painful ones.

Creativity

A huge portion of this book is devoted to the pursuit of webcomics as a business, but as much as it is an independent business venture, it would be foolhardy to ignore that a webcomic is a creative venture. And it's that creative aspect that threatens webcartoonists more often than wrestling with sales tax.

This chapter features some of my favorite posts from Webcomics.com. It addresses the very soul of what it means to do comics. Bookmark it. You're going to be coming back to this section a lot.

WHEN IS IT DONE?

How do you know when a comic is "done"? After all, there's always a small improvement to be made here or there. When is it time to move on to the next one?

As the old art-school axiom goes: "*Perfect* is the opposite of *done*."

This is a problem that is usually solved indirectly by adhering to a regular update schedule.

For me, a comic means a Monday-Saturday commitment. When you're determined to have a new comic up at that kind of frequency, you lose the precious nature of each individual update pretty quickly, focusing instead on the long-term goal of sustaining your feature.

On a certain level, I knew that the strip (below) for Feb. 14, 2000, wasn't an amazing strip. But it was only by posting that one — and posting a strip every Monday through Saturday ever since — that I could get to the point where I'm very confident in my work.

In other words, if I had reworked and reworked and obsessed over Feb. 14, 2000, I couldn't have made it to today.

Is this an excuse to post shoddy work? Of course not.

Deciding when done is *done* is a line that each of us must find for ourselves.

But holding to a regular update schedule is a great way to coax that decision along.

PLATEAUS

I looked back in the sand, and I saw that my footprints had formed a chart of my pageviews over the years. And I said, "Look at all of those times that the chart flattens out and doesn't increase for months on end ... what's with that?" And the answer came back, so simple and pure:

"That, my child, is when you were improving as a cartoonist ..."

You need plateaus.

The work you do during a plateau is the work that takes you to your next breakthrough.

And, inevitably, the next plateau.

Listen, no one wants to plateau — we all want to experience dramatic growth — but the fact of the matter is that plateaus do happen. And they happen to everyone. Ask any overnight success you happen to meet and they'll tell you about the years and years that led up to that "overnight."

In my opinion, the worst thing you can do is panic during a plateau. Stop obsessing over site traffic and pour that energy into doing your comic. Obsess over that writing for a while. Push yourself to draw better scenes. Ignore the stats for a week or two. They'll be there when you decide to look again. In the meantime, let's take a moment to discuss plateaus in some honest light.

PLATEAUS HAPPEN ONLY TO NEWBS

Wrong. In fact, it has been my experience that as a comic goes on for year after year, the plateaus stretch longer and longer.

Furthermore, over time, the growth of a comic gets so gradual that in a month-by-month view it looks exactly like a plateau. Only by pulling back and looking at several months in a row can you see the overall upward trend.

NO SPIKES!

There have been times in the past in which — perhaps through a review or a link — I received a major influx of traffic and my traffic spiked. But spikes are horrible! Traffic spikes happen when a huge number of people come to your site ... and *don't* return the next day.

The effort that you put into improving the quality of your work during a plateau will put you in the position in which the next time that you're the recipient of a large influx of traffic, you'll have a better chance of holding a greater quantity of those visitors. Your work on that day will have a better chance of holding readers, and the archive you offer will do the same.

But to get to that traffic jump, you have to pay your dues in the plateau days first.

SLOW AND STEADY WINS THE RACE

Although we all secretly yearn for that hit-the-lottery traffic jump, I'm actually a very big fan of slow growth. Slow, steady growth is a sure sign of actual improvement in the comic. In other words, you're not increasing traffic through an advantageous link or a great ad campaign (mind you, those things are dandy, too), but a steady growth in readership means that you're holding your current fans and earning new ones day by day on nothing more than the strength of your work.

LOOK ON THE BRIGHT SIDE

A plateau is a period of time in which you're not gaining new readers, right? Yes, but it's also a period of time in which you're not losing readers, either. We usually forget that part.

WHEN LIFE GETS IN THE WAY

I received the following e-mail shortly before Father's Day:

> *Is it doable for the father of a newborn to keep cartooning at night (three strips a week) if he has a day job? (Wife's due any day now.) And do you think that temporarily updating less frequently (less than three/week) will hurt a comic's readership long-term?*

I, of course, told him that it was extremely doable — as long as he was willing to exercise his time-management skills. And, as far as the update schedule goes, I didn't have any personal experience there. Kris Straub once backed his Starslip.com schedule down to three times a week and suffered little (if any) traffic loss. Of course, Kris had worked very hard to build an audience for his work for about 10 years before that, and that can't be discounted.

But fatherhood and webcomics. That got me reminiscing. In 2002, my wife was pregnant with our first baby. A baby shower was being thrown in Michigan, where my side of the family lives, and I was golfing with my dad and one of my younger brothers (who already had one kid at that point).

"So ... what am I in for?" I asked with a nervous chuckle.

The response I got, paraphrased, was that my life was over.

My entire existence was about to be handed over to a responsibility that I could never fathom. And anything that wasn't directly related to raising, caring for and providing for that little life was about to be jettisoned.

"And that comic strip of yours? Forget it."

Needless to say, I was pretty distraught. I had been doing my first comic strip, *Greystone Inn*, for a couple of years already, and it was beginning to build a decent readership. And, for me, doing a comic strip was a dream that I'd nurtured since kindergarten. It was beginning to take shape, and ... now this.

I grieved for the rest of the weekend.

Returning to Philadelphia, I sat, morose, in the cafeteria of the *Philadelphia Daily News* with a friend of mine, a photographer in his late-50s, who had two kids — one in college, the other in high school. He opened with, "Why the long face," and all of my grief came tumbling out.

Then, he smiled. It was a smile that I didn't understand. But today I do. He put a hand on my shoulder and he said words that I still remember as clearly as if I were still sitting in that cafeteria.

"You dumbass."

"Listen," he said, "your life is going to change, and it's going to change drastically. But having kids doesn't mean that you stop doing the stuff you love to do. It just means that you find new ways to do them. You might find yourself doing your comic later at night or earlier in the morning, and I'll guarantee that you'll get better at getting more done in less time. You'll stop doing the stuff that doesn't matter so there's more time for the stuff that does — like your family and your comic.

"And here's the kicker ... when he gets old enough for you to share comics with him, it's going to make you see and appreciate the thing you love in an entirely new way. You're going to take joy in his discovery, and it's going to become fresh and new and exciting again, just like it was when you first started reading comics yourself."

And he was right.

I woke up earlier. I worked later. I found out I didn't need as much sleep as I thought I did. I've drawn strips while holding an infant over my left shoulder. I even set up a playpen in my studio so my son could play as I worked. Today, both he and his little brother have extensive comic collections and their own pull lists at the comic shop, and they get tons of reading practice on stuff like *Mini Marvels, Pet Avengers, Super Friends,* and other kid-friendly tomes.

And I enjoy comics tons more than I did before. I share their joy over jokes done well. I tie a bathroom towel around my neck and "fly" along with them. By the hoary hosts of Hoggoth, I even made a homemade Dr. Strange costume for Halloween and went trick-or-treating through my Philadelphia neighborhood. (Try that without having kids.) I'm more creative, more free and more comfortable being silly than I ever was.

Your humble author, dressed for a night of Halloween hijinks.

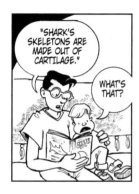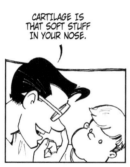

The strip above was, line for line, taken from a conversation with my older son, 3 years old at the time. And it's one of a handful of times that one of my kids has inadvertently written a comic for me. Like this one, years later:

At the risk of being immodest, not only did fatherhood *not* prevent me from doing comics, but, comparing my work from 2001 and 2011, I even *improved* my skills a little during that time.

Don't get me wrong. Parenthood can be challenging as hell. The schedules. The priorities. The balance. But the payoff is so worth it. My life wasn't over when my kids came into the world. It began. You certainly can do a regularly updating webcomic and be a parent.

And you can love every minute of it.

IF IT ALL FALLS DOWN

I was part of a panel discussion — it may have been in San Diego — and the question was asked, *When should I give up?* The guy had been working on his webcomic for a about nine months.*

My philosophy on this remains unchanged. And it's based on my "worst-case scenario" thinking. I ask myself if I can live with the worst-case scenario. If I can, it's a justifiable risk for me.

So: What's the worst-case scenario if your webcomic never pans out? What if "webcomics" are a flash in the pan, and all of the major success has already been snapped up by the others who arrived on the scene earlier than you?

The answer for me is that I will have had several years of doing what I love to do best — creating comics for an appreciative audience. See, I couldn't have reached my audience before webcomics. And all I've ever wanted was to be a professional cartoonist. Webcomics have made all that possible.

* *I've experienced something I've come to name "The Nine Month Itch": After nine months, many, many people expect to have become a Major Internet Sensation — and are despondent if they're not.*

Q&A

Q: Recently, I went through my entire archives and noticed that there were a handful of comics with themes or punchlines similar to other creators' work. I would never purposely plagiarize anyone's content; however, subconsciously something must have slipped through the cracks. Ultimately, I became somewhat obsessed and ended up redoing the "problem" comics in my archives because I felt really, REALLY uncomfortable with them. I've seen my work get ripped off before, ranging from general ideas all the way to stolen punchlines, word for word. How should I handle:

• When you look back and realize you've accidentally appropriated someone's idea?

• When others rip you off?

A: Really, they're both the same question. Because at the heart of it, you have to realize that so much of our humor is based on the language itself — idioms, cliches, figures of speech, homonyms, etc. — that it only stands to reason that a number of humorists are going to mine the same cliche and come up with similar results.

So, the answer to the first question is simple: If you've found that you had written a gag similar to someone else's, accept that this sort of thing happens. Assuming that the convergence is an innocent one, enjoy the knowledge that great minds sometimes do think alike.

Which, of course, leads you to the second question — handling a situation in which someone else treads a little close to your own path. Knowing that this sometimes happens, I think you have to give the other person the benefit of the doubt.

Of course, if you see a pattern emerge — the same cartoonist seems to "think alike" with your great mind repeatedly — or if there's an outright rip-off in presentation or design, then you're faced with something a little more serious than an innocent overlapping of thought processes.

I think a polite note to the other cartoonist, pointing out that you've noticed that this seems to keep happening, is a good first step toward at least setting the other artist on notice that his swiping is not going unnoticed and that continued thought-theft is going to be outed.

WHAT IF IT COMES CRASHING DOWN TOMORROW?

What happens — as that "hard-drinking calypso poet" Jimmy Buffett once lamented — "If It All Falls Down"? Buffett's answer, paraphrasing the lyrics: If I lose all my success, it will have been worth it for the fun I've had and for the things I learned along the way.

For me, it means that I will have had several years of being able to realize a childhood dream of being a cartoonist. How many people get that in their lives? Damned few, pal.

WHAT IF IT NEVER TURNS INTO A CAREER?

You take those skills you learned — and the name that you've hopefully made for yourself doing a comic that was read widely and appreciated by a number of people — and you move on to the *next thing*.

WHAT NEXT THING?

Comics have been around for more than a hundred years. In that time, the basic format has changed very little from those early *Mutt and Jeff* strips.

That makes me confident that strips have a life that will go on for a decent stretch further. But even if I'm wrong about that — in that particular worst-case scenario — there will always be the basic human need to tell stories. And there will always be those among us who do that with a combination of words and images.

THERE WILL ALWAYS BE CARTOONISTS

You may never quit your day job. You may never make this a career.

And, realistically, if that's what you're in it for, you're setting yourself up for disappointment.

But if you're in this thing because you *need* to be ... because there is no other way of self-expression that satisfies your itch.

In that case, your worst-case scenario is the same as mine. You'll have years of satisfying creation behind you ... maybe a few books to show your kids ... maybe a few fans who remember you fondly.

And that ain't so bad.

TIME TO END THE COMIC AND START A NEW ONE

There comes a time in every webcartoonist's life when he has to answer for himself: Do I really want to keep doing this comic, or is it time to try something new? The comic seems to have failed to get traction. It's not a complete miss with readers, but it doesn't seem to be growing significantly, either. So is it better to keep plugging away, hoping for that *big break*, or is it better to end the old comic and launch something new?

That's pretty familiar territory. In June 2005, I officially ended *Greystone Inn* (after working on the strip for four-and-a-half years) and launched *Evil Inc*.

That's how the press release read, anyway.

Evil Inc actually started on May 5, 2005. The week before, I had brought the main storyline in the *Greystone Inn* comic to a close — the syndicate that handled the fictional comic strip had gone out of business, and all of the main characters found themselves unemployed. The *Evil Inc* concept was introduced as one of those characters, Lightning Lady, went to *Evil Inc* to find a job. That story ran on the *Greystone Inn* Web site for the next four weeks as an extended story line.

May 28, 2005: The day *Greystone Inn* actually ended. Samantha's new job would turn out to be with *Evil Inc* — as would be the case with another *Greystone* character, Lightning Lady. The comic would continue to update simultaneously on both the *Greystone* site and the new *Evil Inc* site, facilitating a smooth handoff between the two.

In late May/early June, I launched the *Evil Inc* Web site, but I didn't announce it publicly. I updated the site with the same comics that were running on the *Greystone* site, and I used the time to work out any bugs that I could find. I gave some friends and superfans the tip-off and enlisted their help in finding bugs.

In June, I made the official announcement and unveiled the new site. I sent press releases, posted copious amounts of information on the blogs on both sites and ran announcements directly above the comics, saying that they were running in both places.

And then I let the comics update on both sites for the rest of the year and into the next.

The *Greystone* site had a large banner directly above the comic that said that *Greystone Inn* had ended and that the comic was now called *Evil Inc*. It was linked to the new site, and it mentioned that soon the *Greystone* site would not update anymore (it would become an archive for the old *Greystone* comic).

Evil Inc, meanwhile, welcomed the emigrating *Greystone* readers and positioned itself to indoctrinate the new readers who had been directed to the site by the publicity the switchover had generated.

Sometime in January, I stopped mirroring *Evil Inc* on the *Greystone* site, and I placed an announcement permanently above the comic that explained that the comic had ended, and that the new comic was at the *Evil Inc* site.

SO WHAT?

"That worked for you because there was a smooth transition between the two strips," you'll say, "but my new project is radically different."

Perhaps. But you've put a ton of work into driving readers to that old site. You've trained people to go to that old RSS feed. There are an awful lot of bookmarks out there that point to the old URL.

And that's a valuable commodity.

So valuable, in fact, that it would be foolhardy for you to deny yourself the fruits of your labor in launching a new comic.

I would strongly recommend the same approach I took with *Greystone/Evil* to anyone transitioning strips.

You can handle the outward appearance of that switchover in several creative ways — like cross-

'ENJOY OBSCURITY'

The year was 1997, and I was working a deadline shift in the graphics department of the *Akron Beacon Journal*. My nighttime co-worker Dennis, an old-school comics guy with significant connections to comic-book, comic-strip and political-cartoon creators, was looking at some prototype strips for something that would one day become *Greystone Inn*.

He didn't like the main character, a gargoyle. He didn't like the character; didn't think it looked like a gargoyle; didn't think people would relate to a gargoyle. He, very gently, asked me: "This gargoyle ... are you sure ... ?"

My response could be best described as indignant. After all, wasn't the comics page crammed with enough talking cats and dogs?! A gargoyle is *different*! What if Berke Breathed had shied away from using a penguin because of this same logic? And of course it looked like a gargoyle. And besides, I would refer to him as such and people would just understand that that is what a gargoyle looked like in my universe. And of course they would relate to him. How could they not?! He's a classic archetype. What's not to love about this goddamned gargoyle?!?

My diatribe lasted for a good 20 minutes.

I addressed his advice from every angle but one — what if he was right?

He smiled. He was a father of three. This was a well-practiced smile:

"Enjoy obscurity."

Two words. Gently said.

"I'll show him," I said to myself. Me and my gargoyle. We'll show 'em all.

In 2000, I launched my comic-strip-about-a-comic-strip-starring-a-gargoyle. And in 2005, after four-and-a-half years of trying to get traction with it, I brought it to a close — using what little momentum I had built to launch *Evil Inc*, which eclipsed *Greystone's* traffic in less than a year.

I've discussed this before, but I really wish I would have had the creative maturity to listen to intelligent advice back then. The time I spent on *Greystone* was well-spent, mind you, but I always wonder if I wouldn't be a little further along today if I had started smarter back then.

And part of that would have included listening to good advice when it was offered.

Nope. Not me. Not then.

I'd get my back up against the wall and insist that I was right, I was right, I was right. And if you didn't agree, then clearly you were missing my genius. I was just that confident.

Confidence is an integral part of creativity. You can't do what we do without confidence. At some point you say, "This is worth sharing," and you foist it upon the world daring the world to frown back at you. Without that confidence, you fade away.

Part of creative excellence is the ability to temper that confidence with humility. Without that, you'll never be able to take advantage of some key moments in your development as an artist.

ing out the old logo and overlapping it with the new one. It doesn't matter a bit if the old URL is PeterThePrettyPony.org and the comic that is running is a HALO parody comic. You're done with *Peter the Pretty Pony.* You don't owe that old URL anything. But it's crucial that you reap your due in transitioning *Peter the Pony* readers to the new comic.

You can always go back to the old site — after the new site is on its feet — and take off the strips that don't fit. You can have your shrine to your *Pony* years.

But not until you've maximized your reader-transition process.

You've earned those readers fair and square. Don't deny yourself access to them.

GEEZER MODE

When I made the transition from *Greystone* to *Evil Inc,* my two most powerful tools were press releases and blog posts — including Livejournal (remember that?). There are tons more opportunities to spread the word about a situation like this today. Twitter, Facebook, YouTube and other social media have plenty of creative uses in helping you move readers from one site to the other.

Let's talk about the headspace of the average cartoonist. After decades of comic-properties that have been running since the invention of ink — from *Spider-Man* to *Beetle Bailey* — it's not unreasonable to equate longevity with success. And it's not unfathomable that a cartoonist who switches from one title to another does so with a certain feeling of failure.

Of course, that's pure crap.

And how you handle that mentally is up to you. But don't let that mentality seep into how you present this new project to the world.

This is a chance to generate a little buzz about your work. It's one thing to make the announcement that you've been working on the same comic for X years. But announcing that you've launched a new project has an inherent air of excitement. People love checking out something new. They're liable to be more excited about a new project than they would be to hear about yet another year of the same-old-same-old.

So your announcement should be filled with excitement and joy. That kind of stuff is contagious, after all.

I'LL NEVER FORGET OL' WHATSHISNAME ...

Certainly, some of your old readers will prefer your old stuff over this new thing. Assure them that you'll be bringing the same creative energy to the new that they loved about the old. (And offer to sell them a book of the old.)

After all, comics are more than concepts. As a matter of fact, when you boil them down to their essentials, there are only a handful of concepts to choose from.

What makes a reader into a fan is what you bring to a concept.

And if a reader likes what you brought to the old concept, they'll probably like what you bring to the new one.

Assure them of this. And realize that you'll probably lose a few nonetheless.

Luckily, there are a few billion more where that came from.

WRITER/ARTIST COLLABORATIONS

Creating a comic requires a blend of two very different disciplines — visual art and writing. Some people may be good artists, but they're not so good at writing. Others may be good writers, but their art is standing in the way of their storytelling. And still others simply haven't admitted to themselves that they fall into one of those two categories.

Which is why a collaboration is such an attractive proposition. A good writer teams with a skillful artist, and the two cooperate to make an amazing comic. When it works, *Penny Arcade* being a shining example, it works tremendously. But when it doesn't work, things get dark quickly.

So how do you establish a successful collaboration? It's the same as any relationship you might have in real life: honesty, communication and fairness.

HONESTY

I think this is the most important aspect of an effective collaboration — and it's crucial to establish in the opening days of the collaboration. It's important to be honest — with yourself as well as with your potential collaborator — about how you both approach creativity and what your expectations are.

Let's face it, everyone has a slightly unique way in which they execute their craft. Some writers might crave outside suggestions during their process, while others might find that distracting. Likewise, some artists might welcome direction in regards to their visuals, while others might become insulted.

So each participant must be honest about how he expects to be treated in this partnership — as well as how he prefers to interact with the other. There are four variables here:

> How the writer wishes to be treated
>
> How the writer wishes to interact with the artist
>
> How the artist wishes to be treated
>
> How the artist wishes to interact with the writer

If there is a conflict in any of those four variables, it needs to be addressed in the opening stages of the partnership. These conflicts don't disappear, and if they're not addressed in an effective way, they'll lead to the destruction of the team.

As a writer, do you see this comic as your unique vision, with the artist following your detailed directions to bring the piece to fruition? Then say so. This is no time to be polite. Better the collaboration ends now than after each party has invested six months of his or her time.

Conversely, do you expect the artist to bring the full weight of her experience to the partnership, using your writing as a leaping-off point for the creation?

I guarantee, there are artists out there who would prefer to work with the first writer and some who would prefer the second one.

If there's a conflicting approach to creativity that can't be met with compromise, end it now. You'll save a lot of heartache in the future.

COMMUNICATION

At the risk of making the overworked marriage metaphor, many collaborators will tell you that they work best together when they're communicating clearly.

For example, asking an artist to "make it pop" isn't exactly helpful. A writer complaining that a page "just doesn't look right" is being unfair unless he can accurately put into words what it is she finds upsetting. (After all, that's what a writer does, isn't it?) And an artist isn't being a good communicator if he comments that a certain passage "doesn't work."

If you've started the collaboration in honesty, the communication should come naturally. However, I will say this. It pays to be aware of the communication needs of your partner. I cringe at the stereotype of the oversensitive artist or writer, but there's just a grain of truth to it.

Both disciplines require that we put a portion of ourselves into our work, so any kind of rejection stings doubly so. That's not to say that having a thin skin in this line of work is OK, but if that person is your partner, it's in your best interest to find what it takes to nurture and inspire his full creativity.

In an early Webcomics Weekly podcast, Dave Kellett described a concept used in an improvisational comedy class he attended. During any kind of creative exercise, the instructor forbade participants to use the word "*no.*" Instead they were encouraged to use the phrase "*yes, and...*"

There's a big difference between the two.

FAIRNESS

No collaboration can thrive in which one of the participants feels as if she's being cheated. Both partners need to feel a full sense of ownership in the final product — and both need to feel a level of comfort in the collaboration that inspires top-level commitment.

The best way to guarantee that both parties have a sense of fairness is to put it in writing.

I'm a big fan of collaborators establishing their partnerships in contract form.

This doesn't have to be a strict, legal document full of threats and rejoinders. But it should lay out in plain English what both parties can expect through this teamwork:

- Who owns the final work?

- Who owns the copyright?

- How are site profits split?

- How are book/merchandise profits split?

- Who has final say over merchandise?

- How are decisions about future opportunities (iPhone apps, publishing contracts, etc.) met?

- How can the partnership be brought to a fair termination — and what happens to all of the above if/when that happens? (See Bucket 4 in Robert Khoo's guide to reading contracts in Chapter 8.)

Collaborations can be extremely powerful creative entities. Just remember: "With great power comes great responsibility" — an important warning from the collaboration of Stan Lee and Steve Ditko.

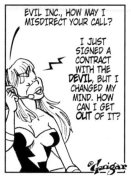 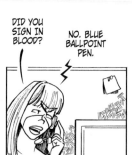 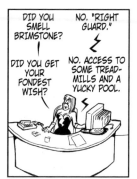 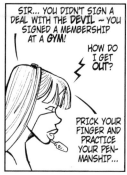

CONFLICT RESOLUTION

One of the crucial aspects to forming a beneficial creative team is being honest about yourself, your partner — and how both of you work in a collaborative setting. Think about how you and your partner react to each other. Do you have a healthy creative relationship in which you're both free to offer suggestions and negotiate fair compromises? Or do you constantly debate and argue with one another because you disagree on a part of the comic? Or perhaps you avoid conflict when you see something your collaborator does that you disagree with.

Regardless of how confident you are that your partner's point of view is absolutely wrong, you need your collaborator in order to make the project work.

So here are some suggestions to improve the relationship you have with your partner:

1. Talk about what you both want the comic to be. The type of genre, the story's tone, right down to why you're doing this project together.

2. Now that you both know what the other wants, make an agreement. Reach some middle ground that both parties can agree to. Try to keep everything as fair as possible. Remember, it could take awhile — and there may be things you won't want to shift on — but to make it work, you're going to have to grit your teeth and go for it.

3. Once you reach an agreement on how you two individuals can best work together, put it in writing and then stick to it. Hopefully, by the end of your discussions, you will have everything worked out and the two of you will be able to put together a webcomic that will make all the others jealous of your talents.

CREATIVE COLLABORATIONS FROM A LEGAL STANDPOINT

The following has been contributed by Eric Menge (Snowbynight.com). Eric is an attorney licensed in Maryland and the District of Columbia with more than ten years' experience practicing administrative and contractual law.

A webcomic is a lot of work. At some point, you may consider working with another creator to share the load, or you may have developed your idea with another creator from the beginning. Either way, when you start to collaborate with another creator, your relationship is going to have a number of legal and financial implications. You are going to need to know what those implications are and how they can affect your webcomic.

MAKING AN AGREEMENT

At the heart of every collaboration is an agreement between two or more artists. The agreement is what defines how you and your collaborators are going to work together. This agreement can be informal or formal, written or oral.

If you decide against operating under a contract, keep in mind that the law will make certain assumptions for you. Most importantly, the law will assume that, as co-creators, anything you produce is evenly created by both of you, and any profits and benefits will be divided right down the middle. This includes derivative products. If this is not the case, then you're going to need a contract.

WRITTEN CONTRACTS

Written contracts are more work than oral agreements, but the added hassle is worth it. I highly suggest that you have one for every collaboration regardless of the situation, even if it is with a long-time friend — actually, *especially* if it is with a longtime friend. Contracts clearly define the relationship and let everyone know where they stand, what is expected of them and what they will receive in return. A good contract can prevent a lot of headaches down the line. They can even save a friendship.

Contracts can seem intimidating, especially if they contain a lot of legalese. But your contract doesn't have to be that way. In fact, the more plain English you use, the better it will be. The goal of a contract is to have clarity and agreement between the parties. So make sure everyone understands what they're agreeing to. A contract with collaborators should cover the following:

> **1. Parties.** Who is a party to the contract? Are you signing for yourself or your studio? If your studio is a company or an LLC, then you are signing on behalf of the studio.
>
> **2. Duties.** Who is responsible for doing what and when? This is the meat of the contract, so make sure it covers how you intend to collaborate.
>
> **3. Rights.** Who owns the rights to anything created?
>
> **4. Payment.** Who gets paid and how and when? What triggers payment? Do your collaborators prefer to be paid by check or PayPal?
>
> **5. Term.** When does the term of your contract begin? How long will this contract last? Does it automatically renew?
>
> **6. Termination.** When and how can the contract be terminated?
>
> **7. Notice.** What is the contact information of the parties? This should include snail-mail addresses as well as e-mails and phone numbers.
>
> **8. Signature.** You and your collaborators need to sign the contract to show agreement.

You don't have to be a lawyer to write a contract, but as with all things, practice and familiarity help a lot. If you need help getting started, find a template. Templates are a time-honored legal tradition. There is no shame in using them. You can find plenty of sample contracts on the Web to draw from. If you can, borrow a contract from a colleague in the industry and use that as an example. You'll want to make changes to fit your situation.

You can always hire some expertise if you need it. Get a lawyer to help out. There are a lot of lawyers in this country. One of your friends or family members is bound to know one. Have her look over your contract and make sure you didn't leave any important issues unaddressed.

INTELLECTUAL PROPERTY

When you work with collaborators, you will want to work out who owns the rights to the material created. Unless you specify otherwise, any intellectual property you create in a collaboration is considered jointly created. This means you and your collaborators have equal rights to the entirety of the work.

This doesn't just apply to what you've created together, but also to any derivative products based on what you made together. So even if your collaborator leaves and you continue to make your webcomic, your collaborator's ownership interest continues. Some other fun facts: Any collaborator can grant nonexclusive licenses to the material, but all collaborators are needed to grant exclusive licenses. Likewise, any collaborator can cancel a nonexclusive license for the material. Sound messy? Yes, it is.

Since it is your webcomic, the best route is to get your collaborators to assign their rights in your joint creation to you. This most often means giving them money up front for their rights. Be sure to specify all rights worldwide in all media, including those not yet in existence. In our constantly changing world, it's best to be careful about that. Some earlier author contracts did not include clauses that would apply to e-books, forcing the publishers to go back and make new contracts for those rights.

Another option is to ask for an exclusive license, such as for posting on the Web. This would allow you to use your collaborators' material for the webcomic, but your collaborators could sell prints. The least encompassing is the nonexclusive license. This allows you to use your collaborators' work, but so can they, and they can license it again to other people. Having other people with the same rights to the art in your webcomic isn't very helpful, and I would suggest avoiding this option. Try to get an assignment of rights or at least an exclusive license.

You may have heard of something called "work for hire." Work for hire allows an employer or commissioning party to be legally considered the owner of the intellectual property from its creation, leaving the original creator with no rights at all. Most of the contracts by the large comic companies use work for hire.

But work for hire is available only in a few situations — specified by statute. Even if a contract describes the arrangement as work for hire, a court might strike down that determination because a federal statute trumps a written private agreement every time.

The first way you can use work for hire is if your employee is creating content in the scope of his or her employment. Is your collaborator an employee? Didn't think so.

Work for hire can apply to independent contractors if you specifically commission the work and the work fits into one of nine categories defined by statute. These categories are: contributions to a collective work (such as periodicals and anthologies), movies, translations, supplementary works to a larger work, compilations, instructional texts, tests, answer materials for a test, or atlases.

Out of all of these, chances are the only category that will apply is supplementary work, which includes introductions, conclusions, illustrations, maps, appendices and the like. Even then, your collaborators would have to be doing only secondary work that is supplemental to what you're creating. That limits how much involvement a collaborator can have.

If a court finds that your arrangement does not fit one of these nine categories, it could invalidate your contract, leaving you without the rights to the work done by your collaborators. My advice? Leave the work-for-hire contracts to DC and Marvel. Go with an assignment of the rights instead. It's cleaner and easier, and you get nearly the same result.

NEW YEAR'S REVOLUTION!

Ask anyone who regularly attends a gym.

For the first six weeks of every year, it's impossible to find an empty treadmill, stair-climber or elliptical workout machine.

And then, on the seventh week, everything's back to normal.

New Year's resolutions tend to flicker and die within six weeks of the ball dropping in Times Square.

So, how about you?

Remember those New Year's resolutions you made? Are you one of the people leaving an empty treadmill at the Webcomics Gym? If you haven't made any real progress, there's a reason.

That's because resolutions are like wishes. They feel awfully good when you make them, but they don't actually accomplish anything.

I hereby put forth a challenge. Declare three main resolutions and then, for each, do this:

- State how you're going to advance a third of the way to this goal by April.
- State what you will do to push to the 66% mark by August.
- State what you will do to finally achieve this goal by December.

For example: If the resolution has to do with gaining more readers, then there are a number of factors that play into this — establishing a quality comic, updating at a frequent/consistent rate, using viral marketing, tapping into social networking, spending money on advertising, etc. State what tools you will use — and be specific. If you want, say, 500 new uniques by the end of the year, write how you plan to get to 165 by April. No fair saying that you're going to start using Twitter. Describe how you're going to use Twitter. Make a plan.

Any doofus can make a resolution. Winners plan success.

Image Prep

Preparing an image is an incredibly important issue for a webcartoonist. Your work has to look good on a computer screen as well as on a printed page — and those are two very different formats.

RESOLUTION

Computers generate images in a low-resolution ("low-res") format. 72 DPI is currently the standard, but that's changing, as we'll discuss at the end of the chapter. The abbreviation "DPI" stands for "dots per inch," and it's a term carried over from the printing world. Technically, digital images are measured in PPI (pixels per inch), but the two are virtually interchangeable.

Printed projects are produced in a high-resolution ("hi-res") environment. The following resolutions are standard for printed pieces:

- Grayscale images: 300 DPI (or higher)

- Color: 300-400 DPI (or higher)

- Black-and-white lineart: 600 DPI (or higher)

Every strip I produce is saved four times:

- Master: 600 DPI TIFF file, linework only (which we'll refer to as "lineart")

- Book: 300 DPI TIFF file, CMYK

- Web: 72 DPI JPEG file, RGB

- Self-syndication: 300 DPI grayscale TIFF, converted to halftone bitmap

Please don't make the rookie mistake of thinking that you're never going to print a book. At some point, you're going to, and when that time comes, you're going to need hi-res files to do it. Prepare now by saving a hi-res master file of each one of your strips as you produce them. You'll thank me.

If DPI measures how many dots (or pixels) comprise an image, LPI (lines per inch) measures how closely together those dots are spaced. The higher the LPI, the more refined the image. As a general rule of thumb, however, LPI is usually one-half of the DPI. So, if I have a 300 DPI image, I'll try to keep the LPI around 150.

SAFELY ENLARGING DIGITAL ART

You can always reduce digital art without sacrificing image quality. However, trying to enlarge art will usually result in poor image quality. That's because you're effectively reducing the DPI and the LPI of the image as you stretch it. If your original art has a high enough resolution, however, there's a workaround. As with most of the instructions in this book, I'll assume you're using Photoshop, but if you're not, you'll quickly find that most image-editing software share common terminology.

Select **Image -> Image Size**.

Place a checkmark inside the box near **Constrain Proportions**.

Make sure there's *no* checkmark in the **Resample Image** box.

By typing a lower number in the resolution field, you'll notice that the physical size of the file increases. For example, a 5x7-inch file at 600 DPI will enlarge to 10x14 inches at 300 DPI. As long

GRAYSCALE VS. LINEART

A grayscale image is a black-and-white image with continuous shades of gray.

A black-and-white image with no grays is called lineart.

You can simulate grays in lineart by using crosshatching or dots to form areas that read as gray to the eye.

PIXEL VS. VECTOR

A digital art file is said to be "pixel" if the image is composed with pixels (or "dots"). Photoshop yields pixel art.

On the other hand, art created in applications like FreeHand, Adobe Illustrator, Corel Draw or Adobe Flash are said to be "vector files" because the shapes are defined by math —not pixels.

Vector art can be infinitely enlarged because there are no pixels to degrade image quality.

as the file's resolution doesn't fall below the guidelines listed above, your image will print at a good image quality.

LOW-RES ART

In the past, I would have been adamant: The standard for Web images is 72 DPI, and that is that.

Then manufacturers started releasing high-resolution monitors (like Apple's Retina display), and the standard is rapidly changing. I'm still uploading my comics at 72 DPI, but as higher-resolution monitors become standard, that's going to change. (This is another good reason to make sure you have hi-res master files of each comic you create.)

For the time being, you can assume 72 DPI is adequate for comics that are being delivered to desktop monitors.

And in the meantime, if you're using a WordPress-based content-management system, look into one of the available plug-ins that will adapt your images for both 72 DPI and Retina display (and deliver the appropriate one to your reader based on what she is using to view your site).

I use **WP Retina 2x**, and there are others to experiment with.

CMYK VS. RGB

CMYK color mode is used for an image that will be printed at some point. It gets its name from the four inks used in process printing: cyan, magenta, yellow and black (which is designated "K" to avoid confusion with cyan, which is sometimes called "blue" by some old-timers). Using these four inks, printers can create a spectrum of 5,000-6,000 colors on paper.

RGB is named for the three colors of light that monitors use to create images (red, green, and blue). RGB mode is used for images that are intended to be seen on TV or computer monitors. A spectrum of 16.8 million colors is possible using RGB mode — far more than CMYK mode.

I strongly recommend working in CMYK mode for the simple reason that there are some RGB colors that are impossible to achieve in CMYK. Many people work their color images in RGB mode because several Photoshop filters don't work in CMYK. To make sure they don't inadvertently create unprintable colors, they activate a CMYK preview

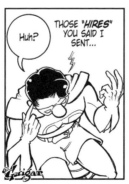

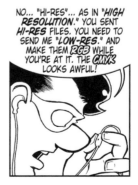

You can get a CMYK preview of an RGB file by selecting **View -> Proof Colors**. Notice: In the title bar of the document, the color mode reads "RGB / 8 / CMYK."

in Photoshop — so although they're in RGB mode, their monitors show them what the image will look like once it is converted to CMYK. However, the final image must still be converted to CMYK mode before it can be printed correctly.

If printing a book is in your future, CMYK colors are a must.

This is true despite the fact that print-on-demand printers will happily accept RGB files for print. Printers that use a traditional offset process-color printing system insist on CMYK files. And as your business grows, switching to offset printing will become imperative if you're going to reduce unit costs and maximize profits.

So my advice is to convert your final image to CMYK. Much better than being faced with trying to adjust a few hundred RGB files a few years from now.

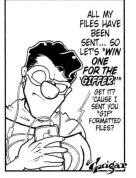

SAVE FOR WEB

Use Photoshop's "Save for Web" function when saving your work for the Web. It strips out a lot of extraneous file information, which reduces the file size.

Experiment with the different options to see if you can get the file size as low as possible without sacrificing image quality.

FILE FORMAT

There are several types of file formats — and each of them has a designated purpose. Using the wrong file format for any given use is sure to cause image-quality problems. Here's an overview:

- GIFs are great for black-and-white lineart, solid colors and tones with no gradients. Files sizes are usually fairly low. Web only.

- JPEGs work well for images with gradients and shifting tones — like photographs and more complicated illustrations. File sizes may vary, depending on the art. Web only.

- PNGs are good at both lineart and images with gradient tones, and they keep files sizes low. Web only.

- TIFFs are the industry-standard file type for print. TIFF offers compression choices (LZW and ZIP), but I don't recommend using these options for files that are going to be printed. I would apply those options only for storage. Print only.

- EPSs are generally used for vector-based digital art files. Print only.

SCANNING LINEART

I'm going to assume that you're scanning black-and-white lineart in for coloring via Photoshop or some other image-manipulation software. If you're working in Photoshop using a tablet, feel free to skip this section.

- Never do the initial scan in black-and-white or lineart mode!

- Make sure you're scanning at 600 DPI or better

- Do the original scan in grayscale (or, barring that, color mode — and then in Photoshop, switch to grayscale).

Once you've completed the initial scan, open the file in Photoshop.

Go to **Image -> Adjustments -> Threshold**. You can play with the slider, but I generally set mine between 110 and 130. I'll explain this step in a moment.

It will look jaggy on your screen, but as long as you're working at a high resolution (I suggest 600 DPI or higher for B&W lineart), it will print just fine.

By the way, if you want to save this file as a master copy of the B&W lineart, do a Save As, go to **Image -> Mode -> Bitmap** (50% threshold) and save as a TIFF. Saving in bitmap mode crunches that file size down to practically nothing, and makes it easy to archive your B&W master files without taking up much space. Just remember to convert it back to grayscale if you ever go back to it to edit it or add color.

The Threshold dialog box.

COLORING LINEART

Now you have nice, crisp lines in a grayscale-mode file. The time to add words — if you haven't already done so — is now, before you add the color. Follow these steps to prepare the image for coloring using Photoshop:

- Switch to CMYK mode.

The Bitmap dialog box.

- In your main toolbox, make sure your background color is set to white.

- In the image area, Select All.

- Open the Channels palette.

- Click on the CMYK channel and Copy.

- Click on the Cyan channel and hit Delete.

- Click on the Magenta channel and hit Delete.

- Click on the Yellow channel and hit Delete.

- Now ... click on the Black channel and PASTE.

Your lineart is now pure black. True, you could have simply deleted the C, M and Y channels, but that would have degraded the line. You've basically taken the original image and isolated it to the black channel while eliminating the other channels.

Why do this? In the printing process, the color image is produced by pressing four plates (cyan, magenta, yellow and black) onto the paper. The goal is to hit the paper on the exact same spot every time, but since the press is whirling away at breakneck speeds, this is awfully tough and sometimes one or more of the plates are *juuuuust* a little off. This is referred to by printers as being "out of register." If your black lines are built up of all four inks, being a little out of register will mean that your lines will look fuzzy (and your text will be downright unreadable).

You're not done prepping. Close the Channels palette and open the Layers palette:

- You'll have one layer: it will likely be called Background.

- Duplicate it, using the Duplicate Layer command found by clicking that little downward arrow on the upper-right-hand corner of the Layers palette.

- Now you have two identical layers in your Layers palette.

- Double-click the one on top and name it Lineart.

- Double-click the one on the bottom and name it Color.

- Click on the Lineart layer and, using the scroll window near the top of the palette, select Darken.

- Now click the padlock symbol to lock the layer.

- Now click on the Color layer.

- Move to the image area and begin coloring the image.

This is what your Channels palette should look like when you're through: No data in the Cyan, Magenta or Yellow channels — only in the Black channel.

This is what your Layers palette will look like. The Lineart layer is locked. You're working on the Color layer, underneath. You may choose to either view or hide the Lineart layer as you work.

CREATING A PHOTOSHOP ACTION

To maximize my studio efficiency, I use Photoshop Actions for much of my repetitive image-processing needs. Once I've recorded the steps of a process into an Action, I can simply play that Action the next time I need to enact that process on a new file (or set of files). Here's how:

- Go to **Window -> Actions** to open your Actions palette.

- Click the options key and then select New Action. Name it.

- Click Record.

- Now open a sample document and enact the steps of your process on the sample.

- Close the document and then click the Stop button in the Actions palette.

- Later, when you need to enact this process

Stop Record Play Delete

COLOR FLATTING

Since a comic is dependent on black text (and, often, black lines), color flatting becomes a crucial part of image prep. In the process of coloring your image using the previously described process, the colors will be bounded by the black lines. But if the image is printed even slightly out of register, you may wind up with white borders around the black lines.

You need to make sure that, on the color layer, the color pushes inward and eliminates the black lines completely.

Luckily, there's a Photoshop plug-in that does this automatically. Go to bpelt.com and download the plug-in that works with your computer's operating system.

Once it's installed, you'll see two new options under Photoshop's Filter menu: **Bpelt -> Flatten** and **Bpelt -> MultiFill**.

MultiFill is a good way to start your coloring process. It converts all of the white space in your comic to a color so you can quickly color the comic by selecting the shaded area with your Magic Wand tool and using the Paint Bucket to drop in the correct color.

Once you're finished coloring, use **Bpelt -> Flatten** to make the colors butt up against one another in your Colors layer. The lines in the Lineart layer will not be affected by this.

I've found that the Flatten plug-in doesn't work too well with Photoshop's tendency to anti-alias lines to make them look smooth. To address this, sometimes I have to do a little end-run around Photoshop's good intentions:

- **Select All** in the Colors layer (before coloring) and **Cut**.
- Open a new Photoshop document.
- **Paste.**
- Convert mode to bitmap.
- Convert mode to grayscale.
- Convert mode to CMYK.
- Select All and **Copy.**
- Open up the original document and **Paste** back into the Colors layer.

This usually addresses the problem nicely.

Here's a look at the Colors layer of a comic before color flatting.

This is what the Colors layer looks like after the Flatten filter is applied.

FILE SIZE VS. PHYSICAL SIZE

Your digital art has two sizes: a physical size and a file size.

The physical size is the actual dimensions of the art when it is presented at its proper resolution.

The file size is the amount of data that is stored in the file that comprises your digital art.

When you're preparing to present your work for the Web, you want a big enough physical size to be legible on most readers' Web browsers (currently, 900 pixels across is a safe bet), while keeping file sizes low enough that they load on the readers' screens quickly.

on another file (or group of files), open the Actions palette, select the Action you saved and hit the Play button. The dialog box will ask you to choose a file. If you choose a folder, your action will be applied to each of the files in that folder, one by one.

COLOR THEORY

If you're like me, you feel completely awkward when it comes to adding color to your comic. After all, finding two hues that harmonize is difficult. But harmonizing enough colors to make a pleasing scene? That's a color-theory challenge that has eluded me for almost a decade. It doesn't help to read about the old-time animation colorists who point out that sometimes they'd use purple for a tree trunk because it made the scene better.

When I start trying to turn tree trunks purple, I know I'm in over my head. So I do what any self-respecting cartoonist does when he's out-matched. I cheat.

OK, it's not really cheating, but it's an awfully good way to generate a harmonious palette of colors. Color Schemer (colorschemer.com/online) is software that generates a color scheme that works with whichever base color you choose. It's RGB-based, so you're going to experience a slight shift when you plug the colors into your CMYK file, but I find that the overall effect is an images composed of colors that work together very well. You can download the full-feature version for Mac or PC for about $50.

PHOTOMERGE

Perhaps you have an oversize piece of art that you have to scan in two pieces. Or maybe your scanner isn't large enough for your originals.

Either way, you're faced with scanning your image in two pieces and pairing them up digitally.

To be sure, if you're very careful with your initial scans, you can do this manually with a little effort.

However, with recent versions of Photoshop, you can let the app do the

work (and, in some cases, do it better than you could unaided).

Start with two or more scans that, pieced together, form one continuous image.

- Go to **File -> Automate -> Photomerge.**

- Select the files that comprise your image.

- Under Layout, select Auto.

Hit OK, and Photoshop will combine all of the partial scans into one continuous image — tweaking, rotating and mating the individuals so they fit seamlessly with one another.

You are left with a new image file to inspect — in a fraction of the time that it used to take to do it manually. If it passes inspection, flatten the image in the Layers palette, and move forward as you would with any lineart scan.

Your Web Site

Your Web site is your headquarters — your base of operations. A great comic can be utterly destroyed by being placed on a poorly functioning site. This is where you gather your community, generate ad revenue and encourage merchandise purchases. Granted, it has to look good. But don't sacrifice looks for those functions I just mentioned. For example, nobody enjoys Web advertising. If we had the choice, we'd all prefer to visit sites that exclude advertising. But ads put money in your pocket, and I'm assuming that's part of what you're trying to accomplish. So your site has to give its advertising space as much thought as the space reserved for content. It can't be an afterthought. Your site has to find a workable balance between aesthetics and application.

WHAT IS HOSTING?

This section was written by Philip M. Hofer ("Frumph"), Comic Press developer and creator of the Comic Easel WordPress theme (Comiceasel.com). He also consulted on all of the WordPress- and Comic Easel-related material in this chapter.

Hosting is the 'place' on the web where your site is located and being delivered to its audience. The Internet is not magic. Your site is on a computer somewhere. When you go to a Web site by way of its address (URL) in your browser, you're contacting a host, which then makes a request for the page to be displayed by its Web daemon. There are several types of hosting available: free (managed), shared, VPS and dedicated.

FREE HOSTING (MANAGED)

Free hosting is managed by a company, and often it will not allow you to make changes beyond simple cosmetics. In many cases, free hosts will not allow you to plug in your own advertising code if you want to monetize. Instead, they provide the advertising and give you a portion of the revenue. On the other hand, most of those free-hosting solutions have very large communities and can increase your readership as well as promote your comic's activity. Some examples are:

- WordPress.**com**, which has a theme for webcomics called "Panel" (*see sidebar to the right*)
- Comicfury.com
- Smackjeeves.com
- Comicgenesis.com
- Drunkduck.com

SHARED HOSTING

When you purchase hosting space, you are making the determination that you want complete control over your site — everything about it is your responsibility. Something to remember when you buy your own hosting space: Each pageview requested from your host takes a little bit of processing and memory to complete. The more traffic you get, the more of the processing it requires from your host to deliver its content. The more popular your site becomes, the more it will cost for your site to be hosted. If you are generally getting fewer than 5,000 pageviews daily, a shared hosting is perfect for you. Some hosts can handle up to 15,000 daily pageviews with no problem (especially if you utilize caching or if your host has a cloud available to it). Some good choices are:

- Cirtexhosting.com
- Bluehost.com
- Hostgator.com
- Hostmonster.com
- Dreamhost.com
- Inmotionhosting.com

WORDPRESS: THEMES, WIDGETS AND PLUG-INS

Using WordPress can be pretty confusing for a first-timer. It's easy to get confused when you're talking about themes, plug-ins and widgets.

THEMES

A WordPress theme is the template for your Web site. The theme determines the look of the site. Individual pages on the site can be modified and adapted, but the theme provides the general outline for how the site is going to look.

WIDGET

A widget is available as part of the theme, and it allows you to fine-tune the individual features of your site. For example, Comic Easel comes with a Bookmark widget. If you activate it on your site, users can bookmark their place as they read through your archive.

PLUG-IN

A plug-in adds elements to be used by the theme. For example, a plug-in can be installed to enable you to track your Web traffic through Google Analytics.

VPS AND DEDICATED-SERVER HOSTING

Most of the companies in the shared-hosting-service list also provide virtual private servers (VPS) and dedicated hosting: you really need to shop around for this service and find the best price possible. WHM and Cpanel are must-haves to make a site easier to manage.

CPanel (Control Panel) is software that allows a simplified way to manage the hosting itself — the e-mail, SQL (structured query language) and DNS (domain name system) information for individual hosting accounts.

WHM (Web Host Manager) is a program that allows administrative access to the back end of CPanel. Most of the command-line run funcions that are needed to execute the installation and maintenance of software on the VPS or dedicated hosting can be run within this menu-driven software — ultimately making it easy for those of us who do not know Unix-based commands.

AFTER GETTING HOSTING

If you are using free hosting, those services mentioned earlier have plenty of documentation available to explain how to add your comic to the site. Start reading to take the plunge to start adding your comics.

If you are paying for hosting, you will need to decide if you want to use a CMS, use blogging software or design your own site with HTML. All of these options output HTML, which is read by browsers to determine how the site's content is displayed to the browser, but the CMSs and blogging software make it easier to manage (and you don't have to do all of the coding yourself).

The most common CMS/blogging software is WordPress (wordpress.**org**). Don't confuse this with the free hosting at WordPress.**com** — those are two different services. WordPress.**org** gives you the software that is executed with a language called PHP to be hosted by you on your own site. WordPress.**com** is where you go to get free hosting.

From WordPress.**org**, download and install the software to your host, and then follow the installation guides. Most of the shared-hosting recommendations previously mentioned have one-click installs of this software.

With WordPress, the site's user interface is controlled by a **theme**. There are thousands of themes available to WordPress. Nearly all of them are specifically geared for blogging. However, there are **plug-ins** available that allow you to add comic management to those blogging themes.

Comic Easel is one of those plug-ins. It allows you to easily manage your comics and control how the comic looks on your chosen theme. The default theme is called "Easel." If you are not using the default theme, you will need to add some PHP code to the theme you are using.

After you install WordPress on your host, add the Easel theme and then add the Comic Easel plug-in. Now you're ready to start adding comics to your site. It's not a bad idea to use the Easel theme for a little while to get used to WordPress and the Comic Easel plug-in.

INSTALLING COMIC EASEL

We're going to focus on installing Comic Easel for WordPress. However, you can take much of what we detail here and apply the principles to installing nearly any webcomic CMS for WordPress.

Assuming you've installed WordPress already, go to the WordPress dashboard from your Web site. Go to the **Plug-ins** area and search for "Comic Easel" using the search box in the upper right-hand corner. Install and activate the plug-in.

In your WordPress dashboard, go to **Appearance –> Themes**, and then click the Install Themes tab. Search for "Easel." Install and activate the Comic Easel theme.

As a result of your having installed the Comic Easel plug-in, you now have a new section in the WordPress dashboard, and you can see it in the left-hand column: Comics. This is where you upload, organize and manage your comics. It's pretty straightforward. The interface looks like this:

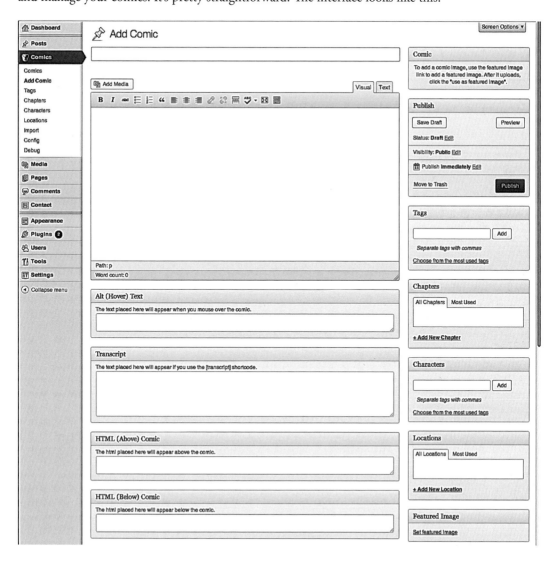

Your comic is going to be uploaded as a **Featured Image.** See that little box all the way at the bottom of the right-hand column? Here's a pro tip: You can click-and-drag that box to the top of the column, and it will stay there. You're going to be using it so often, you'll want it in easy reach.

Click Set Featured Image and upload a comic. When you're finished, you're returned to the Add a Comic interface. Near the top of the right-hand column, you'll see a section called Publish. This is where you set the publication details for your comic. You can set it to publish immediately or you can schedule it to update at the date/time you specify.

There are also a ton of extras here, including tags, hover text, transcripts and chapters. Once you've uploaded a few comics, your Comics dashboard will look like this:

But your site is going to look like an out-of-the-box Comic Easel site. And, while that's not bad, you're probably going to want to change it to make it fit your comic. And that's going to mean ...

CREATING A CHILD THEME

Never — ever — make changes to your WordPress theme. If you do, you'll lose them when the developers release an update to the theme. Instead, create a child theme and make changes to *that*. It works like this. The site uses all of the coding from the theme except for the coding found in the child theme. The child theme is a selective overwriting of the original theme.

• Using a text editor, type the following into an empty page:

```
/*
Theme Name:    ***write your theme's name here***
Theme URI:     ***write your URL here***
Description:   My Child Theme of Comic Easel
Author:        ***your name***
Author URI:
Template:     easel
Version:      0.1.0
*/

@import url("../easel/style.css");
```

- Create a folder on your desktop with the name of your theme. Don't use spaces; rather, use "_" or "-" between words instead. Save your text file (name it **style.css**) inside this folder.

- Upload the folder to **/wp-content/themes**.

- Go to the WordPress dashboard.

- Under Appearance -> Options click Disable Default Design.

- Go to Appearance -> Themes.

- You'll see your theme's name. Click it.

Now you have an official, honest-to-goodness child theme.

To make changes to your site, simply type the code that you want to overwrite the parent theme into the style.css file of your child theme. You'll find it in your WordPress dashboard, under **Appearance -> Editor**.

This is a good place for a little experimentation, if you don't have a huge CSS-coding background. Look at a section of the CSS of the parent theme that you'd like to change, and copy/paste it into the child theme's CSS. Now, make some changes. The effects will be instantaneous. Don't like it? Delete it. And the site will revert to the parent theme's coding. No worries!

The rule about not changing the parent theme extends to its template files, too. You'll need to do this to install advertising code, for example. In your WordPress dashboard, go to **Appearance -> Editor**. You'll see your child theme, by default. Using the drop box at the upper right-hand corner of the dialog box (**Select theme to edit**), select your parent theme (in this case, Comic Easel). Along the right-hand column will appear several template files, including **header.php**, **sidebar-left.php** and **side-bar-right.php**.

If you need to drop code into the header of your Web site (many advertising providers like Google AdSense require this), you'll want to copy header.php and paste it into your child theme. The easiest way to do this is to use FTP and path to your Web site's WordPress files. Under **wp-content/themes/easel**, you'll find all of those template files. Don't delete them! Just copy the ones you want to work with into the folder of your child theme. These newly copied files are the ones you'll want to work with. Leave the files in the parent theme alone.

PERSONALIZING COMIC EASEL

I can't devote all the space that it would require to cover this topic fully, but there are a few things you can do to make this site fit your unique vision.

First, you'll want to turn off the default design. In your WordPress dashboard, go to **Appearance -> Easel Options**, and place a checkmark in the box next to Disable Default Design. At **Appearance -> Header,** you can upload your comic's logo to display at the top of your site. And go to **Appearance -> Background** to upload a background image/pattern for your Web site.

And, most importantly, go to **Appearance -> Widgets** and check out all of the cool options you can add to your Web site. The interface is pretty easy. Click-and-drag widgets from the central area of the dashboard to the section in the right-hand column in which you want them to appear. For example, to place a calendar into the right-hand sidebar, under the comic, click Comic Easel - Calendar and drag it to **Right Sidebar.**

NAVIGATION BUTTONS

The navigation widget comes with a variety of different sets, but it is also possible to create your own set. To create your own set of navigation buttons, you may want to consider copying a current set. They are located in the **/wp-content/plugins/comic-easel/images/nav/** directory. Drag a copy of one of the folders to your desktop. Open the image files inside the folder and redesign them to fit your site's look.

Along with the image files, each folder has its own **navstyle.css** file. This CSS file has all the information inside that determines which graphics to use and how the buttons display on the screen.

Open one of the images and look at it. I'll use the "previous" arrows from the **Box** button design. Notice that there are three image "states" inside a single image file. The first state is the "active" state. This part gets displayed when there is a comic it can travel to but the mouse isn't hovering over it. The second image

is "hover" — it's used when the user's cursor hovers over the button. The third state is "inactive." It's used when there's no comic to travel to (and it can't be clicked). For today's comic, the "Next" button would appear in the "inactive" state because there's no "next" today, only "previous."

The **navstyle.css** file takes this image file and moves it back and forth to display the portion of the image that corresponds to the state (active, hover or inactive). In our example, the button displays in a 44x44 pixel area. The image file is 132 pixels wide (and 44 pixels deep). Here's the code that does it:

```
.navi {
    width: 44px;
    padding-top: 44px;
    margin: 0 5px;
    font-size: 0.9em;
    color: #555;
    display: inline-block;
}

.navi:hover {
    background-position: -44px 0;
}

.navi-prev {
    margin-right: 10px;
    background: url('prev.png') no-repeat;
}

.navi-void, .navi-void:hover {
    color: #999;
    background-position: -88px 0;
}
```

Active state

What you see

The code moves the image 44 pixels to the left.

Hover state

What you see

Inactive state

What you see

The code moves the image 88 pixels to the left.

In the above **navstyle.css,** ".navi" is the element that contains the base information that is used in all its states. This element contains the height and width along with other information on how the button is displayed. The **.navi-hover** code moves the image 44 pixels to the left. The **.navi-void** and .navi-void hover code moves it 88 pixels.

Once you're happy with your new buttons, you'll want to upload them to your child-theme folder — **not** the folder you originally got them from! On your desktop, rename the folder that contains your new buttons (so you don't get *these* buttons confused with the originals). Go to **/wp-content/themes** and open the folder of your child theme. If there's not an "**images**" folder, create one. Create a folder inside this one named "**nav**." Upload your custom-made button set here.

When customizing your own set of buttons, you can use whatever height and width you want for the buttons, but remember to alter the code in the **.navi** portion of **navstyle.css** to reflect that change. The **.navi-void** and **.navi:hover** numbers will need to be changed as well. For example if your new buttons are 50x50 pixels, the image itself will need to be 150x50 pixels (width x height), then the **.navi:hover** will then need to be -50 pixels instead of -44px, and **.navi-void** needs to move two states over so it needs to be -100 pixels.

The comic navigation widget will only work inside one of the comic sidebars, so those need to be enabled in **Comic -> Config** (under the **General** tab). Now, go to the **Navigation** tab and disable Default Navigation. Select your personal navigation buttons from the drop-down. Finally, go to **Appearance -> Widgets** and drag the **Navigation Widget** into its proper place (usually the **Under Comic** sidebar).

OPTIMIZING PAGE-LOAD SPEED

This is based on a Webcomics.com post by Mo Jones (jesusandmo.net).

Page-load speed isn't just a user-experience issue — although it is certainly that — it can also affect your Google page rank. Useful tools for monitoring and analyzing your page-load speed are **pingdom.com** and the **PageSpeed** Firefox plug-in (**YSlow** is also handy). Pingdom tests your site from a server in Europe, so if your host is in the U.S. it might show slower results than if you tested with **WebPagetest,** with its multitude of locations to choose from.

There is an argument that says if speed is your priority, you shouldn't use Wordpress at all — and that's a fair point. Wordpress is great, but it's big. If there is a leaner system out there that does everything I need and is secure, I'll switch to it.

CACHING

Caching is essential when using WordPress. The three main ones are **WP Super Cache**, **W3 Total Cache** and **Hyper Cache**. Super Cache had issues with my host because of PHP safe-mode — but that's an unusual quirk of my host and probably won't affect you. W3 Total Cache gets a great press,

WORDPRESS PROTECTION

WordPress is an overwhelmingly popular CMS for webcomics — and for bloggers in general.

That means it's also incredibly popular with hackers.

Here's how to protect yourself.

CHOOSE A STRONG USER-NAME/PASSWORD COMBO

Your main line of defense is a strong password with letters, numbers and characters like $ @ & and *.

NOT "ADMIN"

Also, your username should not be "admin." If it is, you've already betrayed half of your username/password combination to potential hackers.

UPDATE

Keep your version of WordPress up to date. As soon as a potential breach in security is identified, WordPress releases an update to seal it off. But that update doesn't work unless you install it. Don't put it off one minute.

COMICPRESS BUTTONS

The process for personalizing navigation buttons featured on the opposite page works for Comic-Press users, too!

and it certainly does lots of clever things, but I found it to be bloated — and it actually slowed down my load time (I may have configured it badly). Hyper Cache is about a tenth of the size of those two and works flawlessly, speeding up the site better than either of them.

FILE OPTIMIZATION

I look at a lot of webcomics, and I'm often surprised at the sheer size of the image files I need to download. Your full-color comic doesn't need to be hundreds of megabytes if you save it in the right format. After much experimenting with Photoshop's "Save for Web" function, I've discovered the PNG-8 is ideal for my comic. If you're using PNG-24, your images are much bigger than they need be (and they'll take longer to load). You may notice a slight fade in the color when you change from PNG-24 to PNG-8, but your readers almost certainly won't. It can make a big difference in the page-load time. Different settings produce different results. Experimenting will help you make an informed decision.

CSS OPTIMIZATION

You should optimize your CSS, too. If you have time, take a look at your code, and strip out all the lines you don't use. Then put it through a CSS cleaner (such as **cleancss.com**). You probably don't want to make it all one spaceless block if you are ever going to edit it again, but you should be able to shrink it a lot without sacrificing legibility.

CDN

Your readers are located all over the world. If your server is in the States, then people who are looking at your site from Australia are suffering slow loads because of latency. This is where a content delivery network (CDN) helps. If you hire space on a CDN, it will distribute your static files to a network of servers all over the world, and your reader downloads from the one nearest to them geographically. This makes a huge difference.

My host provides space on **Internap CDN** on a pay-as-you-go basis (with my optimized files, it's very cheap). If your host doesn't offer this, you can still rent space at competitive rates elsewhere. **Akamai** is the king of CDNs — and it's awesome — but it's expensive. There are others that are more affordable. Fifty dollars per terabyte is a decent range to shoot for.

Once you've got space on a CDN, put all your static files on it: images, CSS (edit header.php to point to it) and your comic folder, too. The latest ComicPress plug-in has the ability to automatically load your comic onto your CDN. Only my WordPress install exists on my host server. Everything else is either on my CDN or is a third-party ad — all of which have their own CDNs.

SPRITES

You can reduce the number of objects a reader has to download by putting all your frequently used images (navigation, masthead, etc.) into one big image and calling them up using the CSS sprite technique. If you optimize that big image, too, you'll save a lot of time. It's a bit of work, and not recommended if you change your images a lot. You can learn about sprites and create them at **spritegen.website-performance.org**.

DATABASE OPTIMIZATION

I had dragged the same database through three separate hosts over the space of five years when I realized that maybe it was causing my site to load more slowly than it should. There are optimization buttons in **php-MyAdmin** that you can use, but that wasn't going to help me. In the end I created a fresh WP install with a clean database and copied over from the old database only the essential tables (comments, posts, transcripts, subscribers, etc.), one by one. I left a lot of stuff behind — mostly in **WP-options**, where the remnants of long-discarded plug-ins and goodness-knows-what-else were festering. That resulted in the most significant speed-up I've experienced.

There are lots of other little things you can do that **Google PageSpeed** and **YSlow** will recommend — such as putting javascript at the bottom of your page code. Submit your URL to each to get some helpful advice.

NAVIGABILITY

Many webcomic sites fall into the same design traps that prevent readers from accessing the site to its fullest. Tweaking your site in these areas will make your site more navigable to new readers — which will translate into greater reader-retention and higher pageviews. Navigation buttons (the ones that navigate readers forward and backward through your comic's archive) are the most important navigational tools on the page. They must be as close to the comic as possible. Too often, navigation buttons get separated from the comic — sometimes by too much space, and sometimes by an actual line that separates the comic from the buttons. I advocate making navigation buttons foolproof, such as in the following ways:

ICONS

Use standard iconography (single forward arrow, double forward arrow, single backward arrow, double backward arrow) that most readers are familiar with from other sources (DVD players, iPods, etc). Combine iconography with words (i.e., the single forward arrow with "next"). And make them large enough to carry significant visual importance

DON'T...

- Draw cutesy icons your readers will have to interpret.

- Rely on text-only navigation links.

- Place the navigation alongside a comic — unless it's a vertical shape.

Based on your readers' experiences from other media, they will be expecting the buttons to be directly under the comic. I would recommend navigation links above the comic *only* if the comic is presented in a vertical format — and in that case, I'd prefer to see navigation buttons above and below the comic.

Finally, look at your comic and determine whether you should be doing more to help the reader navigate your comic. Does your comic require the reader to scroll down to read it? Consider placing the navigation above *and* below the comic.

MIGRATE FROM COMICPRESS TO COMIC EASEL

If you're using ComicPress and want to switch to Comic Easel, it's very doable.

There's a downloadable plug-in at **wordpress.org/ plugins/cp2ce/**.

• Install and activate the plug-in.

• Go to **Tools -> CP2CE**.

• Make sure your ComicPress comics directory is in the root WordPress installation in the /comics directory.

• Select the comic category you want to migrate.

• Choose how many you want to do at a time. Slower servers require this number to be low; faster servers can handle larger loads. Start small.

• Click Migrate.

• Migrate all of your comics from all of your comic categories. Do *not* migrate your blog categories.

• When you are done migrating your comic posts, go to **Post -> Categories** and delete the old comic categories.

• Deactivate Comic-Press Manager and delete it.

• Install the Easel theme.

Video tutorials can be found at **comiceasel.com/ ?s=migrate**.

Separating the navigation from the comic is possibly the single biggest Web-design mistake you could make. The reader may miss the navigation entirely or — since the navigation buttons are located near the blog and separated from the comic by a line — assume the comic is a static decoration and the navigation applies only to the blog.

LOGO DESIGN

Designing a logo for your comic is an exercise in branding that, unfortunately, many people don't put a whole lot of thought into. However, that logo often says as much about your comic as your comic itself. In fact, it might arguably have a little more weight — since it sits there as a repeated visual on page after page ... reiterating its message to your readers. Here's how to help make sure the message comes through loud and clear:

- Make sure the logo is legible — even when it's reduced to a very small size. This means choosing a lettering style or font that is bold and wide. As a general rule, this is no time to opt for thin, wispy lettering.

- Try not to get too horizontal or too vertical. First of all, these logos can become unwieldy when you're trying to use them in practical applications such as book covers and Web-site architecture. And furthermore, the next time you see one of those T-shirts in which every company in town donated money to get their logo on the back, pay attention to the ones you're actually able to discern. (It's usually the square ones.)

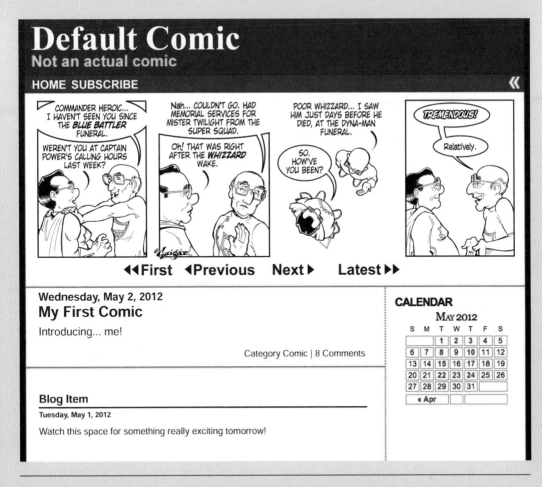

Navigation buttons should be placed as close to the comic as possible — and never visually separated from the comic. Icons should be placed in logical order and coincide with accepted representations — a double arrow for a long jump through the archives, and a single arrow for a one-step jump.

- If your logo is going to appear on top of a dark background, be sure to put a white border around it to help it from getting lost.

- As always, keep it simple. The less clutter you try to jam into a logo, the more clearly it's able to communicate what you do put in.

This is a bit subjective, but I think a good test of a logo is that it looks just as good in black and white as it does in color.

THE BIG HEADER

In newspapers, the terminology is "above the fold." It refers to all the material on the front page that can be seen from a newspaper box when the paper is folded and inserted. Everything "above the fold" is designed to get a potential reader to buy a newspaper. On the Web, it's referred to as "first screen." To help see what's "below the fold" on your own Web site go to whereisthefold.com.

Everything on a site's "first screen" is the material that is visible without scrolling as the site loads on the reader's Web browser. Of course, this is considerably more difficult to pin down because of things such as individual screen resolutions and how the user is using his browser window.

DON'T LET IT GO TO YOUR HEAD(ER)

A large, decorative header wastes a lot of space and pushes much of your site's content "below the fold." By making smarter use of the header space, you can bring much more of your site's content to your reader's "first screen" view.

But we can strive to get all the important content (comic, site navigation, blog) as high up on the page as possible. And, for many comics, that means reducing the depth of the title header.

Let's face it, most of us have title headers that take up *way* more real estate than they're worth. The best headers present the title of the comic — often as a nicely designed logo — and little else (maybe a small tagline). It's simply not imperative to get huge illustrations of your characters up there. All of that space is so much better used in getting the rest of your site on the first screen.

If your Web-traffic counter allows you to track screen resolutions of your users, you can test it out. Set your own monitor to the dominant resolution, and load your site. If readers have to scroll to see important content, chances are good that they're missing it entirely. Readers will scroll, but we have to give them a reason to do so.

CREATING A FAVICON

This is one of those little touches that help to elevate a Web site's professional polish.

A favicon is a small (16x16 pixels), custom-made symbol that appears in your readers' browser (in the address bar) when they visit your site. It also gets carried over to other places like bookmarks, tabbed browsers and shortcuts.

MAKE IT IN PHOTOSHOP

You can do this quite easily in Photoshop, but you'll need to download the ICO file format. Go to Adobe.com, and do a search for "ICO format." Copy the file to your Photoshop Plug-ins folder.

Designing on a 16x16-pixel area can be daunting. You may want to start bigger (64x64 pixels, for example) and then reduce. In fact, if you make your favicon file larger (32x32 for example), your browser will automatically reduce it to 16x16.

But I suggest testing your image out at 16x16 even if you plan to upload a larger file. That's the size your reader is most likely to experience. And I'd also suggest trying to keep that file size as small as possible.

Now it's decision time. Do you want to use your logo or are you better off using a character's face? You could just use the first initial of your logo in its distinctive font. And you might be better off with a unique symbol that relates to your comic's theme.

If you're working at 64x64, you can test out the final image by simply going to **Image -> Image**

http://www.evil-comic.com/

The favicon appears to the left of your site's URL in the browser window.

Size and changing the dimensions to 16x16 (remember to select **Resample Image: Bicubic Sharper**). You may need to go back to the original, so if you save at all, do a **Save As**. If the image needs improvement, consider sharpening it more and/or making the colors stronger.

When you're happy with the image, convert it to 16x16 pixels, and go to **File -> Save As**. Choose **Windows Icon (ICO)** as your format.

UPLOAD THE ICON

Upload your ICO file to the root level of your Web site (the same level your index page is on). If you name it **favicon.ico**, most browsers will find it automatically. If you want to be thorough, add the following code to the <head> section of every page you'd like the favicon to appear on:

- <link rel="Shortcut Icon" href="/favicon.ico">

I've also seen tutorials suggest the following code instead:

- <link rel="icon" href="/favicon.ico" type="image/x-icon">

You could probably use them both, if you so desire.

IT DIDN'T WORK!

It doesn't show up right away. Usually you have to refresh the page or even clear your browser's cache.

A neat trick I picked up is to put a "?" at the end of the URL. This tricks the browser into thinking it's loading the page for the first time, and it doesn't access the cache.

Chances are, your readers will notice the change in waves as their browser caches clear and reset (or as they do things like add your URL to their bookmarks).

ONLINE GENERATORS

If you don't have Photoshop, or if the process seems a bit oblique for you, you might want to try an online generator such as Favicon.cc. The interface is pretty direct, and you can even upload images to start from. This generator even produces an animated GIF as one of the potential favicons for you to choose from.

THE OBLIGATORY IPAD/IPHONE ADJUSTMENT

You can also provide a custom icon for iPads and iPhones. iPad's home-screen icons are 72x72 pixels, so I would start there. OfZenAndComputing.com has a template you can download.

Once you've designed the icon, export it as a transparent PNG named apple-touch-icon.png and upload it to your server's root directory.

Add the following to the <head> section of your page:

<link rel="apple-touch-icon" href="http://www.yoursite.com/apple-touch-icon.png" />

Instruct your readers to click the "+" in their iPad's Safari browser, and then tap **Add to Home Screen**.

This also doubles as an icon for people bookmarking your site using iPhones and iPod Touches.

WHAT ABOUT 'ABOUT'?

Is there a more under-sung hero on a webcomic's home page than the About page? In one simple file, it allows us webcartoonists to achieve something that no previous cartoonists were able to efficiently do: quickly indoctrinate a new reader. Newspaper comic strips have to be ruthlessly standalone. Every day they have to be completely accessible to a new reader. While the same is somewhat true for the daily webcartoonist, we have an ace in the hole. The About page, when organized and presented well, takes that moderately interested onlooker and prepares her to become a new reader. It's easy to become jaded with the About page. It's as obligatory

WELCOME! MEET THE CAST

COLE RICHARDS

PVP's always well meaning and often conflicted editor in chief and occasional father figure. Focused so much on the problems of others he sometimes is in denial of his own.

O Adventure Time

O Forced Perspective

O Pride Goeth Before A Fall

BRENT SIENNA

A pseudo-hipster and Cole's best friend. Brent is a coffee addled man-child, in serious danger of growing up. His recent marriage to the fierce and lovely Jade is not helping matters.

O Memories of The Future

O Missed

O The Jesus Phone

JADE SIENNA

The reluctant matriarch and consummate writer. Jade enjoys her job as a columnist but longs to be a writer. Married to Brent whom she loves dearly. Refuses to accept how smart she is.

O The Dungeon Mistress

O The Wedding

O Bookends

The *PVP* "New Reader" page offers introductions to the comic's main characters and links to story lines that help define each character. (pvponline.com)

as the copyright at the bottom of the page. And with familiarity comes contempt. Many webcartoonists aren't using them to their full potential. So let's look at some aspects of About pages that work:

- **List and describe the main characters.** This is the single most important aspect of the page. You must quickly provide the personality constructs of your core players to replace the weeks of missing backstory that a new reader lacks.

- **Do a quick recap of the overall story.** You don't have to go into a great deal of detail here. Just set the new reader up with the framework that your storytelling uses.

- **Key arcs or episodes.** Provide links to the story lines or individual comics that are definitive to your comic. Allow yourself a little introduction for each (to once again fill in missing backstory for your new reader).

RSS FEEDS

You'll forgive me a Moment of Geezerness, but you kids have no idea how good you've got it. There was a time before RSS. And even after RSS was widely in use by Web sites, it was a long time before the average Web user was familiar with it.

RSS is now a ubiquitous component of Web browsers — altering readers to the potential to subscribe to the feed and be alerted every time the Web site updates with new content.

However, if you feature your comic itself (as opposed to a link to the comic on your Web site), you have to understand that you may be blocking yourself from a significant chunk of Web traffic. Unless you have ads in your RSS feed, you're not getting compensated for the people reading your comic via RSS.

Furthermore, including your comics in your RSS feed makes it easy for others to write codes to swipe your comic and display it as part of their own apps and sites. We call these folks "scrapers."

If these issues make you uncomfortable, you may want to limit your RSS feed to links to your comic.

Remember, the About page is your welcome mat. It's your opportunity to show off your work in its best light and prepare a potential reader for a long-term relationship with your comic. You can't spend too much time getting it just right. The harder you work on it, the better it will work for you.

E-MAIL DELIVERY

Before RSS, I was e-mailing my comic out to my readers who didn't want to visit the site daily. Believe it or not, when I first started, I was doing it manually. Luckily, I moved to a content-management system that included the feature as an automatic option. And even after RSS crested, becoming the default choice for following daily updated Web content like ours, I kept my e-mail list — and I still send out the comic to a couple hundred e-mail subscribers. Here are some thoughts if you'd like to do the same.

SOFTWARE

ComicPress offers this functionality. But if your content-management system doesn't offer an e-mail-subscription option, you may want to try a third-party provider like MailChimp. MailChimp is free for under 500 subscribers and is $15 per month for 501-1,000 subscribers.

UNSUBSCRIBE

Be sure to include an unsubscribe button on the bottom of your template so every e-mail allows the subscriber to opt out.

ADD-ONS

If possible, deliver as much extra content to the daily comic as possible. In my opinion, it is not acceptable to simply deliver the day's comic and nothing else. My daily e-mail features the most recent blog posts under the comic and an ad for my merchandise above the comic. I also include links for my Twitter feed, Facebook fan page, etc.

SIGN-UP SHEET

I encourage fans to sign up at conventions. Let's face it, this is one step better than having them walk away with one of your flyers. This ensures that they're going to get further exposure to your comic. And this is an excellent "out" for that guy who is clearly interested in your work but unwilling to buy a book. You gracefully take the pressure off by offering to e-mail him the comic for free, and it's a win-win.

'WHY DID I STOP RECEIVING YOUR E-MAIL?'

You'll get this comment from time to time — sometimes in the most unlikely places. It really is a mystery why it happens, but my personal theory is that when someone's e-mail software sees incoming mail — particularly HTML mail — delivered daily, it automatically marks it as spam. If a longtime subscriber stops getting your e-mails, tell him or her to add the e-mail address that your comic/newsletter originates from to their list of contacts. That often solves the problem.

BE COUNTED

I include my Google Analytics code at the bottom of my e-mail subscription template. I'm not 100% certain that the data is counted, but I want to at least try to have that traffic included in my overall pageviews. I earned it, after all.

This is the sign-up sheet I used for my monthly comic download

WEB-TRAFFIC TERMINOLOGY

We all obsess over our Web stats — even though we know we shouldn't. But paying a little healthy attention to your Web stats is actually a good way to gauge your progress and tweak your site's performance. Don't get hung up on the numbers. Instead, pay attention instead to *trends*.

DEFINITIONS

- **Hit:** A hit is the result of a file being requested and served from your Web site. This can be an HTML document, an image file, an audio track, etc. Web pages that contain a large number of elements will return high hit scores.

- **File:** Indicates a hit that resulted in a successfully downloaded file. The number of files will always be lower than the number of hits. In a perfect world, they would be equal.

- **Page (also Pageview):** A page is one complete Web page, most likely composed of a number of files. If your home page has five images and some text, there will be six hits (and hopefully files) that make up one page.

- **Visit:** When a user visits your site, the user often clicks to a few more pages on your site. The period during which the user looks at those pages is called a visit. If the user leaves your site but comes back within a few minutes, it still usually counts as just one visit.

- **Unique visitor:** A unique visitor (combined with pageviews) is an incredibly useful metric. It is someone with a unique IP address who is entering a Web site for the first time that day (or some other specified period). When you log on to the Internet, you are assigned a unique IP address (cable-modem users are designated as "static" — their IP addresses never change). Your IP address is an identifier, and while you are using it, no one else on the Internet can use that particular set of numbers. Your number is counted once, usually for a 24-hour period. So no matter how many times a visitor refreshes or navigates through your Web site, they will be counted only once for the specified time period.

- **Bandwidth:** Bandwidth represents the total amount of data sent out from your server. All images and text take up space on the server. The total amount of data sent to your visitors during a day is your bandwidth.

- **Bounce rate:** The bounce rate is the percentage of people who visit a site or specific page who proceed no further. For example, if your bounce rate is 32%, then 32 out of 100 visitors to your site viewed only a single page. Don't panic if your number is high. Daily comics tend to have very high bounce rates — readers hit the day's comic and leave. It's the nature of the beast.

- **Search terms:** Often, when someone gets to your site through a search-engine result, the log file will record what words the visitor searched for to find your site. This can be very helpful information, especially if you are trying to measure how effective certain keywords are for you.

- **Errors:** You're probably familiar with the 404 Error — File Not Found — on Web sites you've tried to access. That information is in your Web stats. And if you have too many of these, you should take action.

WHAT TO LOOK FOR

General, steady growth: Unless you've captured lightning in a bottle, you're not going to see skyrocketing numbers, but when you look at your stats, gravitate to pageviews and unique visitors. These numbers will ebb and flow over the course of a week, but over months and years, these numbers should gradually rise.

Robots and spiders? They're good things. They're automated programs that follow all the links on your site, indexing them for search engines. If your Web-stat software collects visits from these programs, look for Inktomi Slurp (from Yahoo), Googlebot and MSNbot. If your site is new, you may not see one of these. If that's the case, go to sites such as Yahoo, Google and MSN, and submit your URL to their directories. This is where joining link farms and participating in shady link exchanges will hurt your site. It will be reflected in how these search engines classify your site. (We'll talk more about this in Chapter 9.)

Search phrases: If your Web stats include the phrases used by search engines to find your site, pay close attention. The most popular phrases collected should be ones that you're using to describe your site — especially in your meta tags. If not, you need to do a better job of talking about your comic on your site — using the words that you'd hope would be used in a successful search for your comic. As you do, those robots will sweep in and associate that content in their updated directories — better enabling search engines to point to your site when people enter those terms.

Daily and weekly trends: At what time every day does your server traffic peak? And on what day of the week do you receive the most visitors? Use this information to plan announcements, time blog posts and update content. If you're planning a schedule adjustment, this information is crucial.

INSTALLING GOOGLE ANALYTICS

As with everything else on the Web, it seems, Google is establishing its Analytics as industry standard. It has some very useful functions.

Once you register with Google Analytics, you will be assigned a tracking code. To find it:

Log into Google Analytics.

Go to the **Overview** page, and select the proper profile.

On the far right, click **Edit**.

At the upper right, click on **Check Status**.

Your tracking code can be copied and pasted from the text box.

Place this tracking code into the body section of your HTML code, immediately preceding the </body> tag of each page you wish to track. If you use the asynchronous code, you should add it immediately preceding the </head> tag.

TRACKING OUTGOING LINKS

Knowing which links your readers are clicking can give you the feedback you need to fine-tune the site to the interests of your community. Here's a nifty way to gather some information about how your readers use your site.

Add this code to every hyperlink that leads away from your site:

onClick="javascript: pageTracker._trackPageview('/link/linkname');"

It will allow Google Analytics to track the clicks. For example, to log every click on a particular link to www.example.com as a pageview for "/outgoing/example_com,"

you would add the following attribute to the link's tag:

It is a good idea to log all of your outbound links into a logical directory structure as shown in the example. This way, you will be able to easily identify what pages visitors clicked on to leave your site.

There are also plug-ins, like WordPress' Ultimate Google Analytics, that accomplish the same result.

GOOGLE PAGERANK

Your Google PageRank is used by Google to gauge the quality and popularity of your site — and that helps determine how near the top it appears during a search for pertinent keywords. (The exact formula Google uses is a closely guarded trade secret.)

If you want to be near the top in as many keywords as possible, it's a good idea to maximize your PageRank. A high PageRank places you near the top of Google's search results for certain keywords. And advertisers will pay more to get their ads on a site with a higher PageRank. (We'll talk about that in more detail in Chapter 9.)

First, a couple of easy hints: Don't fall for the spam that promises to submit your site to a truckload of search engines. And don't accept text-only ads (which we'll discuss in Chapter 9). Both of these could actually harm your PageRank.

Google recommends installing its Toolbar to check your PageRank. You can also find a number of free sites that offer the same thing. For my own use, I haven't installed the Toolbar.

KEYWORD PHRASES

Back in the day, the trick was to put keywords in meta tags in your site's HTML code — and that's still good practice. But Google is a little slicker now, so it's also a good idea to have a few keyword phrases in your back pocket that relate to your site. A keyword phrase is a combination of two or three words that you think people would be likely to use when they search for a particular image or page. The trick is to use these phrases to catch the attention of Google's spidering.

So, if one of my keyword phrases is "supervillain comic," I might write "don't forget to visit your favorite supervillain comic at C2E2" in one post and "*Secret Six* is a favorite supervillain comic of mine" in another. I don't go out of my way to use the phrase, but if it fits, I consistently use that same phrase (as opposed to "comic that features supervillains," for example).

DENSITY

Google also tracks keyword density — the frequency of keyword phrases on your site. Again, I advise caution. It's one thing to try to get an edge on your PageRank. It's quite another to find yourself accused of "Black Hat SEO."

One tool you might want to check out is the Google Toolbar. You can, among other things, track your keyword density with it. Google has announced a keyword tool that might prove useful as well.

‹TITLE› TAG

Make the most of your <title> tag. Don't waste an opportunity to get a few choice, descriptive keywords up there. Since Google uses this information when yielding a search result, it's your best bet in enticing someone who does find your site in a Google search to actually click the link.

HYPERLINKS

Google looks at links both to and from your Web site. It also looks at the words you use in links to help determine the content of your page. So stop writing "click here to see a great comic" and start writing "read this great supervillain comic." PageRank is also determined by links to your site from other sites. You can nudge your PageRank up by exchanging links with other sites that fall into the same classification as yours.

‹ALT› TAGS

Add <alt> tags to your image. It's helpful to your visually impaired readers and an opportunity to insert keywords where Google can track them.

SEO MATTERS

Don't let anybody misinform you: Search-engine optimization (SEO) matters, and it matters a lot. Google is the No. 1 Web site in the world (with an estimated 900 million unique visitors per month). Yahoo is No. 3, and Bing is No. 10.

Most of the people who go to those sites are looking for content. As a webcartoonist, your primary goal is to make your content available to as many people as possible. Search engines provide the conduit for this to happen. To that end, I want to share some tips I've collected to help you move towards making your site as attractive to search engines as possible.

TITLE TAG

The page title is a search engine's primary target. It gets checked first, and it has a tremendous amount of relevance towards a search result. Word yours carefully. It should be descriptive, and it should use words that focus on your site's content. However, cramming it with keywords will make your site look like spam, so don't get carried away.

WORD PRESS

WordPress sites are well-tuned to search-engine optimization. Just using WordPress gives you a leg up on SEO optimization. If you use one of the SEO plug-ins, experiment first to make sure that it's not slowing down your site. I use Yoast SEO (and I like it a lot), but there are several from which to choose.

KEYWORDS IN THE URL

Again, WordPress makes it easy. Go to **Settings -> Permalinks** and choose the option of Month and Name. When you name a post or a comic, use descriptive words in the title. That's why it's there.

SOCIAL MEDIA

Search engines find things more quickly when links to the content are posted on Twitter or Google Plus.

THINK MOBILE

This is a hard one for most of us, but I want to put it out there. A lot of those searches are being done on a smartphone. If your site isn't optimized to be viewed on a mobile device, you're going to have a high bounce rate from those users.

GET VALIDATED

W3C has a free validation service. It will flag errors on your Web site. Fixing these errors makes your site more accessible and increases search-engine rankings. Go to validator.w3.org.

GET LINKED

It's always good to get linked-to from a higher-ranking site. If that site has a forum or a commenting function, it's a great idea to become an active participant and find appropriate ways to link to your comic. That's not a license to spam. Meaningful, appropriate links get clicks, and that's what it's all about.

CONTENT, CONTENT, CONTENT

Your ability to blog regularly (and well) is a huge asset to improving your traffic. It's crucial for community building, and it gives those search-engine spiders something to chew on. Make time for it.

GET INTO THE HABIT

This isn't a fix-it-and-forget it thing. You have to make this a regular part of how you put content on your site. It has to be something that's always in the back of your mind. Make it habitual.

TRACK THE SOURCE OF A TRAFFIC SPIKE

Chances are you've been there (or one day will be). You check your Web-traffic stats and you see — YOWZA! — you've had a tremendous spike in traffic! The pageviews settle off after that day, and you're left wondering: "Waitaminute ... what just happened? And how do I make it happen again?"

If you've installed Google Analytics, you can follow this step-by-step guide to track down the source of your one-day windfall.

- Under **Content**, click **Site Content** and then **Pages**.

- Adjust the date range to begin and end on the day you want to isolate.

- You now have a list of the busiest pages on your site during that day.

- Click on the most popular page on the list.

- Click **Secondary Dimension.** Toggle to **Traffic Sources,** and select **Source.**

Click on Pages (under Content / Site Content) and limit the date range to one day to isolate the statistics of an important traffic event.

Voila! You are presented with a list of the sources of your traffic for that day.

You can go back to Content Detail and click on Entrance Keywords to see if you had the SEO juice a-flowin' that day to boot.

This kind of information is crucial. If you're getting a huge response from the forum of a Web site, you know you'd do well to advertise on that site. Or build a relationship with the site's authors. Or promote the products that the site promotes.

A day in which your traffic unexpectedly spikes is like getting struck by lightning. (Friendly lightning.) You may not be able to generate that kind of voltage again, but if you save a few sparks, you just might be able to ignite something that runs for a bit longer.

A list of the traffic sources for a specific page on a specific day.

RIDING A SPIKE

If you're lucky enough to be tracking a spike as it is occurring, you have an enormous opportunity. After taking a moment to congratulate yourself, swing into action and make sure your site is making the most of that excess traffic. A quick adjustment to your Web design might be in order, for example. Here are some things that I would try to be sure to have on the "first screen" during a spike:

- Links to archive pages or story lines that the people causing the spike traffic might also be interested in.

- Prominent links to store items.

- Prominent links to About or New Reader pages.

This spike isn't going to last forever. Make the best of it while it lasts!

WEB EQUITY

All of this is daunting. CMSs and child themes and hosting costs ... it can seem insurmountable. And it can be very tempting to sign with a free hosting site that offers to solve all these problems at once. They'll provide the hosting and the CMS and a domain name — and all you have to do is upload your comics. But that's kind of like renting an apartment instead of buying a house.

See, when I was in my 20s, I rented an apartment. All of my more experienced friends tried to explain to me that I was wasting *equity*. I never understood it until I tried to *buy* a house. Then equity became extremely important to me.

Equity is the ability to convert your mortgage payments into a down payment on your next house. The hope is that your property will rise in value and be worth more than what you owe on it when you're ready to move. And that's money that you can apply to your next property.

Establishing a Web site is similar. A turnkey blog site is not *really* yours to control even though the landlord might give you considerable flexibility. When you start your own Web site, all of the gains (SEO, page rank, profiting from traffic, etc.) are yours to keep and build from. And those gains can be built upon as time goes by until they become quite significant (with enough hard work).

Of course, there's every chance that this will not be your last "house." You might start a second site or bring this one to a close in favor of a new one. When that happens, it's your responsibility to transfer the equity you've built to the new site.

But the longer you continue to "rent," the longer it's going to take you to build that equity in the first place.

Bottom line: Domains and hosting are not *that* expensive. And the sooner you tackle learning a CMS, the sooner you'll find out that you're *actually capable* of the technical stuff.

What are you waiting for? Start building Web equity now.

Community Building

Community building is perhaps one of the most important components of a webcomic's success. Every beginning webcartoonist wants to be able to gauge success in terms of pageviews and unique visitors. They think a larger audience will automatically yield larger revenue. But as with so many other aspects of life, it's not about size — it's about what you make of it. I'll take a webcomic with a small readership but an intense sense of community over a large, disjointed readership any day.

Understanding community building is understanding that everything a person does is a way to express his own sense of self to the outside world. The man in a Nike cap driving to the golf course past the woman with the Greenpeace bumper sticker knows who he's sharing the road with — even though they've never met (and probably never will).

That same principle hold true in the Web sites a person visits in the course of the day. You give me a person's list of bookmarks (or RSS feeds), and I'll tell you volumes about that person.

So your objective as a webcartoonist is to determine who your community is — and then do everything in your power to make your site a gathering point for those people.

Once you achieve this, you won't have to work very hard to sell them merchandise; they'll buy it happily because it helps them explain who they are to the outside world. And that's a powerful psychological need to tap into.

ENCOURAGING DIFFERENT KINDS OF FAN SUPPORT

It's something that webcartoonists hear from fans all the time: "What's the best way for me to show my support?" Obviously, the best way is to buy merchandise. But it's not always about money — at least not right away. There are other ways for a reader to support his or her favorite webcomic.

CLICK ON ADS?

Some readers offer to click on ads every day when they visit my site. I actually discourage that. Although I'm not sure, I have a feeling that some of my advertisers can easily track incoming traffic, and seeing click-through via my site from the same ISP address is not going to reflect on my site in a positive way. It also skews my view of the performance of a given ad or type of ad — which might encourage me to pursue advertisers that aren't necessarily the right fit for my site. So I don't recommend auto-clicking.

CON INVITES

When a fan drops a polite line to the promoters of a favorite comic convention (or other trade show/speaking opportunity), it carries an impressive amount of weight. That kind of outreach is noticed by promoters. And if it leads to a free table and/or travel expenses, that fan has helped your bottom line considerably.

VIRAL MARKETING

This is the big, cost-free, high-return way that your readers can support you without spending a dime: Spread the word using the social media of their choice.

Whether it's Twitter, Facebook, Google+, StumbleUpon, Digg, Reddit, Delicious or one of the myriad other ways that people can share their finds on the Web, your fans spreading the word about your comic is exponentially more powerful than any kind of advertising that you could buy. And it doesn't cost a dime.

WHAT TO BLOG

Beyond the comic itself, the most important tool you have in your community-building pursuit is your blog. It should appear as close to the comic as possible. In the best-case scenario, the majority of your readers will be able to see at least the first few lines of the blog without having to scroll down.

Once you get those issues settled, all you have to do is *say* something.

Imagine you're hosting a party, and all of your readers are there. Everyone is at the table, but they're not familiar enough with one another to start conversations with each other. That's your job as a host.

DO introduce topics that are relevant and meaningful to your audience.

DON'T talk about divisive subjects like religion and politics — unless that's central to your community.

DO share personal stories — to the extent that you're comfortable.

DON'T complain, moan, whine or bellyache. People are coming to your site to escape their troubles — not to become immersed in yours.

DO share stories behind today's comic. For example, if you were inspired to write the comic based on something you overheard a Starbucks barista say, then feel free to share that story with your readers.

DON'T explain today's comic. The comic has to work on its own, independent of the blog. If you feel it needs explanation, you need to rewrite the comic.

DO promote personal appearances, sales and other news related to you as a professional webcartoonist.

DON'T make excuses for missing an update — unless there's one heck of an interesting story behind it.

No matter how good your blog is, it's pretty likely that you're going to have to direct eyeballs down there before it generates much action for you. Even the best-designed webcomic sites are going to face a little trouble in this regard. After all, most of the activity takes place in the area the comic inhabits. The vast majority of your readers are going to zoom in on the space and then zoom out. Your challenge is to try to catch their attention in that nanosecond between the last panel and their departure — and direct it to the blog. Here's a good strategy for doing just that:

DROP ANCHOR

A named anchor tag is a short piece of HTML code that, when clicked, scrolls the user's browser to a specific place on the page. It has two parts, the anchor and the target. The anchor behaves like a standard hyperlink, but when it is clicked, it scrolls the reader's browser down the site to where you've placed the target.

In the example on the opposite page, I have a JPEG that I use as a header over the blog. It is a lightning-bolt shape that separates the comic from the blog.

I have the target code set around that JPEG.

The complete code looks like this:

The "blog" part can be any word. You could just as easily choose . But whatever you choose, you're going to have to use exactly the same word in the anchor code.

The anchor code itself looks like this: *text*

Inside the brackets, you'll type the name of the page on which you have placed the target — in this case it's my index.html page. Then a number sign — #. Then the word you're using in the target — in this case it's "blog." With this setup, I can write a short promo above the comic that, when clicked, whisks the reader down the site to where the blog post is.

DIRECTING TRAFFIC FROM OFF-SITE

If you're using that blog for all it's worth, it quickly grows from being some kind of auxiliary function of your site to the principle one, and you'll find that you're writing stuff down that you want

The hyperlinks directly above the comic (next to the "Today in the Blog" icon) are anchor-tagged to the lightning-bolt shape above the blog. Clicking on one of those links takes the reader directly to the first item in the blog.

readers to know about just as much as you want them to know about your comic.

I use the anchor tags when I'm promoting my blog from off-site as well. For example, when I tweet about a blog update, I'll link to evil-comic.com/#blog — which loads the page and immediately snaps it down to the appropriate target.

PUT DOWN THE PUT-DOWNS

Self-deprecating humor. We all know how it works. If I put myself down, then it makes it harder for someone else to put me down. And maybe someone else will actually be moved to say something positive.

Before we go too much further, I want to be sure to mention that I'm not talking about the occasional remark, but rather a pattern of remarks over the course of several months of blogging, tweets, Facebook updates, etc.

In our pursuit to be interesting on the Web, many of us mistake self-deprecating humor for humility. For example, "My ability to draw women is only outdone by my ability to draw flies" is a much more intriguing sentence than, "I'm trying to improve my figure drawing."

So time and again, we end up going to the joke — even if it's at our own expense.

The problem with that is that people always believe what you tell them. Even if they know you're joking. When you deride something about yourself, it becomes part of the knowledge cloud that your reader forms in describing you. Worse yet, when you write stuff like that often enough, you begin to believe it. It becomes part of your own self-image.

We're talking about dangerous psychological grounds here. I hate to see people talking themselves down. Even if it's a derisive tag in their Twitter description.

You have enough challenges without putting yourself in a negative mental state. So choose not to go there.

THE KING OF ALL MEDIA

So what am I suggesting? That you should crow about how great you are? Well ... maybe a little.

Radio personality Howard Stern is widely known by the moniker "The King of All Media." Do you know how he got that title? He gave it to himself. And repeated it on his radio show a few thousand times over the course of several years.

Today it's hard to find a news story about Howard that doesn't include the words "King of All Media." Of course, Howard had the raw talent to back up the claim.

So proclaiming yourself the King (or Queen) of Comics might not be in your best interest if your work lacks a certain amount of polish. But a little shameless self-promotion — a little swagger in your posts — is much more preferable than a self-put-down.

A LITTLE TOOT NEVER HURT

It's difficult. It's against our nature. We're taught from a very young age that we shouldn't toot our own horns. But it's a pretty noisy world out there. And it's pretty easy to get lost in all of the sound. I say a little toot here and there is perfectly fine. And if you're not going to toot, at least refrain from giving yourself the gong.

TWITTER

When we wrote the original *How To Make Webcomics* book, Twitter and Facebook had barely begun to crest. Now it's impossible to imagine the Web without them. Social-networking sites have redefined the Internet experience. I'm going to spend a lot of time discussing Twitter and Facebook, but before I do, it's very important to mention MySpace. For a few months, MySpace was the definition of social networking. It was impossible to escape. Then Twitter and Facebook outperformed it, and it's now relegated to the backwaters of the Web. And that's important to understand because one day something will do the same thing to either Facebook or Twitter (or both in the case that one buys out the other, as I predicted on Webcomics.com at the beginning of 2011). Your job as a Web-businessperson is to keep an eye out for these trends and be prepared

to catch the wave before everyone else does.

By now, you're well-aware that Twitter is a powerful tool for promoting your work on the Web. If you're not incorporating it into your daily Web habits, I'd encourage you to start today. Here are a few things to get you started (or take you to the next level).

The first rule of Twitter is that the best promotion is simply being yourself. You don't have to limit your tweets to comic-plugging. In fact, if the only thing you're tweeting is plugs, you're not going to get a whole lot of followers (and you're gonna lose the ones you have).

The No. 1 mistake most people make is trying to be profound in their tweets. This is not where you showcase your best creative prose. This is where you talk about going to the corner store for milk. Of course, you can be creative and funny and entertaining ... but you don't have to be. Get in and start tweeting about anything. You'll be surprised at how interesting everyday life really is.

And of course, never miss an opportunity to engage someone who wants to discuss the strip.

guigar @guigar 20 Apr
You wanna know who was a severely underrated musical genius? Roger Miller. youtube.com/watch?v=XSXM3Z... This song gets me every time.
▶ View video ← Reply 🗑 Delete ★ Favorite

guigar @guigar 20 Apr
This Date in Evil Inc Hisrory: Everything I needed to know I learned from Mario evil-inc.com/archive/201004...
Expand

guigar @guigar 20 Apr
Courting Disaster: Her b/f still shares a bed with his ex. courting-disaster.com Have a question for CD? bit.ly/I7uGXX
Expand

guigar @guigar 20 Apr
Evil Inc: The doctor is IN. evil-inc.com/archive/201204...
Expand

guigar @guigar 20 Apr
Could Annie be a future superstar comics letterer? gizmodo.com/5903688/first+... This 7yo won a nat'l handwriting award. She was born with no hands.
Expand

guigar @guigar 19 Apr
@bethisomething It was called Din Tai Fung
💬 View conversation

guigar @guigar 19 Apr
Thanks to everyone who joined me on UStream tonight! That was fun!
Expand

guigar @guigar 19 Apr
Coloring tomorrow's Courting Disaster. Keep me company! ustream.tv/channel/evil-i...
▶ View video

guigar @guigar 19 Apr
@pvponline they weren't in that league. But they were good. The hunt continues.
💬 View conversation

I try to keep my Twitter feed balanced between casual conversations and promotion of my comics-related projects.

ENCOURAGE RETWEETS

Mention that you welcome retweets. Thank people for their retweetage. Remember: So much of what we do on the Web boils down to the behavior modification principles they teach in Psych 101. If you see a behavior you want to see repeated, then reinforce it with a positive reward. You'd be amazed at how rewarding a simple, kind acknowledgement is. And, while you're at it, lead by example. Do a little retweeting yourself.

GET THE WORD OUT

Make sure you're getting the word out about your Twitter feed. There should be a link to it from your comic's main page. And to maximize your social-networking potential, allow Facebook to duplicate your tweets on your profile and Facebook fan page. Just go to **facebook.com/twitter/** and follow the directions.

TWITTER AND RSS FEEDS

You can no longer connect your comic's RSS feed directly to your Twitter account, thereby pushing out notifications of updates automatically. However, there are a number of third-party developers, like Twitterfeed.com, that offer this functionality.

TWITTER SCHEDULERS

There are a lot of online apps that allow you to write tweets in advance and then schedule them to appear on your Twitter feed at a predetermined time. Here are a few to check out:

• Twuffer

• HootSuite

• TwitMessenger

• 14Blocks

14Blocks (14Blocks.com) is a handy app that allows you to schedule tweets to upload at a predetermined date and time — and uses the online habits of your followers to tell you when the best times are to tweet. I schedule important announcements and site plugs for the times that 14Blocks tells me I'm most likely to have the greatest number of Twitter followers to see it.

PREVIEWS OF COMING EVENTS

I've started using **TwitPic.com** to upload photos of my comics — as I'm working on them — to offer readers previews of upcoming comics.

The practice has been heartily embraced by my readers, and it has given them an additional reason to follow me on Twitter.

Experiment with sending tweets at different times of the day. Maybe scheduling morning tweets is better than evening for you. Track your results and determine your own sweet spot. Remember that some of your readers will be reading on the West Coast and others on the East Coast — and still others in Europe, Asia, etc.

If you're going to schedule tweets, try to keep them from sounding cold. Try to say something interesting about each strip. "New comic is up" is a little tiring. "Jason discovers the cold truth behind hot oatmeal" is intriguing.

MY TWITTER STRATEGY

I dedicate the first hour of my studio time to Twitter. I use 14blocks.com to schedule important tweets (like site updates and stuff like "*This Date in Evil Inc History,*" which sends readers into my archives). Then, I start brainstorming topics for the day. For me, the best way to do this has been to check out the news sites for interesting stories that I can share — with an emphasis on presenting them in a fun, entertaining way.

• Fans are upset that the original Hooters is being remodeled. [link] After all, who goes to Hooters to see the enhancements?

I spend the first part of the morning writing a few of these tweets, and then I fire them off with a little time in between them. If I have too many, I can always schedule them to be released later through 14Blocks.

I'm seeing a significant amount of participation among my followers. My tweets are mirrored on my Facebook page and my Facebook fan page, and I'm noticing that they're generating reader participation there as well.

Q&A

Q: We recently had an overzealous reader leave a ton of comments on our site at once, with a handful of them talking about how much I "fascinate" him. He even asked for a photo of me (mentioning that he already checked google but couldn't find any). He also doesn't seem to understand that the character in our comic and me aren't one-and-the-same.

A: One of the ways to build a supportive readership is through community building. And part of that means sharing yourself (and your life) with your readers. There are as many boundaries as there are webcartoonists, but no matter how carefully you set yours, the time will come when a reader crosses it. When that happens, you have three options: modification, mediation and moderation.

Modification

For me, the first step is always what I learned in Psych 101 — behavioral modification. If you want to see less of a certain behavior, don't reinforce it. This reader may simply want to get your attention, so any kind of response is reinforcing the behavior. Beware: He may actually get *more* inappropriate in an attempt to regain your attention (instead of catching the hint and curbing his rhetoric). But stick to your guns: Don't reinforce unacceptable behavior.

Mediation

If you've ever been to a comic convention, you already know this to be true: Fanboys (and fangirls) can often have a bizarre definition of social grace. We have a tendency to read that awkwardness as anger or abrasiveness. But if we take a step back from our initial reaction to this behavior, and point out to the person that his behavior is hurtful (or odd or threatening), you'd be surprised how often the response is a quick and sincere apology. What we regard as bizarre reader behavior can sometimes be a reader who just doesn't know the appropriate way to handle his or her own fandom. And a polite — and private — note that kindly points out how this behavior is unacceptable can often correct the problem in short order.

Moderation

If refusing to reinforce the undesirable behavior fails, and a polite, private message fails as well, you have only one alternative left, and that's moderation — as in site moderation. Disable the reader's posting privileges on your site, block him on Twitter and Facebook, ban his e-mail address from your inbox, and make it impossible for him to interact with you in the areas that you can control.

As a webcartoonist, you try to gather as many fervent fans as possible, but sometimes you have to be willing to part ways with the ones whose fandom leads them to become disruptive forces in your community and in your personal life.

Above all ...

Don't feed the troll. The time you spend tangling with an angry, mean rabble-rouser is time better spent with the more valuable members of your comic's community. You only have so much time. Spend it on the ones who matter.

Beyond the retweets and favorites, I'm seeing an added benefit. This is an excellent warm-up for my brain. After doing this for an hour, I'm finding that my creative energy is already flowing by the time I turn to the more important items on my agenda for the day. Writing has gone particularly well.

And, bringing the whole thing full circle, some of the stuff that I wrote that either wasn't strong enough for the strip or simply didn't fit became grist for the next day's Twitter salvo. Like this one:

- They said it was a discount oyster store, but I still think I got a raw deal.

FACEBOOK

One of Facebook's most powerful social-networking tools is the Like button. Using "Like," users can spread the word about good things to all of their friends — who can Like them and spread the word further, etc. Having a Like button on your Web site is an excellent way to enable excited readers to spread the word about your site.

The easiest way to add a Like button to your site is to use Facebook's code generator: developers.facebook.com/docs/reference/plugins/like/

Back in the day, geezers like me had to code it ourselves:

```
<iframe          src="http://www.facebook.com/widgets/like.php?href=http://
YOUR-URL-HERE" scrolling="no"          frameborder="0" style="border:none;
width:266px; height:28px"> </iframe>
```

FACEBOOK FAN PAGE

A Facebook fan page is like a profile for your comic. To set up a fan page, go to Facebook's site for creating a fan page (facebook.com/pages/create.php).

At first, your fan page will be a glorified Facebook profile page — wall, photos, news feed, list of fans and so on. Of course, you don't want to stop there.

You can add your site's RSS feed to your fan page using a third-party app such as RSS Graffiti. With the app, every time a new comic updates, a preview will appear on the fan page with a link back to the appropriate place on your Web site for fans to read it in its entirely. Anything that appears in the RSS feed (comic updates, blog posts, etc.) will be pushed to your fan page.

You could experiment with posting your actual comic on your fan page (instead of a link that directs traffic to your site). This is particularly enticing if you're doing a single-panel comic with a fair degree of "meme" appeal. However, although you may be gaining a significant amount of exposure, you'll need to plan how to direct that traffic in ways in which you can benefit monetarily. All of that traffic is useless otherwise.

Most importantly, though, is to make your Facebook fan page a place where your readers can go to get something extra out of your comic. Run a contest from the site, offer extras, announce Facebook-only sales ... just give your readers an excuse to keep returning.

The benefit to you is that they're more likely to use Facebook to promote your work while they're hanging around your fan page — and that's a pretty powerful promotion machine.

FACEBOOK PLUG-INS

Facebook has a number of Social Plug-ins at **developers.facebook.com/docs/plugins/** that can help you extend your ability to promote your comic through the social-media powerhouse. This includes simple stuff — like building a Like button for your site — to more ambitious applications, such as LiveStream, which lets your users share activity and comments in real time as they interact during a live event.

UNDERSTANDING EDGERANK

This section is based on a Webcomics.com post by Zachary Smith (Soulofsteelcomic.com):

As nice as it is to include your site's RSS feed on your Facebook page, there's a compelling reason *not* to do so. Facebook has internal algorithms, called Edgerank, that determine which of your fans see your posts in their feed. They do this with your Facebook friends, too. You may have noticed that once you comment or like a friend's post, you start seeing a few more posts from them. If you comment on or "like" those, you start seeing more and more and more. They didn't suddenly become more active at the same time you starting liking and commenting on them. Facebook specifically serves you people that you take more action on. It makes sense to try to serve you things you find interesting as much as possible.

Because of this, only a small percentage of your posts are actually seen by your fans on Facebook. There is a website called pagelever.com that claims that news figures reveal this be, on average, between 3 and 7.5%. If you want to increase this percentage, you have to start earning interaction on Facebook.

Therefore, the best things you can do to increase your Facebook presence to as many people as possible are pretty simple:

- Get more "likes" and comments on your Facebook fan page.

- Give people a reason to click.

Otherwise, every time you make a post that *fails* to engage a fan in the form of "likes" or comments, the less your fans see your posts. This is a major reason why you see major corporations putting links asking you to like them in exchange for a bargain or a coupon. It boosts their Facebook Edgerank to their fans — cheap marketing.

To maximize your Facebook Edgerank, you need to understand that not all user actions are created equal. The more engagement it takes to accomplish, the more it increases your Edgerank.

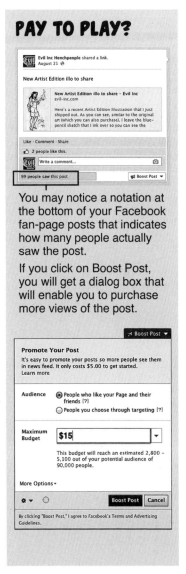

PAY TO PLAY?

You may notice a notation at the bottom of your Facebook fan-page posts that indicates how many people actually saw the post.

If you click on Boost Post, you will get a dialog box that will enable you to purchase more views of the post.

- The lowest form of engagement is the simple click to view your content. If someone views it, but doesn't take further action, it isn't particularly engaging.

- Next up is the simple "like."

- Comments are worth more than "likes."

- If a reader shares your content on his page or profile, it carries the heaviest Edgerank boost.

Different types of content have different effects as well. Acting on your status update is of the lowest importance, followed by links and photos/videos. Pagelever.com suggests a number of basic strategies, including posting frequently and consistently (*sound familiar?*), the best times to post, and using direct (rather than third-party) postings. Several sites recommend that you post your Web site entries directly rather than via RSS. Edgerank prefers direct posting.

'WHAT A WASTE OF TIME.'

I was lucky enough to get a generous review on io9.com one weekend. And in the comments section under the review, the response was overwhelmingly positive. I was being tweeted and e-mailed and "liked" on Facebook posts.

It was a really good weekend.

Until I read this.

> *I tried giving this comic a read, and it wasn't funny at all.*
>
> *What a waste of time.*

My pageviews were astronomical. People were clearly poring over the archives. And the positive comments were kind to say the least. Obviously, I was doing something right.

But you know which comment stayed with me: "What a waste of time."

SO, HOW DO YOU PROCESS CRITICISM?

This is where I'm supposed to say something wise and relevant and maybe even witty — something that puts a lightbulb over your head ... something to either make you see things my way or solidify your opposition. It's what I do, right?

Well, guess what? I can't.

Let's face it. We do what we do because of love — every last one of us. We put a lot of love into our work. We put a lot of ourselves into our work.

And "What a waste of time" feels just like being laughed at when you ask your crush to the prom.

Or ... ahem ... so I'm told ...

We talked about this on Webcomics Weekly a long time ago. I remember Dave Kellett saying that he always tries to consider the motivation for a trollish comment. "A lot of people lead very, very sad lives," he said. "And, let's face it, as webcartoonists, we're living out our dreams."

Nothing makes a sad, angry person more sad and more angry than seeing a happy person. And it's only natural to lash out.

'WHAT A WASTE OF TIME.'

Nope. It still stings.

OK. Try this. Maybe the guy is naturally a jerk. The io9 Web site lets me see all of his recent comments, and it's clear, the guy has a track record of being That Guy who likes to boo when everyone else is cheering.

So, he's just naturally a crank, right? Can't take a crank seriously, can you?

"What a waste of time."

That didn't help either.

In that same podcast, Scott Kurtz said that if you automatically discount the mean comments, then you have to automatically discount the praise.

But I really liked the praise. I liked getting "liked."

And if I accept that, I have to accept "What a waste of time."

It's time to face facts. This guy just did not like my comic, and there's nothing I can do about it. It was unreasonable to think that 100% of any audience was going to be completely enthralled by my work, after all, and he was in the percentage that was decidedly unenthralled.

So then I looked back on what I had been doing since the review was posted.

I was reassuring myself with Web-site stats, rereading tweets, recounting "like" scores, using my stats to project tomorrow's figures, rereading the comments in the io9.com thread, researching the negative poster for insights to why he didn't like my comic, re-rereading tweets ...

Whew!

WHAT A WASTE OF TIME!

Because while I was doing all of that, I neglected to update my store to include the newest *Evil Inc* book! So, when a bunch of those new readers ordered book packages, they ordered four when they could have ordered all five. Some people just ordered Volume 4 when they could have ordered Volume 5 — which I think is the stronger book for a new reader. Updating that storefront would have been — far and away — the better use of my time.

EPILOGUE

Some people don't like my strip.

But if I allow myself to pay too much attention to those people, I run a serious risk of not paying enough attention to the people who do.

Forget the Legion of Doom or the Evil League of Evil. The employees and shareholders of *Evil Inc.* know that the vilest supervillain organization is the corporation, where they can pull off dastardly deeds in full compliance with the law.

Evil Inc. is the brainchild of Brad Guigar, who's also known for the webcomics *Greystone* Inn and *Phables*. With *Evil Inc.*, Guigar takes his newspaper strip style and mixes in his love for superhero comics, criticisms of corporate America, and so many puns you'll go hoarse from all the groaning.

The comments below this piece were overwhelmingly positive: "Well, there goes all my free time for the next few days." "I've been reading all weekend ...," "This guy does good work ...," "... I've been plowing through it for the last 90 minutes and can't stop ... AND IT'S FUNNY AS HELL!" "Evil Inc is a great daily strip ..." "Damn, there goes my Saturday. Can't believe I've missed this!" "Yet another comic I will have to read in its entirety ..." But there was only one that stuck with me ...

spring a good trapdoor; the R&D department — Lightning Lady, the recovering villainess of same challenges any company does: budgetar managing interns, and spinning the occasiona

DISCUSSIONS

I tried giving this comic a read, and it wasn't funny at all.

What a waste of time.

MEASURING
SOCIAL-MEDIA OUTREACH

As I'm focusing all of this effort into something as transient as Twitter, I can't help but reach for ways to measure my effectiveness.

ANALYTICS

Watching my Google Analytics track traffic sources is a good start. And using that, I can see that Twitter is sending me a large amount of traffic since I started putting more attention to the endeavor. In December 2011, it was my seventh-biggest source of outside traffic, delivering an average of 2.9 pages per visit. The previous August, it ranked at No. 19.

To be honest, that's really the only yardstick I need. I'm bringing traffic in through this effort. I'm reinforcing my brand as a Web entertainer, and I'm enabling my followers to introduce me to new readers with every reply, favorite and retweet. A strong referral rank and a healthy pages-per-visit stat is about all I can expect.

Maybe it's the baseball fan in me, but I love stats. I love seeing how they change and trying to figure out what caused the change. It's a fascination with me. And, lucky for me, there are dozens of sites that have found different ways of drilling through your Twitter feed to mine some nuggets of wisdom for you to devour. If you're as fascinated as I am, here are a few sites to explore:

KLOUT

By submitting your Twitter handle, Facebook page, etc., Klout measures how effectively you're using social media on a number of categories, including:

- **True Reach:** The number of people you influence. Klout filters out spam and bots and focuses on the people who are acting on your content. When you post a message, these people tend to respond or share it.

- **Amplification:** How much you influence people. The more retweets, shares and responses you generate, the better your Amplification score.

- **Network Impact:** The influence of the people in your True Reach. The more top influencers share and respond to your content, the higher your Network Impact score.

- **Klout score:** A measurement of your influence on a scale of 1 to 100.

PEERINDEX

PeerIndex is an enlightening visualization of the topics you choose to discuss on Twitter. It shows you a chart that represents how often you tweet within eight categories: technology, science, health, lifestyle, sports, politics, arts and business. Your "PeerIndex" is determined by comparing your audience, your authority (measured by reader interaction) and your activity.

RETWEET RANK

This site does exactly what you think it does. It ranks you based on your retweets — and then it places you in a percentile category. If you register, you can use the site to chart your retweets and other related stats over time.

TWITALYZER

Twitalyzer amasses data from other Twitter gauges (like PeerIndex and Klout) to give you a much more detailed breakdown of your statistics. Perhaps most interestingly, Twitalyzer attempts to give you an indication of where your followers are geographically. However, that's a feature of the paid

subscription service, and I haven't been enamored enough with what I've seen there to subscribe yet.

TWEETREACH

TweetReach measures how many accounts received your tweets, how far your message traveled and who is influencing the conversation about your brand or product.

TWEETSTATS

This site goes as far back as 2007 to give you a bar graph that represents how often you tweet, month by month. Clicking on any one month gives you a detailed breakdown of daily tweets, how often you were retweeted (and by whom) and how often you replied to the tweets of others.

BOUNDARIES

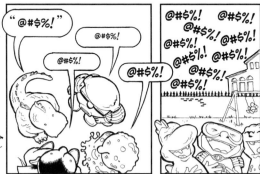

It's one of the most liberating aspects of webcomics: the complete lack of boundaries. Very few — if any — webcomics exist under a structure that imposes boundaries on the language or visuals used by the cartoonist. Most of us are completely independent, and therefore set our own boundaries.

For example, *Penny Arcade* veers into blue language, but the comic certainly doesn't hinge on it. *PvP* rarely, if ever, drops a curse word. In fact, many of the top comics on the Web follow much the same boundaries as network television (albeit late-night broadcast standards).

So, why aren't webcomics a wall-to-wall, full-frontal swearfest? Generally speaking, why aren't we using that "freedom"? Well, you could argue that many of our readers are viewing our site in stolen moments at work. And you'd be right in saying that getting your site rated as NSFW by a company's firewall software is going to affect the growth potential of your site.

And you could also argue that webcomics do break boundaries — and they do so wildly — if the comparison is made to newspaper comics. Syndicated comics follow an incredibly strict standard for language and imagery. But that's kind of a straw-man argument. I mean, the newspaper's comics section follows a moral code that seems outdated — even when compared with the rest of the paper.

After all, it's easy to poke fun when a cartoonist like Greg Evans (*Luann*) is forced to use punctuation as a word to describe his character's first menstruation (I got my "."), but before we howl with derisive laughter, take a moment and ask yourself: Why? Why do newspaper comics follow such rigorous standards? Because they have to appeal to as broad an audience as possible. And therein lies the rub for webcartoonists. To a certain extent, so do we.

Let's face it. There's nothing to stop me from dropping an F-bomb in my strip. I can edit it out for the newspaper version easily enough. And I could tell myself that the language fits the character and that I was being true to my muse. But the fact of the matter is that I would be alienating a certain percentage of my readership for whom that kind of language is offensive.

Same with nudity. I can draw cheesecakey images of heroically proportioned females in ultra-tight spandex all day long. (And believe me, I have.) But I don't dare let loose with a nipple. It's a societal line. It doesn't have to make sense. And you don't have to agree with it. But you do have to know that it's there. And you have to know that crossing the line has repercussions. Does that mean you should edit your strip as if it were going to appear in a newspaper? Well, that's not what I'm advocating.

What I am arguing is that **these no-boundaries decisions have consequences, and you should be aware of them before you make the decision to use foul language or sexually suggestive images.** You have to decide what fits best with the site that you're trying to build. The only wrong decision is an uninformed one.

HANDLING NEGATIVE COMMENTS

You've launched your comic and you're encouraging comments on your blog/forum. The good news is that you're getting them. The bad news is that some of them are negative critiques of your drawing style or writing. How do you handle the situation before this negativity infects your community — without looking like an oversensitive cry-baby?

You are under absolutely no obligation to have anything on your site that you don't want to have there. In fact, you have an obligation — to yourself — to moderate your site to suit the community you're trying to build. If you were running a site devoted to journalism, it would be a different case. But you're not. You're running a business.

Look at it this way, if someone walks into my house and insults my wife, he gets escorted out of the house. He can have a polite argument, but the minute he crosses the line, he's out. And I decide where the line is. My house; my rules. Following the analogy, of course, if I spend all my time throwing people out of my house for minor infractions, nobody is going to come to my parties any more. Your site is the house your webcomic lives in. Being a good host means laying out a doormat — not behaving like one.

I've been doing a webcomic for more than 13 years. And I've received my fair share of negative comments from my readers. Every time it happens, the overriding urge is to jump into the fray and say, "No, no no! You don't get it! It's like this ..." But that would be a mistake on so many levels.

FILTERS

First of all, even the most misguided reviewer is doing nothing more than sharing his opinion of the work that I've presented. It would be foolhardy of me to think I can say a few words and make him feel differently. He feels the way he feels. Same goes for the angry e-mails. Those are perfectly valid emotions.

As an artist, I can't fully control how someone reacts to my art. I can try to fine-tune my story as much as possible, but I can't account for the filter that the individual reader sees my work through.

Using my comic strip as a case in point: During one storyline, Captain Heroic, under an enchantment that makes him forget his marriage, sleeps with another woman. When that story beat appeared, the anger really started. And I can't say that I was completely surprised. A lot of people have deep religious beliefs that make any kind of marital infidelity abhorrent to them. Others might have been cheated on in a relationship — or might have, themselves, cheated — and this subject brings up a lot of discomfort for them. There are a lot of filters that people read those strips through that can make the idea very distasteful for them.

MISUNDERSTANDING

Sometimes, the negative comments rise from an obvious misunderstanding. The angry reader has read something into your work that wasn't there. His argument is valid, but it doesn't apply to the

work you presented. In an open forum, like a Web site, addressing a misunderstanding gets a little tricky. If an artist starts engaging a reviewer on a Web site, it's very easy to come off sounding touchy and thin-skinned.

For every bit of misinformation you may be correcting, you're also demonstrating that you're out there, reading reviews and getting bent-out-of-shape enough to engage reviews you disagree with. That's not how I choose to present myself.

Your readers will defend you, if a defense is necessary. But getting involved in a conversation like this seldom ends well. As soon as you post your rebuttal, the reviewer (whose reputation is on the line at this point) is going to have to find a hole in it and exploit it. Now you have to argue his rebuttal — or else it stands. Now you're in a back-and-forth in which nobody wins.

HANDS-OFF

For about 90% of the criticism you receive, I recommend a hands-off approach. For e-mails, your response should be polite and nonconfrontational — but completely unapologetic for the "offensive" content itself.

> *I'm awfully sorry to hear that this story is hitting you wrong, but if you're following me on Twitter, you'll be sure to know when the story line moves on.*

Besides, when you engage, you're entering a time-sink of massive proportions, as you post rebuttals, come back and check for responses, rebut those responses, and so on.

On Twitter and Facebook, your engaging a negative comment could very well bring *more* attention to that comment than it otherwise may have had. It's not very polite to admit, but I always look at the number of followers a person has before I engage them on Twitter. If that number is lower than mine, I have to ask myself if it's worth exposing *my* followers to a comment that may have been seen by only a dozen of that person's followers.

THE BOTTOM LINE

Criticism is a compliment. It's an indication that you've created something that's worth commenting on. It's a sign that you're doing something right. Don't spoil that by whining and crying and pouting (in public, at least) about the negative commentary. Rather, elevate yourself to a higher plane, and allow your readers to argue on your behalf (it holds so much more weight when that happens). You've got much better uses of your time, and you know it. Brush it off, clear your head and get back to the drawing board (or Wacom tablet, or whatever). With a little luck, you might just do something good enough to tick somebody else off tomorrow.

Business

Webcomics is a business venture. Its strength comes from cutting out the middleman. But that comes with a certain amount of responsibility, and part of that responsibility is to conduct your business within various legal guidelines. It's not necessary to get a legal degree, of course, but it is necessary to be familiar enough with the issues that you know when to solicit competent legal consultation.

COPYRIGHT

Copyright is, simply put, the *right* to make a *copy* of a specific work of art.

Copyright is automatically granted to the creator of the work upon completion of the work (unless there are special circumstances, like a work-for-hire contract).

A provision in the 1976 Copyright Act protects not only the work itself, but also derivative work, from infringement.

You really don't need to do anything to gain copyright over your own work. It already exists once you've created the art.

However, I recommend a few steps to strengthen that claim of ownership.

COPYRIGHT NOTATION

For starters, I include a copyright notation on every Web page, individual strip and book that I produce. Standard copyright notation is as follows:

© Artist's Name, Date of Publication

For example, a work by Brad Guigar published in 2011 would have the following notation: ©Brad Guigar, 2011. You can type the © symbol by hitting option-g on your Mac (alt-g on a PC). It is acceptable to spell out "copyright" instead of using the symbol. Also, you may choose to include a disclaimer like "All rights reserved."

U.S. COPYRIGHT OFFICE

You can register your copyright online with the United States Copyright Office. Click the eCO Login link to start the process. The Web site (copyright.gov) has tons of downloadable information. This section — copyright.gov/circs/ — has a number of circulars you can grab. Check out 40, 40a, 41 and 44. Those all have information that pertain directly to cartoonists — especially 44, which includes the following:

"This protection extends to any copyrightable pictorial or written expression contained in the work. Thus a drawing, picture, depiction, or written description of a character can be registered for copyright. Protection does not, however, extend to the title or general theme for a cartoon or comic strip, the general idea or name for characters depicted, or their intangible attributes. Although the copyright law does not provide such protection, a character may be protected under aspects of state, common, or trademark laws, and titles and names may sometimes be protected under state law doctrines or state and federal trademark laws. Consult an attorney for details."

Maybe there wouldn't be such widespread misunderstanding about copyright if people like me wouldn't misrepresent it. Needless to say, a phrase can't be copyrighted. A copyright is, literally, the *right* to make a *copy* of a work of art. The better word for the strip would have been "trademarked."

If you file your work with the copyright office, there is a small fee required.

If you're working on a comic strip, I recommend waiting until you're ready to print a book, and then you can register the book itself with the U.S. Copyright Office instead of trying to register every individual strip.

CREATIVE COMMONS

Creative Commons is a licensing classification that allows creators to share some of their rights with others. Created by the Creative Commons nonprofit organization (creativecommons.org), it is billed as "a simple, standardized way to grant copyright permissions to ... creative work." The Creative Commons licenses enable people to easily change their copyright terms from the default of "all rights reserved" to several derivations that allow the work to be shared in pre-determined ways. There are six types of Creative Commons licenses:

Attribution (CC)

This license lets others distribute, remix, tweak and build upon your work, even commercially, as long as they credit you for the original creation. This is the most accommodating of licenses offered, in terms of what others can do with your works licensed under Attribution.

Attribution Share-Alike (CC BY-SA)

This license lets others remix, tweak and build upon your work even for commercial reasons, as long as they credit you and license their new creations under the identical terms. This license is often compared to open-source software licenses. All new works based on yours will carry the same license, so any derivatives will also allow commercial use.

Attribution No Derivatives (CC BY-ND)

This license allows for redistribution, commercial and noncommercial, as long as it is passed along unchanged and in whole, with credit to you.

Attribution Noncommercial (CC BY-NC)

This license lets others remix, tweak and build upon your work noncommercially, and although their new works must also acknowledge you and be noncommercial, they don't have to license their derivative works on the same terms.

Attribution Noncommercial Share-Alike (CC BY-NC-SA)

This license lets others remix, tweak and build upon your work noncommercially, as long as they credit you and license their new creations under the identical terms. Others can download and redistribute your work just like the BY-NC-ND license, but they can also translate, make remixes and produce new stories based on your work. All new work based on yours will carry the same license, so any derivatives will also be noncommercial in nature.

Attribution Noncommercial No Derivatives (CC BY-NC-ND)

This license is the most restrictive of the six main licenses, allowing redistribution. This license is often called the "free advertising" license because it allows others to download your works and share them with others as long as they mention you and link back to you, but they can't change them in any way or use them commercially.

As always, whenever I talk about legal issues, I'm honor-bound to remind you that I'm not a lawyer, and I encourage you to seek qualified legal counsel in all legal matters.

SHOULD YOU USE A CREATIVE COMMONS LICENSE?

When it comes right down to it, this is a judgment call. There are two ways of looking at it.

Stick with plain-old copyright

As soon as we post our work on the Web, it becomes easy pickin' for anyone to steal. Registering a copyright provides legal means of rectifying that theft. A registered copyright gives you firm footing to fire off that initial cease-and-desist, and it helps delineate ownership if and when you find yourself in the unenviable position of defending your rights in court.

If this license doesn't offer protection above and beyond that guaranteed by standard copyright, then I'm not sure it's a benefit to me. Worse, what if a layperson misunderstands notations like CC BY-ND and CC BY-NC? What if they just think sharing is *sharing* — and there's no difference between one kind of sharing and another?

In fact, isn't CC BY-NC (Attribution Noncommercial) the same as standard copyright? Take, for example, someone who prints your comic out every day and pastes it into a book. That's a blatant copyright violation. But as long as that book stays tucked away in his house being used for his own private enjoyment, it's not an issue. It becomes a violation only when he tries to sell copies of the book.

Couldn't I achieve the same effect by selectively enforcing my copyright? In other words, if I see an infringement that I'm comfortable with, I could simply choose to turn a blind eye to it. Of course, this doesn't exactly *encourage* the use of my work. And furthermore, if I ever get into a *serious* legal battle over my copyright, the other party's lawyers might point to my failure to exert my rights in those other matters and make the argument that I had forfeited my rights entirely.

Switch to Creative Commons

We're living in a sharing society. We share everything on Facebook, Tumblr, Twitter, Pinterest, etc. You may as well get used to the idea. With a Creative Commons license, you can acknowledge this fact of life — even encourage it. And as you release your work into the world, you leave yourself open to all kinds of opportunities and potential collaborations.

After all, you can still prohibit the kinds of use that you don't find agreeable — and that prohibition is every bit as legitimate (in a legal sense) as copyright.

Finally, a Creative Commons license encourages the right kind of sharing — the kind that exposes your work to a wider range of potential readers.

Get a grip —or loosen it?

When I discuss Creative Commons, it always seems to boil down to one thing: control issues. On one side, you have the people who want complete control over their work. If you want to use the work, you have to go through the proper channels. They look at a Creative Commons license that encourages certain types of sharing and they think, "I've yet to see someone who needs to be encouraged to share my intellectual property — but I see *plenty* who need to be *discouraged*."

On the other side, you have people who are much more relaxed with having their work redistributed (and even reworked) after it is finished. They don't see a lot of protection in standard copyright, so why not encourage people to share it in predetermined ways? It might lead to all sorts of exciting things.

Only you can decide which one is the right fit for you.

Panel 1: EVIL INC... HOW MAY I HARM YOU? THIS IS THE GRANITE GARGOYLE.

Panel 2: I JUST FOUND OUT THAT MY HEALTH CLUB HAS BEEN STRAINING THE HOT TUB AFTER I USE IT.

Panel 3: THEN, USING PARTICLES THAT HAVE ERODED OFF MY STONY EXTERIOR, THEY'RE CREATING THEIR OWN MONSTER.

Panel 4: I THINK I HAVE A TRADEMARK-INFRINGEMENT CASE. DO YOU AGREE?

Panel 5: I'D SAY YOU'RE DUE TEN PERCENT OF ANY EARNINGS GENERATED BY THIS KNOCK-OFF AS LONG AS YOU CAN PROVE BEYOND A DOUBT THAT THE ERODED MATERIAL CAME FROM YOU AND ONLY YOU.

Panel 6: MY SEDIMENTS EXACTLY.

TRADEMARKS

You can't trademark a comic, but you can use trademark law to protect the title, slogan or logo of your feature.

Your first step is to do a check in the Trademark Electronic Search System (TESS) at uspto.gov. If you find your comic's title in this search, you know you might have a problem. Especially if the classification number ("IC") listed is similar to how you would intend to use the trademark.

For example, Class 016 is for paper goods and printed materials (like comic books and graphic novels); Class 041 includes such things as entertainment services, namely, providing a Web site featuring photographic, video and prose presentations.

There's a complete breakdown of trademark classifications at **uspto.gov/trademarks/ notices/international.jsp**. Obviously, there are other classifications that might present a problem to a webcartoonist, but Class 016 and Class 041 are the two that, in my opinion, present the biggest threat.

Once you become serious about your webcomic, I would recommend the investment in establishing a trademark over the title. The worst-case scenario is that another entertainment entity launches a feature that has the same name (or a similar one), and it registers the trademark before you do. If that's the case, its registered trademark could possibly win out over your nonregistered claim — even though you had been working under that title for years.

FOR THE SYMBOL-MINDED ...

There are three trademark symbols: TM, SM, and ®.

TM and SM

These symbols are for unregistered words, phrases and symbols, and they imply protection through "common-law trademark." TM is used for goods (like a graphic novel), and SM is used for services.

This says to any potential competitors that although you haven't filed the formal paperwork, you are doing business under this name.

But beware, a formally registered trademark trumps a common-law trademark any day.

®

Use this symbol only after you have registered your distinctive word, phrase or symbol with the United States Patent and Trademark Office. The ® symbol gives you exclusive rights to your registered word, phrase or symbol in the business use under which it was registered.

That last phrase is important, incidentally. For example, my comic strip, *Evil Inc,* is registered as a trademark to be used in graphic novels, comic strips and a few other related formats. So I could block an Evil Inc comic book. But I would have no ability to stop Evil Inc Plumbing.

Also, note that you may not use ® until after you receive formal notification of registration by the USPTO. Doing so could land you in serious hot water.

CONTRACTS
WORK FOR HIRE

In the course of your work as a cartoonist, the chances are overwhelming that, sooner or later, you're going to hear "Work for Hire." It's a very good idea to understand it.

A work made for hire is an exception to the general rule that the creator of the work has legal rights as the author of that work. Under a work-for-hire contract, the employer — not the creator — owns all of the rights to the work. In other words, a work-for-hire contract establishes the employer as the rightful creator of the work.

So, obviously, anything that you pursue under a work-for-hire contract has got to be something that you give a great deal of thought.

I've accepted work-for-hire projects in the past. And they worked out well. But I knew what I was getting into.

For example, on a book I wrote for a publisher, I accepted the terms because:

> **1. I wasn't going to create anything that I would miss in the long term.** This was a one-shot deal. It wasn't going to prevent me from future projects. I wasn't creating characters or concepts that the company would be able to develop and monetize over the course of decades. The product had a very limited application.
>
> **2. The pay was very good.** I wasn't going to get long-term payment, but the up-front was impressive. I could easily justify the lack of royalties.
>
> **3. This was valuable writing experience.** Mind you, I wasn't working for exposure, but it did open me to further opportunities with similar publishers. And, in some of those cases, when the deals were presented, my proven track record (completing a book that sold very well, meeting deadlines, working with editors, etc.) made it such that they had to offer royalties in these subsequent talks.

Signing a work-for-hire contract is never something that I'd advise taking lightly. I would take a long, hard look at the worst-case scenario over the long term before putting your name on the line that is dotted.

ROBERT KHOO ON READING A CONTRACT

This is from a special guest post that Penny Arcade's *Robert Khoo wrote for Webcomics.com.*

I've become pretty competent at dissecting and drafting contracts, so much so to the point that I'm known as the "contract guy" within my group of business-school friends. By no means am I a lawyer, but I'm solid enough to know when to pick up the phone for our attorneys versus what I can handle on my own. I'm going to try to distill my own steps in going through and breaking down contracts and what my thought process is for kicking it over to the billable-hours guys. Please note: This is also where I'm supposed to tell you that I'm not a lawyer and that any advice I give you here is not legal advice. Blah blah blah. Look — you guys want to know how I do things? This is it.

FIVE 'BUCKETS'

There are official parts of a contract that make it legal and binding, but what I'm after is figuring out what a person with 20 minutes can figure out from a lengthy document. The five "buckets" I look for when doing my first pass are:

1. **Who it's between** (the "parties").

2. **What the term/length is** (how long the contract lasts).

3. **What each of these folks is getting for what** (legal folk call this "consideration" / what the purpose of the agreement is).

4. **What happens if s*** hits the fan** (when one party doesn't do what he's supposed to — aka "breach").

5. **How to get the f*** out** (terms of ... termination).

If you can take that checklist and identify each of those elements with a highlighter (and understand each of those elements) and then look at what's left and understand those extra terms, you'll be in pretty good shape.

Of course, whether "good shape" means hiring someone else to figure it out or "good shape" means you can do it yourself, hey — that's all up to you. My hope is that you can look at an agreement and not throw your hands up in the air.

WHY FILL THE 'BUCKETS'?

By compartmentalizing what normally would be a wall of intimidating text, you put yourself in control and realize how complex (or simple) a situation is, rather than do what most people do, which is see a contract and get butterflies in their stomach.

WORST-CASE SCENARIO

But wait, there's one more thing. The last question above all else when considering signing a contract is "What's at stake?" If the worst thing that can happen is hey, you lose a few hundred bucks in a dispute — not a big deal. Not worth bringing in an outside party that would cost you hundreds anyway. If you feel there's a good deal of money that's either on the line or being transacted because of the agreement — or even more so, anything to do with intellectual-property rights — you'd better scrutinize the hell out of that agreement or have a pro look at it.

SAMPLE COPYRIGHT LICENSE

This Agreement (the "Agreement") is made by and between _____ ("Owner"), and _____, with its principal place of business at _____ ("Organization").

RECITALS

A. Organization is [describe organization], engaged in [describe activities that are relevant to the desire to license Owner's copyrighted material].

B. Owner owns the copyright to certain materials relating to [describe activity] and is willing to allow Organization to copy and utilize such materials under the terms herein set forth.

NOW THEREFORE, in consideration of the mutual covenants and promises herein contained, the Owner and Organization agree as follows:

1. This Agreement shall be effective as of (the "Effective Date").

2. Owner hereby grants Organization a nonexclusive right to copy certain materials described in Attachment A (the "Material"), in whole or in part, and to incorporate the Material, in whole or in part, into other works (the "Derivative Works") for Organization's internal use only.

3. All right, title and interest in the Material, including without limitation, any copyright, shall remain with Owner.

4. Owner shall own the copyright in the Derivative Works.

5. This Agreement may be terminated by the written agreement of both parties. In the event that either party shall be in default of its material obligations under this Agreement and shall fail to remedy such default within sixty (60) days after receipt of written notice thereof, this Agreement shall terminate upon expiration of the sixty (60) day period.

6. Attachment A is incorporated herein and made a part hereof for all purposes.

7. This Agreement constitutes the entire and only agreement between the parties, and all other prior negotiations, agreements, representations and understandings are superseded hereby.

8. This Agreement shall be construed and enforced in accordance with the laws of the United States of America and of the State of Texas.

IN WITNESS WHEREOF, the parties hereto have caused their duly authorized representatives to execute this Agreement.

WHO

HOW LONG

PURPOSE

BREACH

GET OUT

DECISION MAKING

Comic contests, solicitations to have your comic reprinted in a magazine, offers to run your comics on other sites ...

It would be nice if opportunity actually *knocked*. But let's face it, sometimes opportunity stands outside the door and kinda ... waits. Or maybe skulks out by the shrubs.

Most of the time, it's hard to tell if it's opportunity at all. So how do you know when to open the door? Here are a few things on my own checklist.

MONIED TRANSACTIONS

Opportunities that involve a money-for-comics exchange are no-brainers, right? Wrong.

- Is the money offered enough for what I'm giving them?

- If this is an original piece, what would my hourly rate be?

- If this is a reuse of a previous piece, are there strings attached? (Am I signing over more than just a one-time reuse of my comic? And if so, am I being compensated appropriately?)

One of the most often-repeated complaints I hear from cartoonists is, "I never know how much to charge for my work!" I always say the same thing: Go high. You can always negotiate down, but you can never negotiate up.

In negotiating these issues, if I'm met with a "Hey, that's more money that you would have had without the opportunity" kind of logic, it's an immediate red flag. Of course it's more. The question is, is it *enough*?

NON-MONIED TRANSACTIONS

These are harder to weigh. In general, the minute someone explains that part of my compensation in a deal will be "exposure" for my webcomic, it's another automatic red flag.

As Rich Stevens (*Diesel Sweeties*) once said, "People *die* of exposure."

No site — no matter the traffic — has a lock on Internet traffic. You can drive just as many eyes to your site as any other site can drive to you. Furthermore, big sites don't get big by sending readers away from their sites.

I'm not saying these are never good deals, but I am saying that when I'm faced with exposure as an opening salvo, I immediately switch into a defensive posture.

BESIDES THE MONEY...

Is it possible that your comic brings more to the other guy's site/publication than that site/pub can deliver to you? Sites need content. That's one thing we webcartoonists deliver in droves. Take a close took at your opportunity. It just might be someone trying to make an opportunity for himself.

- How much control will you have over your work after engaging the opportunity? If you disagree with its use, will your voice be heard?

- Will your comic be used to build community elsewhere — when that's exactly what you need to be doing on your own site?

- If you decide to leave — or when the opportunity reaches its natural conclusion — will the fruits of your efforts be directed back to your site?

Go in with your eyes open. And, by all means, get a written contract.

WARNING SIGNS

I've been pitched some pretty lousy opportunities. You wanna know what they all had in common? In every instance, the person spent less time talking facts and figures than he spent weaving a narrative. And there are some common themes to those narratives. Besides "exposure" and "more money than you had," here are some narratives that set off the red alert:

- This is your chance to be seen by (a) a much larger audience or (b) decision-makers in X industry. (This is a variation on the exposure gambit.)

- So-and-so was instrumental in launching the career of Joe Famous. (Jack Kirby *still* would have been the King of Comics if he had signed with any other publisher besides Timely/Marvel.)

- Our top participants regularly pull in $X-astronomical sum. (Amway uses a similar pitch.)

- We can't offer you money now, but as soon as we make money, you'll make money. (Hey, that's the same opportunity you have waiting for you back at your own URL ... only you don't have to share.)

- You're on the ground floor of Something Big. (So's the doorman at the Ritz.)

- Money isn't everything. (Seriously, sometimes they'll try to sell you on all sorts of intangibles that have value only if you let them have value.)

- Hey, no one is making money in this industry. (Is this a person you really want to do business with?)

- The false proposition. In a logical argument, propositions are used to build to a conclusion. A false proposition is an untrue statement designed to lead you to the other guy's way of thinking. The introductory video to social micropayment site Flattr contained a doozy: "When you create, there's not really a good way to get money for the content; and when you find something you like, there's no good way to show love for it." Both propositions, as you should know, are patently false.

The Acid Test

You wanna know the all-time best way to know you're looking at a weak opportunity? Explain it to a total webcomics outsider. Your spouse ... a parent ... a co-worker ...

They should be able to understand (a) that it is a great opportunity and (b) why it's beneficial to you in under two minutes. If you have to start breaking into a narrative of your own to get them to see that, you've got to take a long, hard look at it.

PROTECTING YOUR INTELLECTUAL PROPERTY

It's the oldest opening line in publishing. "I can't pay you, but I can offer you thousands of potential readers. Just think of the exposure."

And cartoonists have been falling for it for years — despite the fact that self-publishing on the Web allows them to gain readers on their own (given the quality of their work and willingness to promote themselves).

I strongly advise against letting a publisher use your work without payment. You don't need a publisher to get your work in front of readers.

Think of it this way: If you're operating a webcomic, you are a publisher. So enter into any negotiation with a publisher as an equal — not as a subordinate.

As far as payment goes, if the publisher values your work, he or she will pay for it. I guarantee they pay for other features. They can pay for yours, too. If not, my advice is to move on. You're putting yourself in a weak negotiating position if you're going to hope to negotiate payment after your work is already being used by the publisher. A good negotiator knows the best weapon is the ability to walk away from the deal. If you allow the strips to run before negotiating payment, you can't walk away without a loss. The publisher can — and can count the number of free cartoons he or she got out of you as an asset.

There is an exception to this rule, of course, and that's when the publication offers undeniable marketing potential for your strip. I offer my strips to college newspapers for free, for example (it helps when you know the publication has a minuscule operating budget). The URL runs plainly in each strip, and I consider it excellent marketing to a key demographic.

For some of the publications, I've even entered a quarterly free ad for my books into the negotiation. It costs them nothing to give me the space every three months, and it's beneficial to my business.

As you're deciding what to charge, your best bet is to consult a book called the *The Graphic Artists Guild's Handbook: Pricing and Ethical Guidelines*. It will have detailed information to guide you in pricing cartoons for different size publications. The book also offers comprehensive information on contracts and other legal issues. It's a fantastic resource.

PUTTING THE 'IP' IN R.I.P.

Later on, we'll discuss taxes, but for now, let's switch to that other constant: death. Webcartoonists leave behind a boatload of intellectual property — much of it uploaded and stored on remote servers that our family has no idea how to access. Interestingly enough, I've found two vastly different ways of addressing this issue.

BECOME AN IP DONOR

Evan Roth, an artist whose work focuses on open-source issues and pop culture, has initiated the idea of an IP donor. It's a sticker that he suggests putting on the back of your driver's license — like an

organ-donor card — that notifies authorities that you want your intellectual property to pass into the public domain. Of course, it has questionable legal merit, but it's certainly an idea worth considering.

INCLUDE YOUR IP IN YOUR WILL OR IN A LIVING TRUST

One of the basic tenets of Webcomics.com it that your work has worth. And, like anything of worth, I would think that you'd prefer to pass that along to your family or other loved ones so they could either benefit from it or decide what they'd like to do with it. To ensure that happens, it's time to get legal.

I would strongly suggest defining the recipient of your intellectual property through legal means — such as a will or a legal trust. Most of us are familiar with a will. A legal trust is merely a document that you create while you're alive ("living") that entrusts certain property to another individual or institution. This has the added benefit of avoiding probate court, which can be a hassle and an unwanted expense.

NO ONE WANTS TO TALK ABOUT DEATH...

... but it's something we're all going to have to deal with. And creative people like ourselves are liable to leave behind plenty of valuable creative property. How many of us have referred to our comics as our "children"? Well, any parent can tell you the importance of making out a will to protect their kids if they die. This falls along the same lines.

As long as we're being morbid, here is some other information your family might need:

- Server addresses and passwords to access your Web site(s)
- URL registration information
- Locations of DVDs, hard drives with archival images/data
- ISBNs you've used/acquired

NEGOTIATING A CONTRACT

Every time we're asked to name a price for our work, we rack our brains trying to come up with the Magic Number — the price that will be satisfactory to the client while remaining rewarding to ourselves.

And it occurred to me that the last thing we should be trying to do is hit the Magic Number! What you should be aiming for in this process is a long conversation — not a short one. In fact, a short conversation ("Ten bucks? SOLD!") is the worst possible outcome.

'I DON'T WANT TO BE INVOLVED IN THE BUSINESS SIDE, I JUST WANT TO MAKE COMICS.'

I was exhibiting at a comic convention in 2010, and I was invited to join a panel discussion about digital comics. During the conversation, a successful creator said a phrase that makes me cringe every time I hear it:

"This is bad advice, but ... I don't want to be involved in the business side, I just want to make comics."

Now, this person and I are on very friendly terms, so I took him to task quite openly. But I think it's time to codify our stance toward this attitude.

See, it didn't matter that he prefaced his comment with "this is bad advice, but ..." — the fact remains, he has achieved a level of success in comics. And many of the people in attendance, it could be argued, were imprinting on that attitude. In other words, they might be saying to themselves, "I can have that attitude, too, and still be a success. Clearly it worked for this guy ..."

IF YOU DON'T WATCH YOUR BUSINESS, SOMEONE ELSE WILL ...

"I don't want to be involved in the business side, I just want to make comics."

This phrase has probably been uttered during at least one panel discussion at every comic convention since they started having them. And the fact of the matter is, that attitude has led to the downfall and defeat of almost every creator who has ever uttered it. It's not a sentence ... it's a curse. A hex. And it's the worst kind of black magic. It harms the person casting the spell as it infects others, tempting them to cast it as well.

The world was never safe for that attitude — from the Golden Age on. The only difference between now and then is that back then it was excusable. You could actually excuse a Silver Age artist working for Marvel or DC who thought that he or she could concentrate on the creativity and that the company would handle the business — and look after them in their own, personal Silver Age.

You could excuse a syndicated cartoonist working in the '60s, '70s and '80s for having the attitude that their job was to make the comics, and the syndicates' job was to keep those checks coming. But we have *decades* of history to learn from, folks. And those institutions have nowhere near the clout they once did. This is no longer news.

THIS ENDS NOW

Why do we keep hearing that sentence? Our heroes espoused it openly when we were learning the ropes. It's like a virus that we spread from generation to generation.

So it's time to start fighting it. It's time to stamp it out wherever it is uttered.

When you hear that phrase — that curse — it's your responsibility to stand up and say, politely but firmly, something similar to what I said this weekend during that convention:

I respect your work immensely, and that's why I have to state emphatically that the attitude you expressed is unacceptable and inexcuseable in today's day and age. We have seen enough of the same stories played out decade after decade to understand now, once and for all, that if you don't watch your business, someone else will. And that person may not be your friend.

It's time the virus ends. Do it for the children.

What you want in this process is a negotiation — a longer conversation between you and the other party. Arriving at the right amount to charge a Web site that wants to run your comic requires fuzzy math, and there are probably dozens of ways to arrive at a figure.

Here's the one I suggested: Figure out how much your comic is worth in terms of ad revenue. If you make $400 a month on your comic, it's worth $100 a week, and $20 a day (Monday through Friday). That's a base rate. If the Web site is larger, double or triple it. The cartoonist's common reaction to this is to scream, "No! They'll never accept that!" Well ... what if they do? Besides, as I stated before, we're not aiming for a *short* conversation here — but a *long* one.

So when I pitch a high number, I'm not hoping to get an immediate *yes*. If I do, it tells me I should have gone higher. What I hope to hear is that the number is too high. Because then, I can start adding on to my compensation package with some nonmonetary goodies.

Mind you, I'm willing to accept nonmonetary compensation only in addition to a healthy monetary exchange.

And by aiming higher than the mark, I know I've helped to ensure the latter, so it's now safe to address the former.

For example, I'll back off somewhat from my original quote along with a positive comment about the prospective partnership:

> *I understand your budget might not allow you to spend $400 a month on a daily comic, but I'd really like to work out an arrangement that benefits us both. Would you consider $325 per month plus 100,000 ad views per month on your site that I could use to promote my work?*

Remember, these numbers are hypothetical. Some other nonmonetary benefits might include:

- Ability to post on their blog (for a predetermined number of posts).
- Promoting your work to their Twitter/Facebook followers.
- Free/discounted merchandise from their store.
- Access to services they might provide.

Remember, you bring up nonmonetary compensation only after you've started to negotiate down from your original rate quote. And back off slowly, always adding in more nonmonetary items as you do.

At some point, one of two things will happen:

- You will strike a deal with the client that involves a satisfactory money compensation along with additional benefits.
- The negotiation will carry the fee below what you're willing to accept.

If it's the first path, congratulations! You've successfully negotiated a deal. Now, get everything in writing.

If it's the second, politely bring the negotiation to a close and decline the offer. There are worse things than failing to bring a negotiation to a satisfactory conclusion. (For example, succeeding in bringing one to an unsatisfactory conclusion ...)

If you have to walk away, do so with politeness and gratitude. Remember, if you burn a bridge, you've burned it with the company and with any company your contact moves to in the future.

INSURANCE

Insurance, the saying goes, is making a bet that something bad is going to happen ... and hoping you lose. Nonetheless, if you're going to move forward in your role as an independent businessperson, it's worth a quick call to your insurance agent to discuss coverage where it pertains to your comic.

HOMEOWNER, WORKING AT HOME

If you own a home, you have homeowner's insurance. But that doesn't necessarily mean that all of your equipment, and merchandise are covered by your insurance in the event of a disaster.

You may need to include a special rider to cover things like your computer, any specialized drawing equipment, and your storage of merchandise like books or T-shirts. Even something as basic as a leaky pipe could do thousands of dollars of damage to your merchandise, rendering it unsellable.

RENTER, WORKING AT HOME

Even if your complex doesn't require renter's insurance, it's an awfully good idea to purchase some. And, in the same way that riders can be added to homeowner's insurance, you can make sure that there are provisions made for your comics-related equipment.

WORKING IN AN OUT-OF-THE-HOME STUDIO

You can purchase renter's insurance even if you're renting only a single room or studio in a larger complex. If you're a homeowner, your insurance carrier might be able to include the coverage with your existing policy. Or you might need to take out separate coverage.

BE FORTHCOMING

No matter which of these apply to you, take a few moments to explain your entire situation to your insurance agent. The natural position to take in these situations is to divulge information on a need-to-know basis. After all, if you get too lippy, they're just going to keep selling you more and more insurance, right?

But it has been my happy experience that giving more information actually turned out to be helpful. For example, when I moved into my studio, I contacted the agent I deal with for my homeowner's insurance.

Originally, they thought they might be able to simply include the coverage under my existing policy, but that didn't work out. So the next step was to open a renter's policy for the studio. As we worked through the process, I found that I was eligible for lower rates because I didn't have exterior signage (like a big, rotating Evil Inc sign in front of the building).

At the end of the day, I had coverage for my computer, my equipment and my merchandise for a price that I can honestly describe as peanuts.

STAY UP-TO-DATE

As your needs change — and as your business grows — be sure to check in from time to time with your agent to review your policy. If your work area has expanded or if you've upgraded your equipment, let your agent know so the policy can be adjusted to meet your new needs.

HEALTH INSURANCE

The good news is that you've developed your webcomic to the point that you can quit your day job. The bad news is that the day job provided health-insurance benefits that you and your family rely on. Here are a few possible solutions to getting health insurance independently.

JOIN YOUR LOCAL CHAMBER OF COMMERCE

By joining your local chamber of commerce, you might become eligible for health insurance at a decent rate. Clearly, this is going to vary from city to city, but it's something that's definitely worth a little research.

HEALTHINSURANCEINFO.NET

Here's another source that might help you in your research. HealthInsuranceInfo.net is a project of the Georgetown University Health Policy Institute. You click on the state you live in to download a document that covers everything from what kinds of programs are available for small-business owners to whether there is an option available for those who have been rejected by insurance providers. These documents are comprehensive and frequently updated. The site also does a good job of explaining insurance terms.

SMALL BUSINESS SERVICE BUREAU

Joining the Small Business Service Bureau will make you eligible to purchase health insurance through that organization. You'll want to check it out before you join. It has a toll-free number (1-800-315-9933) for your questions about its insurance policies.

EHEALTHINSURANCE

Finally, eHealthInsurance is a good place to do some broad searches to get comparative pricing by which to judge your other results. You very well might find out that you can get a comparable-or-better policy on your own.

GET A JOB, YA BUM!

All kidding aside, you wouldn't be the first person to take (or keep) a day job for the sole purpose of qualifying for the health insurance it offers. My personal advice for people living in the U.S.? The federal government is hiring. Sites like USAjobs can help you with your job search and application process. The jobs are often the kind of work that you can do for eight hours a day without bringing your work home with you. It's steady work, and fairly reliable. And it brings darned good benefits. If you have to have a day job, it's a pretty good option.

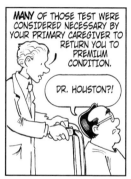
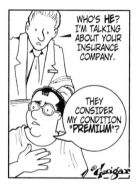
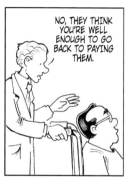

I'm not advocating putting your goals as a cartoonist aside, but if you can find a nice, mindless job as a government drone, you could easily incorporate both. And that could make reaching your goals an awful lot less frightening.

SALES TAX

If you're going to be conducting commerce — on the Web or at conventions — that means collecting sales tax. The chapter on Comic Conventions has a special section dedicated to the sales-tax implications of exhibiting, but in general you should be registered in your home state to collect sales tax, and you should be filing sales-tax returns on the regular basis demanded by that state.

Every state handles sales tax somewhat differently, but it's most likely that you are going to be required to register your business with the state government (most likely as a "sole proprietor"), and after you've completed that, you'll have to register for a sales-tax license. Depending on your state, you may be required to register for a special number — an Employer Identification Number — that identifies your business as a legal entity.

A good CPA can help you navigate these waters — and so can a call to the state-government agency that handles small-business issues. Call in the morning, early in the week, and have all of your questions written out. Take good notes, and then follow through. It's not as painful as it sounds.

INCOME TAX

Chances are, if you're relatively new to running your webcomics business, tax time is a time for confusion and anxiety. You made some money running your site, went to a couple of conventions and sold some swag. Now it's time to settle up with Uncle Sam. But what should you claim, and how?

This is one of those times when you need to invest in yourself (and your future). Find a good CPA with whom you can sit down and discuss the past year — as well as your plans for the future.

It's going to be expensive. But my personal experience has been that my tax refund often pays my CPA fees with a little left over. And I've not had that experience with tax software. (And your CPA's fees are deductible on next year's returns.)

A good CPA can help guide your business, so use your meeting to ask all of those business questions that nag away at you.

- Should I incorporate?
- Am I better off living inside or outside the city limits?
- Do I need a sales-tax license and an Employer Identification Number?
- Are my convention expenses deductible?

Moreover, a CPA can help navigate a very confusing landscape of requirements and regulations. Not only does this allow you to avoid trouble, but sometimes, proper navigation of these issues can actually give your business an edge that it was missing before.

Need help finding a good CPA in your area? Your best bet is to find a freelance artist working in your area and asking him or her for a recommendation. Freelancers rely heavily on being able to survive tax season, and the CPAs they work with are often keenly aware of the unique issues we face.

Otherwise, you're going to do some good old-fashioned phone screening. Don't schedule an appointment without first calling and discussing the special concerns that you'll be bringing along.

Lastly, some advice for the coming year. Now is the time to start preparing your tax return for next year (unless you're reading this book in early April). This is your best opportunity to get organized and stay organized during the coming year. Develop a system through which you can save receipts, track payments and store paperwork. Maybe it's as complex as investing in some business-accounting software, like Quicken, or maybe it's as simple as clearing out a file-cabinet drawer and organizing some hanging folders. Whatever your system, this is the time to start — especially if you're staring down at a pile of assorted paper and relics wondering if you saved that hotel receipt from San Diego.

SURVIVING AN AUDIT

Mention the IRS, and the first thing most businesspeople will share is that they fear an audit.

Of course, fear is counterproductive, so let's discuss a few things that you can do to (1) avoid an audit and/or (2) be better prepared to survive the experience in the event that it happens.

Because, let's face it, as much as audits have been used as dramatic hooks in pop culture, they're a pretty straightforward procedure. You'll review your return and correct any problems — for example, any ineligible deductions will be disallowed. If some of your deductions aren't allowed, you'll have to cover any new monies you owe, and you'll move on. And, always remember, some lucky people have walked out of audits having discovered that they were allowed more deductions than they had originally thought.

GO PRO

In case it isn't painfully obvious, ask around and find a reputable CPA in your area who is familiar with the needs of a small business and a freelance artist. Make a list of questions and take notes.

DON'T DEDUCT CRAZY STUFF

If you work out of the house, you can't deduct your entire mortgage (or rent) as a home office. You have to allocate a proportional amount equal to the relative size of your work space to the entire house. Same with utilities like heat and electricity.

I've always been advised that if you do work out of your home, it's a

PAYMENTS FOR SERVICES

If you pay an individual (as opposed to a corporation) for services in excess of $600, you should submit a form 1099-MISC with the IRS when you file your tax returns.

You can download a blank copy of the form and get detailed information at irs.gov/form1099misc. You can also phone 1-800-TAX-FORM for more information.

This would apply to an independent contractor who you pay for services such as illustration, writing or coloring. It may even apply to the money you pay an attorney.

If this person is a paid employee of yours, however, you would process a W-2 form instead.

good idea to make sure that the space is used *only* as a studio (and not a combination studio/home-work nook). As always, your CPA can advise you on your specific situation.

KEEP GOOD RECORDS

This is the Big Magilla. If you get audited, you're going to have to prove those deductions. And that means your record keeping will have to be top-notch.

I advise keeping every receipt you handle in the course of business. Better yet, write a note at the top explaining how this relates to your business so you can easily sort through them and group them appropriately. If you're going to deduct an expense, you're going to need proof, and your receipt is a key part of that. The IRS' Publication 583 (PDF file) has some great information on recordkeeping. It says the following about proving business transactions:

"Purchases, sales, payroll and other transactions you have in your business generate supporting documents. Supporting documents include sales slips, paid bills, invoices, receipts, deposit slips and canceled checks."

Purchases are items you buy and resell to customers. Required documentation includes:

- Canceled checks
- Cash-register tape receipts
- Credit-card sales-slip invoices

DISADVANTAGES OF SOLE PROPRIETORSHIP

As people who manage small businesses, most of us start out in the legal category of a sole proprietor —and remain there until our businesses are large enough to justify creating a formal legal structure (such as an LLC or a corporation).

However, as our businesses grow and the revenue grows to a more significant size — not to mention the intellectual property (IP) being amassed — it becomes increasingly important to be aware of the two major drawbacks of the sole proprietorship.

Liability

First of all, as the sole proprietor, there is no buffer between you and any liability your business might incur. Your home, car, personal savings and other property could be taken away to pay a court judgment. Granted, the chances that your webcomic would fall into such a situation might be fairly slim, but it's a part of the sole proprietorship that you need to be aware of.

Here's a great example. The Consumer Product Safety Improvement Act (CPSIA) purports to protect children from poorly manufactured goods. However, the rules — and the application of those rules — seem to be murky at best (and in a state of flux at worst). I'll freely admit, I'm very unclear on the full ramifications of CPSIA. However, if you are manufacturing plush dolls and shirk CPSIA, you could conceivably find yourself in some pretty hot water if someone decided their child was harmed by your non-CPSIA-compliant product. And as a sole proprietor, you would be held personally responsible in that action.

Death

Since the sole proprietorship is, essentially, you — and you are the sole proprietorship — both of you die at the same time. When you cease to exist, so does the sole proprietorship. Unless you name an executor in your will — and give that person authorization to handle your business duties — your business might have to be liquidated in order for your family to see any value from it. Furthermore, your family might not be able to access the money in your business bank account until the estate is completely settled.

You can address some of these problems by writing a will and authorizing specific people in the handling of your sole proprietorship. For that, I would strongly suggest talking to a lawyer. And when you do, be sure to discuss any possibilities for handling both of the valuable commodities you've generated — the actual revenue and the IP that could potentially generate income for your family after your passing.

Expenses are the costs you incur (other than purchases) to carry on business. Your supporting documents should show the amount paid and that the amount was for a business expense. Documents for expenses include the following:

- Canceled checks
- Cash-register tapes
- Account statements
- Credit-card sales slips
- Invoices
- Petty-cash slips

The IRS can audit you three years after you file, so hold on to those records after you've completed your taxes.

WHAT IS MY TIME WORTH?

It's the most important question you can ask if you're going to charge money for your work: What is my time worth? Figuring it all out can take a little soul-searching (not to mention wallet-searching), but the time spent can make things really simple when it comes time to suggest a price for your involvement in a project.

First of all, take the source of your primary income and divide it by the number of hours you put into it.

- Day job? If you have a day job, this is pretty simple.
- Freelancer? Total up your earnings from last year and divide it by your estimate of the amount of time you spent working.
- New to freelance? Total up the amount of money you need to make this year and divide it by the number of hours you think you can reasonably work.

You can use this hourly rate as a guideline. This is your baseline rate. And, beyond pitching rates for projects, here are a few ways you can use that number.

TAKING ON MORE WORK

Let's say you're already covering your expenses. For example, maybe you have a day job that sustains you. Or maybe your comic (and/or freelance work) covers your monthly bills.

What do you tell the person who would like you to take on something else? Does a reader want a commissioned piece of art? What if an opportunity comes along outside your comic that you'd like to jump on? More math:

- There are 168 hours in a week.

- Subtract seven nights of sleep and you're probably left with something close to 112.

- Meals? Let's say an hour for each meal. That leaves 91.

If you're spending 40 hours a week paying the bills, you're left with 51 hours a week to live your life. Those 51 hours are pretty precious, right? I mean, that's the whole reason you're working — to be able to enjoy those hours. So anything that nibbles away at your 51 has got be be worth more than your baseline hourly wage.

How much more depends on a boatload of variables — how badly you want to work on the project, what the quality of your 51 is, etc.

Do you have a spouse? Kids? Those 51 hours are double precious. I'd charge double.

WHICH SHOULD I DO?

Sometimes you are faced with conundrums. You have a project on the drawing board but the front walk needs to be shoveled after last night's snowfall. It will take about an hour to shovel. There's a guy standing on your stoop who will shovel it for $20. And your baseline rate is $25 per hour. You hire the man and stay ahead by five bucks. It's simple math.

IS MY DAY JOB WORTH IT?

How much is that day job bringing you down? Is it worth the time you're putting into it? Or could you actually make more by shifting to a lower-paying day job that allows you to devote more time to making money through your craft?

Again, you're dealing with a ton of variables — especially if your day job provides health insurance for your family. And you can make this move only if you're relatively certain you can maintain the non-day-job revenue flow, but I guarantee there are people working menial jobs that free up more time for their craft. They know what their baseline rate is.

EARNING INTEREST WITH YOUR COMICS

Finally, a word to those of us who were a little stunned to find that our baseline rate was lower than we thought it would be. One of the strengths of webcomics is that you own your work into perpetuity. So you'll make a certain amount of money today when your comic appears on your site, earning pageviews and ad revenue. But you'll keep earning money from that investment over time.

- For starters, if you're doing this thing right, today's strip has the potential to turn a first-time reader into a regular reader. Regular readers are vital for the financial success of your webcomic.

- You're probably going to collect today's comic into a book.

- Keep with it long enough and you'll be able to sell omnibus volumes that collect your books into books.

- Finally, when you're going to get ready to do other merchandise (like T-shirts), where are you going to start your brainstorming? Your best comics.

TIME MANAGEMENT

Beyond the ability to do a great comic — and beyond the ability to build a cohesive community around your comic — one of the defining characteristics of a successful webcartoonist is the ability to successfully manage his or her time. Chances are, you have a "day job," and this comic is not your full-time pursuit. So fitting time in for the comic — along with all of your other real life priorities — is a challenge. It's a little overwhelming to face a list that says:

- Assemble a book, and send it to the printer
- Complete taxes
- Expand the comic buffer
- Update the blog

That's a daunting mountain of work. So start dividing those huge, monthlong goals into smaller, easy-to-achieve milestones. For example, your book project might be divided into these steps:

- Collect the comics for Book 4
- Lay out first half of the book
- Lay out second half of the book
- Design the cover
- Collect printers' quotes
- Ship book to printer

And your taxes might be divided like so:

- Collect receipts
- Gather W-2s, 1099s and other forms
- Set aside two hours to fill out IRS paperwork
- Schedule meeting with CPA

See? Now those are some pretty doable to-do items.

PRIORITIZE

Now that you've chipped those huge projects into manageable tasks, prioritize the list:

- Collect receipts
- Work on Tuesday's comic
- Collect comics for Book 4
- Gather W-2s, etc
- Ship out merchandise sold on the site
- Remember spouse's birthday is next week

Every day, you'll cross some items off the list. And, life being what it is, every day a few new items will be added.

VOLUNTEER LAWYERS

Some of the most vexing issues for people in the creative field are matters of the law. The law permeates every part of what we do, and many of us understand little of it.

One potential source of help is Volunteer Lawyers for the Arts — an organization that delivers legal services and legal information to members of the arts community.

For more information, please call the Art Law Line: 212-319-ARTS (2787), ext 1.

WORK MADE FOR HIRE BLOG

Work Made For Hire (workmadeforhire. net) is the Web presence of Katie Lane, a lawyer who specializes in comic artists and other creative professionals.

She posts informative pieces on the legal pitfalls encountered by creative professionals.

And she provides legal services and private negotiation coaching and teaches negotiation seminars.

And if you find yourself in need of more personalized attention, she is available as a consultant and/or lawyer.

As a result, every day, you're going to have to re-prioritize that list:

- Spouse's birthday is tomorrow
- Work on Thursday's comic
- Lay out first half of book
- Schedule meeting with CPA
- Design ad for new storyline

Here's the thing. You're probably never going to get to the end of that list. (And if you do, it just means you get a little windfall freetime. Enjoy! You earned it, sport!) But every day, you'll do the stuff that is most important.

Just remember, the important stuff isn't always about the comic.

RETIREMENT

Retirement is a weird topic for webcartoonists. The fact of the matter is that so many of us are working so hard to simply grow our businesses that we can't even fathom putting away extra money for retirement. But time marches on, and we're each going to be dealing with this issue sooner or later, so let's take a few seconds to tackle the subject.

PAY YOURSELF FIRST

One of the most oft-repeated pieces of advice you'll hear from financial advisers is this: When you sit down to pay bills every month, the first check you should write should be to yourself. Decide what you can afford to pay yourself (based on what your projected income is for the next six months), and commit to putting that money away every month into a reliable place (like a Roth IRA, for example). Then and only then, use the rest to pay your bills.

If you come up short, you have only one option: Cut back on your spending. You may not give away the money that you've set aside for yourself. It's for you. The cable company may not have it. And if that means giving up HBO, then that's the choice you have to make.

If you have an option to automate your savings, then use it. In other words, if you can set up a direct deposit into a separate savings account, then do so. The less you have to think about it, the more likely you'll be to avoid the temptation to rationalize your way out of it.

Did you recently get a windfall? A new project? An unexpected increase in ad revenue? If you were maintaining a budget before that point, then that is money that you know you can comfortably bank. Don't spend it. Keep it.

INDIE RETIREMENT

That's daunting. I know. So here's a little something that might take the sting out.

Story One: Over my years of convention-going, I've met a lot of people. One of them was one of the top artists at one of the Big Two comic companies for the better part of a decade. He worked on the publisher's flagship title. He was at the top.

He was working hard, but he realized that he could be doing half the work and making twice the money by landing a job with an advertising agency. So he did. When the money in the advertising industry dried up, he got on the phone with the comics publisher. He found he couldn't get his former employers to return his calls. Styles had changed, supposedly, and the new people in charge were unfamiliar with him. He's working, but he's working on vastly different projects from the one that he made his bones on.

Story Two: Different guy, working on a popular project — once again for one of the Big Two. A separate — and similar — project is launched by corporate. The suits feel uncomfortable promoting two titles that are so similar — thereby risking confusing or diluting the marketplace. So his project is discontinued — despite the fact that it is a well-done, popular, high-quality comic. He's back to square one, working hard to master self-publishing and trying to land new paying gigs.

So What?

As independent businesspeople who cultivate our own relationships with readers — and, more importantly, retain the rights to our creative properties — we have a much better chance to avoid pitfalls such as these. And that means that our potential earning curve, if graphed out, will be much more steady and regular.

So if you can commit — right now — to the Pay Yourself First philosophy, you can afford to be somewhat conservative with your monthly stipend with the understanding that your earnings will not suddenly be interrupted because a suit on the corporate ladder has decided that he "wants to go another direction." If you can make your payment to yourself routine now, you will have years and years to build up that nest egg.

If you have one boss, it's very easy to get fired. Webcartoonists don't answer to one person. We answer to the hundreds or thousands (or tens of thousands) of readers who pledge their support every day. It's harder to get fired when you have a thousand bosses.

And, since you retain your rights, you may be able to get to the point at which you're able to re-package your work and sell it over and over again in different ways — for example, collecting comics into trades and then collecting trades into hardcover omnibus volumes.

And that means, if your work is good enough and if you've developed a strong community, that earning curve will rise steadily the longer you're able to stay productive.

MAKING THE TRANSITION TO FULL TIME

Every cartoonist dreams of quitting her day job and posting the announcement for her readers to celebrate: "Today, I am a full-time webcartoonist!" But when is it the right time to make that transition?

The answer is going to depend on the webcartoonist in question. (Is she supporting a family or is she young and single?) It also depends on the amount of money that the day job brings in — and the benefits associated with the job. The bigger the family and the better the day job, the harder it is to leave.

Q&A

Q: My comic has been going for about nine months, and I get about 20,000 unique visitors a month. But I don't know how many of those are actual readers as I get a lot of hits from Google from blog post keywords that really don't have anything to do with the actual comic. My webcomic doesn't seem to be getting any more popular and I am sick of busting my butt for little or no reward. What should I do?

A: I checked out the site. The work seems to be written pretty well. The art is very good. The site uses a WordPress/ComicsPress system (and could benefit from some fine-tuning). The update schedule is erratic. In other words, this is a very typical webcomic in its first year.

And he has reached the point that many people reach right around this time: The work is hard and the progress is slow, and there's no guarantee that it's ever going to get better for him. *I am sick of busting my butt for little or no reward*

Well, let's regroup, shall we? You're not going to be receiving a lot of reward for your first years of creating a webcomic — unless you're the fortunate creator of one of those mystifying comics that skyrocket to the top in their first months. For those of us who haven't captured lightning in a bottle, the act of building a webcomic into a business is one that is going to take a lot of time and a lot more work than just creating the comic — which is monumental in and of itself.

So maybe it's time to quit. Or maybe it's time to re-evaluate your goals.

Let's start with "little or no reward." I get e-mails from people all the time wondering why their comic isn't providing a livable income after their first nine months of doing a three-day-a-week comic. (See "If It All Falls Down," in Chapter 4.) I think expectations can get a little unrealistic. So maybe it's time to discuss reasonable expectations.

YEAR ONE

In the first year of doing a webcomic, you can reasonably expect the following rewards:

- Pride that you made it through your first year
- Creative satisfaction upon seeing how your skills have matured.

There is no more than that. You might be making money, but, realistically, you probably won't. And you definitely won't unless you're pouring a whole lot of work into the site besides simply doing the comic. You need to spend time promoting your work, for example. You need to make sure that your Web site is performing the way it should (and, ahem, if your navigation buttons are too far from the comic, it isn't). If you're like most webcartoonists, though, these things are still taking a back seat to the actual performing of regularly scheduled updates. And that's OK. But you can't expect more reward than pride.

But here's the deal: If you've made it to the end of Year One and you're still updating, and you still have the fire that makes you need (not want, *need*) to tell stories on the Web, then you win. You get to Level Up. If you don't have that need — if posting your comic doesn't make you giddy with anticipation — at the end of the first year, then you have to sit down and take a long while to decide whether this is really something you want to pursue long-term. Because it only gets harder from here on in, and the workload increases exponentially.

And that's a question that only you can answer for yourself.

But, assuming that the fire is still there, let's see what you can expect in the following years.

YEAR TWO

- The previously described sense of pride and creative satisfaction.

- A small sum of money generated from merchandise.

- A widening support group of fellow webcartoonists.

- A better understanding of marketing and ideas on how to apply them in Year Three.

YEAR THREE

- Pride, creative satisfaction and the confidence that comes from knowing that you can actually keep this up for the long haul.

- A larger sum of money generated from merchandise. Perhaps even merchandise on the level of books and T-shirts.

- Significant ad revenue.

- One or two comic-convention appearances that generate revenue to either break even or bring home a small profit.

- A reliable support group of fellow webcartoonists.

- One or two successful ventures into marketing your work to a wider audience.

YEAR FOUR

You've achieved a certain degree of familiarity with the business of webcomics, and you know what you're going to have to do to make each of the individual parts of the business grow. You have an understanding of the scope of work that's necessary, and you have a firm plan on how you can achieve your short-term and long-term goals.

You'll notice that there's no mention of Web traffic in there anywhere. That's because it isn't about the size of your readership, it's what you're able to do with it. I'll take a small readership with a strong sense of community over a large one with no feelings of community any day of the week.

That's what you can expect during your first four years of doing webcomics. You'll notice a few things — like quitting your day job and persuading groupies to maintain an orderly queue — are absent from the list.

That's not to say these things aren't achievable sooner (well, groupies will always be disorderly), but hitting goals beyond these expectations is going to take a lot more work, and a willingness to constantly educate yourself about the business you're in. Having a site with the usual WordPress/ComicsPress mistakes in this case would be unforgivable. Not maintaining a consistent and frequent update schedule would be indefensible. Making use of advantages such as social-networking sites to spread the word on your work, learning how to market beyond the sphere of webcomics and becoming a savvy businessperson would be crucial.

If you're not there yet — or if you simply can't spin all of those plates at the same time — don't despair. You'll get there. You'll learn.

In the meantime, focus on what brought you to the table in the first place: your comic.

It comes down to a life choice — with no right answer. Some cartoonists will choose the option that makes them a full-time cartoonist, and others will decide it's more prudent to split their time between the two (and reap the benefits from both).

One person who had made the transition to full-time freelance (which is very similar to full-time webcartoonist) described it to me as "hitting the wall." At a certain point he knew that he couldn't make his own business take off without spending more time on it — time that he had previously been spending on his day job.

Only by quitting that day job was he able to push his career to the point at which his own business was making money similar to what he had been making while working two jobs. And, I would imagine, there was an interim period during which he was making much, much less. Dave Kellett (sheldoncomics.com) has said on the Webcomics Weekly podcast (ww.libsyn.com) that before he took the leap to full-time cartooning, he and his wife had saved up enough money to cover living expenses for two years. This money was leap-of-faith insurance.

Once Dave was ready to leave his day job, this money was his safety net to allow his family to weather any unforeseen bumps in the road.

So, it's not a question with a definitive answer. Each of us, if we're good enough and work hard, will find ourselves staring at our own wall. And each of us will have to decide to either punch through or assimilate the wall into our lives.

But understand this: Making the leap to full time isn't the Finish Line. It's the Starting Line. You'll work harder than you ever worked holding down your day job and your comics job. On the bright side, you'll probably enjoy it twice as much.

WHY AREN'T THERE MORE FULL-TIMERS?!

I get this question a lot: "Why aren't there more people making a full-time living self-publishing their work on the Web?"

The short answer is because doing a high-quality comic that will generate a full-time income is an incredibly difficult task.

For example, If you want to do a comic strip as your full-time occupation, you have to be able to create an engaging, enjoyable strip several times a week. And you have to do that week after week after week until you've done it for a year. And at the end of the year, you get to try to pull it off week after week for another year.

Doing a comic strip is easy. Doing a comic strip *well* is difficult.

Doing a comic strip well week after week for a year is phenomenally challenging.

Doing a comic strip well week after week for the number of years it takes to build to a full-time income is *Herculean*.

There aren't a huge number of full-time daily comic-strip artists because it's incredibly hard.

It's always been hard. And yet, to the Average Joe, it seems as if there really ought to be more full-time webcartoonists.

To understand this better, it's useful to compare the predominant business approach of today's comic-strip cartoonist (webcomics) to the predominant business approach of a comic-stripper from

10 or 20 years ago (syndication).

Under the syndication model, you would first prepare several weeks of sample comics, and you would submit them to a submissions editor who would then wade through the thousands of submissions to find the ones that had the kind of broad appeal that would enable them to have a good chance of success when offered to the market (in this case, newspaper editors purchasing features for their publications).

And there were very, very few people making their full-time living doing a daily comic strip. Not only were there few chosen, but you have to remember that even if you were chosen by a syndicate, you didn't actually start making money until the newspapers started buying the strip. You could only become a full-timer once you crossed a threshold of a certain number of actively subscribing newspapers.

PULLING BACK THE CURTAIN

So why is there an expectation to have more full-time webcartoonists? Part of it is the ease of publishing, thanks to the Web. And the other part is transparency.

Ease of publishing

It's incredibly easy to start a webcomic Web site. The buy-in is low. You need a computer and access to the Web — both of which are very common. You need either a scanner or a drawing tablet — neither of which is necessarily a high-end purchase.

Once you have these in place, you can start publishing a webcomic now.

Contrast that with the previous business model that a cartoonist would have to access to become full-time: six to nine weeks of samples (without feedback) that are then mailed to a submissions editor who responds months later. The entire process might take six months from the beginning of the creation process to the response.

The response was usually a photocopied form letter explaining that the work was "not suitable for publication at this time." That was the complete payoff for several months' work.

With a webcomic, there's a low threshold to cross to enter the arena. Therefore, there's a larger pool. And because of this, there are an awful lot of webcartoonists out there. And since there are so many people doing this, there is a heightened expectation that more of them should be successful.

Transparency

That low threshold of entry also means that there's an overwhelming chance that the webcomics you read today are ones that a submissions editor would have deemed "not suitable for publication at this time."

In other words, most of the webcomics you read are ones that are learning. They're practicing. They're not ready. Yet. They might be someday, but the stuff you're reading now is the stuff that they're going to be (hopefully) learning from as they make their journey to proficiency.

Under the syndicate model, these people would have been hidden by the process. They would have toiled away at the submission level, unseen by anybody but family and friends. Or they would have worked in almost equal seclusion in a development process that brought them into contact with a small group of editors who would try to quicken the learning process and speed them to the point at which they would be "ready."

Just strippers?

I think the above argument applies to a wide range of comics. You could apply it to webcartoonists

doing single-panel gags (by comparing them to the freelance, magazine, gag cartoonists). And you can definitely apply it to comic-book creators submitting work to publishers to get full-time work.

So what?

From the perspective of the casual observer, the only cartoonist that he ever heard about was a full-time cartoonist. There was no one else. The novices and students and wannabes were hidden.

In webcomics, there is complete transparency. The market is flooded with people with skills that range from zero to 100.

The success rate, I'll argue, is the same, it just seems as if it should be higher because we see more people attempting it.

What a jerk. He said "wannabes."

Make no mistake. I spent several years being in the "not ready" category. The syndicates told me "no" repeatedly. The entire run of *Greystone Inn* was exactly that: the practice I needed to be ready to do something better. And if it hadn't been for webcomics, I would have never developed my skills past the wannabe stage. I owe everything to that time.

Furthermore, you can find any number of people who will argue that my work still belongs in that category.

But a comic like *xkcd* would have never been accepted by a syndicate.

Yeah. And that's why I love webcomics.

Although the success rate is about the same, the pool of successful comics is more diverse than it has ever been. From that standpoint — the standpoint of someone doing a narrow-cast feature — the chances for success are much greater than they have ever been.

LOST IN TRANSLATION?

One of the strengths of webcomics is the ability to transcend geographic limitations. Add in the fact that Asia is booming with new Internet users (most of whom use smartphones as their primary interface, incidentally), and you have the globalization of comics.

So when you're approached about a version of your comic translated into another language, it's a no-brainer, right?

Nyet.

I've seen this go down a number of ways. In one, I'm approached by some "businessmen" who offer to translate my comic for free. Heck, they even offer to host the translated comic on its own Web site. The talks have almost always broken down when I started asking if I would be sharing in the ad revenue for that site.

Then there's the well-meaning fan who offers to do translations of your work. It's always heartfelt and genuine, but almost every crappy work-related quagmire I've gotten myself into has started with a heartfelt, genuine gesture. Unfortunately, a fan-run translation has an enormous probability of fizzling out (as the well-meaning fan finally succumbs to having a real life), and then you have to answer to disappointed fans who grew attached to the translated version of your comic. And it's hard enough to apologize for something like that when both parties speak the same language.

And finally, there's always the surprise of finding out that somebody has been swiping the comic and

translating it without your knowledge. Of course, that's an easy one. "Cease and desist" is a fairly universal concept, and if that doesn't work, you have to take the steps needed to render the images on your site unswipeable.

TOWER OF BABBLE

Of course, you may decide that it's a very good idea to have your comic translated. If that's the case, here are a few thoughts:

- **Sign a contract with the translator.** This translated version of the comic should be treated as a completely unique entity — and separate from your original comic. Delineate clearly how compensation should occur, and define the rights assumed by all parties to the new, translated property.

- **Plan for print.** If you're going to build a foreign-language audience, then you'd better plan to make that effort worthwhile by having foreign-language merchandise. And that means that the physical translation should take place on a high-resolution digital file — if possible, using the same lettering font you use. In the case of hand-lettering, it might be beneficial to chose a replacement font unless the translator is also a skillful letterer.

- **Maintain control over your property.** Host the foreign-language Web site yourself. If you run ads, be sure to split the revenue with the translator (unless you're paying her upfront for her services). But don't cede control over your intellectual property to a person who is, in the legal sense, more contractor than collaborator.

- **Track your success.** Inevitably, you're going to come to the point at which you have to gauge whether this is worth the time you're devoting to it. And if it does become a successful venture, you'll need that same tracking to help determine when it's a good idea to start rolling out merchandise.

As webcomics continually diversify their revenue streams, translated material is going to evolve as a viable component of the overall business model. So it's best not to take it too lightly.

DEALING WITH CHANGE ON THE WEB

Webcomics — or, more appropriately, independent cartooning in the digital age — was brought about as the World Wide Web brought sweeping changes to the publishing industry. Even as those changes enabled people like me to build an independent career on the Web, it crippled my colleagues who had existing careers in traditional print publishing (syndicated cartoonists, cartoonists who worked for magazines, etc.).

So you'll forgive a few geezers like me who jump a little at anything — *anything* — that indicates a change to the Internet. We've seen what change can do to some people.

So my blood runs cold a little bit when I hear the words Orphan Works Act — a piece of legislation that could make significant changes to copyright law in the U.S. And my teeth set on edge when Congress debates changing net neutrality — which could grant corporations the ability to control

consumers' equal access to the Internet.

But, like good businesspeople, we have to be willing to adapt and shift.

The takeaway lesson from the syndicated cartoonists who saw their careers diminish because of the Net isn't that change can devastate — it's that refusing to adapt to change can be devastating.

For example, let's say that Congress acts against net neutrality. If that means a narrow bandwidth for lowest-tier Internet users, we're going to have to pare down our sites. Goodbye, embedded movies. Goodbye, Flash.

LEAN AND MEAN

In a way, many webcomics are tailor-made to take advantage of this very environment. Our work can be made to load quickly, and we can easily do without a lot of the extraneous doodads.

COUNT ON INNOVATION

This I guarantee: Any breakdown in net neutrality is an opportunity for some brilliant coder to devise a way to beat the system. And if that person makes a fortune for himself in the process, so much the better.

But by next summer, someone will unveil a way to access multiple tiers and get around the barriers that the telecoms will set up. It might mean paying a fee for the service, but for those webcomics that truly need the access, it will be a price they're willing to pay.

We're already seeing the rise of the app. And, let's face it, people don't have the same hang-up about paying for an app that they do when it comes to Web content. In fact, people are downright accustomed to paying for app-content. Even when there are free alternatives (like the free version of Angry Birds that almost inevitably leads to a purchase of the full version).

This may be our cue to make the leap to app-comics.

WHEN IN DOUBT, TRUST KHOO

I was chatting with Robert Khoo one day, and I sprang this on him: "What keeps you up at night?"

"What do you mean?"

"I get the 2 a.m. sweats every now and again," I explained. "I wake up in the middle of the night and I wonder, 'How am I going to survive if net neutrality vanishes?' or 'What happens if the Orphan Works Act passes?'"

"Do those things wake you up in the middle of the night, too?" I asked.

Khoo calmly assured me that they did not. Those were merely challenges to running a business, and businesses would always face those kinds of challenges. See, a guy like that doesn't cower in front of a challenge. The challenge is the reason he's in the game. No challenge, no fun.

I'm no Robert Khoo.

But at 2 a.m., sometimes I have to pretend I am.

WE DID IT BEFORE AND WE CAN DO IT AGAIN

The Web really stunk back in 1998. Anybody remember phone modems and waiting for AOL to connect? Yet, that was the breeding ground for comics like *PvP*, *Penny Arcade*, *Sluggy Freelance*, *User Friendly* and a whole slew of others. That's where *Keenspot* was formed. And *Modern Tales*.

We tried "Web syndicates" and micropayments. Some stuff worked and other stuff failed.

And we finally built it to the point where we can say: "This ... this is webcomics."

Perhaps a FCC ruling on net neutrality could put us back to 1998. Yes, that would stink.

But an awful lot of great things trace their roots to that time.

Despite the boinging modems and "You've got mail!" — don't let anyone fool you — it was exciting as hell to live in those conditions.

BOTTOM LINE

Change is going to come — like it or not. And when it does, you have to believe that it's not the end of what we do.

It's the beginning of a new way of doing it.

Advertising

The biggest misperception of webcomics is that we "give our work away for free." Of course, what people really mean when they say that is that we don't get paid up front by traditional sources — like publishers or syndicates. In fact, webcartoonists generate revenue through a large number of revenue streams. Our business model is to attract a large number of readers to our Web sites as frequently as possible, and then use that traffic to generate money. The sale of books, for example, thrives when it's offered to a strong, healthy community of readers.

Along with actively offering merchandise to your readers, you can bolster your revenue by running ads on your Web site. This is a much more passive process. In other words, you simply install on your site the necessary code, and, in many cases, you can begin to generate profits immediately.

Make no mistake, however. Internet advertising is not a get-rich-quick scheme. On the Web, a dollar will typically buy thousands of ad impressions. Unless your site is generating significant traffic, you're not going to earn much more than beer-and-pizza money at first. But as your ability to pull in traffic grows, so will this revenue source.

TERMINOLOGY

Here are some terms you need to be aware of when dealing with Web advertising.

CPM: Cost Per Thousand (M is the Roman numeral for 1,000). This is how much a publisher charges an advertiser for every 1,000 times the ad appears on the publisher's page(s). A single appearance of an ad on a site is called an impression or a view. PulsePoint, Tribal Fusion, Gorilla Nation, Burst Media and many of the other Web-advertising servers use a CPM pay structure.

CPC: Cost Per Click. This is how much a publisher charges an advertiser for every time the ad is clicked on by a visitor to the site. Google's AdSense uses a CPC payment method.

CPA: Cost Per Action (sometimes Cost Per Acquisition). This is a payment method that generally accompanies affiliate-marketing structures. The publisher gets paid only if a visitor clicks on the link and then proceeds to carry out a desired task — such as buying the item on the advertiser's Web site. The Amazon Affiliate program works like this.

CPV: Cost Per View. The publisher is paid every time an ad is viewed. This usually applies to pop-ups, pop-unders and interstitial ads.

CPD: Cost Per Day. This is a rate charged by the publisher to present the ad on the site for an entire 24-hour period. Project Wonderful uses an auction system to establish a CPD for its participating publishers.

In general, each of these is a mutually exclusive payment option. In other words, if a publisher is displaying ads and charging by a CPM scale, it is unlikely that it's also getting paid on another basis such as CPC, CPA, CPV, etc.

Ad views: Simply, this is the number of times an ad is served as part of a page. This is not to be confused with pageviews, since many publishers serve ads as part of an ad chain, and therefore many of the publisher's pageviews may very well display without the ad in question. Many people mistakenly try to estimate a site's pageviews based on ad views.

CTR: Click-Through Rate. This is the number of clicks an ad received, divided by the total number of ad views. A good CTR is generally thought to be around 0.5%. If you're getting 1% or even 2%, that's considered to be a very successful ad.

PROJECT WONDERFUL

Project Wonderful is a very useful tool for displaying ads on your webcomic site. Created by webcartoonist Ryan North, this system allows pro-

STANDARD SIZES

The Interactive Advertising Bureau has established the following standard sizes for Web advertising (all measurements are in pixels, width x height).

Leaderboard
728 x 90

Banner
468 x 60

Half-banner
234 x 60

Medium Rectangle
300 x 250

Square
125 x 125

Skyscraper
120 x 600

Wide Skyscraper
160 x 600

Button
120 x 90
(or 120 x 60)

There are no standards regarding placement. However, it is very popular for sites to run a leaderboard along the top of the page, and skyscrapers along the left and/or right side of the page, below the site's most important content.

spective advertisers to bid on ad space on your site. The highest bidder wins the space for the day. But if they're outbid by another advertiser, they pay only a prorated payment based on the number of hours they held the spot.

If you're just starting out, Project Wonderful is an awesome way to get started offering advertising on your site. It's unlikely to pay out big until your traffic improves, but it's a great way to get used to the interface and process of running ads.

If you're an advanced webcartoonist who is offering merchandise to readers, you can fine-tune the way you use Project Wonderful. By setting a minimum bid, and creating a default ad to run when that bid is not met, you can maximize the effectiveness of that ad space.

Think of it this way. If you were selling ads on your site the traditional way — billing on a CPM basis — you would make about $50 a day for a site trafficking about 10,000 a day displaying a $5 CPM ad.

Of course, beginning or intermediate webcartoonists aren't able to command a $5 CPM. (And if they are getting $5 CPM through an ad server like PulsePoint or Tribal Fusion, chances are they're not serving ads to all of those 10,000 impressions.)

So, let's do the math on a much more modest $1-CPM basis. The same 10,000-pageview site would have a earning potential of $10 per day. Then, why is your minimum bid less than $10 per day?

I should pause here and note that $10 is not a magic number.

My point is that your Project Wonderful minimum should be set to what you feel you could make in a day selling the same number of ads on a CPM basis. That might be a $1 CPM for you. Or it might be $5. Or it might be $0.50.

Many Project Wonderful users keep their minimum bid low (or at zero) because they feel as if setting it higher would result in a complete loss of advertising. And if they're not offering merchandise, they may be absolutely right. If you don't have merchandise, you have two options: Bide your time or use Project Wonderful in a rotation along with other CPM-based ad servers (this is called an ad chain, and we'll talk about it a little later).

PROJECT WONDERFUL IN AN AD CHAIN

If you want to use Project Wonderful as part of an ad chain (which we'll discuss in a couple of pages), you'll need some special setup on your PW account.

You'll have to create a separate page on your site that's got just the PW ad-box code for that ad box on it. (You can call it something like pw.html.) That page doesn't need to link to anything your readers see — they just need to be able to reach it by URL.

• Once that's set up, head to **Publishing -> My Ad Boxes -> Edit**.

• Click on **Name and location** under **Description**.

• Go down to **URL to ad box code**.

• Enter the full URL to that special PW code page you created. For example:

http://www.evil-comic.com/pw.html.

• Click **Save these changes**.

Project Wonderful will find and confirm these ads quickly.

Interested advertisers checking out your page will still be sent to the main URL, so they can see the full layout, but Project Wonderful will follow this separate address to find the ad-box code even when your site is displaying a different ad.

If you use Project Wonderful as part of a chain, please make sure that you're disclosing that fact to potential bidders. It prevents a lot of confusion.

When there are no bidders, Project Wonderful defaults to the "Your ad here" message.

But if you are selling merchandise on your site, you might be much better served setting a higher minimum bid and using a "house ad" instead of a "Your ad here." In your Project Wonderful publisher settings, you can upload a banner ad of your own and set the link URL. (Click **Edit** on an existing ad box, and look for **"Your ad here" image and link** under **Publisher Options**.)

After all, you can solicit Project Wonderful ad purchases through elsewhere on your site. You don't really need the "Your ad here" message. Consider uploading an attractive ad for your own merchandise and using it as the default for when there are no bids. How many sales do you have to make before you've made back the amount that you "lost" by setting a higher minimum bid? One? Two? It shouldn't take much to make that money back. And over the course of a few months, you might find that you actually make more.

PULSEPOINT

PulsePoint (PulsePoint.com): I'm going to devote a fair amount of space talking about PulsePoint because it has an interface that allows a publisher to easily set up an ad chain. Even if you don't end up using PulsePoint, you can apply the concepts we discuss here to other ad networks. In PulsePoint, you set your own CPM price. If you set a high CPM, it will fill only a small number of your site's impressions with paid ads (this is referred to as "fill rate"). If you set a lower CPM price, you will see a higher fill rate. PulsePoint is little tough to qualify for, however, so you'll want to make sure to follow closely some of the advice offered in this chapter to make your site attractive to an advertiser. Payment is made on a net-30 basis, which means the company cuts a check 30 days after the last day of the month in which you earn enough revenue to qualify for payment ($50).

CPM

PulsePoint pays on a CPM basis. So, if your ads are selling for $5 CPM, you will get $5 for every 1,000 ads that are served by PulsePoint on your site. That rate is prorated, so if you serve only 100 ads during a given time, you will make only 50 cents.

ASKPRICE

PulsePoint's AskPrice is the price that you set for serving ads on your site. PulsePoint commits to paying 100% of your AskPrice for all of the ads that it serves to your site. But that's the rub. Set the AskPrice too high and it'll throttle back on the ads.

MANAGER

Most of your administration will take place in the Manager area. It's the second tab from the right, once you sign in.

Using the Manager, you can establish variables (such as AskPrice, Performance Price, default ads, etc.) and you can get feedback on how your ads are performing for a given time frame (which is determined by the Date Range dropdown).

SO WHAT'S A GOOD ASKPRICE?

That's up to you, and it's a decision that has more variables than "what's everybody else doing?" My own, personal philosophy is that a 100% fill rate is an indication that I've set my AskPrice far too low.

I'll generally try to keep my fill rate between 25% and 35%.

My recommendation is to set an AskPrice and watch the fill rate. Let it stand for a couple of days to get a good measurement. If you'd like to see the fill rate rise, lower the AskPrice a little. And as you're tinkering, watch your daily total ad revenue. As I said earlier, a larger fill rate does you no good if you're not selling the ads at a decent CPM. So your daily total revenue is going to be the final arbiter of whether you're maximizing your sales.

DEFAULT ADS

So why do I recommend a fill rate of under 100%? Because PulsePoint isn't the sum total of the ads that I run on my site. It's the top of a chain of ads.

Backup Tags: Edit	Rotation: Edit
Evil Inc Leaderboard / PW	53 %
Tribal Fusion	11 %
Google Adsense 728x90	25 %
Advertising.com leader	11 %

The process is simple. As a user loads an ad, PulsePoint gets first crack at serving an ad in that position. If PulsePoint declines, the position is thrown to a default ad. If I have multiple default ads for a single ad position, they are served according to a percentage that I determine.

Take my leaderboard for example. By clicking on the Leaderboard link on the far left of the Manager page, I get a list of my default ads.

As a result, any ad impression that PulsePoint passes on is then delivered to one of my backup ads. Twenty-five percent of those backup ads are handled by Project Wonderful, 25% goes to another ad network, Tribal Fusion, and so on.

I just happen to have all of the percentages set equally. During the holiday season, I had about 10 back-up tags set, with some of them set to 1%.

HOUSE ADS

Don't forget that you can make your own house ads and place them into the rotation of back-up ads as well. This is as simple as a line of HTML code for a hyperlinked image (hosted on your own server). Here's my house ad for the 2012 Evil Inc calendar:

As I've stated in the past, I think house ads are an important part of your ad chain. Your ad space has value. You should be availing yourself of some of that value. This could be the case during those times (like the first quarter) during which your advertisers aren't willing to pay for the space. Or it could be during times when you have merchandise you want to be sure your readers are aware of.

PERFORMANCE PRICE

I recommend you enable Performance Pricing in all of your PulsePoint ads. Your Performance Price allows PulsePoint to beat your backup ads with paid advertising.

You should set your Performance Price to be slightly higher than the eCPM (estimated CPM) of the default ads you're serving (even Project Wonderful).

Otherwise, you'll be passing over a higher-paying backup ad in favor of a low-priced Performance Price ad.

Cool tech hint: If your Performance Price is under a dollar, enter it with a zero before the decimal point. Like this: $0.50 ... otherwise, it won't take.

PERFORMANCE PRICE OPTIMIZATION

So, how can you set the best Performance Price? PulsePoint added an optimization chart to its Dashboard. Using this, you can look at each of your default ads and see where the optimal Performance Price lies.

INLINE-TEXT ADS?

PulsePoint offers the option of serving inline-text ads (also called in-text ads). Theses are ads that show up as hyperlinks in the text of your site. For example, if you blog about "Star Trek," it might place a hyperlink on the word "tricorder" that takes the reader off-site to a place where he or she may purchase a tricorder toy.

I strongly recommend against inline-text advertising.

In participating, you're diluting your own ability to link effectively from your site. See, aside from a double-underline, there's nothing to alert a reader that this is an advertising link. And you have to know that you're going to be disappointing a number of your readers — especially the less-Web-savvy ones — who are going to click on a link and be taken to an advertiser's site against their will. And after they've been burned once, they may be very reticent to follow any links from your site — thus eroding your ability to direct readers anywhere on your site.

BLOCKING

Some ads may not be appropriate for your site. And some ads may be downright malicious, delivering harmful material to your readers through the advertising. (See "When Ads Attack!" in a few pages.) One way of patrolling this is to establish a list of known offenders and block them from your site.

Most ad networks allow you to do this in two ways. First, you can block ads by ad type. So you can automatically block that content from your site. For example, one type of ad I block outright are lead-generation ads. These are ads that are placed for the sole purpose of gathering user data to deliver spam to at a later date.

Secondly, you can block ads by domain. When I was struck by a malicious advertiser, one of my first steps was to add their URL to my list of blocked domains.

GOOGLE ADSENSE

Google AdSense (google.com/adsense) is a fairly intuitive plug-and-play ad server, and it's a good introduction to the standard ad-server interface. It pays on a CPC basis, so the revenue it generates won't be extremely high until your traffic increases, but I recommend it highly to new web-cartoonists if only for the learning experience.

INSTALLING ADSENSE

After you've created an AdSense account, you'll log in and click on **My Ads** in the top navigation bar and you'll see a button labeled **+ ad unit**. Click on that button, and you can begin creating ads. From here, it's pretty much about deciding what kind of ad you're going to create.

Ad Size: You have a number of standard ad sizes to choose from.

Ad Type

You can choose to display:

- Text only
- Text & image / rich media
- Image / rich media only

Google suggests choosing Text & image / rich media ads, claiming that it delivers the best revenue.

Backup Ads

I wish this were more robust, but you have three choices if AdSense can't (or won't) deliver an ad during a particular view:

- Show blank space
- Show other ads from another URL
- Fill space with a solid color

Actually, you have a fourth choice: Google delivers a free public-service announcement from the Ad Council.

That middle choice, show ads from another URL, would be awesome except for one thing. It's not really an ad. It's an image. Choosing this option gives you a single box to fill in with the image's URL. So you can show an "ad" ... but nothing will happen if you click on it. I'm sure there's a workaround involving creating the ad in Flash, but for most of us, this isn't really a viable option.

Custom Channels

A custom channel lets you group ad units however you choose, such as by size or location on a page. You can track performance by custom channel, and turn your channel into a targetable ad placement so advertisers can target their ads to your ad units. Since I run AdSense ads on several of the sites I operate, I separate my channels by the names of those sites. You may need to first create a Custom Channel by clicking the blue link.

Google AdSense's user interface for creating new ads.

Ad Style

These styles apply mostly to the text ads that Google delivers. You can select from several defaults, but it's much better to create your own custom styles that work well with the colors on your site. You can create your own ad styles by clicking the Ad Styles link in the left-hand column.

Save and Get Code

You can either choose to Save the ad or you can Save and Get Code. Don't worry, if you choose to Save for now, you can always go back and get the code later.

When you get the code, copy it to your pasteboard and then paste it in the appropriate place in your site's HTML code. The ads should start appearing instantly.

MAXIMIZING ADSENSE

The key to making money with Google AdSense is CTR (Click Through Rate). AdSense pays out every time someone clicks on an ad (as opposed to other ad services that might pay per view). So to increase your revenue, you have to increase your clicks. And that means you need to help Google deliver ads that your readers want to see.

AD PLACEMENT

On a traditional web-comic site layout, you have four main, above-the-fold hot spots:

• Top of site
• Comic
• Under comic
• Under comic, left-hand side

Here are a few thoughts on how you can maximize your hot spots:

Leaderboard: 'Nuff said. The leaderboard goes at the top of the site.

Comic: Don't underestimate the power of using the space directly above and below the comic. Comic Easel/WordPress has this as a built-in function. Certainly, you could use this for simple advertising, but I find it much more valuable to use this space to send my readers important messages.

Below comic: This is usually where most of us place our blogs, but it can also be a space for a shallow horizontal ad (like a banner).

Below comic, on the left: This is prime real estate that many of us are undervaluing. Consider a 300x250-pixel ad (or even 300x600) for this space.

Many of us know the basics — like including keywords in your meta tags that help define your site. The more descriptive the meta tags, the better-targeted the advertising.

Title tags can be as effective as meta tags. Don't pass up the opportunity to make them as descriptive as possible.

But beyond those basics, there might be a section of your site that routinely holds text that would provide excellent guidance in determining good ads for your site. You can highlight that area so Google's spiders can't miss it.

Use the following code to highlight a section for Google:

```
<!--google_ad_section_start-->
```
blog, text, whatever
```
<!--google_ad_section_end-->
```

Conversely, you can rope off an area of your site that you'd prefer Google's spiders to ignore:

```
<!--google_ad_section_start(weight=ignore)-->
```
blog, text, whatever you want ignored
```
<!--google_ad_section_end-->
```

Finally, the pretty permalinks we discussed in Chapter 6 aren't just SEO-builders — they help AdSense maximize your ad revenue, too. If your content-management system facilitates pretty permalinks, activate it. Using this to its fullest will mean rethinking how you write the headers to things like comics and blog posts. When you're writing the headline, you'll want to replace a simple "Good news!" with something more descriptive such as "Good news for fans of Jack-O'-Lanterns!"

GOOGLE ANALYTICS

If you use Google Analytics to chart your Web traffic, you can track AdSense performance under Content. In that section, under AdSense, is a section titled Top AdSense Content. Looking at that information can help you determine what pages/content are driving the greatest amount of ad revenue.

MANAGING THE ADS THAT APPEAR ON YOUR SITE

Most ad servers will allow their publishers to block certain kinds of ads that they don't wish to see on their sites.

For example, you may not want to host ads that feature adult content if that wouldn't be appropriate for the readership you're trying to foster at your site.

The same goes for ads for cigarettes and alcohol and political ads.

Beyond content, you also may want to place restrictions on the *types* of ads that appear on your site. For example, although they pay at a higher rate, I block pop-up ads because they interfere with the reader's experience on the site. I block pop-under ads, too, because readers have reacted in a very negative way toward them. I block lead-generator ads because they tend to prey on my audience, and I block ads that incorporate sound and rapid blinking. Both of these detract from the comic.

If your readers react negatively to a specific ad that appears on your site (or if you do), most ad servers allow blocking the advertiser's domain.

Mind you, it's a trade-off. Some of the ads we're talking about pay a much higher price than standard Web advertising. However, if that comes at the expense of your readers' pleasant experience, it's a bad trade.

THE WEBCOMICS HANDBOOK

OTHER AD SERVICES

Of course, there are a number of companies that serve ads to participating Web sites. These companies generally pay on a CPM or CPC basis — meaning you get paid on a per-impression or per-click basis. Here's a quick overview of some (and by no means all) of your options.

Tribal Fusion (tribalfusion.com): This is another ad server that is popular among webcartoonists. The interface is quite a bit more difficult to manage than some of the others I've dealt with, but it has resulted in *excellent* revenue for me —and is spoken highly of by many of my colleagues. Tribal Fusion takes 45% of the revenue generated on the ads it serves (paying the publisher 55%). It pays on a net-45 basis, which means that it releases a payment 45 days after the last day of the month in which your site generates more than the minimum revenue required ($50). You must have 500,000 unique visitors per month to qualify.

Burst Media (burstmedia.com): Burst takes a 50-50 split of the revenue generated under a monthly contract. If you sign on for a year, it pays 55%. It requires a minimum of 25,000 monthly pageviews for acceptance. Burst pays on a net-45 basis after a revenue threshold of $50.

ValueClick (www.valueclickmedia.com): Perspective publishers need to have at least 3,000 monthly pageviews. ValueClick Media works on an "effective cost per thousand impressions" (eCPM) model (more on this later). The eCPM for each campaign is clearly listed in the publisher interface, so for each impression you serve you will know exactly what you will earn. It also provides tools to help you determine exactly which campaigns to serve, to maximize revenue for your inventory. You will see all campaigns available to you so you can make a decision based on the actual eCPM. ValueClick pays on a net-25 basis after a revenue threshold of $25.

AdBrite (adbrite.com): AdBrite takes an undisclosed percentage of revenue. It pays on a net-60 basis after a payment threshold of $100 (which can be changed to $5 after sign-up).

REQUIREMENTS

Look at the requirements for almost any ad server and you're likely to see the following:

- Site may not have: Adult content; sexual content; profane content; illegal drugs or related content; hate speech or hate graphics.

- Site may not engage in, promote or facilitate illegal or legally questionable activities such as pirating, hacking, spamming and infecting.

- Site may not be hosted by a free service, be a personal home page, provide free URL redirection, or not own the domain it is under.

- Site may not be under construction.

- Site may not sponsor "incentivized clicks," or "pay-to-surf" programs, or use resident desktop objects such as bars and window frames.

- Site may not use timed banner rotation or other "auto-loading" methods.

- Site may not consist mostly of forums (chat, message boards, etc.).

- Site may not have an excessive amount of advertising.

- Site may not distribute or promote spyware.

- Site may not contain non-English Web pages.

- Site may not lack a privacy policy.

WHEN ADS ATTACK

During the fall of 2011, a company that seemed to be located in Beijing started delivering a malicious, pop-over ad to Web sites, offering readers a chance to win a free iPad — and implying that the deal was an exclusive offer from that site — even including a deceptive trademark identifier (®) after the site's URL at the bottom left-hand corner of the ad.

When the user tried to close the ad, another pop-up appeared, with one of those "do you really want to leave this site — Yes or No" messages that make you wonder what you're really answering "Yes or No" to if you click it. In the end, most users force-quit their browsers and wrote the webmasters of the site an angry e-mail (and rightly so).

Here's what to do if this happens to you.

BLOCKING AD CONTENT

If you're using an ad service such as PulsePoint, Tribal Fusion, etc., you should be making use of the ad-blocking features to nip potential problems before they occur.

This is a good place to decline pop-ups and pop-unders, for example, if you (like me) dislike the effect they have on the reader's site experience. This is also the place to stop advertising for certain things like cigarettes and alcohol (if you choose) or prevent religious or political ads before they appear on your site.

And you may want to look for this category in your options to block ads: lead generation. Lead-generation ads basically gather the personal information of the users who click the ads. That information is then collected and sold to other advertisers.

ACTIVATE YOUR COMMUNITY

This is no time to hide and hope the problem goes away quietly. Your readers are the best line of defense you have when your site is being attacked by malicious ads. If this happens to you, you need to alert your readers to the danger immediately, educate them and activate them. Here are the main talking points you should cover:

- Tell your readers that a malicious ad has been reported on your site. It is not being delivered by your site, rather it is being delivered by one of the companies that you partner with to deliver paid advertising. That company has been alerted.

- After providing an accurate description of the ad, advise your readers to do a force-quit of their browsers if they are faced with the ad. They should not click the ad or engage it in any way.

- Encourage your readers to take a screenshot of the ad if they see it, and collect as much data on the event as possible, including recent browser history, time, browser type, page URL, etc. Ask them to send you this information as you work with the ad company to track and disarm the ad.

- Apologize for the inconvenience this may cause, and promise to keep you readers updated. Explain that this is an unfortunate part of the business of webcomics. You can only afford to bring your readers free entertainment on the Web if you're supplementing your revenue with money made by serving advertisements. This sort of thing happens rarely, but when it does happen, combating it is your top priority.

FIREBUG AND FIDDLER

I installed Firebug on my Firefox browser and suggested that my readers do likewise, if they'd like to help. I also advocated using Fiddler (found at Fiddler2.com), which can be used on practically any browser.

Now, when I see an ad that I consider inappropriate — like the one that launched a pop-up that followed my cursor around the site one day — I can simply launch Firebug from a convenient button on the upper right-hand corner of my browser (it looks like a little winged insect) and get the information I need to halt the ad and flag it for my ad service.

Launching Firebug adds a window under your browser. In that window, there's a tool in the upper left that looks like an arrow inside a rectangle. Click on that icon.

Click on any element on your Web page to inspect it. Code pertinent to the ad you select will be highlighted in the window at the bottom of your browser. Simply copy and paste that code into an e-mail to your ad network(s) along with any other information you can provide. They will be able to use it to shut down the offender before they can pester more of your readers.

NEXT TIME...

This will not be the last time a malicious ad will attack webcomic readers. And although I've learned a little bit about handling the situation, I'm still not sure I have a completely efficient policy toward addressing the situation when it happens again. As it stands, here is my protocol for addressing malicious ads in the future:

- Make a best guess as to the source of the malicious ad.

- Divert as much traffic away from the assumed source as possible.

- Engage in reader outreach immediately.

- Be the squeaky wheel. Start firing off e-mails to your ad services (containing as much useful information as possible) on a daily rate, if necessary. Be polite, but be firm. This is a problem they need to address, and you're going to be a constant part of their lives until that has been accomplished.

- Vigilance. Maintain reader outreach after the threat has passed. Your readers should understand your policy on which ads are acceptable on your site and which ones are not. The more they understand, the better prepared they'll be to alert you when the next malicious advertiser comes around the corner.

AD CHAINS

As I mentioned earlier, you can set up an ad chain to increase the earning potential of your Web site. No ad company is going to fill 100% of the pageviews that your site generates. So if an impression is being generated that the ad server doesn't want to place a paid ad on, it has two options — place a free public-service announcement or kick that ad space to a default defined by the publisher (that's you).

You might use that default to present a house ad, as we discussed earlier. Or you might choose to set up an ad chain. Setting up an ad chain is very simple. Instead of defaulting to a house ad for an unpaid impression, you direct the ad server to default to another ad server that you're registered with. And, of course, you may set up that second ad server to default to a third ad company that you're registered with. And so on.

As a reader clicks on one of your pages, if one ad company passes on the impression, the second ad server has the opportunity to place a paid ad there, and if that one passes, there's a third. And so on.

At the bottom of your ad chain, you should set the default to a house ad. Ad companies aren't very pleased if you loop your bottom of your chain to the top.

If you use Project Wonderful as part of your ad chain, make sure those people bidding for ad space understand that their ad will appear in rotation with other ads. You can provide this information in the ad's description.

You can manage an ad chain from almost any ad network, but if you want a greater degree of control — and/or if you want to sell ads directly for your Web site — look into Google Doubleclick for Publishers (DFP). I'll share a top-down tutorial on Google DFP in a few pages.

COMPARING AD PERFORMANCE

You can compare the ad performance of one ad server to another by determining their eCPM. eCPM stands for "effective cost per thousand impressions." PulsePoint and Google AdSense both use it to track ad performance.

eCPM is calculated by dividing total earnings by total number of impressions and then multiplying by 1,000. It's used to compare how two different ad campaigns are doing, but I think it could have a distinct use for those of us who use Project Wonderful.

Project Wonderful ads are sold auction-style, with the money spent by the highest bidder earning his or her ad being placed in the Project Wonderful position on your site (or in your ad rotation) for

a 24-hour period (or until the bidder's funds run out). In other words, Project Wonderful ads are bought by the day. But how do you compare your Project Wonderful ads with traditional Web ads that are sold on a CPM (cost per thousand impressions) basis?

You can figure out the eCPM of your Project Wonderful ads and compare them with the eCPM of the other ads on your site. Why? Maybe your PW ads are outearning your other ads. Maybe you need to weight them more strongly in your ad chain. Conversely, maybe Project Wonderful is underperforming and you need to direct more pageviews toward the other ads servers.

Here's an example. Let's say you have PulsePoint ads, Project Wonderful ads and Tribal Fusion ads running in a rotation in the leaderboard position on your site.

Comparing all three over the same 24-hour period, the leaderboard generates ...

> **PulsePoint:** $7.64 (net) through 9,778 impressions
>
> **Project Wonderful:** $4.95 over 12,180 impressions
>
> **Tribal:** $1.17 through 4,623 impressions

Doing the math ...

> **PulsePoint:** 7.64 ÷ 9778 x 1000 = 0.7813 eCPM
>
> **Project Wonderful:** 4.95 ÷ 12180 x 1000 = 0.4064 eCPM
>
> **Tribal:** 1.17 ÷ 4623 x 1000 = 0.2531 eCPM

By comparing the eCPM of each site, you can compare the performance of each ad server even though they are operating at different pageviews — and even though one of them doesn't operate on a CPM basis.

DESIGNING WITH ADS IN MIND

In designing a Web site for your comic, Rule No. 1 is that your comic is the most important thing on your page. That's unchangeable and irrefutable.

However, if you want to generate income through advertising, you can't afford to hide the ads or bury them. You have to give careful consideration to where they're going to go and how they're going to interact with your site's content.

The leaderboard ad goes at the very top of the site. This is a good rule of thumb to follow for a number of reasons. Placing it at the very top of your site allows your ad server to charge top dollar for the placement. And that doesn't run afoul of Rule No. 1.

First of all, even it it's only a comic strip, the amount of space that your comic takes up on the page is still perceptively larger than a banner ad,

FIX YOUR BROKEN LINKS

If you want to improve your ad revenue, fix your broken links.

Broken links bring your Google PageRank down, and advertisers prefer sites with high PageRank scores.

For more information on PageRank itself, see Chapter 6.

To get a list of links that are broken on your site, first type a few random letters after your URL in a Web browser. You'll get an error page. Note the title of the page. (On *Evil Inc*, it's "Page Not Found.")

Sign in to Google Analytics, click on **Content -> Site Content -> All Pages**.

For Primary Dimension, select Page Title.

Enter the page title that you noted earlier (in this example, "Page Not Found") into the search box and click Enter.

In the results, you'll see an entry such as "404 Error - Page Not Found." Click on it.

Yikes.

You now have a list of broken links for your site — prioritized by the number of times that users have unsuccessfully tried to access those pages.

and therefore it's going to command more attention (as long as it's near the top of the page).

Since the comic is the most important thing on the site, I wouldn't recommend placing anything to the side of your comic unless your comic is a strong vertical shape, in which case you're going to have the flexibility of running an ad to one side of the comic without risking interference.

Under the comic, you typically have the flexibility of running any number of types of ads, depending on your site's layout. Skyscraper ads work very well here, as do squares and smaller banner ads.

THE IMPORTANCE OF BLOGGING

Ad networks use scripts (called "spiders") to search their members' sites to identify content that will work well with the ads their clients want to place. They're looking for keywords, yes, but they're also looking for original content. They want stuff that hasn't been copied and pasted from elsewhere. And that's the major drawback to webcomics from a Web-advertising perspective — even if you generate daily, original content, it's invisible to ad networks because it can't be spidered.

One potential solution is to place the transcript of the comic somewhere on the site. As long as it doesn't interfere with the blog's ability to help shape your community, this is a very good solution.

I've heard of some cartoonists who try to get around this by hiding the transcript on their page. They'll put it at the bottom of the page or they'll run it in black on top of a black background somewhere on the page. I'm not sure either of these is a good option, and they *might* get flagged as "black hat" tactics by some ad servers.

But the best solution is to use that blog for its intended purpose — building community by talking with your readers. I've

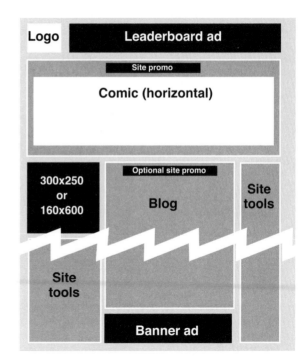

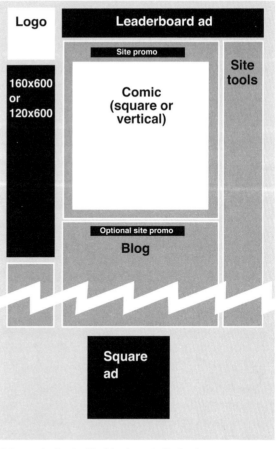

Ads are indicated in black and site features are gray. A good ad layout keeps ads near central points of interest like the comic and the blog.

become a huge believer in frequent blogging under the comic. I was always a proponent from the standpoint of community building, but having seen the effect that frequent blogging has done for my ad revenue, I'm even more strongly in favor of using that blog to its fullest extent.

It's a win-win for you. You're building community and increasing your value to your ad network — both of which puts more money in your pocket.

AFFILIATE MARKETING

Affiliate marketing is a method of Web-based advertising in which the publisher (you) gets paid on the basis of how many times you send a reader to the advertiser's site (clicks).

This advertisement may take the form of an image ad or a simple hyperlink, but the common denominator is that you don't get paid on a CPM basis (cost per thousand views), but rather on a CPC basis (cost per click).

Personally, my opinion of affiliate marketing is very low. First off, to make any real money at affiliate marketing, you have to put in an incredible amount of time trying to get people to leave your site. I'd rather put that energy into keeping people on-site for as long as possible. Of course, all Web advertising has the aim of encouraging readers to click the banner and leave at some point, but in affiliate marketing, it's the only way you get paid. That means you have to be aggressive about it. And that means you're spending way too much time shooing your readers away.

Secondly, if the affiliate advertising includes banner ads or other images, you're not being compensated for the mindshare that you're offering the advertiser. In other words, even if a reader doesn't click on an ad for a new product — say, Raspberry Cola — she's now aware of it, and might look for it next time she's in a store. Your banner ad may have participated in that mindshare, but in an affiliate-marketing framework, you didn't get compensated for it.

Lastly, of course, there's the other form of affiliate marketing, the in-line text ad. In this kind of advertising, a code converts several words or phrases on your Web site into links that point to advertisers' sites. As I mentioned earlier in this chapter, I highly recommend against this type of advertising, as it can erode your ability to direct readers anywhere on your site. And that's playing with fire.

MAXIMIZING YOUR ARCHIVE

One of the benefits of having a large archive is that you exponentially increase your potential pageviews as new readers catch up on previous comics. But beyond that, how can you get more out of that stockpile of comics?

RANDOM BUTTON

Many comics content-management systems feature a button that sends the reader to a random comic in your archive. You can do it in other Web-publishing applications, too. It's the sort of thing that a reader, bored and scanning the Web from work, will gravitate to. Keep it handy, within plain view of the daily comic.

THIS DATE IN HISTORY

Another unique approach to this is to point out what was happening on this date in the history of your comic. In other words, On Jan. 1, 2014, you might take a moment in your blog to point out your New Year's comics from 2013 and 2012.

FAVORITE STORY LINES

Another great blog post is to share the starting-off comics from some of your favorite story lines — complete with a link to take readers where they need to go to read from the beginning. You can come up with all sorts of excuses for doing this:

Topical: It can be a story line in your archive that covers a subject that's making news.

Thematic: It can point out a pivotal time in your comic's history that's particularly relevant to the current story line.

Fun: You can just do it for the heck of it.

Keep sending your readers back to your archives. It's a tremendous pageview-booster, and it's great for reinforcing the bond your longtime readers feel for your work.

DIRECTING TRAFFIC ON-SITE

I have a small, unobtrusive line of text directly above the comic. It features a small art element that says: Today in the Blog. And following that lead-in, I have a simple line of hyperlinked text with headline-style teases to the top three topics in the blog. Each of the teases is hyperlinked with an anchor link — — that points to an anchor that I've coded into the header above the blog itself — .

Now, whenever I update my blog, I take a moment to change the teases above the comic. When readers click on the link, it scoots them right down to the blog.

I've seen a lot of success in this strategy. In a recent survey, I asked my readers how often they read the *Evil Inc* blog. The majority of respondents said "Two-to-three times a week." After that was "daily" and then "once a week." Some people responded "Seldom." And one person responded "Never."

Incidentally, the only place I announced the readership survey was in the blog.

But the central message was clear. The site does a decent job of directing traffic down the page. And, in part, I think I have those anchor tags to thank for that.

GENERATING PAGEVIEWS WITH YOUR BLOG

You spend an awful lot of time trying to get a reader to come to your site, and yet, if you're like a lot of site owners, you're pretty nonchalant about sending them away. If you're running ads, it's in your best interest to generate as many pageviews as possible. Here's a strategy to do that.

The Web-reading public is a very visual group. They're not going to be wowed by scroll after scroll of gray type. You're going to need some images to go along with that profitable prose. And there's

Q&A

Q: I have spaces for three ads on my site (a leaderboard and two skyscraper ads). All of the ad slots are being taken by companies that "own" that ad slot for that month (they have the option to submit up to five ads of their own to rotate throughout the month). Currently, in total, I am making $250 per ad slot for a total of $750 per month. Am I charging enough for these ads?

A: I think you're making a big mistake.

You don't sell ownership of slots. Each view of the ad has a monetary value. That's why ads are sold on a CPM basis. CPM is "cost per thousand."

If you sell your advertising without taking CPM into account, you're bound to give away ads for free. And that's going to have an effect on your bottom line.

So, let's say you offer a CPM of $1, and your advertiser gives you $1. You promise that advertiser 1,000 pageviews. (*Of course, if the advertiser ponies up $1,000, you have to make sure you can deliver 100,000 page views during that time frame. It cuts both ways.*)

So let's make a hypothetical argument. Let's say you sell an advertiser an ad space for $250/month, and your site delivers 470,000 pageviews during that month. That's a CPM of about 50 cents. And that's not very good. In fact, you can probably do better than that with any number of ad networks.

Now let's say you offer that same advertiser a $1-CPM deal and it pays $250. The advertiser gets 250,000 ad views for the month. That leaves 220,000 ad views for you to fill with paid ads from an ad network.

Let's say you're getting 50 cents CPM through AdSense. (And I think that's low, but let's keep it low for the sake of the hypothetical.) That's an extra $110 for a total of $360. You just increased your ad revenue by 44%! Now, instead of making $750/month for a site with three ad slots, you could be making about $1,080. Or more.

What happens if you get a spike in traffic? Let's say you generate about 200,000 additional pageviews that you would have given away for free! Now instead of earning an extra $110 from AdSense, you'd make almost $200 more. You get rewarded for your hard work with a check for, say, $1,300.

If you would have sold those spaces for sponsorships, you'd have left about $600 sitting on the table — almost as much as you took!

Ask yourself ... what happens if I sell those same 250,000 ad views at a $2 CPM? What if you're getting $1 CPM from one of your ad networks? How much money are you leaving on the table now?

In short, you need to switch from a "slot-ownership" ad-sales model to a CPM as soon as possible.

Clicking on the thumbnail image of the poster in the blog announcement transports users to a larger view (right), which also displays ads — and a handy "Back" button above and below the image.

where the opportunity lies. Never send a reader away to look at an image. Ask yourself: How often do you link to an image on another site? Now ask this: How do you know the reader's coming back?

Whenever possible, I copy the images for my blogs to my own server. First off, I think it's good manners. In other words, I don't want to steal someone else's bandwidth by presenting an image on my site that's hosted elsewhere. But furthermore, it allows me to place that image on a separate page — one with my ads on it.

Let me pause for a moment here. There were a couple of key words in that last paragraph that I want to go over: "Whenever possible." This is not a good strategy to apply in all cases. For example, if I'm linking to a webcomic, it's a little more polite to present a single panel and send the traffic to the webcartoonist's site to read the entire comic. After all, the point of something like that is to send the traffic away. In other cases, I might not have the right to host the image on my site and profit from the views. Use your own discretion.

USING YOUR THUMBS

Taking this concept to the next level, I decided to try to get some extra pageviews by using thumbnails for many of the images I use in my blog. On my site, I blog about comic books several times a week. Often, when I present a cover, I'll show a clickable thumbnail in the blog — which directs to a full-size image on another ad-bearing page.

Did you get a nice piece of fan art this week? Don't show it in the blog. Talk about it and run a thumbnail. When readers click the thumbnail to enjoy the image, they're (1) interacting with the site and (2) increasing your pageviews. Both are good things.

I usually include a note (in italics) to click on the thumbnail for the full view. It takes a little more effort. For example, you'll have three files for every image you're going to use this strategy on — a thumbnail, an image and an HTML doc to hold the image. To make things easier, I use variations on the same file name. For example:

hulk101.jpg

hulk101_thumb.jpg

hulk101.html

Don't forget to leave a clear trail back to the blog so people can continue reading after they've seen the image. This handy code places a back button above and below the image (in this case, SAMPLE.jpg).

```
<table width="600" height="360" border="0" cellpadding="0" cellspacing="6">
<tr>    <td width="600"><FORM><INPUT TYPE="button" VALUE="Back"
onClick="history.go(-1);return true;"> </FORM><br /> <img src="/images/
blogart/SAMPLE.jpg" ><br />                 < F O R M > < I N P U T
TYPE="button" VALUE="Back" onClick="history.go(-1);return true;"> </
FORM></td>   </tr> </table>
```

I plug the above code, with the proper slug for my JPG, onto a template page with my ad codes in place, and I have my HTML document. Now, when I'm ready to blog about it, I link the thumbnail to the HTML document, and I'm all set.

GOOGLE DFP

For most beginner webcartoonists, running a set of Project Wonderful ads — or setting up a simple ad chain using the defaults of an ad network like PulsePoint (discussed in the beginning of the chapter) is enough for their site. However, you may find yourself wanting a little better control over the ads on your site. You may be selling ads directly for your site, or you might simply want to maximize the revenue you're getting from several different networks. Google Doubleclick For Publishers DFP (google.com/dfp) is an ad-management tool that's set up to deliver and distribute ads from different sources — including ads you sell yourself, ads from ad networks and house ads that promote your own merchandise to your readers.

FIRST THINGS FIRST ... SET UP YOUR INVENTORY

Google DFP has three main sections: Orders, Inventory and Reports.

Orders are like folders full of ads — from ad networks, from direct sales and your house ads.

Inventory contains your ad units. Consider an ad unit the "window" through which your ad is seen on your site. One ad unit might display a Google AdSense ad one moment and a PulsePoint ad the next.

Reports assembles the statistics on your ad performance.

You'll want to set up your inventory first.

Click on New Ad Unit. Unless you're setting up ads for a mobile site, you'll choose Web from the resulting drop-down.

- Give your ad unit a name. It would be helpful to establish and maintain a standard nomenclature.

- Description is optional.

- Size: Select the size of the "window" for this ad unit — leaderboard, skyscraper, etc.

- Placement: You'd use this if you're establishing ad units that a potential advertiser could target all at once. For most of us, we'd leave that blank.

- AdSense inventory setting is set to default to "Enabled," and it is wise to keep it that way.

- AdSense inventory setting = Enabled

Setting the AdSense inventory to Enabled allows your Google AdSense ads to compete with any ads you set up through DFP. *If you leave this enabled, you do not have to set up an AdSense order in the next step!*

Once you have set up an ad unit for each of the types of ads you plan to run on your site, you can click over to the Orders section.

ORDERS

Think of orders as folders full of ads from a particular advertiser.

Line items are individual ad types.

So, I will establish an order for all of my PulsePoint ads, and inside the order will be three line items, one for my PulsePoint leaderboard, one for my PulsePoint skyscraper and one for my PulsePoint Square ad.

Click on + New Order.

- Give your order a name ("Pulse-Point," for example).

- Enter a name for the advertiser. Chances are, it will appear as part of the dropdown. If not, you can click Add new company and add it.

- Trafficker. That's you.

NEW LINE ITEM

You now have to create a line item because it's impossible to have an order without at least one line item. If you have more than one, you can ad the others later.

- Give it a name. Again, establishing a standard naming convention will be advantageous.

- Target platform: Web.

- Inventory size: Enter the size of the ad type. For example, you'd type 728x90 for a leaderboard.

- Comments: Optional.

Settings

There are several types of settings:

Sponsorship

Standard

Network

Bulk

Price Priority

House

Most beginners will be using those last two: Price Priority and House.

Price Priority: For ad networks such as PulsePoint, Tribal Fusion, Advertising.com, etc.

House: Your own promotion — "house ads."

Assuming we're setting up an ad-network ("Price Priority") ad, you'd set the following properties:

- Start time: Immediately.

- End time: Unlimited.

- Limit: None.

- Rate: *Set this to $0.40, but we're coming back to it because it's important.*

- Do not set a Value CPM (unless it's a house ad).

Adjust delivery: The only one of these options we're going to set is Frequency. Click on Set Per User Frequency Cap and enter: 4.

Add targeting: Click Ad Units. You will see the ad units you set up under Inventory. Click on the one that matches the ad size you're setting up in this line item. and then click Include.

You can see Geography over on the right-hand side of this section. You can use this to select the geographic areas in which these ads will appear. For example, if one of your ad networks insists on U.S.-only pageviews, you can set that constraint here. You can set those restrictions right down to the ZIP code if you want to — for example, if you sold an ad to the neighborhood butcher, to whom pageviews outside of that area are kinda useless.

Click on Save and ... upload creatives.

UPLOADING CREATIVES

Wait a minute ... what the heck are creatives? Relax. This is simply where you're going to upload the specific ad.

If you're working on a line item for an ad-network ad, click on Third Party. You'll see a place to post ad code. Go to your ad network, copy the pertinent ad code, and come back to DFP and paste it here.

If you're setting up a house ad, you can drag-and-drop the image file into that gray box at the top. This will take you to a place where you can assign rollover text and a click-through URL for the ad.

You've set up an order with one line item!

Now, go back to that order and set up a line item for each of the other ad sizes you're using.

At right is my order for Advertising.com.

If you remember nothing, remember this:

You will not set up an order (nor line items) for Google AdSense. As long as you have an AdSense account, your AdSense ads will compete through all of the ad units that have AdSense inventory settings set to "enabled."

Once I addressed this error, my revenue doubled.

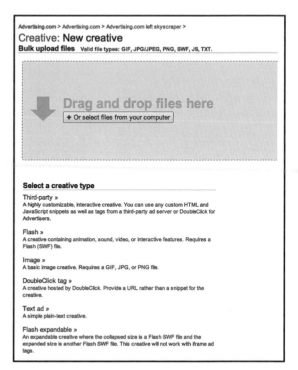

HOUSE ADS

If you're going to set up house ads (and you should ... this is part of DFP's strength), you'll need to keep a few things in mind.

When you set up the order, click on Add a New Company to create an advertiser name for yourself, but be sure to use that drop-down to identify yourself as someone serving House ads. It defaults to Advertiser. Google DFP will use this setting to properly assign your ads so they're not competing with paying ads.

Along those lines, that's where you're going to use that set value CPM setting when you're setting up a line item for your house ad.

The Value CPM establishes the price at which Google AdSense competes with your house ads (since the actual value of your house ads is $0). If you set it to $0.05, then AdSense will replace the house ad with any ad offering more than $0.05 CPM for that pageview.

NOW ... LET'S GO BACK TO 'RATE'

Remember when we put $0.40 CPM in for the rate of the line item we created? The rate is the CPM price at which Google AdSense competes with the ad defined in your line item. (Except for house ads, which use Value CPM to define this competition.)

To calculate the number that should go into this space, you'll have to log into your ad network and find two statistics for each ad unit: Fill rate and CPM.

Multiply the CPM your ad is earning by the fill rate. For example, if I'm getting a CPM of $1.50 for a skyscraper ad through PulsePoint, but my fill rate is 25% ...

1.5 x .25 = .375

Therefore, I'd set my rate at $0.38

Now ... you can update these rates as often as you'd like. You can adjust these rates daily, weekly, monthly, annually ... or never, for that matter. But, obviously, the closer this rate matches what's happing for each of your ad networks, the better your ads are going to perform.

For example, if you're getting $.40 CPM for a leaderboard through PulsePoint and your rate is set to $0.50, then Google can't replace the PulsePoint ad with a better-paying AdSense ad — at least not until Tribal Fusion reaches $0.50. And if that never happens, you're going to be stuck getting a $0.40 CPM.

Promotion

When I started my first webcomic, *Greystone Inn*, it used a remedial Web-traffic counter that tracked visitors from only the day before.

I remember getting up every morning to check my stats, watching them climb slowly into the double-digits (my wife and my mother-in-law dutifully went to the site every day). Then I started to regularly surpass 30 daily visitors; and then 40; and then 50.

I could barely sleep the night I crossed 90. I mean, crossing into *triple-digits* would be the first major milestone of what I was sure would be long-term success, I told myself. One morning, I woke up early to check the previous day's visitors.

99.

When I shouted in frustration, my wife asked me what the problem was.

"I was just *one* visitor away from 100 yesterday. I guess I shouldn't be upset, though," I told her, "If it wasn't for you, the number would have been only 98."

"Um … yeah …" she said.

BUYING WEB ADVERTISING

I would be remiss if I didn't mention the all-time best form of promotion in all of webcomics:

Do a great comic.

If you do an amazing comic, your readers will spread the word on your behalf — and there's absolutely no advertising as powerful as a recommendation from a friend.

So if you're not doing the best comic you can possibly do, my heartfelt advice to you is to shelve paid advertising and put that time into improving your core product. And that's advice that you're probably not going to want to hear, is it? So before you storm ahead through the rest of the section, I want to put a thought into your head:

You have only one chance to make a first impression. If you sink a bunch of time, energy and money into advertising and promoting a not-ready comic, you risk bringing over readers who will look at the comic and leave with an overall negative feeling about the work. Later on, when your comic has developed and your skills as a cartoonist have improved, you're going to have to overcome that negative connotation to get those readers to come back and give your comic a second chance.

I'm not saying you shouldn't advertise your work.

I'm saying it's to your own benefit if you take a long, hard look at your comic and ask if it's ready to be advertised yet. You might be better off saving your money and directing your energy in a more productive direction.

BUILDING AN AD THAT WORKS

This is what I've experienced in Web advertising. People tend to jump over ads on the way to the content. If people do look at them, they don't look long. And people don't click ads freely — they have to be enticed.

- Your ad has to stand out visually.
- It has to deliver a clear message.
- It has to be compelling enough to get the reader to want to click on it.

VISUAL EFFECTIVENESS

Part of designing a good ad is knowing your place. Readers didn't come to the site looking for your ad. They came to the site to see that site's content. Your job in designing an ad is to steal their attention. And your best bet in doing that is a strong visual.

What makes a strong visual? Does that mean "big"? Not necessarily. Sometimes you can make a bigger impact with a smaller image — allowing the empty space around the image to draw readers in.

If you try to cram too much type into that little space, the result is a jumble of words and too little room for the visual. The text should be edited to the bare essentials needed to convey your message. Everything that doesn't do that should be edited out.

Choose your colors wisely. Remember, you are renting a limited space on the Web site your ad appears on. You need colors that will attract attention without being jarring. Limiting your palette to a few hues that work together well is going to be a huge benefit to you in this regard. When in doubt, stick with black, white and red — it's a can't-miss design secret that has been passed down from designer to designer for centuries.

MESSAGE

Your message is usually going to be "try my comic" (unless you're using the ad to do something like announce new merchandise). To achieve this goal, it's a good idea to identify some of the "selling points" in your comic. A selling point is something about your comic that you hope will entice a potential reader to try out your comic — something that makes your comic unique. It's the reason you give to convince the reader that you're going to be a good choice for how he or she spends the next 30 seconds. Your comic probably has more than

one selling point, but your ad is going to choose one and focus on it. If you have another selling point that you think is strong, you should devote a separate ad to it.

A selling point might be your genre — for example, maybe you create a sexy sci-fi comic. Or it might be your niche — your comic is about a boy and his dog, so pet-lovers are going to be drawn to it. Or your selling point might be the strength of your writing — the gag in the ad is so very funny that people have to click on it.

The selling point of your comic might change as your ad placement changes. For example, a comic that plays off the Dungeons & Dragons role-playing game might have a very different selling point for an ad that's going to be displayed on the Wizards of the Coast Web site than the one that gets played on another webcomic site such as PvPonline.com. The selling point has to be targeted to the intended audience.

FORMING A COMPELLING AD

Making an ad compelling is using the message and the visual to create the sense of urgency that's going to snap the reader out of his or her planned browsing activities and click on your ad for something different. It's a real challenge, and many webcartoonists throw their advertising money out the window neglecting its importance. Here are a few rules of thumb to remember.

Your update schedule is *not* a selling point — with the possible exception of a daily update schedule. No one cares about your update schedule. No one goes out looking for "a good three-day-a-week comic." No one looks at an enticing ad and thinks, "If only I could be assured this doesn't update more than once a week ..." Update schedules are important to cartoonists, not readers. You can worry about communicating the update schedule once the reader arrives ... which is only going to happen if the ad is compelling. And update schedules are not compelling.

AD PERFORMANCE

You can use Google Analytics to track the performance of your ad campaign. For information on installing Analytics, flip over to the chapter on your Web site. First, go into Analytics and do the following:

- Click on Goals in the left-hand column.
- Click on Set up Goals and Funnels.
- Under Goals, click on + Add Goal.
- Give your goal a name.

- Next to Goal Type, click URL Destination.

- Choose Exact Match.

- Enter the URL of your landing page.

Whenever a visitor from your ad gets to this landing page, it registers as an "achieved goal" with Analytics. If you need more information on setting up Goals, you can check out Google's guide. This is nice, but it's not spectacular. So let's go a little further.

TAGGING AN AD

To track your ad's performance, you're going to tag the URL you submit for your ad to point to. You're going to add the following:

- **Source:** Where the ad appeared.

- **Medium:** What kind of ad it was (banner, skyscraper, etc.).

- **Name:** Which campaign was this? You may as well start naming them, because you'll be doing a few until you find some that work consistently.

Now we'll go to a handy tool called the Google URL builder. Enter the URL for your landing page and then fill in the blanks for the three fields (if you'd like, you can enter terms for the other ones like Term and Content, but that's up to you. Click Generate URL, and the tool creates the new URL that you will use for your advertisement.

Now, I would suggest the following. For this to really rock, you're going to have to be somewhat specific. For example, I wouldn't suggest a source of "Project Wonderful." The source should be the Web site on which you're advertising through Project Wonderful.

If you're advertising on three different sites through Project Wonderful, you can set up three different tagged links using the URL builder. In other words, any time one of your variables change, you need to build a new tagged URL to reflect that change.

CHECKING YOUR RESULTS

So, assuming your advertisement used the tagged URL, Analytics will begin gathering data based on when that landing page is hit — and from which source/campaign/ad style. To view your results, go to Analytics and look along the left-hand column. Go to Traffic Sources, and click on Campaigns. You'll see your new goal under the fever chart, next to Site Usage.

You can also get tons of great metrics under the Goals section, such as conversions and conversation rate.

Now you can begin to compare how certain types of ads with certain types of content play on certain types of sites. And you can see which ones are working best — and *where* they work the best.

FROM 400 TO 80,000 PAGEVIEWS IN ONE DAY

This piece is courtesy of Jeffery Stevenson of the comic Brat-Halla *(brat-halla.com).*

I took our comic from 300-400 pageviews one day to more than 80,000 pageviews the next day through advertising. I didn't have the funds to maintain that level every day, but after a few weeks (advertising a couple of times a week), I pulled in enough new returning readers to keep us around 5,000 pageviews a day on average.

Now, even though that one day made a big jump for us, I didn't just go out there on a whim one day to see if I could do it … I planned for months. Here are some of the steps I took in preparing for that day:

MAKE SURE YOU HAVE A SIGNIFICANT ARCHIVE BEFORE SPENDING ANY MAJOR MONEY ON ADVERTISING

If a new reader likes what he sees, he'll go through the archives. The more archives you have, the more chances you'll have at hooking that reader into becoming a return visitor. Not every comic strip/page is gold, but if they're consistently bronze medal-ish with occasional gold, the archives will have a good chance to convert new readers.

Along with this, you need to make sure the archives are easy to navigate. If readers can't get through the archives easily, it wastes a lot of advertising money and research time on your part. It doesn't pay to be wasteful when potential readers are on the line.

PLAN THE ADVERTISING FOR THE DAYS YOUR COMIC UPDATES

Readers like comics that update, for some reason. I haven't determined the root cause of this phenomenon, but they seem drawn to comics that keep on rolling with the updates. I think it's because they dread a bad breakup one day in the future after they've dedicated a portion of their life to reading your comic. Or they just want to make sure they can get their comic fix on a regular basis.

So if you drive them there and they see a recent update, you've overcome one aspect they'll judge your comic by. And if they see consistent updates in your archives, you'll make them feel more comfortable about following you. You'll be that comic dealer on the Internet street corner they can always rely on to get them through the rough patches.

Special thanks to Kickstarter supporter Olaf Moriarty Solstrand (nettserier.no).

RESEARCH POTENTIAL PLACES TO PLACE ADVERTISING

At the time, I wanted to do focused advertising, so I decided to use Project Wonderful. The first thing I did was break down audiences that would be amenable to my comic:

- It's a webcomic.
- It's based on Norse mythology.
- It's part comedy, part familial drama/dysfunction.
- It sometimes hits the adventure genre.

Determine potential targets. For audiences, I started with three major genres: mythology, humor and fantasy. My secondary consideration as a genre: webcomic. I dug through all the Web sites available for advertising in Project Wonderful at the time and listed sites that were in those genres with a preference toward webcomics.

Rate the targets by traffic. The next step was to find Web sites with decent readerships. Unfortunately, PW didn't let you search on unique users back then ... just pageviews. It gives the option now, so the steps I had to go through aren't as time-consuming (but it can be helpful to see the thought process behind them).

Because it was pageview-based searching then, a lot of people wasted a lot of money on sites with inflated pageviews. If a site on my list had a lot of whitespace between unique users and pageviews in that nice little chart at PW, I would mark it off the list.

Paying a lot to have my ad seen by 100 people 75,000 times in a single day doesn't make a lot of sense. If they don't click the first 50 or so times they see the ad, what'll make them click the other 700 times they see it?

Get the most readers for the least money. In the long run, it's best to skip over sites that don't have decent readerships (especially the ones with small readerships and high price tags). So after determining readership, I needed to look at the average cost of advertising on the site. I know Project Wonderful lists its costs at dollars per day (or cents per day in some cases), but that wasn't the scale I was looking at — I was evaluating by the hour.

Maximize your ad dollars by taking advantage of per-hour advertising. Why look at per-hour charges? To maximize how much I could diversify my funds. Twenty bucks per day is equivalent to eight hours on three Web sites (with similar pricing). With that, I could stagger those eight-hour periods to cover most of the daytime-reading timeframes in the U.S. — morning East Coast to early evening West Coast (with a one- or two-hour period in which the ads run on all three sites simultaneously).

This hourly evaluation also allowed me flexibility in other ways. That same $20-a-day for a Web site could get me four hours on a site that cost $120 a day. Would it be worth it to spend the money that way — blow it all on just four hours of exposure, or just ride it out with the smaller sites? Usually, yes.

The difference between a day at a $20-a-day site and four hours at a $120-a-day site back then could easily be thousands more potential readers in those four hours.

Determine the site's hourly readers. I also needed to break down the unique users into an hourly estimate. That way, I could estimate the number of readers I could reach in one hour for a certain amount of money.

Chart update days. It was important to know when the Web sites updated. If they updated daily, the unique visitors and costs would be more consistent. If they updated twice a week, they would have spikes on those days — in both price and readership.

For those latter sites, I needed to store two values — one for update days and one for non-update days — so I could compare the differences in cost (and determine whether to hold funds and advertise on an update day or a nonupdate day).

Once I had all that information, I could then order by the best bang for the buck and plot out my strategy for diversifying my saved-up advertising allowance.

DO'S AND DON'TS OF WEB ADVERTISING

DON'T use the words "webcomic" and "free." I would advise against using either word in my ad. The reader doesn't care about the format — she cares about content. So if the target reader loves pugs, they will click on an ad that features a little pug puppy, and then judge the site she's transported to on the basis on content — whether it's a comic, a blog, a photo journal, etc. Your selling point is content, not format.

DON'T waste space writing out your URL — unless you have a very memorable URL. You've got the hyperlink; that's plenty. I don't give a lot of stock to a potential reader memorizing a long, convoluted URL for future use. You have a finite number of pixels in your advertisement. I wouldn't waste any of that valuable real estate on a URL.

DON'T include your name — unless you have a significant degree of name recognition. Put yourself in the reader's shoes for a moment. "Read 'No Shoes for Tuesday!' by Vern Blanston!" Do you care? You're darned right you don't.

DO make sure your text is legible. It should be large enough to be read easily at a glance as the potential reader skims past it to see the stuff he actually came to the site to see. There are two ways of achieving this goal. If your text is too small, chances are you need to edit your message so you can make your point in fewer words. Fewer words equals bigger words. Secondly, once your message is refined and edited, make sure there is plenty of contrast between the text and the background. Legibility is all about contrast.

DO remember that sex sells. 'Nuff said.

DON'T use art in the ad that is noticeably better than the art that the reader will see if he clicks over to the site. You want a new visitor's initial reaction to be one of excitement — not of confusion or disappointment. In other words, that sexy drawing of the bikini model might get users to click in droves, but the stick figures on your site are going to drive them away just as quickly.

DON'T try to shoehorn one of your comic strips into an ad — unless it has few (or no) words. Most comic strips take too long to read in a Web-advertising situation. However, taking a well-crafted punchline or gag and playing it in a single-panel fashion in your ad is a fantastic idea. Single-panel gags make terrific ads.

DON'T write that it's a funny comic. *Be* funny in the ad.

DO craft a clever, witty tagline that describes your strip.

DO show your ad to a number of different people, and get their honest opinions before devoting money to the ad campaign. And listen to what they say — the good and the bad.

　　　　　THE WEBCOMICS HANDBOOK

RE-EVALUATE ONCE THE BIDS ARE IN PLACE

Even with the best plans, something can go wrong. Within an hour or two of my bids being active, I could generally tell if they were under- or overperforming. By keeping an eye on the performance, I could cut ads that were seriously underperforming and move those funds to the ads that were performing well. And I'd take note of the time of day those ads were running.

A quick scan of the site would tell me if there was something unusual going on. (I've run into sites on which the images weren't showing up for the comics and extremely slow-loading sites.) Instead of cutting a site loose forever because it didn't get numbers, I could put a note about the problem and try again when it got resolved to see how the site really performed.

I'd also complete this step on sites that were pulling in numbers way beyond my estimates. Maybe I got lucky and there was a big article about the site, which drove a lot of extra eyeballs that way while I happened to be advertising there. Sure, it's really nice when it happens, but if I'm going to advertise there on a regular basis, I need to know that's not the norm. (And I need to re-evaluate the site's performance once things settle down.)

GAUGING YOUR RESULTS

That's all I did. With all the preparation, it wound up costing me about 1.4 cents per reader and was well worth the cost. But I don't always see that kind of result.

I make a push like this every six months or so, and my last one saw a jump of only about 1,500 readers. If you're capturing part of a Web site's audience as returning readers, you'll inevitably see a decline on returns when advertising there again.

You always need to adapt and adjust. For example, some bigger advertisers have moved on from PW to other ad networks. Sure, tapping into their readership was nice, but it was inevitable they'd move on to better paychecks.

Things also change with sites over time. Some stop updating (or update very infrequently). If they're not updating, it's a waste of my time and money to advertise there (unless they recently stopped updating and then I can advertise on their update days more cheaply and hope to capture some of their frustrated audience looking for something to fill the void).

There could be many other reasons for a possible change — loss of domain name, for example. Getting too big for their britches (i.e.: bringing their server down or getting the ax from their hosting service) ... steady growth over time ... the universe loves and/or hates them ...

One thing remains constant: In a constantly changing landscape, you do need to keep up with the research to make informed decisions and keep your advertising as effective as possible.

INVESTING IN YOURSELF

This piece was contributed by Joseph Stillwell of TheHiveworks.com.

Marketing typically has one of two goals: brand recognition or conversion (like selling an item). Most webcomics will fall into brand marketing. Conversion marketing is best suited for selling a product, service or subscription.

Be realistic about your budget. Marketing can be cheap (such as handing out pamphlets at a college), or it can get very expensive (for example, the hundreds of millions of dollars it takes to run a U.S. presidential campaign). For a person marketing a webcomic, the typical budget falls between $1 and $3,000 — pretty small. Here are some things to keep in mind as you proceed:

1. What is your goal? If this is a brand campaign, your goal is to increase the awareness of your work and get potential readers interested in your comic. This will pay off when those new readers buy your merchandise and/or increase the number of ad views on your site.

2. How do I start? You need graphic ads. The current standards are leaderboard (728x90 pixels), medium rectangle (300x250 pixels) and wide skyscraper (160x600 pixels). This isn't just a sales pitch — it's brand awareness. A good ad will earn clicks — if not during the user's first exposure, then during subsequent encounters. If your ad is bad, people will avoid clicking it, no matter how often they see it. An ad will only go in one direction over time — so keep track of how it's doing. If it's doing well, stay the course. If it's failing, then re-evaluate your approach and try again. Most marketing offices spend almost as much money *testing* their advertising as they do on the advertising itself.

3. Know your readerbase. Who reads your comic? Do you have a core subject matter (like video games or gardening)? If you have Google Analytics installed (Chapter 6), you can also use geolocation to study trends in your user base. Polling readers on their interests is also a good way to identify what types of people tend to be interested in your work.

4. Where to market. Knowing where to market is key to building your user base. To do this, look for sites that feature those interests you know your readers share. You may also make informed guesses as to which sites might attract people who might also like your comic. Spend some time researching your Google Analytics data. For example, you may wish to track sites that send your Web site significant amounts of traffic.

5. What to spend. If you want a good target to start with, go to buysellads.com or shinyads.com. These have low minimum buys for 25¢-$1 CPM. You can test what works before investing in a larger purchase.

Most premium branding ads cost between $1 and $4 CPM. If that's too high for your budget, you may want to look into Google's DoubleClick for Advertisers (advertisers.doubleclick.net). If *both* of these options are too high for your budget, I would suggest Project Wonderful. It has a large amount of inexpensive inventory.

6. How do you know if it's working? When doing marketing, you should always have a cooldown period of a few weeks. During this time, study your traffic data. Are you retaining those new readers or are they draining away? You won't keep them all, but you should be able to keep some of them. If you're happy with the results, launch another campaign that has the same strengths. If not, it's time to rethink and retool. Launch a second campaign that corrects the mistakes you made in the previous one.

Q: It seems the comics that do well are the ones that don't necessarily have a story arc but continue indefinitely until the writer decides it's time to stop. Given this, I'm wondering about your opinions of the wisdom of deciding from the beginning that a comic will span, say, four years, and after that will absolutely and without question be finished — of course, giving way to a new project.

A: I don't know that I necessarily accept the premise that only nonstory comic strips can be successful on the Web. However, there is a much more fascinating question behind that, and that is, is it wiser to brand the comic or the cartoonist?

Because most of the webcomic branding that has been done in the past several years has been focused on the comic and not the cartoonist. Of course, some personalities have overshadowed their comics — Scott Kurtz is a great example of this — but even so, what's his Twitter handle? **@pvponline**. The act of promoting comic over cartoonist is a hard habit to break.

But I think as we head into the second decade of webcomics, we're going to see an awful lot more branding behind cartoonists and less behind the comics.

If you don't own a URL that's based on your name, I'd strongly consider getting one.

As that happens, we're going to see a lot less hand-wringing over ending a comic. It's going to be a more natural progression: "This was the comic Joe Smith did last year, and this is his new comic."

Part of this transition is due to the new blood that is flooding webcomics. Remember, Dave Kellett, Scott Kurtz and I all grew up wanting to be syndicated cartoonists. And part of being a syndicated cartoonist is creating one property that the syndicate can exploit (and I don't mean that in its negative connotation) for decades. The new guys didn't grow up with that.

People like Kris Straub, David Malki and Ryan Estrada are terrific examples of this. They're known by their core comics — but they're very well-known for their overall ability to deliver terrific Web-based entertainment. And they're not as torn over ending one project to move on to another.

I'm often tempted to start to move all of my energy behind guigar.com, making it a hub for following updates of both of my live sites, plus pointing into the archives of both of my static sites, along with promoting my other sites, podcasts, essays, etc. I haven't gotten my head completely around it, and until I do, I'm reticent to devote a lot of energy to it. But it's a definite possibility.

As we see this shift in attitude, I think the obsession over creating a comic that lasts for decades will gradually give way to the goal of having a career in Web entertainment (including comics, but not necessarily exclusively) that spans decades. And when that happens, the problems posed in the question above will seem like a very small matter, indeed.

Even the most savvy marketing campaign comes down to the quality of the product. If that's not satisfactory, there's no amount of promotion that will be able to generate a following for it. But don't get disenchanted by seemingly low numbers. If 100 million people are driven to your site by your marketing, then keeping 3% of them is awesome. But keeping a higher percentage of a smaller number of new readers is *also* good.

TOP-WEBCOMIC LISTS

They're all over the place. "Top 25 Webcomics!" "Top 105 Webcomics!" It's no secret. I hate all of the "Top XX webcomic" list sites that require you to put their buttons on your site and then beg readers to vote. This might generate a small amount of traffic for your site, but when you aggregate all of the participants, the big winner is whoever is running the "Top XX webcomic" list site itself. I think it identifies your comic as amateurish and, more importantly, I think it's distracting you (and your readers) from taking advantage of some seriously powerful social-networking entities (Twitter, Facebook, StumbleUpon, etc.) that are readily available and widely in use.

If I've got an engaged reader, and they're going to express their fandom, I want them using a Facebook Like button or a tweet — not a vote button on a list site. I think the results are way more powerful and bring in potential readers who are 10-times more likely to be responsive to your comic.

COMIC SCRAPERS

Comic-scraper sites (and apps) pop up at the rate of every other month or so. Typically, they use a webcomic's RSS feed to "scrape" the comic and use it for their own purposes — whether it's a collection of their favorite comics in one site or an app that allows a reader to easily surf all of their favorite comics in one easy place. In general, comic scrapers take only the comic, leaving behind the other elements of the webcomic site — like the blog ... and the site's advertising.

THE SCRAPER DILEMMA

Scrapers tend to present a heck of a dilemma for webcartoonists.

On one hand, they're having a negative effect on your ads. If they're taking your comic out of the RSS feed and displaying it on their own site/app, they're stealing ad views outright. Some of them even go so far as to place their own ads above your content — in a sense, helping themselves to the ad views that you're helping to generate.

On the other hand, they're presenting your comic to new readers who may not have discovered your work otherwise. And, some will argue, these new readers just might one day support the comic

by purchasing merchandise, etc. So those nickels you're losing in ad revenue might just come back dressed up like dollars.

SOMETHING FOR NOTHING

In discussing this issue with a member of Webcomics.com, I think I finally put my finger on an important aspect of webcartoonists' attitudes toward comic scrapers. Here's my response to someone who discovered his comic on a scraper site after he tracked an uptick in Web traffic to the site.

> • You found out about this site only after they sent you some traffic. You hadn't advertised to get the traffic surge. You hadn't gotten the extra traffic as a result of your readers spreading the word about your great work. You hadn't done a comic that had gone viral and garnered new looks from people on Facebook, Twitter, Reddit, StumbleUpon, etc.
>
> • You hadn't earned it. It was just given to you. You got something for nothing.
>
> • When was the last time you got something for nothing and realized later that it really *wasn't* for nothing ... there was actually a hidden cost that you hadn't been able to see originally?
>
> • I'm suggesting that maybe — *maybe* — these kinds of sites offer exactly that kind of deal.
>
> • So if you do participate, do so with your eyes wide open. Know your risks and know what you stand to lose if this doesn't exactly work out. If you can accept the risks, you're entitled to any rewards.

Speaking only for myself, I'm not willing to give up my ad revenue in exchange for new readers. I can find new readers. New readers are everywhere. And there are lots of ways to direct them to my site.

Ad revenue isn't so easy to come by. Ask anyone who fights to see his or her Project Wonderful slot to be filled by anything other than "YOUR AD COULD BE HERE!"

Comic scrapers take away something that is scarce (ad money) and offer to replace it with something that is plentiful (new readers).

But there's another piece to the equation ...

ACTIVE READERS VS. PASSIVE READERS

"Anything that exposes new readers to my comic is a good thing."

That's another one of those sentences that makes me cringe a little. Mostly because it misses an important point. There are two types of readers: active and passive.

Active readers are the ones you count on to support your comic. They tweet, they "like," they Stumble ... and they *buy*.

Passive readers are people who read the comic, enjoy it and do little

AND NOW ... A COMIC-SCRAPER ENDORSEMENT

It's unfair to call this guy a "scraper," but technically it's true.

However, Henry Kuo *gets* it. As the name of the site implies, **Just the First Frame** (at JustTheFirstFrame.com) "scrapes" only the first frame of participating comics. (The site is operated on an opt-in basis.)

The image is linked to the comic's site so interested readers can click over and read the entire comic on its native site.

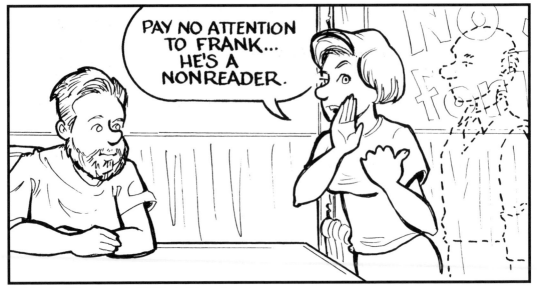

Special thanks to Kickstarter supporter C.M. Ridge (goblinboycomics.com).

else. They're the ones who come up to you at a convention and say, "I just want to say thanks for doing a great comic." And that's *just* what they do. They're not bad people — they're actually wonderful. And they're a crucial part of your business. Whereas active readers give you money overtly, passive readers generate income for you passively — through ad views.

Now, it's completely possible that *some* people might discover you through the scraper site and eventually buy a book or post about you on Twitter — they *could* become active readers. And some of your scraper-bound readers could possibly convert to reading your comic on your site — they could become passive readers. (But let's face it ... why *would* they?) Overwhelmingly, however, the people who read your comic on scraper sites will remain exactly what they are right now ...

Nonreaders are not actively supporting you, and they're not even passively supporting you. And if they're not exposed to your reader outreach (blog posts, etc.), we may as well call it what it is: nothing.

Actually, that's a little unfair. They aren't nothing to the person running the scraper site. In fact, if they're running ads on the scraper site, those readers are *very* important. To them. Which is why they're using *your* content to get them and keep them.

SOMETHING FOR SOMETHING

With that in mind, here's what you must understand when it comes to comic scrapers. You're not getting free traffic/exposure. You're not getting something for nothing. You're paying — maybe not much, but paying — for that site to accumulate readers that you have a slim chance of ever profiting from. If you understand the hidden cost, then you can make the choice that's best for you.

MERCY FOR SCRAPERS?

For me, I tend to disallow my comics to be used on comic-scraper sites. However, when I'm drafting my cease-and-desist e-mail, I always bend over backward to be as polite and nonaggressive as possible. Because, in my experience, *I've yet to find a malicious comic scraper.*

Every last one of them has been somewhat shocked that I wouldn't want to participate because every last one of them was convinced that they were doing something that would help both webcartoonists and readers. Every scraper I've ever e-mailed with had nothing but the best intentions. Even the ones running ads on their sites — they just never seem to connect the dots. So, if this is something that you decide doesn't work to your best interests, be firm but be *polite*. Scrapers need love, too.

DAILY PAGEVIEWS

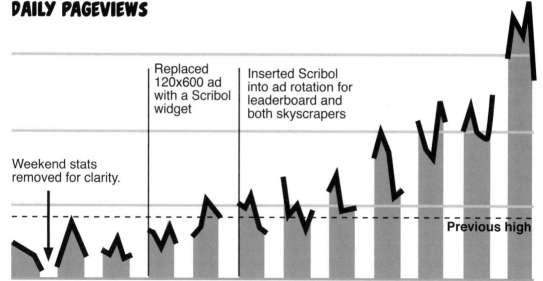

Replaced 120x600 ad with a Scribol widget

Inserted Scribol into ad rotation for leaderboard and both skyscrapers

Weekend stats removed for clarity.

Previous high

This chart is not baseline-zero.

This was my experiment with Scribol. Having seen such dramatic results, I've removed the Scribol widgets from my ad rotation and simply installed a permanent widget beneath the comic on my site's index page.

SCRIBOL

Scribol.com is an update on the old concept of a link exchange. You run a widget that delivers simple ads for other comics, and in return, ads for your comic run on other sites. I started out by testing it in my 120x600 skyscraper spot, to the left of my blog. Not prominent, but enough to gauge any traffic bumps.

I saw an improvement, but I knew that I wouldn't see a serious spike unless I was able to get the widget higher on the site. Unfortunately, I'm somewhat remiss in giving up real estate "above the fold."

So I decided to see what would happen if I included Scribol into my ad rotation. It was easy for me to do 120x600 and 160x600 widgets, and it custom-built a leaderboard-size widget for me.

Three weeks in, I started to see significant results. A few notes about the chart above. I've removed weekend stats. There's such a drop-off on the weekends that it tends to make it hard to see the actual peaks and valleys. Also it's not "baseline-zero" — which means that you're seeing a somewhat exaggerated view of the results. You're not seeing how tall the mountains are from the ground up — you're just seeing the peaks of the mountains. If the charts were adjusted to a baseline-zero view, you'd still see a spike, but it appear more modest.

PROS

• Increased pageviews.

• Although you can submit comics to be presented in the Scribol ads, Scribol editors seem to be keeping track of my updates and have prepared many ads on my behalf based on my daily updates. None of them are phrased or visually presented exactly the way I would do them, but they've all been delivering traffic.

• You can opt to run Scribol at the bottom of an ad chain, at a relatively low percentage. In other words, the top ad network has first shot at as much of the traffic as it wants. After that, it's the second network down, and so on. At the

bottom is Scribol. In a way, this is traffic that would most likely be house ads otherwise.

- It's been a real delight to work with.

CONS

- While pageviews have increased, unique visitors have not had much of a noticeable bump. In other words, I may be getting new eyeballs, but I'm not so sure they're staying in large numbers. This extra traffic may be largely transient. I'm continuing to track this.

- The ads can sometimes be *ugly*.

- You can't prescreen advertising.

TO BE FAIR ...

- I've found myself clicking on a few of the ads myself. Even the ugly ones.

- Although I can screen the ads that show up on my site through ad networks by theme and domain, I'm certainly not personally approving each ad my site delivers.

JOINING A COLLECTIVE

The main benefits of joining a webcomics collective are:

- Cross-promotion
- Pooling resources
- Collaboration

Cross-promotion is probably the most popular reason for joining or forming a collective. A certain amount of reader-sharing can easily take place under a collective's umbrella. And it forms a comfortable format for touting a stable-mate's work. Most collectives have systems for interlinking among member sites — reminiscent of the Web rings of the late '90s. Collectives may also use their combined traffic to lure better advertising money. And, further, they might use portions of that revenue to fund things for the collective — such as comic-convention appearances. And finally, collectives facilitate the collaborations among the members — guest comics, special events, anthologies, etc. Of course, collectives also have their drawbacks:

© 2013, Patrick Rodriguez @patthewanderer

Shown left to right: Scott Kurtz, Kris Straub, Brad Guigar and Dave Kellett. Together we formed Halfpixel. Although it wasn't a collective in the strict sense of the word, it was the best creative partnership I ever participated in. We did a lot of amazing things together — not the least of which were the *How To Make Webcomics* book and the *Webcomics Weekly* podcast.

- Audience disparity
- Money distribution
- Group dynamics

If one of the benefits of a collective is cross-promotion, what do the highest traffic-earners in the group get out of the deal? Is it enough to argue that the smaller fish still bring some new eyes? Or should there be a balancing factor to reward the members with the largest readerships? Sharing revenue is nice, but whenever money gets involved, the arguments get more serious. Throwing money into a "con pool" is a great idea. But to which convention should the money be applied? And what happens to the members whose money was contributed to a convention that they can't/won't attend? Finally, any time you gather creative personalities, you know you're in for some sparks. This is an especially important consideration when collectives decide to add new members. The wrong person can divide a previously peaceful collective into warring factions overnight.

DOERS VS. USERS

There are two types of members in almost every group: Doers and Users. Doers are the people who can be counted on to take responsibility for getting things done. They volunteer to do things on behalf of the group, and once they volunteer, the group can depend upon them getting the job done and done well. Doers know when they have to delegate parts of their job to others, and if they're smart, they'll try to delegate to other Doers. Doers know the strength of unity and cross-promotion, and can always be counted on to spread the word of their partners' latest projects.

Users are the people in the group who, well, benefit from the work that the Doers do without contributing to the group themselves. And, more often than not, they'll happily reap the benefits of the work of the Doers — and then ask why more hadn't been done. Most Users don't even know they're Users. The work of the Doers is transparent to a User. To a User's eyes, the work just gets done. Somehow. Users don't participate in the group. Until they need that group to provide them with something — without their active involvement, of course.

How does this happen? When collectives are formed, the conditions for membership are often all the things that have nothing to do with the success of the collective. They're offered membership because they do a comic the other members admire. Or they're friendly with one or more of the other members. Or their comic offers a large audience. All of which are meaningless in terms of collective-building.

Want to know how to make a successful collective? Make sure your group is all Doers and no Users. It takes work, but it's possible. Do you have Users in your group? Lose them. Do whatever it takes, but lose them. It doesn't matter if they do a wonderful comic or if they're the nicest people in the world, if they're not contributing to the group, they're dead weight. You think you need their pageviews to increase your ad revenue? You don't. A collective of Doers with a low number of pageviews will outearn a mixed collective by the end of the year. Every time.

You think you can't risk losing their friendship? If you're a Doer and your friend is a User, you can't be in the same group without becoming bitter toward that person. You're doing the friendship a favor by separating.

You think you need the popularity of their comic to bolster the importance of the collective? You don't. A collective that can get things done will always be more important than a collective of popular titles that can't manage simple tasks.

TO JOIN OR NOT TO JOIN ...?

Joining a collective is like any other business decision you have to make. It's best to try to separate your emotions and then look at the facts and how they balance out. For example, you may want to join a collective simply because many of your friends are part of the collective. But if it's a bad fit for

you, don't you risk alienating those friends? So, take a look at the facts and how they add up.

- Do the other members offer significant cross-promotion?

- Do you offer anything significant to the group?

- If the collective pools ad revenue, are you sure you couldn't do better running your own ads?

- Will the pooled resources be used in such a way that you'll approve?

- Are there members of the group whose personalities you might not appreciate?

Then, when you're ready to take the plunge, do this: Plan your exit. Everything has a beginning, a middle and an end — and this collective will be no different. You've planned your entrance, now plan your exit. Talk to the members about how and why you may leave the group. Ask how that's going to affect the things that you will have done as a member (and the money you may have made). Make sure the members understand why you're joining and what your expectations are.

In doing so, my bet is you'll really determine whether you want to be involved with this particular collective at all. And if you do, you'll be going in with your eyes wide open, and a perfectly reasonable expectation of how you'll be leaving if and when you decide to do so.

SELF-SYNDICATING TO COLLEGE CAMPUSES

College newspapers present a unique opportunity to try your hand at a little self-syndication — and get some promotion to an enviable demographic in the process.

Campus newspapers, in my experience, have been way more open to dealing with a self-syndicated cartoonist than traditional newspapers. This is probably due, in part, to the fact that many of the decisions are being made by people young enough to "get" what we do — and operate in a decision-making structure with much less bureaucracy.

THE LURE

Here's what you get in terms of a readership:

- A dedicated readership of 18- to 24-year-olds.

- They tend to spend their discretionary income on light entertainment in the $10-20 range.

- They are computer-literate enough to become regular online readers.

- They are receptive to "edgier" content found in webcomics (when compared with our syndicated counterparts).

THE APPROACH

If you were approaching a city newspaper with a self-syndication offer, I would advise a promotional folder with printed-out samples, a cover letter and other promotional filler. I would suggest mailing it to the correct staff member and following up with a postcard.

But campus newspapers respond to a much different approach.

You can do most or all of the promotion for this venture on your Web site — including the preliminary solicitation. This is because campus newspapers will actually respond to a student who suggests a comic for print. If a student — or better yet, students — rally the editors and advisers of their campus paper in support of a comic, the paper will often respond in a positive manner.

Open with a solicitation inviting any college-bound readers of your comic to suggest your feature to their campus newspaper's editors. Tell them that this is a way they can support the comic they love at no cost whatsoever to themselves. Make it clear that you'll work within the paper's budget, and you will make the files for your comic available to the paper the week before publication. (This addresses the two main fears the editors and advisers will have when they're presented with a self-syndicated feature.)

Set up a special page on your site in which you can present a couple dozen of your best comics, a synopsis/explanation of your comic and contact information. Don't rely on people browsing your archives. You must be in control of the experience. This page is your sales tool, so pick the comics and the content wisely.

PAYMENT

As far as your rate goes, you have to make a decision. Some campus papers actually have a budget that they can work within, and getting paid is not impossible. If you'd like to angle for some of that dough, don't list a rate on the promotion page, but do note that you will work within the budget of any newspaper that wants to print your comic.

Or, of course, you can simply offer the comic for free to any campus paper and cut out the negotiation, relying on the demographics discussed above to make this venture worth your while. I've seen both done, and both are valid.

Special thanks to Kickstarter supporter Lindsay Hornsby (Fizzlebit.com).

If you're negotiating a price, here's something you should know. City newspapers pay for syndicated comics according to their circulation rate. Larger papers pay more and smaller papers pay less. Of course, more popular features are able to charge more than unpopular features, as well. The range I'm aware of is between $10 and $40 per week for a daily comic (Monday through Saturday).

So expecting more than about $10 per week might be pushing it.

You'll have to decide, based on the size of the paper that contacts you, what you want to open price negotiations at. And always remember, their counteroffer might be zero. With no wiggle room.

If you come to that point, here's something to have in your back pocket: payment in kind. What if the paper paid you for your feature by giving you a free ad elsewhere in the paper? You could use this to advertise new merchandise you have on your site or you could simply advertise the site itself. Maybe one half-page ad per semester (or quarter) would do the trick. Realistically, it costs them nothing, but it could pay off in a nice bump for your site.

If that's not even an option, don't be too quick to back out. Remember those demographics we were discussing a few seconds ago. As long as you retain the right to affix your URL prominently with the comic, you can think of the comic itself as a free ad in a paper that is dominated by a favorable demographic. And that's actually pretty valuable to you.

GETTING STARTED

If they agree to run your work in their newspaper, send them a contract. The contract will simply state that they're purchasing one-time publishing rights only and that you retain all other rights. Go to the Graphic Artists Guild Web site for more information on contracts. Or better yet, buy the guild's amazingly helpful book.

Then, set up a place on your server on which you can upload hi-res TIFFs for them to download and print.

And finally, make sure to have those files available for review a week before publication. The editors may want to review the feature before they print it. And if they have concerns about content, you'll want to have time to address them. They may also operate on a production schedule that makes it important to have things like their features pages nailed down early.

TAKING IT THE NEXT STEP

Once your comic starts running in a campus newspaper, make it your business to either subscribe to that paper or follow the goings-on of the campus online. You may find out about a speaking opportunity or some other event that you could trade your campus involvement in for an invitation to participate on the campus.

And when you go, bring some books to sell. That "free" comic just paid for itself and then some.

E-NEWSLETTERS

Sending out a monthly e-newsletter is a great way to keep in touch with readers — and an awesome way to get the word out on new information about your webcomic. It takes a little time to prep, but it's a well-targeted message to an interested audience that is incredibly valuable as you build your community. Here are some thoughts.

COLLECTING E-MAIL ADDRESSES

Obviously, this is something you can promote on your site, but this is also something you can pursue at conventions. Have a sign-up sheet handy at your table for interested parties to print their e-mail addresses. It's a great way to make sure that someone who has expressed a passing interest at a show is further exposed to your work after they go home.

Q&A

Q: I'm projecting I'll reach 1 million unique visitors/month for the first time. I'm curious if this is something appropriate to celebrate, or even mention.

My natural instincts are telling me to keep my head down and quietly chug along. I don't see a lot of upside to mentioning it publicly.

The other problem is that this instinct is keeping me from seeking help where I need it. I want to ask people here what they would do with that level of traffic because I'm certain I'm not maximizing the business side of things, but I don't want to sound like a jerk.

A: On one hand, promoting your comic with numbers is dicey. How big does a number have to be to be considered a big number? No matter how big a number is, there's always a number that's bigger. For example, as Webcomics.com neared the end of its first six months, some people wanted me to release how many members had subscribed. I refused because no matter what the number was, some people were going to think it was too big (and question its authenticity) while others would have sneered that it wasn't big enough.

On the other hand, sending out a press release that a comic has passed certain milestones such as 1,000 updates are almost expected. The same goes for anniversaries — although anything smaller than two years is kind of silly in my opinion. And I'll be honest with you — I like to err on the side of too much self-promotion rather than realize I hadn't taken advantage of all of my opportunities.

Would I recommend a press release over crossing the 1 million uniques-per-month mark? Honestly, no. First of all, the main reason to send out a press release is to use news media to attract the attention of new, potential readers. And the typical webcomics reader really isn't able to parse the significance of 1 million uniques per month. It certainly sounds big, but we're all pretty used to astronomical numbers where Web traffic is concerned — especially since so many news reporters fall for "hits" instead of asking for "pageviews" when they write their stories.

The second part of the question asks whether it's OK to share the number publicly among peers. I make it a habit to never discuss things like Web-traffic numbers unless I'm among very close friends. It's just too problematic. If your number is too big, you're bragging, and if it's too small, everybody looks at you funny.

And at the end of the day, an issue like "am I maximizing my traffic" can be discussed whether you've got 1 million uniques or 10 million because "maximization" isn't a constant. No one can say that you should expect a certain level of book sales based only on your uniques. We can give you conventional-wisdom-type advice, such as expecting 1-5% participation, but beyond that, maximization is a function of several variables including traffic, community building, merchandise saturation, etc.

In other words, you can discuss the things you want to discuss without bringing numbers into it.

SPAM RULES

Before sending out the first newsletter, take a couple of minutes to look into the Federal Trade Commission's Compliance Guide for Business regarding spam. Understanding these regulations will help you avoid any misunderstandings with readers and fans who may have forgotten that they signed up for your newsletter in the first place!

USE A SEPARATE E-MAIL PROVIDER

I would suggest not using your main e-mail provider to send out the newsletter — and I definitely wouldn't send it from your main e-mail address. Inevitably, someone is going to flag your newsletter as spam, and that may effect how different e-mail providers treat e-mails from your account.

USE HTML

I know, there are a *few* people whose e-mail accounts don't process HTML, but these days, most everyone can. This newsletter is as much a marketing tool as it is a communications effort. Send something that puts your best image at the forefront.

CONTENT

When I sent out a regular newsletter, I often ran content from the previous weeks' blog posts. My thought was that the blog-reading segment of my readership and the newsletter readers had very little overlap. This was a quick way to fill the bulk of the newsletter. But I also added content created especially for the newsletter — and often this was more insider information — stuff that I wouldn't be so quick to share on my public Web site.

DISCOUNTS

I also strongly recommend offering discounts on items in your store through the newsletter — to reward this already-motivated portion of your audience.

Most importantly, this newsletter allows you to communicate important announcements with your readers — convention appearances, new merchandise, etc. It should be a wall-to-wall plugfest, but your calls to action should be prominent.

GAUGE THE RESPONSE — AND REPEAT WHAT WORKS

There are lots of ways to see what your newsletter readers are responding to. For example, you can make a thumbnail link to a larger image hosted on your site and track the traffic for that specific file. You can also see if your orders spike after offering a discount. Knowing what this microcosm of your readership is responding to might help you make better decisions when approaching the overall readership as a whole. And it will definitely strengthen your ability to communicate with your newsletter readers.

E-COMICS?

"If I'm sending newsletters through e-mail, maybe I should consider the same thing with my comic itself." Back in the day, before RSS feeds and tweeted update reminders, that's exactly what a few of us old-timers did (and still do). You'll have to either set this up through your publishing software or use a third-party provider (type "auto e-mail RSS feed" into your browser's search engine for a good start).

SPAM OR SELF-PROMOTION?

Most of us are shameless self-promoters — it's the nature of what we do. We wouldn't be publishing our own work on the Web if we didn't want people to read it, and people aren't going to read it unless we tell them about it.

But in the process of trying to tell people about our work, it's very easy to cross the line and end up angering the people we're trying to enlist as readers. And that's bad for business.

So the question becomes: When does harmless self-promotion turn into spam?

The key to finding the right answer is understanding the medium you're using to deliver the message.

IMPERSONAL INTERACTION CHANNELS

Some message streams assume an impersonal interaction — Twitter and Facebook are examples. When you subscribe to someone's Twitter feed, there is no expectation that that person will always be talking to you or discussing topics that pertain to you. Same with becoming friends on Facebook — or subscribing to a Facebook fan page. And your site's blog definitely falls into this category. In fact, I'll bet most readers expect a little shameless self-promotion in the blog.

Of course, even with this advantage, you still have to find balance. For example, if you're tweeting every new update of your comic, you need to make sure that there's enough content in between those updates that your Twitter feed

doesn't turn into one long string of update alerts. When that happens, you're in danger of losing followers who may have been expecting a bit more when they originally signed up for your feed.

Remember, you're an entertainer. People expect you to be entertaining. It's OK to pause for a commercial from time to time, but if your feed becomes nonstop promotional messages, you're going to start losing followers (both the ones who unsubscribe and the potential followers who look at the feed and decide against following in the first place). And if you start losing Twitter followers, you're losing an incredibly effective promotional tool.

PERSONAL INTERACTION CHANNELS

In short, people don't automatically see every piece of self-promotion on the Web as spam. People get the "spam" reaction when those messages come across channels in which there is an expectation of person-to-person interaction.

E-mail is a perfect example of this. An e-mail carries the expectation of a personal message exchanged among a small group of people — usually only two. When that e-mail carries an impersonal message meant for a large group of people, many of those people will react in anger.

Often the sender will actually acknowledge that he or she is crossing the line and try to take the curse off with a phrase like ...

> *This is the only time I'll be sending this kind of e-mail. I'm sorry if it comes off as spam, but if you want to keep in touch, please follow me on Twitter.*

... which is a fascinating subconscious admission that this is the wrong place to be making this sort of overture along with suggesting at the same time the appropriate place.

DIGITAL PRESS KIT

If you succeed in enticing the media into covering you and your comic, make it easy for them to do a good job. Build a Web page to hold biography information, hi-res photos and other elements that will enable them to give you the most informative, attractive coverage possible. We'll talk more about a printed version of a press kit in the upcoming chapter about comic conventions. Your digital press kit should include:

• **A detailed biography:** Live text, so it's copy-and-pasteable.

• **Photos:** A headshot and some other photos, shown on the press kit as thumbnails, but each linked to a high-resolution (300 DPI) RGB photograph (JPEG format).

• **Sample comics:** Again, a thumbnail is presented on the site, and underneath, two links to hi-res versions of the sample (one in color and the other, black-and-white). These comics should be chosen by their ability to appeal to a broad audience.

• **Other sample images:** For example, the cover of my most recent graphic novel.

• **Important links:** URLs for all of my comic-related Web sites.

You could build this out in several ways, including optional elements such as:

• **Book samples:** PDFs and other downloadable media containing samples of your work.

• **Site stats:** Particularly if your stats demonstrate strength or growth in a

particular area.

• **Press releases:** Links to some of your most recent press releases might give a reporter some ideas on angles from which to frame his or her reporting.

But it's not just e-mail. Facebook messages (the e-mail-like function of Facebook — not wall posts) carry an assumption of personal interaction. Twitter DMs, too, have the same person-to-person expectation.

CROSSING THE LINE

You'll notice that nowhere here have we discussed the message itself. That's because the message itself is inconsequential. It doesn't matter if you're announcing a new book or a special limited-edition collector's item. If you're sending that message over a channel that has an expectation of personal interaction, you risk alienating the very people you're asking to support you.

PRESS RELEASES

One of the best ways to encourage media coverage of your comic is to do the work for them. A well-written press release makes it easy for a media outlet — print, radio, TV or Web — to help spread your message.

The top priority when writing a press release is to get the most important information out front as quickly as possible.

Getting it into the first sentence is optimal. The first paragraph should contain all of the key points that you want the reader to walk away from the piece knowing. Most people will stop reading after this. Several will start skimming midway through the first sentence.

In a way, it's the exact opposite of writing a comic strip. Instead of setup/punchline, it's punchline/

HARO

Getting media coverage for your comic is a great way to garner some no-cost promotion for yourself. But finding someone who wants to do a story about you can be difficult. Heck, finding someone who wants to do yet another "Look, kids! Comics on the Web!" story is getting to be darned hard. Here's a pretty neat way to get some media attention — from news sources that are hoping you'll get in touch.

Help a Reporter Out (HARO, helpareporter.com) produces three e-mail newsletters a day asking for sources for stories being worked on by newspaper reporters, radio-and-TV producers, bloggers, etc. It's free to sign up for the mailing list. It's broken down by general subject area and takes about a minute to skim.

What you're not necessarily skimming for are stories about comics or webcomics. (Of course, if you see one come down the pike, take a swing.)

What you are skimming for are stories that might have a connection to the central theme of your comic.

For example, for me, I'm skimming the HARO newsletter for stories about villains, the nature of evil, corporate crime, etc. If I see a topic that might be a fit for me — Is American culture more accepting of corporate crime? or Who were the Top 10 super-villains of all time?— then I use the site to make a "pitch."

In a pitch, I use the provided contact information to say — in a short, straightforward manner — one of two things:

(A) I'm an expert on that topic and I'd be happy to provide the necessary information. Or ...

(B) My comic is related to the topic, and I'd be able to provide an interesting angle for the discussion.

If they're interested, they'll contact you and arrange for some sort of interview.

Be brief. Be concise. Be clever. Be honest.

And be sure to provide them with your URL.

Of course, always be on the lookout for something you can tangentially connect to your comic. For example, a recent solicitation asked for stories about kids saying funny things. I responded with some of the things I've posted on Twitter quoting my kids ("My 8yo says he's ready to attend conventions with me: 'I'll hand out flyers, talk to fans, and cover your bald spot during photos.'") and mentioned that sometimes I put their words directly into my comic strip.

setup. The following paragraphs in your release simply serve to provide additional information that you're happy if people know — but not heartbroken if they don't.

KEEP IT SHORT

There really shouldn't be that many supporting paragraphs. Unless you're writing about something complicated that must be explained fully, your press release should be three paragraphs — four tops. I suggest using quotes sparingly. I've written about 90% of my press releases without using a single quote. Quotes are fake sounding, clunky and trite. And they almost always convey zero information. If you can get your information across without using them, then by all means do. Every newspaper reporter I've ever asked says that the quotes are the first things to get summarily deleted from a press release anyway.

CONSIDER HOW THIS IS GOING TO LOOK

I get great mileage from considering the people who will be designing the news I'm sending. I provide links to hi-res art I've made available on my server — sample strips, logos, graphics, headshots, etc. — that can be used to help display my release as attractively as possible. (And, yes, you have to provide a headshot of yourself. This is non-negotiable. Not a drawing. Not a cop-out. An actual headshot — even if it's something you get your buddy to snap — is a must.) Even if you're not tilting toward print coverage, make sure the art you provide is hi-res (300 dpi for color, 600 dpi for lineart). The resolution can always be reduced for the Web or TV.

GIVE THEM AN OPPORTUNITY TO GET IN TOUCH

At the very top should be all of your contact information — including snail mail, phone, fax, e-mail, Web site, etc. Under this (and over the body copy) you may write a short headline. This headline is a super-short synopsis of your lead sentence. If they do contact you for an additional comment, it's an opportunity for you to pour on the charm. Play your cards right, and you'll give the reporter every excuse to elevate this story to higher prominence.

LET THEM KNOW WHEN THIS INFORMATION SHOULD BE RELEASED

Remember to include "FOR IMMEDIATE RELEASE" at the top if this can be released right away. If the information is to be held for a certain amount of time before being released, the terminology is "EMBARGOED FOR (publication date) RELEASE."

MAKE IT PERFECT

Finally, proofread the living blazes out of this thing. Get as many eyes as possible on it and solicit honest feedback — not only on spelling and grammar, but on things such as clear sentence structure and directness.

NEWSWORTHINESS

Now that you know how to write an effective press release, it's important to consider an important question: Is it news? No matter how well you've written your press release, if there isn't something newsworthy going on, no one will be able to bring themselves to run your piece. Judging newsworthiness is difficult — especially if you're considering your own work. In general, here are some justifiable reasons to send out press releases:

A MAJOR MILESTONE HAS BEEN PASSED

That's *major*, please. No one cares that your webcomic cleared the 500-update mark. Come back in another 500. If you're announcing that your comic has been around for a certain number of years, you should be updating at least three days a week. Updating a comic once a week for a year is not news.

YOU'RE RELEASING NEW MERCHANDISE

This is a no-brainer. You've got something for sale and you need to spread the word.

YOU'VE WON AN AWARD

Boy, do we ever blow this one. It goes against everything we're taught about being good sports. Let's be clear about this: When you've won an award, it's perfectly acceptable to send out a press release on your own behalf announcing that fact. The organization that awarded you the honor may or may not be doing a good job of promoting your award, and it may not be announcing it to the outlets that are going to do you the most good. You need to take the bull by the horns, stand up and admit when you've done something right. You'll feel better once you do.

YOU'RE JOINING (OR LEAVING) A COLLECTIVE

If you're joining, you need to express why this is relevant — what this collective is going to accomplish or how this collective is going to make an impression on readers as a group. If you're leaving, you're probably announcing that you're becoming an independent webcartoon-

Special thanks to Kickstarter supporter Eric Menge (Snowbynight.com).

ist. That should be the focus — not any problems you may have had with your former colleagues. Besides wishing your former team well, they shouldn't occupy more than a sentence or two in the entire release.

YOU'RE ORGANIZING AN EVENT

Whether it's a fundraiser or a cartoonist challenge, webcomics events are newsworthy. Your challenge here is to explain it as accurately as possible and clearly state the ways in which people — cartoonists and readers alike — can participate. Remember to get times, dates and relevant URLs early in the first paragraph. Also, design a standard-size banner ad that you can include with the press release. This can be used by the media outlets you send the release to in two ways: They may use it on their sites to further promote your event and/or they may pass the banner along through their sites to their readers who may use them similarly. These next two have to be approached sparingly ...

YOU'RE MAKING A SIGNIFICANT CHANGE TO YOUR COMIC

You really have to use this one sparingly to avoid becoming the boy who cried wolf. Redesigning your Web site is not news. Adding a creative partner to your comic is. There are some changes — update schedule, color/b&w, new fan art — that just aren't significant enough to justify a press release. Of course, if it's a radical change — going from once a week to daily or offering the comic in color and b&w simultaneously — then you might be in press-release territory.

YOU'RE PLANNING A SIGNIFICANT EVENT IN YOUR STORY

This press release is useful only if you already have a relatively large readership. After all, no one is going to want to post a release about a story in a comic that is relatively unknown. But if you're planning a story that's going to change your comic in a major way (the death of a beloved character, for example), you might consider a release. The exception to this rule is sometimes a release about a story based on a headline-grabbing news event. Comics with smaller readerships can get away with that one on the strength of the news event alone. This kind of press release really needs to be accompanied by some sort of preview or "sneak peek" images.

INTERVIEW TECHNIQUE

It happens all the time. A webcartoonist does everything in the preceding pages, and then gets an interview request. After the initial elation comes the sobering question:

Now what?

We've all heard interviews in which a dude drones on about his comic in a quiet monotone. Dull is deadly. And it's a perfect way to make sure that a written piece never gets written. So if you want to close the deal, you'd better be prepared to perform a little.

That doesn't necessarily mean reaching for the rubber chicken and bringing the wacky. But it does mean you should brush up on your public speaking.

YOU KNOW THE QUESTIONS YOU'RE GOING TO GET ASKED... PREPARE THE ANSWERS

Most of these interviews follow a predictable route. "Tell us about your comic ..." "How did you get into doing this ..." "Where do you get your ideas ..." and so on.

By the way, "Where do you get your ideas" is a legitimate question about the creative process. Don't be that snide jerk who dashes off a snide answer that addresses the question literally and then walks away from what is otherwise a challenging and meaningful question. Answer it.

And the best way to answer these questions is to have some responses planned. Write down 10 of the most probable questions and write out answers to them. Need help getting to 10? Listen to or read any interview with a cartoonist. You'll hear the same questions over and over. Be sure to include one or two that might apply specifically to your comic or your situation as a webcartoonist.

This is a crucial step because a huge portion of being a good guest isn't in the answers themselves; it's in the delivery of those answers. And you can't work on the delivery if you're busy trying to form an answer on the spot.

PRACTICE YOUR DELIVERY

Now that you have prepared a few responses for the most probable questions, practice delivering them out loud. Do this a few times alone until you can do it without looking at your notes. Once you have them fully memorized, practice in front of a friend. But have the friend listen for these things:

DO YOU REPEAT THE SAME VOCAL PATTERNS?

Are you like that Band Camp Girl in the movie "American Pie"? Do you end every sentence as if it were a question? Do you know how annoying that is?

Work on making your delivery so that your vocal patterns rise and fall to match the spirit of the content you're delivering. Practice enunciating and emphasizing important words.

Think of it like singing. You can't repeat the same melody over and over again. You need to vary your vocal delivery.

DO YOU HAVE VERBAL TICS?

Of course you do. Like, we all do. But, like, if you let yours, like, run rampant ... especially, like, in a situation where you might be, like, a little nervous, then, like, your message is bound to be somewhat, like, obscured.

There's only one way to get around that one, and that's to know what your personal tic sounds like so you recognize it in the moment. Only then will you be able to suppress them when you're in an interview.

Once again, practice in front of a friend and have him or her pay particular attention to these tics. You might even request that they count them or make a game-show buzzer sound when you say them. Eradicate the tics, and I guarantee you'll be considered an awesome podcast guest.

DO YOU EMOTE?

Being a good podcast guest is a little bit like performing. Only in this case, you're acting the role of you. And like any good actor, you have to exaggerate your character just a little to make sure that it comes across clearly. That means allowing yourself to be exuberant when you're talking about something that's happy. And you have to let your voice drop and slow down a beat when you're talking about something that's more serious or sad. Allow your voice and the cadence of your speech to convey the parts of your message that the words alone can't.

EXPECT THE UNEXPECTED

Hopefully, your interviewer is going to ask you a few questions that you hadn't expected. Here are a few tips on delivering an answer extemporaneously:

Don't be afraid to pause to gather your thoughts. Heck, I'll throw a laugh in (if it's appropriate) just to buy a few seconds. Another suitable strategy is to simply repeat the question thoughtfully while your brain organizes an answer.

Form a statement that makes a single point that addresses the question, and start with that. Chances are that it will lead to either subsequent statements or a list of things that you can talk about that bolster the original statement.

Don't feel the need to vamp for the interviewer. Many people try to fill a subconscious need to speak for a certain number of seconds to satisfy some sort of unspoken time requirement. If your answer is too short — or if it misses the intention of the question — it's up to the interviewer to bring the topic around in another way. Don't repeat the same points in an attempt to fill time.

You'll find that if you allow your friendly personality to come through in an interview, people will want to check out your comic just to "get to know you" better. You don't need to continually slip in your URL or references to your characters. Heck, you don't have to talk about your comic at all — unless you're asked a direct question about it. (Please don't be that cartoonist who finds a way to crowbar his or her comic/story line/characters into the answer to every question.) All you have to do is be friendly and enthusiastic. It's a rare commodity on the Web. People will come to your site just to be exposed to it.

Special thanks to Kickstarter supporter "Mad Jay."

Khoo & A

In 2010, Webcomics.com had the privilege of allowing members to post questions directly to Robert Khoo, *Penny Arcade's* business guy. As you may know, *Penny Arcade* has grown from a webcomic to a multimillion-dollar venture under his leadership. Although some of the material is somewhat dated, the concepts are still rock-solid. This chapter is dedicated to every webcartoonist who ever wished they had "their own Khoo." If you've ever wished you could ask his advice on your webcomic, chances are the topic is addressed in the next few pages.

I seem to have reached a ceiling with existing merchandise (CafePress) and advertising (Project Wonderful) revenue. What are next the steps for those models and for marketing the strip itself?

Our philosophy for "getting the word out there" has always been to focus on the content. If you create really quality work, the audience will do your marketing for you. I'm not saying that marketing *doesn't* work, but I am saying you have a limited number of hours in the day so we're talking about the allocation of scarce resources. I would focus your efforts on your craft and refine the existing ad/merch model.

For the ad side, start looking at what your readers enjoy (via surveys) other than your comic and start approaching small companies. I recall one of our first deals was with a company called Cable Organizer — obvious crossovers with our audience, and they were a small mom-and-pop organization. It was easy to get to the decision-makers and make a pitch for a small monthly sponsorship. For your merch model, I'd get away from CafePress. Instead of having 100 different items that are crap quality that nobody buys, I'd focus on producing one or two that you know people will love.

Is there a marketing strategy that you commonly see used that, in your experience, is a waste of time?

Although I don't recommend traditional means of marketing for webcomickers, I will say that in general, "going small" and putting your advertising eggs into one basket is a bad idea. Repeated exposure in different mediums is key to a solid strategy. People need multiple views of a piece of marketing before they act — that tidbit is important to note for a ton of things you end up doing from both the marketing and sales angles.

Can you describe the pillars of thought behind, "Don't change the creative, it's my job to sell whatever it is"? Are there commonalities behind this that can be used for anything? Or any comic, in this case?

When creating your "micromedia" company, remember there are multiple products you're selling to multiple customers. You, as a creator, are selling your product to readers. It sounds mercenary, but you're selling your comic to them in exchange for their loyalty and their eyeballs. These eyeballs, in turn, are what the business side needs to sell to the advertisers. It's an interesting exchange of multiple currencies, but it works. To clarify, I'm not saying "don't change the creative" — I'm saying that the business shouldn't affect the creative. Having seen many creative endeavors crash and burn, I can say with confidence that when the business folks get involved with creative decisions, it's a recipe for disaster.

"Fake it till you make it." At what point is one going too far with this in terms of their business, dealing with advertising, and merchandise?

Right from the get-go. Do your research. Don't put yourself in a position to look stupid. There are times where you've only got one shot, so don't fuck it up.

Any books/videos/podcasts/etc. you could recommend for those wanting to give themselves a marketing/business general education?

Do You Matter? How Great Design Will Make People Love Your Company (Brunner/Emery)

The Leader Who Had No Title (Sharma) (cheesy, but there's some good stuff in here)

The Prince (Machiavelli) (not for advice, but to keep your guard up ...)

The Tipping Point: How Little Things Can Make a Big Difference (Gladwell)

Crossing the Chasm: Marketing and Selling Disruptive Products to Mainstream Customers (Moore)

It's obvious that *Penny Arcade* is branching into new forms of entertainment (PATV, PAX, etc.). I'm assuming this is to maintain relevancy in a frequently changing environment (the Web). What do you think will grab new audiences/consumers in the future other than just comics (Is it just video? Podcasts?)

As Generic Business Guy 01, I'm not really into content decisions, but I do pay very close attention to market trends and put anything I think is interesting in front of Mike and Jerry. Our growth decisions are more about delivering compelling content to whatever our readership is. Whether that's a comic strip, cool merchandise, a live event, a charity, a scholarship or a reality show — it's all built around the same fundamental idea of creating content for our readership to enjoy. Our dedicated service is to them.

How do you gauge a good business relationship? Meaning, what makes you want to partner with a publisher/clothing manufacturer/etc.? What convinces you that it will be a profitable venture?

I gauge a good business relationship as one in which both parties can walk out of that initial handshake meeting and feel like they both got what they wanted out of it. I'll be honest — when we first started, that wasn't the case. I beat the s*** out of people on deals, and sure, they may have been incredible at first and fun to tell stories about, but over the years I've been burned by that approach too many times.

When both parties don't feel the deal has parity, corners get cut, service degrades and at the end of the day, you get what you pay for.

Determining a profitable venture is pretty easy — forecast the exact costs (which you can do) and then forecast three scenarios on the sales side (worst, decent, best case). If you can't break even on the worst-case scenario, I'd avoid it until you can build a substantial capital base, allowing you to weather those riskier decisions.

Do you think there is a dollop of psychology in what you do (as a businessman and marketer)?

I think understanding people and what makes them tick is critical for everything you do — everyone has their motivations. Getting to know those can only help you.

What is your advice on setting a great first impression?

Don't name-drop. Don't brag. Don't be late. Do your due diligence. If you have something to bring to the table, put it out there. Hand them your business card. Don't ask for theirs. Shake hands. My initial reaction to someone trying to fist bump me is to punch them.

Where do you think someone should start when wanting to learn about small business and how to run one? I'm just starting up my webcomic, so my main focus is the creative part of things right now, but once that's established I wanted to learn more about business. Could you point me in a good direction?

Go online and search for "business plan template." Do your very best in trying to fill it out with what you know. I think you'll be surprised by how much knowledge you've gained and you'll immediately realize the holes you'll need to fill. From there, take some business courses - revisit that business plan every six months.

Suppose you've just started a webcomic, and you know that the content is excellent. Do you have any suggestions on how to connect the content with an audience, aside from the really obvious, like convention appearances and advertising on other webcomics?

You don't get to decide whether your content is excellent or not. If your content is truly excellent, people will connect with you. Not the other way around.

What I'd like to know is what would your strategy be today for a brand-new webcomic. Let's say it's not at all related to gaming. The artist isn't a "name" although s/he is good. The comic has been running for, say, six months, updates two or three times a week and has 500 fans.

Again, creating and refining content is not my area of expertise, but our strategy has been to keep focusing on building out that archive and your craft. Sorry for not being able to give you a more clear answer, but I'm not an artist.

Here's a more general one ... when running Web advertising, what's considered a "good" click-through rate, and what should be a sign to rework the ads or where they're displayed? What numbers (percentage of click-throughs/views, cost per click, etc.) are reasonable goals for a solid campaign?

A good CTR is anything above .25%. Yup. Every 400 ads. One click.

I've never seen any ads for *Penny Arcade* or the Halfpixel guys [Scott Kurtz, Dave Kellett, Kris Straub and Brad Guigar] outside their own sites. I can almost hear a bit of pride when our predecessors say they've never needed to advertise. If it's true that good comics will naturally gain an audience so we only need to focus on making our comics the best they can be, why should I waste money advertising?

However, with today's Internet, regularly posting a comic isn't novel or unique anymore. Careful advertising could pull in an enthusiastic audience that wouldn't otherwise find the newcomer comics among the masses of entertainment options out there. My webcomic is about a year-and-a-half old and the archives seem short enough to not intimidate but long enough to hook people that are going to be hooked. Why shouldn't I advertise when I'm ready to make a good impression?

I can see how it might come across as a bit uppity when we say we don't need to advertise, but I really do believe that content speaks for itself. If it can't stand on its own two legs, then there's a fundamental problem since that's the bread and butter of your operation. That said, yeah — I don't think you should waste your money on advertising.

Why do good comics fail to get an audience? I think we can all come up with one or two comics we really like and feel should be way more popular than they are, but they are just not making it in any sense of the word.

There's a difference between "good" and "marketable." Good is subjective. Marketable actually has tangible goals. Some creators get lucky where their art and creative work is both what they want to create ("good" to them) and marketable. People can argue until the cows come home how a strip *should* be more popular than it is, but I think that's rubbish — a strip is exactly as popular as it should be. Always.

It would be interesting to get your opinion on longform comics. There's been a lot of discussion on the struggles of longform vs. gag. How do you market longform to new readers, especially when you are carrying around a significant archive? Longform has this inverse effect of the longer they are established (which is seemingly a good thing), the harder it is to attract new readers, because people don't want to invest the time to catch up.

For longform stuff, [longform] work has the issue of being challenging to market... as a reader it's challenging to get invested in a longform strip. It's not like a movie sequel where at the beginning they reintroduce you to every character and create an independent story-line that can stand on its own two

legs. Unless your end goal is to create a monster graphic novel, I'd say the challenges are very, very real.

In your opinion, how important is branding/marketing potential? Do you think it separates the comics that "make it" vs. the comics that don't?

I think it's helpful but by no means required. Look at *xkcd*. It looks (purposefully) like crap, and he has more money than God.

I'm interested to know what type of product you think would sell really well through a webcomic but might not work for *Penny Arcade*. For example, not every niche works with T-shirts, and I know you've pioneered the higher-end polo gaming shirts. My audience is also on the more mature-adult professional end of things, and I am looking for alternatives to T-shirts/plushes/posters. Blogs seem to monetize best through affiliate marketing, but I've never thought that would fly with a webcomic. tl;dr: types of merchandise that you think might do well that you haven't seen a webcomic do yet.

I think the T-shirt thing is so popular because it's so easy. With a little extra effort, you can get some pretty slick products that make a lot more sense to your brand that can also really differentiate you from the competition. (A good example of this are the socks from Richard Stevens). I can't really provide you a magic-bullet product that hasn't been done before, because I think the key is looking specifically at your audience and their hobbies, needs and desires, and creating a product that's catered specifically to them.

How do you go about hiring a salesperson? What would I look for in a sales employee, and what should I avoid? By "salesperson" I mean a person to sell ad space, our comic's creative services, and whatever else we happen to be offering. I ask because, though I work with many salespeople, I have zero sales experience myself and have no idea what makes a talented salesperson besides "she or he sells a lot."

Choose someone you can trust and someone that respects your brand. Clearly define your relationship in both the money and social contexts. You call the shots, and he/she needs to be OK with that. Don't hire friends. It's OK to become friends with them, but it's key to not have a pre-existing friendship, in my opinion. Hiring a technical person is more about being able to work with them and you trusting them and their abilities. Since you're probably like me and wouldn't really understand the nitty-gritty of technology, make sure to get as many references as you can.

Before you were hiring full-time people, did you ever hire any contract employees? For example, say I wanted to drop X dollars on having someone work on our Web site to complete goal Y. Would you have any advice on that subject?

It's the same as working with anyone. Define the relationship as cleanly as you can. Figure out what both parties are getting and what happens if s*** goes sour.

How did you go about getting *PA* into the business of creative services, like when Mike and Jerry are making comics for Dragon Age or whatever? How would another webcomic go about that?

Work on the ad model first. Build those relationships. Pitching nontraditional work is a lot easier with that pre-existing relationship. The pitch always comes down to the numbers. X dollars in traditional advertising gets you Y results. Spending X dollars in this new whiz-bang offering will get your Y+Z results!

I'm fairly familiar with the legend/history of how you came to work for *PA*, but I'm not going to be holding my breath for a Khoo to fall out of the sky for my webcomic. In a logical world where people don't agree to work for free for two years, how would I go about getting a business

manager?

Well it was for two months, not two years. :) But looking to get someone involved at an early stage is challenging. You probably can't afford to pay the person, you don't want to give them ownership of your property, and what you can pay them likely means the work you'll receive will be sub-par. These challenges lead to the DIY model and why Webcomics.com exists — once you have stable revenues and *can* pay a person, I would recommend reaching out to your network and even posting a job opening to your fans. By that time you'll have reached critical mass so someone out there will both respect your brand *and* understand your business.

What advice do you have for a first book run, or making books in general? Kind of like what you wrote in the *PA* 11½ Anniversary book, are there a "Top Ten Mistakes in *PA's* Inaugural Book Run" like there were for PAX? (I mean, after you were actually allowed to make books again once you got the rights back.)

I'll give you five:

- If you're going with a publisher, try to get the biggest one you can.

- If you do it yourself, lay some groundwork for getting it out to places that aren't just your own fans. Whether that's using Diamond to get it into booksellers or having someone do PR for the title, don't waste the opportunity of a product launch to spread the word of your brand and the book.

- Don't sign away your rights. Jesus.

- Advances mean very little in my opinion, especially the ones they pay to webcomickers. If you are confident that book sales will be awesome, use the point of lowering or negating an advance for additional points on the book. The flipside to that is that some publishers may not be as motivated to market the book if they don't have the advance-skin in the game.

- China.

Have we seen the end or at least the beginning of the creator-owned model on the Web? What do you see as the successful organizational model for comics going forward? Will creators have to sign away some of their IP right to get noticed among the chatter?

God, I hope not. Like I've been saying, really great content will be successful no matter what you do with it. People think that I was some sort of savior with *Penny Arcade*, but let me make something clear. When I first started, *Penny Arcade* was doing 12 million pageviews a month. The content found an audience — it had nothing to do with those initial years of growth and popularity. I think that still holds true today, where an independent creator can still create a strip, get "dugg" and find success. I will continue to just point to *xkcd*.

What are your opinions on the different methods to monetize content: Merchandise Model; Donation Model; Freemium Model; Hostage Model (where pages are not released until a donation goal is met); Pay for Convenience model (where the comic is free on the Web and pay for PDF download or iPhone app); Advertising Model. How do you think the different models interact with each other? What other models do you think there are?

Merchandise: Easiest to understand, medium degree of capital risk, but there are some up-front costs.

Freemium: For webcomics? Seems weird. Freemium usually offers "upgrades" to the base-level free offering. Let's say the comic is free and then you can pay

for the ... yeah I'm not sure where it would go from there.

Hostage: Depends on how it is positioned, but it could work for specific types of content. The order of model rollout is critical for its success. You can't go advertising first and then decide to put up a pay wall for the exact same content. You gotta make a really compelling case that what's behind that pay wall is compelling.

Pay for Convenience: Need more than just the strip — "DVD extras," for example.

Advertising: Little capital cost, but there are infrastructure headaches you need to deal with, both on the ad-serving tech and sales side.

All the models can coexist with each other as long as the types of content are different — an easy-to-understand example of this is to release the comic for "free" on the Internet, but if you made a different piece of content like a video game, you are welcome to switch to whatever model you would like for it. Other models not mentioned include the donation model (NPR), the paid-sponsor model (with site skins and everything), the offer model (building in means of accessing content through offer/trial sign-ups, although it wouldn't really work that well for webcomics) ... there are an unlimited number of things you can try on the business-development side. Bundling, syndication, digital distribution via different channels, animated flash shorts ...

Many webcomickers have a store that is a list of items with PayPal buttons. Do you think that's fine, or do you think that using only PayPal (as opposed to having a merchant account) and not having a more robust e-commerce store is significantly hurting sales?

Using only Paypal is definitely hurting your sales. For us it's a significant amount.

What are some of the worst mistakes you made when starting out? What would you do differently?

Not looking into sales metrics right from the beginning. Although my excuse was that so many things were happening at once, I should have still classified all of our expenses and revenue streams into their appropriate buckets. You need a barometer for success and failure.

What were some of the cleverest things you did when starting out with *PA*, and what made you think to do them?

Laying down the constraints and roles for everyone Day One was without a doubt the single best thing we ever did. I had been a huge fan of *PA* for years and years before joining them, and it was important to me as a fan to not affect what Mike and Jerry were doing. Having clear boundaries and limitations not only preserved what was already there, but it established trust with Mike and Jerry and allowed me to focus on my little corner of growth.

When dealing with books, how important do you think it is that the start of the first book be at the start of the archive? When the time comes to sell "Book One," can it be the 100ish most recent strips without taking a hit for not starting at the beginning?

I think if you can do it, you should do it. People like having the first strips. Our first book still sells incredibly well, despite the art and jokes being pretty dated. I think readers like having that sense of contrast.

All four authors of *How to Make Webcomics* seem to agree that you should have your own domain and hosting. However — if I understand correctly — *PVP* and *Penny Arcade* actually started on someone else's site (in neither case was it a comic collective nor social network) and then migrated to their own sites. Also, the Net is loaded with entertainment, and very few people will proactively look for anyone's strip before it manages to become "branded" and gains

a regular following.

Although it is possible to start with your own site and become successful, it seems to me that the way to gain an audience at the beginning is to "find a parade and walk in front of it," meaning you find a way to put your strip on a relevant site where people are already going for nonentertainment information. For example, if your strip already has a character who is into modifying cars and you actually have an interest in it, you might find a site where people frequently go to exchange tips and info on how to do it. Once they have seen your strip frequently and have become familiar with it, they would tell others and the audience would grow to include people who just want to see your comics.

Not many artists do this, but then not many comics ever pull ahead to support their artist, either.

Other than the four most obvious points (the artist should actually care about the subject matter, the strip has to be relevant to the site, it still has to be good and this tactic requires work), what are your thoughts on this concept? Does it seem sound to you or am I way off track?

I don't think it's a bad idea, but make sure your contractual relationship with the content provider is clear. You're providing them a limited-use license for your strip. They're providing you with X (whether X is money, promotion, whatever — just make sure you're comfortable with it).

When you first came to work at *Penny Arcade*, what was your business strategy for those first six months?

1. Identify the different opportunities for monetization.

2. Rate each of them based on resource expenditure and chance of success.

3. Focus all my efforts on that one opportunity — for *Penny Arcade* it was building out the advertising model from scratch.

It sounds simple, but what those three points don't include are the 150-hour weeks for six months straight. I'd come to the realization that lots of people can do the job — but how many people are willing to sacrifice their health and personal life to get it done? If you can effectively work, without diminishing returns in productivity, for 140-plus hours a week, yeah — you do have the ability to do the work of four people.

Should we all be making apps for our comics?

No. Not unless it adds true value to the experience. Readers have a Web browser. To browse the Web. That your webcomic is on. Think less about reader apps and more about how your readers use mobile devices and see if you can solve *that* problem. Browsing your comic on an iPhone isn't a large enough friction point to justify a 99-cent purchase.

Can you give us a brief how-to on pitching ad space you'd like to sell to a company? Say I've already found a company I think would benefit from advertising on my site. Are there accepted practices in place for that kind of pitch, or is it cool to simply send them a brief email with my traffic numbers, rates and explanation of my site? And is there any point in doing that if I already have Project Wonderful ads available for sale?

Sure. Figure out what your client's goals are. As in, what are they *actually* trying to achieve with an advertising campaign? Increased sales? Awareness? From there, figure out how advertising on Site X is going to reach that goal. Pitches

come in many forms. E-mails, phone calls, lunches — be persistent though. Selling is an art form — I'm terrible at it, to be 100% honest. Is there a point in doing that if I already have PW ads running? Yes, if you can get more money by selling direct to this other company you should do that. More money is good!

This is more of a discussion point, but I'd like to hear Robert's take on Art vs. Business. It appears that webcomics are becoming saturated in certain areas (gaming, relationships, copy-heavy, anthro, sci-fi) so how do you pitch to an ad client if you're not a *Penny Arcade* or *Girls with Slingshots*, etc.?

For those looking to create a webcomic, would it make more sense to do the research on a particular niche and develop something that caters to it, or just create a comic for the sheer love of it and try to figure out a marketing strategy afterward? It seems like the more successful webcomics cater to a specific niche even if it wasn't their plan from the beginning. *Penny Arcade* and *PvP* cater to the gaming industry. *xkcd* caters to mathematicians and engineers. *Dinosaur Comics* and *Wondermark* cater to writers, satirists and fans of the written word.

> I think that what you're missing is that all of the creators you listed didn't "cater to a specific niche." They *are* that niche. Mike and Jerry are huge gamers. Randall Monroe (*xkcd*) is an intellectual nerd. These guys followed their passion and did what *they* wanted to do. It just so happened that their art form was pretty marketable, and financial success followed.

> I've always thought that anything can be monetized — it's just a matter of finding that opportunity and capitalizing on it.

Is there a future for some sort of comics consortium? Like: places where a bunch of creators band together to create a shared space to draw on each other's readers?

> The problem that I've identified with [collectives] is a problem of scale. In general, the system usually breaks down when one or more of the individuals' properties begins to take off. At some point, it becomes cumbersome to operate a successful business and participate in a consortium. Invariably, one or more of the members will be more successful than the others — and that always causes problems. And for the very successful members, it simply becomes necessary to leave the group so they can grow their business properly without running decisions through the group. Blank Label Comics gave this idea a full-throttle attempt — even forming an LLC that linked the members legally and financially. It didn't work very well, and that LLC is dissolved.

I worry that the ascension of Facebook is a problem for folks creating content like webcomics. Back when Digg and StumbleUpon were the most powerful drivers in this world, it was really good. Why? Because those are browseable sites. I didn't have to be friends with you to see what you were posting. So I could find people who liked stuff like I liked and follow their lead. Facebook is much, much more silo'ed. Sure, more people are on it, but you can really only see what your friends are doing. You can't browse. Is this a problem? Or do I just not get it?

> Change is a bitch, but it is always ripe with opportunities. As mentioned before, we're not making any huge forays into Facebook, especially since it hasn't seemed to affect our readership at all, but there will come a day where we will all need to adjust to some market condition that completely obliterates our existing models. It may be next year, it may be in 20 years, but it will happen. As creators I wouldn't be too concerned — your content will be consumed no matter the means of distribution. Putting on your business hats just means making sure you're aware of the current and future landscape.

Is there a good reason to exhibit and get a table at a con other than to make money?

One of the charms to being an independent artist is the ability to connect with your readers. Doing so in real life strengthens those bonds one-hundred-fold.

Do you think there is a rising opportunity for recent business graduates in the webcomic field?

I think most biz grads will want more money. We are quite greedy.

From what PA TV and your advice shows of your business methodology, you're constantly finding new avenues, new prospects. Where do you generate ideas?

Generating ideas is easy. Those come from just understanding the marketplace and observing trends in whatever space you are in. *Choosing* what opportunity to act on is much more challenging. There is no such thing as an unlimited resource, so placing your bet on an unknown is always very scary.

When do those expand past the business paradigm and how do (or do) you let these ideas develop into new business ideas?

Once you do your due diligence on an opportunity, you spec out the project with budgets, timelines, rate of return, etc. and either green-light it or kill it. This process can take as little as a few hours or as long as a few years. It really depends on the complexity of the idea and the draw on resources.

What do you do with ideas that just aren't immediately viable via a business method?

We either table them for the time being or find a partner that's willing to execute it now and bear that risk of failing until it *is* viable. This is the type of thing where having a really large Rolodex is helpful. Build that out. It can only help.

What is your prognosis for the future as far as self-syndication via the web? Do you have any projections for the next five to ten years, and what are some of your overall thoughts about the future, specifically for strip cartoonists interested in a career online?

Short answer, you'll be fine. Things will get better than they are now. I predict that local advertising and targeting will become more sophisticated, and that's only a good thing for independent sites/creators. The more hypertargeted ads can get, the more valuable they are to advertisers. The gap right now is a technology one, and the solution is only a matter of time.

How do you see your role in regards to the creators of *Penny Arcade*?

Answered earlier, but to go into more detail, I'm an adviser to Mike and Jerry while running the day-to-day of the business. We have a team of 14-15 people now, and I handle everything from accounting to HR. I also am the show director to PAX and PAX East and the managing director to Child's Play. 14-15 seems like a lot of people in our world, but when you've got so many initiatives, you're forced to wear many, many hats.

What do you add to their "raw" craft?

I provide them a space that allows them to be creative and unencumbered from any extraneous bulls***. Well, I try at least. :)

How do you rationalize your separation between business and creativity?

There's no rationalization. It's separate. I run the business around whatever they decide to produce as creators.

Merchandise

Selling merchandise directly to your readers is one of the central concepts of the Webcomics Business Model. In handling these chores independently, we're able to take a larger share of the profits generated by our work. It's extra work, granted. But it's work that will yield a significant return on your investment in time. Self-publishing books is a topic too big to be contained here, so I've given it its own chapter. But here we're going to discuss the broader concepts behind selling merchandise and examine a few of the other usual merch standbys, like T-shirts, calendars and prints.

THE LIES THAT READERS TELL

Picture it: A group of webcartoonists are all gathered. One of them, slightly more inexperienced than the others, shares an idea he had for a T-shirt design based on one of his comics.

"My readers really seemed to enjoy it when I shared the design with them," he says, "so I want to get it on my store as soon as possible."

The other webcartoonists agreed that the idea was funny — just not T-shirt funny.

"It's just not gonna fly as a T-shirt," they tell him.

"But ... I posted the design and a bunch of my readers said they'd buy this T-shirt!" he exclaims.

"Readers lie."

It's one immutable fact of webcomics: Readers lie about what they'd be willing to buy. No one really knows why, but they do. Maybe they're just being nice. Maybe they really think they would buy a T-shirt like that. But when it comes time to reach for the credit card and place the order, well, somehow that enthusiasm dissipates.

If you're planning to launch new merchandise, you can't rely entirely on reader polls and forum comments. If you don't have the down payment to have the merchandise printed or manufactured, your best bet is to set up a preorder (which we'll discuss shortly). With a preorder, you can accurately gauge reader interest — without taking a huge financial risk on untested merchandise.

KICKSTARTER AND PREORDERS

Back in the day, webcartoonists would handle preorders through PayPal. We'd make the announcement that a book was forthcoming and readers could preorder it — with the knowledge that it would be shipped immediately. Once the preorders had generated enough money to pay for the printing costs, the order was placed with the printer, the books were printed, and they were later shipped to the people who had placed preorders.

This was a pretty good system until PayPal started cracking down. In Paypal's Terms-of-Service contract, it states that shipment must be made within 30 days. Several webcartoonists found their PayPal accounts frozen when it was discovered that they had missed that deadline. There's a good chance you could handle preorders through PayPal and not get caught, but for me, it's an unacceptable risk.

The better option for handling preorders is Kickstarter.com, which is made specifically to handle projects like preorders. Kickstarter facilitates a "pledge"-style fundraiser in which people can agree to pay a certain amount of money to support a project. The readers' credit cards are charged only if the target amount for the fundraiser is met. If the target is not met, the readers' cards are never charged.

PROS

This is a completely above-board method of collecting money for a project that you don't have the up-front funds to pay for. And there's no risk. If reader demand doesn't support the production costs, no one gets charged and you move on to the next thing.

Additionally, you can set up several levels of pledging. For example, for a $5 pledge, participants could get their name listed in the back of the book as a supporter. For $20, they could get listed and get a copy of the book. A pledge of $30 could get the listing and a book with a sketch from you in it. Forty bucks could get all of the above plus a limited-edition print. And so on.

©ECCC Corp. **Tales From The Con,** courtesy of Emerald City Comicon (emeraldcitycomicon.com), is illustrated by Chris Giarrusso and written by Brad Guigar

As long as the additional cost of the extras that you're offering don't outstrip the total cost of the project, it's a great way of reaching your goal more quickly. Sometimes, you end up raising more funds than your target, and you get to keep that.

Finally, you can upload a video in which you pitch the fundraiser. This is a great way to deliver a personal message to your readers explaining why this preorder is going to benefit them — and allow you to produce the book.

CONS

Kickstarter does not use PayPal for its transactions; it uses Amazon's Flexible Payments Service. So you will need to open an Amazon Payments account to receive the money generated from a Kickstarter campaign.

Once you've reached your target fundraising goal, Kickstarter takes 5% and Amazon takes an additional 3-5% for processing the credit-card transactions. So pad that goal a little to offset their cuts. And ask your CPA how much you'll need to hold back for taxes!

People can be weird. From what I've heard, it's not uncommon that a small percentage of your pledges never actually become actual donations. Whether it's maxed-out credit cards, improperly entered data, or just plain-old tomfoolery, some of the transactions fail repeatedly until Amazon simply gives up.

Finally, it will take two or three weeks to get your money. Amazon will hold the funds for 14 days after payments are collected. Once this hold is released, project creators can transfer funds to their bank account (which can take another week).

11 TIPS TO KICKSTARTER SUCCESS

Having launched my first Kickstarter campaign, I've been doing a lot of "I make mistakes so you don't have to" research for this book. Here are a few things I learned and a few tips I've culled from others along the way.

START THE VERIFICATION PROCESS EARLY

I started the process for my first Kickstarter campaign in June 2012. It took me *three months* to get verified by Amazon Payments! I got stuck in a logjam that was only broken up (minutes) after I posted a particularly sour account of the process on my comic's blog. My theory is that I encountered

problems when I used my Employer Identification Number (EIN) instead of my Social Security Number (SSN) in the registration process. And I've heard anecdotal evidence from others who encountered a similar situation. I can tell you this: If I had to it do over again, I'd simply supply my SSN and register as an individual.

SET A REASONABLE GOAL

The Kickstarter campaign does not end with the goal. Stretch goals have come to be expected in a Kickstarter campaign. It's much more impressive (to a potential donor) to have surpassed a reasonable goal than to struggle to reach a lofty one.

DON'T END ON A WEEKEND

Pay close attention to the end date of your campaign. Ending on a weekend is murder. Internet traffic slows to a halt over the weekend. You want to be able to ramp up the excitement in the closing minutes of the campaign. And that's not going to happen while everyone's away from their computers.

ENGAGE

Answer questions and respond to comments. Talk it up on your social-media feeds. The more excited you are, the more excited they'll be. I received this compliment on Twitter:

> **@guigar** You're good at this, I only read comics and still felt like it needed to be backed. — *Lager Kire (@MayWeDieInThe) June 21, 2013*

POLL

Kickstarter allows you to take polls among your supporters. What a great way to gauge interest in stretch goals and rewards.

PARTICIPATE

There's a huge social aspect to Kickstarter. People will look at how many Kickstarters you've backed and use that to help decide whether to back *yours*. A healthy number of backed Kickstarter campaigns can replace name recognition or brand.

MAKE IT VISUAL

People don't read. They look and *then* they read (if they're interested). Show pages from the comic or book that you're gathering funds for. Get them interested.

SHORT AND SWEET

Make your video friendly, informal and — most importantly — short! Get to the point. There's nothing worse than trying to slog through a video that takes too much time showing you how cute the creator can be with iMovie. I wanna know who you are, what you're doing and why I need to be involved. Make eye contact. Smile. And talk clearly.

AVOID MAILING

Wanna know what's going to take a bigger bite of your profits than you're prepared for? Mailing costs. They're gonna eat you alive if you're not careful. Avoid shipping anything to anyone until you get to your higher tiers. Make as much use of digital rewards as you possibly can.

ADAPT

Listen to your supporters, study your numbers and adapt your campaign accordingly. I noticed that my Kickstarter was stagnating a bit because my reward tiers topped out at $100. When I included rewards at higher numbers, my campaign took a leap ahead as new supporters joined the campaign. But more importantly, current supporters increased their pledges. They wanted to give me more money, but I wasn't letting them!

CLEAR YOUR SCHEDULE

This was originally a top-10 list, but I can't not include this one: Clear your schedule for the next 30 days. You have a defined window of opportunity, and you need to be completely tuned-in to make this happen. That means a significant investment of time and mental energy. Get ahead on your buffer and warn your family. This is going to be 30 very intense days.

KICKSTARTER VS. INDIEGOGO

Kickstarter was one of the first companies to facilitate the crowdsourcing of creative projects. However, there are other choices — including Indiegogo. If you're trying to decide between the two, it is your responsibility to read and understand the terms of use for each. Comparing the two:

FUNDRAISING

In **Kickstarter**, you get paid only if you reach your campaign goal.

Indiegogo, offers two options: Flexible Funding and Fixed Funding. Many folks choose the Flexible Funding option, in which get paid whether you reach your goal or not. The Fixed Funding option works like Kickstarter — You get paid only if you reach your goal.

FEES

As mentioned, **Kickstarter** uses Amazon's Flexible Payments Service. Once you've reached your target fundraising goal, Kickstarter takes 5% and Amazon takes an additional 3-5% for processing the credit-card transactions.

Indiegogo, too, uses a third-party payment processor with whom you will need to establish an account. It offers two funding options.

Under **Flexible Funding,** you get paid whether you reach your goal or not. A successful campaign will be charged a 4% fee to Indiegogo, about 3% to PayPal and 3% to the credit-card company handling the transactions. If you don't reach your goal, the other fees remain the same, but the Indiegogo fee increases to 9%.

Under the **Fixed Funding** option, you only get money if you reach your goal. Indiegogo will enact a 4% fee, and Paypal will take about 3% of the cut. If the goal is not met, you are not charged anything.

WAIT TIME

Kickstarter will take two or three weeks to get your money. Amazon will hold the funds for 14 days after payments are collected. Once this hold is released, project creators can transfer funds to their bank account (which can take another week).

Indiegogo initiates all necessary fund transfers on Friday, and includes campaigns that have ended by Thursday at midnight, the day before. It takes 5-7 business days for the disbursed funds to arrive in your account. After that, you can transfer the money to your bank account, which can take up to a week.

TAXES

You are responsible to report and pay taxes for the funds you receive whether you use Indiegogo or Kickstarter. Kickstarter requires a U.S. bank account*; Indiegogo can be used internationally.

COMMUNITY

Of the two, **Kickstarter** has the bigger community. One source I read reports the difference being

* Kickstarter recently announced that it would open up to Canada-based projects.

900,000 members vs. 22,000. And that means that despite the fact that **Indiegogo** is steadily growing, right now Kickstarter offers more potential donors.

THE COST OF 'FAILURE'

For me, it comes down to this: Getting money for a campaign that does not reach its goal is not a great idea. Indiegogo's Flexible Funding option sets up the possibility that you could fall short of your goal, *then fall even shorter* by the time the fees are extracted. That might mean that you can't afford to launch the project. Now what do you tell the donors who saw money leave their accounts and expect something in return?

If you offered a perk in exchange for the donation (say, a free book), you're in a tight spot. If you can't afford to print the books, you'll have some very angry donors to deal with. Lots of luck asking for a donation again — let alone asking that donor to buy another book.

Kickstarter's structure — paying out only if you reach your campaign goal — is there to *protect* you. If you don't reach your goal, the money never leaves the accounts of your donors. In my opinion, I feel safer either running a Kickstarter campaign or using Indiegogo's Fixed Funding option.

SETTING A PRICE

Setting a price point isn't a guessing game. It's math. First you need to know your unit cost:

- How much will it cost to do the entire run? (This number should include incidentals like shipping the merchandise to you, storing the book, etc .)
- How many units will be produced?
- Divide the total cost by the total number of units and you have your unit cost.

Your retail price has to be high enough that it will still leave room for a profit after subtracting the unit cost (and any other costs involved).

Sounds easy, right?

ACCOUNTING FOR DISTRIBUTION

If you're going to try to place the merchandise in stores through a distributor, you have to realize that distributors generally buy merchandise for 65% off the retail price — and you're going to have to ship those books to the distributor. Be sure to factor both (even if you have to estimate) into your equation.

No plans for distribution? Now you can get a little creative with your price point, trying to aim at some of those magic numbers ($10, $20) that seem to work so well at conventions (where you're likely to be doing a lot of selling). But in cases like that, I always lean toward setting the price point a little high. I can always reduce the price and offer a sale. But once that price is set, people get awfully touchy if you try to increase it.

STORAGE

Once you begin offering merchandise, you're liable to be faced with the challenge of storing your stock. Here are a few options and some thoughts on each.

BASEMENT STORAGE

I prefer basement storage over any of the options I've experienced so far. First off, it's very well climate-controlled. In general, it's cool and dry. If dampness is an issue where you live, you should invest some time and money into waterproofing. And definitely run a dehumidifier.

Air flow: When storing boxes of books, never stack them directly on the floor. This creates trapped space, which encourages mold growth. If your boxes were shipped on a palette, keep it and stack them on the palette. It will allow the air to flow under the boxes (there's a fancy French word for this). Nonetheless, do what you can to encourage air to circulate under and around your stack of boxes. For example, pushing them directly against a wall is just as bad as stacking them on the floor. The more you allow air to circulate around your boxes, the harder it will be for mold to form.

Water hazards: Try to find a place that will remain driest in an emergency. Stacking boxes directly under a water pipe probably isn't wise. If your basement is prone to flooding, try to find the corner with the highest elevation — or the one farthest from the sump pump (if you have one). Heck, I've even built a makeshift canopy of tarpaulin over a crate of books because of one measly water pipe. Better safe than sorry.

RENTED STORAGE

You can rent storage quite easily. In fact, depending on where you live, this could make accepting delivery much less of a hassle. However, before you sign a lease, do a quick cost-effectiveness evaluation. How much is it going to cost to store this merchandise for a year? How many units will you need to sell before the profits cover this cost? If this represents a small percentage of your total sales, then you're making a good decision. If not, you need to reconsider your options.

WAREHOUSING

Of course, when you start dealing in merchandise at a much greater scale, you're going to have to consider operating with a distributor and having your merchandise stored at the distributor's warehouse — at which point the distributor will be filling orders and you will pay for warehouse space by the square foot as well as a "pull and pack" charge on each order. That's a way off for many of us, but it *is* one of the options.

INSURANCE

No matter which option you choose — or if you decide to solve this problem in a completely different way — please take a few moments to get your insurance agent on the line and discuss protecting your merchandise in the event of a catastrophe.

Accidents can and do happen. We can't prevent them. But we can be prepared for them. The only thing worse than losing a $10,000 in books is losing that investment and not being covered for the loss.

Do it now while you have that lump in your throat.

GET SHIPPING IN SHAPE

Shipping merchandise can create an unnecessary drag on the profitability of your merchandise — not to mention the time that it can steal from your workday. Here are a few tips on handling shipping.

• Pass shipping costs along to the consumer. If your online store's software doesn't allow you to peg shipping costs to the recipient's ZIP code, at least estimate a flat fee to cover shipping. Just don't estimate too high or you may wind up (a) discouraging sales and (b) getting accused of trying to gouge your readers.

• Use "Media Mail" when shipping books (and books only) — but only when you have about 4-6 weeks for delivery. Be sure to use delivery confirmation to track your packages, though.

• You can schedule a home pick-up. Go to USPS.com and click on Schedule a Pickup. (It's in the column on the left-hand side.) You can leave your packages at a predetermined place (and even leave directions for the postal employee to guide him or her to where you put them). As long as you notify them before 2 a.m. CST the day of your scheduled pickup, you're in the clear. Just make sure your packages are sealed and ready for shipping (including postage).

• The United States Postal Service will send you some supplies — such as Priority Mail Flat Rate envelopes and boxes and even Priority Mail tape — at no charge. Using the flat-rate shipping packaging, you pay one flat rate for shipping regardless of shipping or distance. Fair warning: If you use the Priority Mail tape on a package, they're going to insist that you ship that package Priority Mail. It's kind of a thing with them.

• Don't wait in line. You can handle a lot of your postage online. You can print and pay postage at USPS.com and at PayPal.com. (Through PayPal, you can ship using either the post office or UPS.) And, of course, there are systems such as those sold by Endicia.com that enable you to print postage in your studio.

• Uline is an amazing source for shipping materials. The Easy Fold Mailer, for example, is perfect for shipping books. Since the box is variable-depth, I can ship one, two or several books using the same box. This is not water-tight packaging, however, so consider protecting those books with poly bags before boxing them or sealing the edges of the box with tape.

• Finally, consider presentation. You probably can't afford preprinted packaging, but a modest investment into a custom rubber stamp you can turn any package into one that reinforces your brand.

Remember, your entire business model depends on the moment at which a casual reader becomes a supportive member of your community. And when that support is being expressed in purchasing merchandise, you have to do everything in your power to make that experience a positive one. That means shipping as quickly as possible — with the merchandise arriving in great condition — and leaving your reader well-rewarded for his experience.

TRAINING READERS TO EXPECT MERCHANDISE

Special thanks to Kickstarter supporter Chris Watkins (OdoriPark.com)

By offering something new in your online store at a predictable rate (for example, the first update of the month), your readers will come to anticipate the announcement. And that anticipation builds excitement and urgency — which are great things to have when you're trying to generate a certain amount of impulse buying.

MAP OUT NEXT YEAR

In each of the months, try to plan the release of one new item of merchandise. This can include milestone items (such as book collections) and incidentals (like buttons). Try to space merchandise that requires a significant up-front payment and large amounts of preparation (offset-printing projects) between offerings that require little or no cost/prep (desktop wallpapers, PDFs, etc.).

Now chart out the conventions and other personal appearances you're planning. It would be great to plan larger merchandise premieres with personal appearances. Don't forget other important dates — like Christmas, Free Comic Book Day, Comic-Con International — when there will be plenty of ambient comics/shopping promotion in the air for your sails to catch.

STAY FLEXIBLE

Inspiration will strike. A punchline will go over so well that it will become obvious that you have a T-shirt run in your future, for instance. Or your financial outlook will change, and you might have to delay the printing of your next book. You can always move items around on your agenda to compensate for your changing landscape. If money's tight, push the offset run back a few months and move the buttons and the desktop wallpapers forward. If you have a brilliant idea for a T-shirt, jostle the buttons back a month — or plan for the two to dovetail in some way.

FOLLOW THE PLAN

Now, post this guide prominently in your workspace. Chart off the days that you'll plan to release the merchandise — and try to keep the frequency from month to month as consistent as possible. And, while you're at it, chart off important milestone days such as deadlines to send files to the printer, days to start working on the next T-shirt design and so forth. The entire goal of this exercise is to help keep yourself on track in the coming year — eliminating those "Oh no! I can't premiere the book next month because it's not ready yet!" moments.

BEWARE OF SUCCESS

You can "train" your readers to expect new merchandise on a predictable frequency. And that's good for all of the reasons listed above. But that means that missing an update is going to lead to

disappointment and frustration on the part of your supporters. This is a pretty strong sales tool, but it can backfire completely if you're not prepared to commit fully.

T-SHIRTS

After books, the most popular form of webcomics-related merchandise is the T-shirt. Oddly enough, it's also the most misunderstood of all of the merchandise options that webcartoonists have.

For example, after years of trial and error (mostly the latter), we've seen a few truisms develop. With a few notable exceptions, these T-shirt ideas *don't* sell very well:

- A T-shirt that features a webcomic character
- Shirts that feature the comic's logo or title
- Reprinting an entire strip on a T-shirt

T-shirt design takes the concepts that we discussed in designing banner ads, and condenses it even more. The best-selling webcomics T-shirts present one simple, compelling thought and one equally strong, simple illustration.

In creating a T-shirt concept for your webcomic, start by identifying the updates that seemed to resonate the best with your readers — the ones that generated the most e-mails, tweets and comments. Take each one of those concepts and distill them into their most simple form. The goal is to generate something that can be consumed in a split second — without sacrificing meaning. That means that any word that doesn't contribute to this goal has to be eliminated, and the image has to be as direct as possible.

Many webcartoonists are obsessed with making the T-shirt into a billboard for their sites, and they conspicuously brand the shirt with their comic's logo and/or URL. My advice is to avoid doing this — beyond a small URL under the image, along with a copyright notation. I know you think you're going to pick up extra readers when the T-shirt buyer walks around and everyone trips over themselves running to find the source of that hysterical one-liner. But my opinion is that the sales that conspicuous branding blocks far outweigh the benefits of this kind of marketing.

The folks who run Topatoco.com are hands-down the all-time Jedi masters of T-shirt design. Spend a few hours browsing their Web site and taking notes. You'll learn more doing that than you could learn in reading three books on the topic.

PRINT-ON-DEMAND SHIRTS

As with books, you can offer readers shirts through a print-on-demand (POD) process. This eliminates the need to handle a bulk run of shirts before opening sales, and you never have to worry about storing, shipping and stock management. However, there's often a smaller margin for your profit, and in some cases, quality can be lower than a silk-screened shirt.

Some POD shirts are produced through a heat-transfer process (we used to call 'em "iron-ons" back in the '70s) that can degrade significantly after laundering. But POD technology is changing, and some POD T-

HOW MANY T-SHIRTS SHOULD I ORDER?

Ordering T-shirts in bulk is a dicey proposition because, unlike with other merchandise, not only do you have to have the item in stock to make the sale — but it also has to be the correct size for the potential buyer. Although it's impossible to know how many shirts to order in each size, I'll share with you the breakdown that I've used in the past.

10% Small
10% Medium
30% Large
25% XL
25% XXL

shirts are printed with a variation of the same process found in inkjet printers. The quality and durability of their merchandise ranks up there with silkscreen. Do a little research before signing on. You might be happily surprised.

SILK-SCREENING

If you decide to handle the production of a T-shirt run independently, spend a little time finding a good printer. Working with a local printer may mean you can pick up the finished product instead of paying for the shipping. A good printer will also be able to offer you a wide selection of T-shirt styles and brands.

In the printing process, a negative of your image is used to block certain areas on a mesh screen. Ink is spread over the screen and applied to the shirt by pressing it through the mesh. The ink reaches the shirt in all of the areas unblocked by the mesh. For this reason, your design should not feature any fine details that are likely to get lost or smudged during the process. I try to keep all of my linework above two points (0.03 inches) in width.

Remember, silkscreening does not usually apply the same process as CMYK printing. Except in very special circumstances, it uses spot colors — one screen for every color the design uses. That means that you pay extra for every screen. The more colors you use, the more expensive the project is going to be. An American flag, printed on a white T-shirt, would require two spot colors (red and blue). Printed on a black T-shirt, that same design would require three colors (with the addition of white). With that in mind, it might be tempting to print all of your designs on a white T-shirt. However, be careful. White T-shirts tend to sell more poorly than black ones. You can, of course, increase the range of hues available to you by using "screens" of each spot color. For example, if one of your spot colors is blue, you can have a dark blue using 100% of the ink, a medium blue using 50% and a light blue using 10%.

In prepping an image for silk-screening, I strongly recommend using a vector-based software such as FreeHand or Illustrator. You can easily convert the hi-res lineart to vector (the function is called "Live Trace" in Illustrator) and add colors from there. The added benefit (beyond image sharpness) is that you can designate the colors as "spot colors." You can even choose the colors from a Pantone library that will allow the printer to match your color choice accurately. (I choose from the Pantone Solid Coated library.) This is going to make it extremely easy for the printer to produce the image you've created.

SELLING PRINTS

Selling prints of individual comics is an excellent way to boost your revenue and offer something to your readers that many might appreciate — the opportunity to own a physical print of their favorite comic. This merchandise is often going to be an impulse buy — the decision to buy will be made very shortly after the reader finishes the comic — so make the link prominent and close to the strip itself.

You have lots of options for printing — some of which may offer additional features such as matting and framing. Of course, those extras are going to drive the price up and, since this is likely to be an impulse buy, that's going to dampen sales. Here are some options:

- Have them printed at a local print shop. It's not a bad idea to build a relationship with the people who operate the print shop near you. And you'd be surprised how helpful they can be when you bounce questions off them about stock and ink/dye quality.

- Use an online printer. There are several to choose from. I used overnightprints.com for my holiday greeting cards this year, so I priced out their printing. For a single, poster-size print (11x17 inches) on 100# glossy stock, you'll pay $6.95 plus shipping. Of course, your image doesn't have to fill the full page. Just make the image whatever size you want and trim what you don't need.

- Café Press offers prints that are matted and framed (through their partner Imagekind.com). Unfortunately, these tend to be a bit pricey. A 10x3.3-inch print, matted and framed, will run about $70, not including shipping.

- Desktop printers have made amazing strides in the past several years. If you have a good printer, you could very easily process your own prints on high-quality stock.

In terms of size, I favor something that the recipient could easily frame with a store-bought frame if they so desired. For my comic strip, the image size is about 10x4 inches. That's a size that's easily matted-and-framed into a 12x9-inch picture frame.

MATTING

And, for a couple more bucks, why not offer matting? It makes a way cooler presentation when your reader opens his or her package, and adds a bit of prestige to the purchase. And cutting mats is really easy with the correct tools. Go to any arts-and-crafts store and ask. They'll set you up.

However, if you don't want to do that extra work, here's a tip:

Determine a standard image size for your prints — that's the size of the actual image on the paper.

Using that, figure out what the window opening and borders would be on a mat that would contain that image and result in an easily frameable, matted print.

Now, search for "precut mats" on the Web, and discover that you can cheaply order mats, cut to your specific dimensions, quite inexpensively. Pictureframes.com, for example, offers this service.

Order your precut mats and simply place each print into the mat before shipping.

The dimensions of a comic strip dictate that you're going to have a little extra space at the top and bottom of the paper. I don't recommend trimming — that's something the recipient can do. And, depending on how they're going to display it, if you trim too much, it might put them in an awkward spot. It's easier for them to trim than for you to try to explain why there's not enough paper around the image. If you're matting the prints, make the bottom border just a little bit bigger than the top. It helps balance the mat.

Once again, this is liable to be an impulse buy, so anything you can do to keep the price point low is a good thing. You'd be well within your rights to charge more for a signature, but it might dampen sales.

The last thing you want to do is lose your profit on a low-price item by having to replace it. I hoard cardboard for this very reason.

Wrap the matted print in clean, white paper — making sure the tape doesn't touch the mat. If the print isn't matted, I'd suggest cutting a piece of cardboard to size and sliding it behind the print before wrapping it for support.

Sandwich the wrapped print between two pieces of cardboard — also cut to size — and tape the whole thing together.

Place the protected print into a box or padded mailer. I have some awesome boxes from Uline that are just right for shipping books or prints. I use one of those.

CALENDARS

This suggestion gets made by earnest fans regularly: "If you offered a calendar based on your comic, I'd buy it."

We've already discussed how readers can lie, but for now, let's talk about the calendar as a part of your comic's merchandise roster — and why you'll want to give it careful thought.

Doing a calendar is no different from doing a book. The most notable difference is that saddle-stitch or spiral-binding is much more acceptable since the page count is so much lower than that of a book. And, of course, you flip the pages down instead of across the binding.

Aside from that, it's really no different from setting up a book. You can buy software to lay out the calendar, but, let's face it, you can easily get any year's dates with a quick Web search and copy/paste them into a grid of your own making.

Designing a calendar should be relatively straightforward as well. Obviously, you'll want to make your images as appealing (and as large) as possible. As for

the monthly grid, you'll likely end up making a choice between the utilitarian grid that allows parents to pencil in the time of that date's soccer practice — or the artsy-fartsy arrangement of numbers that allow nothing more than a framework of which dates fall on which days.

OFFSET OR POD?

Finally, as with any book, you'll be making the Big Decision of going print-on-demand (POD) or printing through a traditional offset printer. POD, as we've discussed before, allows you to print a

unit only after someone orders it. There's no down payment on the part of the creator, but the profits are considerably less than with an offset printer. With an offset printer, you'll make a much better per-unit profit, but you have to order in bulk.

And there's the rub.

If you order too many, you're going to be stuck with an item that no one will buy after January.

Calendars have a very short shelf life. Sales can start in September, but people tend not to get serious about calendar-buying until about four weeks between late November and early December. And after January, you can forget about it.

So you take a considerable risk in offering an offset-print calendar, and, since POD unit-costs are markedly higher for color printing, you'll make very little profit trying to sell them on demand.

That's not to say that making a fair profit with a calendar based on your comic is impossible. But chances are very good that your time and energy might be much better spent preparing merchandise that has a much longer shelf life.

If you do decide to produce a calendar, don't miss the opportunity to make it a marketing tool for your webcomic. For example, most calendars identify certain holidays on the dates they fall into for the year, so why not include some of the dates that might be special for your readers?

- Your birthday
- The anniversary of your comic
- Any comic-related milestones (500th update, etc.)
- Any planned convention appearances
- Character-related dates

CALENDAR STRATEGY

When I released my 2010 calendar, it was November. And, truthfully, I figured this was plenty of time. One of my readers was very upset with me for releasing it so late.

I was perplexed. I couldn't imagine anyone wanting to purchase a calendar before November, and yet, there was clearly a segment of my readership who had already completed their calendar-shopping for the year — and given the choice, they would have chosen my offering if it had been available.

So, the following year, I offered my calendar in early October. And my sales were brisk.

But my new recommendation is to release your calendars at the beginning of *September*! Why? Three very good reasons ...

Conventions

I brought 20 calendars to New York Comic Con in 2011, and I was sold out either Saturday night or early Sunday. They flew off the table.

Calendars have an edge on the convention table:

- **Low competition:** Not many of your fellow exhibitors will have calendars on their tables (other than your fellow Webcomics.com subscribers). So this merchandise stands out.

- **Uniqueness:** It's different from the usual book-and-a-T-shirt merchandise you find at conventions.

- **Early bird:** Offering calendars at autumn conventions means you get a purchase from somebody who says: "Geez, I'm gonna buy a calendar this year anyway ... I can cross that off my list now and get something cool and unique."

If I had those calendars on my table in Baltimore the month before, I'm convinced that I would have made a killing.

The personal touch

About midway through the convention in New York, one guy who was buying a calendar asked for a sketch inside it — the way I do with books. Thinking on my feet, I asked him what month his birthday fell in. He said April, and I flipped the calendar open to that month and did a special sketch, with one of my characters delivering birthday wishes.

Every calendar after that had a special sketch on the purchaser's requested month.

Artist Editions

Even if you're not planning to attend conventions in September, October or November, you should still plan to have your calendars prepped and available by September, because if you do, you can order yourself a small stack and offer them on your Web site as Artist Editions.

Most storefront solutions include a way for the purchaser to communicate with the merchant. In PayPal, it's "NOTE TO MERCHANT." Advise your readers to indicate the month they want the illustration drawn in — and any birthday messages (if this is a gift for someone else, for instance) — and you've got a rock-solid early-fall merchandise offering.

And your sketches could simply be your characters, or they could deliver birthday wishes, or they could contain references to the person's astrological sign ... the possibilities are endless.

Heck, you could do a very limited number of calendars with sketches on each day and sell it for a premium price.

BOTTOM LINE

Start prepping your calendar in July/August — which is about the same time that you should be working on ...

HOLIDAY CARDS

In 2009, I launched a couple of Christmas cards and the response was so overwhelming, it became a regular part of my merchandizing. It has become very popular with readers, but take a word of warning, this is a project you'll want to start in early fall. You have to be able to ship cards in late-October and November so your customers are able to receive them and then mail them out before the holiday.

Designing Christmas cards — and let's note here that the term "Christmas card" is being used as a catchall phrase for all of the holiday cards that get purchased during the winter holidays — is a lot like designing T-shirts.

No one is going to buy one with your character(s) on them. No one is going to buy them with your strip reprinted on them (unless maybe it's a well-targeted single-panel comic).

What they are going to buy are cards that express your unique sense of humor or your identifiable illustration style. It's perfectly fair game to swipe a punchline from a strip. And it's perfectly OK if the card has little-or-nothing to do with your comic.

Take the earlier discussion about designing great T-shirts and apply it to your Christmas-card concept.

When you think about it, designing a greeting card is very similar to creating a two-panel comic. The cover is the first panel and the inside can be the second panel.

In fact, it's an incredibly effective two-panel comic because it's impossible to look ahead to the punchline and ruin the buildup. You can build a nice amount of suspense that will charge the payoff nicely.

Of course, you can also approach it as a single-panel comic — with a nice themed message on the inside.

Online printers usually offer specials in the fall for printing greeting cards. Check out PSPrint and Overnight Prints for their deals. Make sure your order comes complete with properly sized envelopes for the cards. If it doesn't you'll need to buy some.

Remember, you're shipping off someone's greeting cards. They need to arrive in good shape. I bought cardboard boxes from Uline last year, and they performed beautifully. Uline and other packaging vendors sell boxes that can be sized perfectly for this use.

I've offered this card to my readers three years in a row — with great response each time.

CREATING A PAYPAL GIFT CERTIFICATE

Online gift certificates are a great way to bring in some extra revenue — especially around the holidays. What's more, a gift certificate is an additional way that an "active fan" can express his or her fandom — by encouraging someone else to try your work by giving them a gift certificate to your site. You can build them easily using Paypal.

- Find the form to create a Gift Certificate button, for your readers to buy and give gift certificates to your store, under Merchant Services. It will be listed under Create Buttons.

- You will be brought to a form. Fill it out.

- Place the HTML code for the Gift Certificate button on your site. Readers will now be able to click that button and be taken to a standard PayPal checkout page, on which they can designate a certain amount of money to be designated to a virtual "gift certificate" (a code) that can be sent to the e-mail address of their choice.

- Upon receiving this code, recipients can shop your store, add items into their shopping cart, and submit their gift-certificate code during the checkout process.

DONATIONS

Special thanks to Kickstarter supporter Joe McGlone (Aliencomix.com).

Accepting donations on your site is a fairly well-accepted practice for most cartoonists. But if you're going to ask for money, many people argue, why not offer something in return? It stands to reason that this is not only polite, but it would increase the total number of donations. Offering a downloadable desktop wallpaper is an awesome way to encourage donations. The wallpaper itself is merely a JPEG that users will download and install on their computers. Plus, it's a nice bit of promotion for your site. Luckily, PayPal makes this extremely easy.

- Set up a Donation button. (It's found under the Merchant Services tab.)

- Under Step 3 / Advanced Features, you're able to designate a URL to which PayPal will send users after they have successfully completed their transactions.

- In the field, type the URL that you will use to store a page of links to your desktop wallpaper.

- Design a "landing page" for your wallpapers. This is where users will land after donating the money. You should have links to several sizes of the wallpaper that you're offering — based on common sizes and aspect ratios typically available on monitors.

- Offer to e-mail a special wallpaper to anyone requiring a specific size or ratio.

DEFAULT GIVEAWAY

I have created a default checkout page that PayPal redirects to once a sale or donation has been successfully transmitted. This page is hosted on my site and features links to the different sizes of the wallpaper being offered.

This can easily be set up in your Account profile. Once you've logged into Paypal:

- Click on My Account.
- Click on Profile.
- Click on Website Payment Preferences.

- Turn Auto Return on. In the space provided for Return URL, place the URL of your donation wallpaper page.

Now, when a person successfully makes a purchase or donation, PayPal will redirect to this page, and once they're there, your readers can download the wallpaper on their own.

Incidentally, when I first started offering monthly comics as a digital download, this is the exact same process I used. We'll talk about that in great detail in Chapter 14.

WALLPAPER PAGE

The wallpaper page that you make PayPal redirect to should make it clear that this is a wallpaper download page, and it should offer several sizes and proportions of wallpapers to meet the varied needs of your readers. Offer to make a special wallpaper for anyone who needs a size or proportion not listed on the page.

I always include a note that politely asks the readers not to share the URL of the download page with their friends.

Books

It's one of the great ironies of webcomics: We make a large percentage of our money in print.

Self-publishing books is a huge part of almost every successful webcartoonist's revenue stream. The "book" part isn't the hard part. After all, if you've been working on a webcomic, you've been producing the content for the book all along. It's the "self" in "self-publishing" that trips so many of us up.

Incidentally, it's that "self" part that provides all of the profitability that we need to become successful.

So, yes, it's a lot of work, and there's a lot of stuff to learn that has nothing to do with cartooning. But if you can master this part of your business, you're well on your way to maximizing the revenue potential for your webcomic.

READING A PRINTER'S SPEC SHEET

So, you've decided to get a quote from an honest-to-goodness printer for your next book run. You've e-mailed a quote request, and you've gotten a prompt response. One that you cannot decipher for the life of you. Fear not, here's a quick guide based on an actual book quote:

QUANTITY: 500- 1,000- 1,500 (Tolerance: 10% overs, no unders)

SIZE: 8 1/2 X 11 finished, with bleeds

COVER: 10 pts C2S, Printed 4/0, Process, offset printing. Gloss lay-flat lamination. Customer to supply PDF files, printer to supply 1 set of high-resolution laser proofs.

TEXT: 70 lb text, gloss coated. Customer to supply PDF files, printer to supply 1 set of laser proofs.

BINDING: Perfect bind.

PACKING: In double wall cartons on skids.

FREIGHT: F.O.B. Client: Philadelphia, PA 191** USA- Residential delivery with tailgate. Additional handling, freight or storage is extra.

TAXES: Applicable taxes extra.

TERMS: To be determined - Subject to review.

QUANTITY:	500	1,000	1,500
Total cost:	$2119.00	$2749.00	$3369.00
Per-Unit:	$4.238	$2.749	$2.246

QUANTITY

These are the quantities for which I requested quotes. 500 books, 1,000 books and 1,500 books. 10% tolerance means that, since printing presses don't stop on a dime, I might get up to 10% more than I ordered. And I will have to pay for them.

SIZE

8.5x11 is the finished size. Bleeds mean I have the option of letting the images run off the sides of the pages because the paper will be trimmed after being printed. More on bleeds later.

COVER

"4/0" means it will be printed in full color on the outside and no printing on the inside. This "xx/xx" figure denotes the inks used on the front and the back of the paper. 1/1 means black-and-white printing on both sides, for example. 4/1 would be color on the

EVIL INC.

BOOK-MATE #:

Anticipated Production Date	Trim Size	Quantity	Tolerance	Page Count
June	8 1/2 x 11 Bleed	500 - 1000 - 1500	10% (No Unders)	96

Cover	Paper	10 pts C2S	Spine: 11/64"
	Printing	4/0 - Offset printing	
	Protection	Gloss lay-flat Lamination outside only.	
	Material	Customer to supply pdf files, with laser copy	
		Printer to supply 1 set of high-resolution proofs.	
Text body	Paper	Gloss Coated - 70# text	
	Printing	4/4 - Offset printing	
	Material	Customer to supply pdf files, with laser copy	
		Printer to supply 1 set of laser proof.	
Binding	Type	Perfect Bind.	
Packing/Delivery	F.O.B	Plant - Freight not included in prices.	
		Bulk pack in double-wall cartons on skids.	

Taxes Applicable taxes extra

Terms of payment : Prepaid

QUANTITY	500	1000	1500
Total	$4,443.00	$5,563.00	$6,570.00
Unit price	$8.886	$5.563	$4.380
Additional copies	$8.176	$5.118	$4.029
Freight costs not included	$372.00	$372.00	$409.00
Options			

FREIGHT: F.O.B. Client: Philadelphia, PA 19130 USA- Residential area, small truck with Tailgate:

Prices are in US dollars

Due to material cost fluctuations, the quoted price is valid for 60 days and/or if production begins according to the Anticipated Production Date and completed within 60 days of the quote's date. Each order related to this quotation is submitted for credit approval. See Conditions of Sale on next page.

Upon confirmation of your order, please indicate the desired quantity and return to your CSSC; signed and dated. By signing you recognize and understand the conditions of sales and payment terms.

Accepted by:_____ Page 1 of 2 Date:_____

BOOK SMARTS

Spine: The end of a book that holds all the pages together.

Publisher: An entity that handles all of the production and business aspects of creating and selling a book. It collects the money and pays the creator a portion.

Printer: A company that prints books, etc.

Distributor: An entity that buys books wholesale (usually 65% off the cover price) and solicits retailers to carry the book in their stores.

Cover price: The retail price of the book. The cover price has to be high enough that it covers a book's per-unit costs (printing, shipping, etc.) — even if it's being sold to a distributor at a discount.

Royalty: The portion of a book's profits that a publisher passes along to the creator.

front, b&w on the back. We'll go over cover prep in depth at a later time, too. Process color: CMYK — not RGB. Offset printing: Printing press, not laser or thermal printing.

SUPPLIED BY...

I give them PDFs. They give me high-resolution proofs before committing to press. In my experience, the printer ships a box of proofs for me to examine. If I OK them, I have to sign an approval document and ship the box back to them. If I spot errors, I contact the printer about correcting those errors. They may "soft proofs" — PDFs of the corrected pages — for me to approve in this case. If your printer is in a different country, you may want to budget accordingly for this step.

TEXT

70 lbs. refers to the "basis weight" of the paper — the weight of 500 sheets of this particular paper stock at its "basis measurement" (usually 8.5x11). The higher the number, the thicker the paper.

BINDING

Perfect bound: The pages are held into the book at the spine by glue. Saddle-stitching (i.e. staples in the spine) is one alternative, as is spiral binding (like a spiral-bound notebook).

PACKING

Double-wall cartons: The boxes are packed inside larger boxes for added protection. Skids are wooden pallets.

FREIGHT

F.O.B.: "Freight-on-board" shipping means that the buyer is paying for the shipping. In some cases, it may mean that you're liable for damages made in transit. Be sure to ask. Residential delivery with tailgate means they're bringing it to my house, so they'd better have a tailgate mechanism to get the pallet off the truck because I don't own a forklift. There are several options available to you in this regard, so be sure to discuss it thoroughly with your printer.

TAXES, TERMS, QUANTITY

Natch', natch', natch'...

TOTAL COST / UNIT COST

The total cost is, well, the total cost for that quantity (plus or minus the aforementioned 10%). Notice, my shipping is factored into the cost of the book, which makes my cost-analysis for this print project that much easier. The unit cost is the cost per book.

PRINT-ON-DEMAND VS. OFFSET

Print-on-demand (POD) is a service through which you upload your book (usually in PDF format) to a printer, and it prints and ships one copy of your book for every order that comes in. Then, it sends you a predetermined portion of the profits. **Offset printing,** on the other

hand, is a process through which a large number of books are printed at once on a printing press. Typically, the books are then shipped to the buyer (or the publisher), who is then responsible for order fulfillment.

POD is a terrific way to get started in self-publishing. There is a very limited cost for entering the marketplace, so you are taking a very limited risk. If the book doesn't sell very well, you're not losing a significant investment. And the quality of POD books can be surprisingly good — including variables such as paper quality, print quality and binding. However, color tends to be expensive in a POD book, and that means that you must either raise the cover price or lower your profit expectation.

The unit cost of POD books tends to be much higher than the unit cost of an offset-printed book (depending on the volume of books you're printing). So, once your book sales start to climb, you'll inevitably start looking at buying books from an offset printer. Through offset printing, you can have a large number of books printed for a lower unit cost; however, the responsibility of storing and shipping the books is now on you.

SETTING A PRICE

Although we covered setting a price in the previous chapter, let's take a look at some specific issues that come into play when setting the cover price on a book. The first step is determining the unit cost of the book. This involves adding up all of the money you're putting into getting the books printed, including:

- Printing costs
- The cost of having the books shipped to you
- The cost of storing the books

Dividing that total cost by the number of books will give you the unit cost. The difference between the cover price and the unit cost is your profit. However, that profit has to be large enough to cover incidentals involved in selling the books, such as shipping the books to fill orders. If you're planning on releasing your book to retail outlets through a distributor, the cover price has to be high enough that you're still making a significant profit after selling the book for 65% off the cover price (and subtracting costs such as shipping the books to the distributor).

Your cover price will be printed on the cover of the book and coded into the bar code, so you have one chance to get this right.

LAY OUT YOUR BOOK IN 10 MINUTES

Adobe InDesign is expensive as hell, but it's worth every penny. Let's face it, you're probably going to be using Photoshop (and possibly Dreamweaver and/or Flash), so you might as well take the plunge and buy Adobe's Creative Suite. If that hefty price tag gives you a case of the willies, check into Adobe's new program of offering its software through monthly subscriptions.

One of the reasons I'm suggesting this so strongly is that InDesign has amazing publishing functionality — like the ability to lay out a standard comic book or collection of comic strips in the blink of an eye.

SPINE-SIDE CURVING

The more pages in a book, the more likely it is that a certain amount of each page will be curved into the spine.

And that means that reading words or images in this curved area will be difficult.

If you're planning a book with a large number of pages, leave a little extra room on the side of each page that will connect to the binding.

That way, when the book is created — and the pages curve into the binding — your readers won't have to pry the book apart to be able to read it.

That's not only a better reading experience, but it reduces the chances that the book's binding breaks down and pages start falling out of the book.

INDESIGN CS OR CS2

- Google **ImageCatalog.zip** and download it.

- Place the unstuffed script here:

Applications -> Adobe InDesign -> Presets -> Scripts

- Define your page size and margins: **File -> Document Presets -> Define**. This is a good time to identify things like page bleeds (which we'll cover later in this chapter).

- A pop-up menu will come up. Click New. When finished, name your Preset and click OK.

- Create a new document. Unlike when you've created new documents in past, you'll now see your new preset under the Document Preset drop-down at the top of the menu. Make sure it's selected and click OK.

- A new document will open with the specs for your book

- Create a folder on your desktop and move the files you'd like to import into it.

- In InDesign, go to **Window -> Automation -> Scripts** and select the one labeled Image Catalog.

- The script will prompt you to find the folder with your comic files in it. Once you select it, click Choose.

- After a long pause, it will give you a menu in which you can select the number of strips per page and the number of columns.

- You may have to experiment with the horizontal and vertical offsets to align the strips (do a small amount of test strips first). The numbers should define the size and placement of the strips on your pages, as well as the margins from Preset.

- Make sure the boxes Proportional, Center Content and Frame to Content are checked.

- Turn off the Labels checkbox unless you want file names to appear under each comic.

- Click OK.

INDESIGN CS3 AND LATER

The latest version of InDesign builds the Image Catalog script right into its preloaded complement of javascripts.

- Create a new document, being sure to set any necessary page bleeds and/or margins. Do set page margins because the script will use these margins to size the images as they're imported.

- Go to **Window -> Automation -> Scripts.**

- Double-click **ImageCatalog.jsx.**

- A pop-up dialog box will ask you to locate the folder containing all of your image files. It will look like this:

- You can set the number of rows and columns. A standard comic-strip collection layout, for example, might stack three strips on a page (one on top of another). That would be one column of three rows (as indicated in the sample above).

- Set both the horizontal and vertical offset to 0.

- In the Fitting section, select all three: Proportional, Center Content and Frame to Content.

- Turn off Labels.

- Select Remove Empty Frames.

- Hit OK.

QUARK XPRESS

If you're importing a large number of files into QuarkXPress, I heartily recommend purchasing an XTension called Badia ContactPage. It works almost identically to Image Catalog.

The script places your images on the page according to the settings you define. When one page is full of images, it creates another page. The end result is a multipage document with all of your images imported in alpha-

EDITING

It's not fair to say that cartoonists are poor spellers. I prefer to think of it as a natural side effect of our creativity.

We simply don't seem to accept the fact that there's only one spelling for every word.

Nonetheless, the rest of the world expects words to be spelled correctly. And that's why I strongly suggest that you hire a copy editor to proofread your book before it goes to press.

The money that you'll spend will be well worth it — if not in terms of overall pride, then in not having to answer helpful e-mails from the readers who catch your mistakes!

I know firsthand how important editing is. When my editor handed back the first draft of this book, she caught so many mistakes that it made my head spin. Her name is Elizabeth Slocum, she accepts freelance editing projects and she's the tops. You may contact her at eeslocum@ gmail.com.

Now you can leisurely go about tweaking and fine-tuning your book layout, with the most tedious (and error-prone) part of the process behind you.

PAGE BLEEDS

If you're printing a book in color, you'll likely be asked by your printer to set up "bleeds" for the pages. It can get confusing, so let's go over some of the basics.

Bleed Trim Margin Live **Final page**

TERMINOLOGY

Bleed: When you want your art to go right to the edge of the printed page (without leaving even the tiniest white border around the outer edge of the page), you need to use a bleed. This extends the image a set distance past the physical edge of the paper (your printer will tell you how much). The printer will use a slightly larger piece of paper when it prints, and then trim the paper down to the final page size. Anything that extends into the bleed will be trimmed off in that process. The result will be that it looks as if the image extends to the very edge of the paper.

Trim: The final page size after the bleed is cut off.

Margin: This is a zone around the outer edge of the final paper size that may get partially trimmed during the cutting process. Never ever put words inside the margin area. And if you put visual information there, make sure it's something that wouldn't harm the final product if it were trimmed out.

Live area: This area is guaranteed to appear on the final page. This is the safe zone, where all of your words and all important visuals should appear. Anything that goes beyond the live area is not guaranteed to appear on the final, trimmed page.

SETTING UP A BLEED IN INDESIGN

- Go to **File -> New -> New Document.**

- On the right-hand side of the Dialog box, if you see More Options, click it.

- Midway down the dialogue box, you can set margins, and along the bottom, you can set the bleed. Both measurements will be available from your printer.

- Click OK.

- Once you've done this, you'll have InDesign pages that look like the one on the previous page. On your screen, the red line represents the bleed. The black line represents the actual, finished page size. The margins are indicated by magenta lines.

- Anything between the red lines and the black ones will be trimmed off during the printing process. Anything between the black lines and the magenta ones is likely to appear, but not guaranteed. Anything inside the magenta box will definitely appear on your final page.

By the way, I set the margins on this example page a little extra big for demonstration purposes. Chances are, you'll be dealing with a much smaller margin.

BLEEDS IN ACTION

As you're designing your pages, keep all of the important information inside the live area. If you want to extend an image all the way to the edge of the paper, be sure to extend it to the red line.

If you want a little preview of what the finished page is likely to look like, go to View -> Screen Mode -> Preview. The bleed drops out and you're presented with an image of the final printed page on a gray background.

POD PRINTING

If you're using a print-on-demand printer, you may not be able to set up a bleed. Be sure to ask your printer before you design your pages if this is an available option.

A LITTLE SOMETHING EXTRA

As webcartoonists, we face a bit of a challenge in producing a book compilation of our work — any of our readers can access our entire archive of past work on our Web sites at any time. One option is to discontinue a portion of your archive after a period of time — and that's a valid option. However, it's going to have a significant effect on your monthly pageviews, which will, in turn, have an effect on your ad revenue (as well as your ability to attract better ad networks to serve ads through. So how can we throw a little "something extra" into our books to entice readers to pony up for a book?

COMMENTARY

Many webcartoonists point to DVDs with commentary by directors and/or actors, and they decide that this is a great value-add for their books. However, adding commentary under your printed comics has a couple of drawbacks. For starters, DVDs feature their extra content on an opt-in basis. In other words, if you want to watch the movie without the commentary, you can easily do so. That's not the case in a printed book. Moreover, if you commit to this concept, you're going to have to come up with something compelling to say about your work. That means comments such as *"I really liked this one"* and *"I was sick when I wrote this so it doesn't make sense"* are going to wear thin fast.

REFORMATTING

In my experience, I have found a tremendous benefit in making the format of my comic fit the delivery method. I believe a comic strip has considerable power on the Web, and I very much want to access that power despite the fact that the writing in my strip often resembles a long-form comic. So **Evil Inc** is a daily strip on the Web site and in newspapers, but I reformat it for other modes of presentation. For example, when a weekly newspaper inquired about running the comic, I gave the paper a continuous narrative based on stringing a week's worth of strips end-to-end. And it was met with very positive feedback. And, of course, when I prepare an *Evil Inc* book, I use the individual panels from the daily strip to lay out graphic-novel-style pages.

This has been a fantastic value-add. I can offer my readers a very different reading experience than the one they had on the Web site. But it comes at a cost. I can't simply use InDesign's Image Catalog script to lay out my book as a series of individual strips. As a point of reference, the 416-page *Greystone Inn* hardcover (which encapsulated more than four years of daily strips) was laid out in a fraction of the time I spent on any one of the 100-page *Evil Inc* books.

And as I've progressed, I've gotten stricter with myself. Take, for example, transitions between strips. When you're reading a collection of strips, you understand that the time between those strips is very flexible. Depending on the story, it might be the next moment, the next day or the next month.

But when you're using those panels to create a graphic novel, you lose the breaks between strips. And as a result, the reader is left with a very "jerky" reading experience in which time jumps at uneven rates between panels.

In the early days, I evened out those bumps with narration boxes. Then, I started reusing art from

FORMATTING YOUR BOOK

Your book should have the following:

Title page. This is usually the first inside page. If the cover of the book gets torn off or ruined, the book still has a title page as an identifier.

Copyright page: This is usually on the second page — the reverse side of the title page. It contains your book's copyright notation along with the book's 13-digit ISBN. You can also put other legal information, such as a notification (if it's true) that *all names, characters, events and locales in this book are entirely fictional, and any resemblance to actual persons (living or dead), events or places, without satiric content, is coincidental.* Another useful disclaimer would be: *No part of the publication can be reproduced or transmitted, in any form or by any means (except for short excerpts for review purposes), without the express written consent of the publisher/creator/you.*

10 9 8 7 6 5 4 3 2 1? That's a holdover from a different era in printing. This used to be a method used to indicate the print run of the book. Since the printing plates were expensive to produce, printers simply reused the plates and lopped off the number at the far right. Therefore, if you have a book that has the following series on its copyright page — 10 9 8 7 6 5 4 — then you know you're holding a copy from the fourth printing of that book.

Page numbering: All pages should have correct numbering at the bottom. You may choose to include other information at the bottom of each page, as well, such as title and author.

other panels to create entirely new panels that would soften the more harsh transitions. For the book I'm working on right now, I'm using both of those techniques plus a large number of completely new panels that I'm drawing to the size the layout requires.

For example, the blank panels on the pages above were filled with new, original art and dialogue.

It's taking much longer to lay out the book, but I think the result will be a book that stands on its own as a completely new work of fiction. My regular readers will be treated to a story that reads much differently from the collection of strips that they accessed on the Web.

On the other hand, I have found out that another decision that I made — to break the four-equally-sized-panel format in my daily strip as often as possible and make use of interstitial panels — has given me a firm edge in laying out the graphic novel. Assuming a few lucky transitions between strips, I can lay these strips out, end to end, and do very little to make an attractive page.

For example, the page on the right was built by stacking four consecutive strips from top to bottom. But the page doesn't look anything like the grid you'd expect.

Seems like a lot of work. And it is. And I've been tempted to throw then entire concept overboard and trade off the graphic-novel experience for getting books out more quickly. But then I go to a convention, and I watch people's reaction when they open up a book. They've seen the flyer, they've heard me describe a daily comic strip, and then they open up a

book to see a continuously narrative graphic novel. The reaction is almost always excitement, surprise and intrigue.

Is it perfect? No. When I do a week of standalone gags, it's not as good for the book. And when I do a huge 12-week storyline, it's a little tough to read in four-panel spurts — but it's awesome for the book. But overall, I've found that paying attention to how my comic is formatted — and whether that format fits the overall reading experience — has given me an edge on my business.

REPACKAGING

Another option in publishing your work is to repackage it. *How To Make Webcomics* co-author Dave Kellett (Sheldoncomics.com) does this masterfully. He typically puts out two book collections of his daily comic strip every year. Additionally, he compiles strips with a similar theme into a stand-alone book based on that theme.

For example, all of his comics that feature one of his characters, a pug, were collected into a book he titled *Pugs: God's Little Weirdos*. Not only does this give Dave another piece of merchandise, but it's an excellent "gateway drug" for readers who are unfamiliar with his comic strip.

I exhibit next to Dave several times a year, and I've lost count of the times a reader tells him that they bought the *Pugs* book (or received it as a gift) and then fell in love with his daily comic strip as a result. Based on the success of *Pugs*, Dave has released other repackaged compilations on themes such as *coffee* and *English literature*. And, of course, a second volume of pug-themed strips.

COVER DESIGN

Think about how the covers of comic books changed as marketing departments got more deeply involved in the procedure. At one time, it was completely acceptable to feature a full narrative scene on the cover, with characters conversing while other elements like the book title and story title and other elements blared in competition.

Today's comic-book covers are much more geared toward grabbing potential buyers with strong visuals first — followed by an extremely limited number of words.

I always share Scott Kurtz's advice from an old episode of Webcomics Weekly: Look through a few copies of *Previews* magazine for cover-design inspiration. You can usually find them at most comic-book shops — sometimes thrown in for free with your purchase. It's page after page of great cover-design ideas for you to build on.

FRONT COVER

The front cover has one job, and one job only: to stop someone in their tracks and compel them to pick up the book. Whether it's on a bookshelf or on your table at a convention, the front cover is all about attracting attention. And, as is usually the case in design, less is more. The more images and words that you try to cram onto a cover, the harder it is for the cover to do its job. A well-written title paired with a visually striking image is the perfect recipe for an effective front cover.

BACK COVER

You print the bar code on your book as part of your back cover — typically on the bottom right-hand corner of the back cover. Although the bar code contains the cover price of the book, it is necessary to print the price on the cover of the book as well — usually in the upper left-hand corner of the back cover. Your bar code should be in the range of 1.833 inches wide by 1 inch deep.

Also in the upper left-hand corner, it is advisable to classify your book according to a system developed by the Book Industry Study Group. If you go to the group's Web site (BISG.org) and click on **Classification Schemes** under **Standards & Best Practices**, you can find an updated directory of its classifications and corresponding codes. Take a little time to find the one that best describes your book.

Back cover Spine Front cover

The book's cover is laid out in one document, with the back cover on the left, and the front cover on the right. The width of the spine is based on the number of pages in the book and the weight of the paper stock the pages are printed on. Ask your printer to give you the spine width. The Trim Area of the document will be width: 2 x trim width, plus the spine width; depth: trim depth.

It's customary to use the back cover of your book as an extended sales tool. If the front cover is designed to stop the reader in his or her tracks, the back cover is there to persuade him or her to buy it after the front cover has done its job.

To that end, I recommend the following:

- A great sample of your comic — one that requires no explanation, and one that showcases your talent to the widest possible audience.

- A brief synopsis of your comic — including its characters and concepts.

I'm not a huge proponent of using testimonial quotes, but I understand why some people may choose that option. However, this shouldn't be a knee-jerk decision. Ask yourself the following:

- Does the person I've chosen to ask for an endorsement quote have a wide enough following that a quote from him or her is likely to sway sales?

- Do I know the person I'm asking for an endorsement well enough that I'm not putting him or her into an awkward position with my request?

- Does the quote itself form a compelling argument to buy the book?

If you can't answer in the affirmative to all three of these questions, then you should think twice before devoting cover space to the quote.

Finally, your printer may require that you include the country in which the book was printed on the back cover.

ISBNS

An ISBN is a 10- or 13-digit number that is used to identify a book from a specific publisher. Once your book is in print, you can register the title and link it to the ISBN at Bowkerlink.com.

Do you need an ISBN? Honestly, no. You need an ISBN only if you're planning to release the book through a distributor (like Diamond Comic Distributors) or a retail outlet (like Amazon). You will read sources that insist that e-books and other digital-download projects require ISBNs, but I'm afraid I still don't see the point unless there's some retail or distribution aspect involved — which simply isn't going to be the case for most webcartoonists. If you're only selling directly to readers through your site, you don't need an ISBN.

If you purchase ISBNs, buy them through R.R. Bowker. They are the one legal vendor of ISBNs in the U.S. If you buy it from a reseller, you may not be listed as the book's actual publisher. *(See the sidebar below for an exception.)*

The ISBN is printed on your book's copyright page, and it is incorporated into the bar code that should appear on the book's back cover.

BAR CODES

The ISBN is used (along with the retail price of the book) to create the bar code. A bar code is a series of straight lines of varying width that store information that a computer can translate. A bar code generally carries any identifying information about the product (like a book's ISBN) and the item's suggested retail price.

You can create a bar code using an online generator, or you can purchase software to create one. I've have very good luck with Createbarcodes.com, which costs only $10 per code. Whichever route you choose, you will most likely receive a digital file containing the bar code, which you can subsequently use as you're designing the cover for your book. The cover price is coded in a five-digit number:

- The first number denotes the currency: 5 is for U.S. currency (4 is Canadian).
- The next four numbers represents the price in cents. A $19.95 book is 1995.

CREATESPACE ISBNS

CreateSpace, Amazon.com's POD imprint, offers ISBNs. The options are detailed on its site, but here are a few things you should know:

The CreateSpace-Assigned ISBN means that CreateSpace is the publisher of the book.

A Custom ISBN means that you are listed as the publisher of the book, but you are very limited in how you *sell* your book. You cannot sell through Barnes & Noble. You cannot use a distributor other than CreateSpace. It's not a matter of who the publisher is—you are the publisher—but how you are selling the book. Basically, you can sell only through Amazon and CreateSpace.

A Custom-Universal ISBN means that you are listed as the publisher of the book and you can sell anywhere you want to.

This ISBN is exactly the same as an ISBN obtained directly through R.R. Bowker, only with a better price in a special arrangement with CreateSpace. If another publishing company should pick up your book (such as Random House, for example), then it doesn't use your ISBN, it uses one of their own.

If you're planning to release only one book, then the $99 price tag is much better than buying a single ISBN for $125.

If you can foresee self-publishing multiple books, then your better option is to buy a block of 10 directly from Bowker for $250, which brings your unit price down to $25.

PREPPING FOR THE PRINTER

In the process of compiling a graphic novel, I stumbled upon a problem that took me weeks to solve. In this case, the printer gave me a "PDF preset" to use so the PDF would be created to the printer's standards. Once I uploaded the PDF, I was alerted that some of the images were presenting at a low resolution.

But I was absolutely certain that I had used high-resolution files. So I started hunting around, and I finally found the culprit. Part of the PDF preset — in fact, part of practically every PDF preset — has *image compression* built in. After all, that's what a PDF file does ... it compresses the document for easy use.

But I'm not looking for easy. I'm looking for quality. So I modified the PDF preset (by choosing *no* image compression) and — *voila* — my resolution problems disappeared.

This is the dialog box you get when you export a PDF from InDesign. Click on Compression in the left-hand column to get the view you see to the right.

You see all those instances in which it says Compression: Automatic (JPEG)? Click on the toggle bar in each of these fields (Color Images, Grayscale Images, Monochrome Images) and change it to NONE, then export the PDF. Warning: Without the compression, your file size will be huge. My 104-page book clocked in at 2.5GB.

Why remove the compression? Even if you toggle the Image Quality beneath each of those to Maximum, it's still a JPEG. I'm a little bit of a hardnose on this issue, but I feel strongly that JPEGs are for image storage — not printing. And I refuse to believe that even a JPEG saved to its maximum quality is as good as the TIFFs that I prepped for the book.

PREPARING A COVER

The book's front and back cover are usually prepared as a single document, with the back cover on the left, a spine in the middle and the front cover on the right. Your printer can tell you the width of the spine, based on the paper stock and page count of the book. However, if you want to do the math yourself, divide the number of pages by the paper stock's PPI (pages per inch). The PPI is probably on the spec sheet your printer gave you. If not, you can ask for it. It's the number of pages found in an inch-high stack of that particular stock. Heavy stock has a low PPI value, and thin, lightweight paper stock has a high PPI.

PROOFING

A **proof** is a single copy of the book that a printer will send you for approval before printing. This is your last chance to catch errors before the printing process. In a POD process, the proof is often a "soft proof," which means it's not printed at all, but it's a digital copy you can view (or print yourself). A "hard proof" is a printed version of the book. A "wet proof" is made with real printing ink on the paper to be used on the actual press run. Very often, the pages are unbound.

You should insist on a hard proof for any offset-printing project. And you should assume that the printing in your book is going to look very similar (if not identical) to the pages of the proof. That means you should be looking for image errors as well as spelling and other writing errors.

ARTIST EDITIONS

Having discussed on Webcomics.com strategies for selling books, it came to my attention that "Artist Edition" wasn't necessarily a universal term. So I want to take a moment to explain the practice. An Artist Edition is a book in which the cartoonist draws an illustration (like the one to the right) inside the book (for an additional fee) before sending it to the buyer. In my experience the following elements contribute to a successful Artist Edition offering:

- Signed: The illustration is signed by the cartoonist.

- Limited edition: I offer only 250 Artist Edition books. This makes the Artist Edition a limited series — which increases their value.

- Personalized: I make it possible for people who buy an Artist Edition to request (within reason) subject matter for the illustration.

The illustration should be high-quality. After all, you're charging a premium for it, and you want to cultivate the readers who are willing to pay premiums for your work! And don't forget to number it. I generally use the standard XX / YYY format from the fine-art world, where XX stands for the number of the book in the series and YYY stands for the total number of Artist Edition books that I will do before making them unavailable. So, for example, the fifth Artist Edition I create in a series of 250 would be numbered 5/250.

PROMOTION

Artist Editions are very useful to generate some extra income with your book launch. I usually charge an extra $10 for an Artist Edition book. It's also a way to generate extra excitement. After you've completed a few Artist Editions, post them on your site. You'll find that they do a good job of spurring extra sales.

#1 AUCTION

Ready for another post from the "I make mistakes so you don't have to" file?

When I released my sixth *Evil Inc* graphic novel in 2011, I distinctly remember doing the first Artist Edition and thinking: "Hey, I'll bet some of my more fervent fans would pay extra to have the first Artist Edition of the new book. Next time I release a new graphic novel, I think I'll put it on eBay and offer it auction-style to the highest bidder."

It was a great idea, and I was proud of myself for thinking of it.

I just wish I had remembered it before opening up orders for the seventh *Evil Inc* graphic novel.

So, I'm recording it here. Offer your first Artist Edition on an auction basis to the highest bidder. The winner can then ask for whichever kind of sketch he'd like best, and then you can personalize it and help promote the launch of the new book in the process.

I may even remember in time for Book Eight.

SCAN 'EM BEFORE YOU SHIP 'EM

As we discussed in the preceding chapter, calendars can be great merchandise items if you start preparing them early enough. In the past, I created the *Evil Inc* calendar using some of my favorite strips from the previous year. And it's a good way to create a calendar.

But here's another one that you might be able to act on. Repurpose those Artist Edition illustrations that you're putting so much work into. They're primo calendar material!

This idea hit me as I was doing a stack of Artist Edition sketches for the seventh *Evil Inc* graphic

novel. I had invited my readers to suggest the subject matter of the sketches, and surprisingly enough, many of them were requesting cheesecake-y pinups. I was doing these sketches at the same time that I was prepping the next year's calendar, and it hit me that these kinds of pinups would be great assembled into a calendar. But I was too busy doing cheesecake for the Artist Editions to do cheesecake for a new calendar.

Don't worry, the obvious answer dawned on me eventually.

I now obtain a good, hi-res scan of all of my Artist Edition sketches before I ship them out so I'll have a head start on the next year's calendar. Once they're colored and a few backgrounds are added, these will be some darned fine calendar illustrations.

Digital Downloads

The iPad debuted on April 3, 2010, and I don't think its full impact is going to be realized for a few years yet. It has been a significant force in webcomics, though, because the iPad (and all of its competing handheld devices) is tailor-made for a comics-reading experience.

This brings about tons of opportunity for webcartoonists. For starters, this is simply one more distribution system to deliver a daily comic, via Web site, to a reader. Most digital tablets like the iPad come with a Web browser, and that means that your webcomic is already iPad-enabled.

But more importantly, this is a new format in which to offer merchandise. You can now offer special packages of your comics formatted for these readers. And many webcartoonists are experimenting will offering these digital downloads on a micropayment basis.

PRINT VS. WEB ... VS. APP?

As I've said before, "Print vs. Web" is a misleading nomenclature. Almost every webcartoonist uses print sales (usually self-published books) as a central revenue stream for his or her business.

The real debate is "Corporate vs. Independent."

Under traditional, corporate publishing, the cartoonist focuses on his or her craft, and the publisher handles all of the business aspects — handing the cartoonist a check after the process is done (heck ... sometimes before in the case of advance payments). And there's really nothing wrong with that as long as the publisher is (a) entering into an *equitable* business arrangement with the cartoonist and (b) providing services that the cartoonist couldn't do for himself.

The Webcomics approach is much more of a do-it-yourself proposition. Largely, we're self-publishers, we handle our own distribution (on the Web), we invest in creating our own merchandise, and we often sell — and ship — that merchandise personally to our readers. We tend to enter into a business relationship with an outside party (like a Web host) only when that party offers something that we can't do better ourselves.

APP-COMICS?

Since the dawn of the webcomics movement, the question has been raised among creators — usually during a convention weekend in some hotel lobby in the wee hours of the morning: If webcomics replace "print" comics ... then is it possible for something to come along and replace webcomics?

Now, look at the recent explosion in digital downloads — comics delivered by app, e-books, etc.

Make no mistake: Apple has succeeded in working the micropayment model. And when its competitors catch up with their versions of Apple's iPad — and as other handhelds (both general-purpose tablets and dedicated e-readers) continue to improve — the market for downloadable entertainment is going to move away from the Web.

And, for the most part, that's going to mean a further evolution of the pay-per-download model.

Joy! Right?

MAYBE NOT

Just try to get noticed with an app in Apple's App Store. You'll be buried under a mountain dominated by Marvel, DC, Dark Horse, Image, Dynamite, IDW, Boom and ... (believe it) Archie.

That's right. Archie. Reliable sources indicate it *dominates* the digital-download market.

And that means that app-comics open the door for corporate publishing to step back in and dominate the comics scene.

"But no," you say, "I can sell my comic through an app, too. I can get on the App Store."

You sure can. And you'll be lost in the shuffle almost immediately ... behind heavily licensed properties like Spider-Man and Batman.

And signing with an app such as Comixology is going to present many of the same challenges.

THE END OF THE INDIES?

And that means a movement away from independent comics on the Web — and a movement toward corporate-run digital comics.

Let's say you list with Comixology, and your comic sells a million downloads. Your take is going

to be based on the percentage Comixology offered you in its contract. Just like in the print world.

On the other hand, if you list a comic independently, you still have to win approval by the App Store — which puts Apple in the role of the traditional "print" editor. And don't forget that for every download, Apple is going to take a significant cut no matter who owns the app. And that puts Apple in the traditional "print" role of publisher.

So if you don't believe that Comixology represents a return to the "print" way of doing things, you'd *better* believe that Apple is positioning itself to play that role.

And Apple has a set of standards that make 1954's Comics Code Authority look downright saucy.

SCARED YET?

Well, first of all, I could be wrong.

Secondly, it makes that stuff that kept me awake at the end of Chapter 8 seem like small potatoes.

Thirdly, the Web has an awful lot of years left to go before it disappears completely (or fades into obsolescence). And the Web is still going to be a great place to build readers and refine skills.

Finally, here's a really wild thought from the editor of Webcomics.com: There were some amazing benefits to the "print" model. The publisher assumed all of the risk. There was a fairly steady paycheck if your work was good enough. Sometimes, publishers paid in advance.

The common drawbacks would remain — devious contracts, unfair business practices, etc. — but it's not as if webcomics don't come with their fair share of risk.

PRINT COMICS? WEBCOMICS? APP-COMICS? ... COMICS!

This is not a discussion of comics. It's a discussion of delivery method.

App-comics aren't different comics (any more so than webcomics really differed from print comics) ... they're comics delivered by a different distribution method.

The Web merely provides a distribution method for cartoonists. The nature of the Web lent itself to independent comics much more readily than it did to corporate comics.

What does that mean? It means that you are a cartoonist. The "webcomic" part describes how you do your business — not how you do your comics. If app-comics really do replace webcomics, it's not the end of your doing comics. Rather, it's the end of how you do your business.

BUT IT'S NOT THE END

One of the defining attributes of webcartoonists is their ability to adapt and evolve. This may very well mean that we're going to be challenged to do exactly that on a much broader scale than putting the Facebook Like button on our homepage. And, if the above is right, it's going to be a pretty tough challenge. But not an insurmountable one. (And, no ... there's not an app for that.)

PDF

By far, the easiest file format for digital downloading is the PDF file. It's a fairly universal file format accepted by a wide range of computers, smartphones and tablets. And selling a PDF is easy. You can set it up through PayPal so that once readers pay their money, they are transported to a special page you set up where they to download the file. To learn how to do this, follow the instructions on setting up donations (with a default giveaway) in the chapter on Merchandizing.

Many independent cartoonists have begun experimenting with releasing their work through digital downloads, and from their experience, it seems as if the sweet spot is $2. If you decide to go this route, however, you're going to get eaten alive by the per-transaction fees that PayPal will levy on each purchase. You may want to start a special Micropayments account through PayPal to handle solely these digital downloads

Merchant Rate	Micropayments 5% + $0.05	Regular 2.9% +$0.30
Payment size	$2	$2
Cost to receive payment	$0.15	$0.36
Total cost to receive 100 payments	$15	$36

MOBI FILE FORMAT FOR KINDLE

Amazon's release of the Kindle Fire — a low-priced competitor to Apple's iPad — has brought another very graphics-friendly tablet to the market. It's time to get serious about this platform — and many webcartoonists are in danger of falling behind the curve on this. The good news is that if you, like many of us, use Adobe InDesign to lay out your books, this may be as easy as downloading a plug-in.

EXPORTING MOBI FILES FROM ADOBE INDESIGN

Amazon offers a plug-in that can be used to convert your InDesign book layout to Kindle specs, provided you're using InDesign CS4 or higher.

Download it here: **amazon.com/gp/feature.html?docId=1000234621** (or go to a search engine and type in "kindle publishing programs"). While you're there, download the Kindle publishing guidelines for InDesign. (You have your choice of PDF and Adobe InDesign formats.)

Mac users may have to download and install a security update, and if you're using OSX 10.6.7 or later, you'll want to install the VeriSign Class 3 Code Signing 2009-2 CA (which can be downloaded on the same page as the plug-in). Follow the instructions for installation. Once you've covered these issues, you're prepared to install the plug-in.

Once you have the plug-in installed in InDesign, you can choose "MOBI" from a list of export options under **File -> Export for**.

If you're more comfortable in an HTML setting, use KindleGen, a command-line tool used to build Kindle-compatible eBooks. This works well if you're starting with an HTML book file or an ePub. Download it on the same page as the InDesign plug-in: **amazon.com/gp/feature. html?docId=1000234621** (or type "kindlegen" into a search engine).

KINDLE PREVIEWER

If you don't have a Kindle, Amazon offers a very useful tool for checking your work before releasing it to your readers. You can also download a Kindle Previewer. You can download it on the same page: **amazon.com/ gp/feature.html?docId=1000234621.**

The Kindle Previewer gives an accurate depiction of how your MOBI file will perform on different Kindle units. Click this button 🄰 to see how your download will look in landscape mode.

AFFILIATE-MARKETING LINKS AND DIGITAL DOWNLOADS

When we discussed affiliate marketing in Chapter 9, I shared that I hadn't found a lot of success in it.

However, since I started making monthly comics available on Amazon through Kindle Direct Publishing, I have revised my stance. Slightly.

Since the Kindle version of my monthly digital download is bought through Amazon — and since I have to link to the comic's page on Amazon to send my readers to the right spot to buy it — why not use an Amazon Affiliate link?

Now, I'm making back a small portion of the money that Amazon takes through its Kindle Direct Publishing program. And I get credit for whatever else the user buys during its visit to Amazon after following my link.

I'm linking to Amazon anyway ... why not use a link that earns me money on the transaction?

Furthermore, I use Amazon's widget builder to make attractive Associate links to all of the back issues of my monthly comic — which sell surprisingly well.

KINDLE DIRECT PUBLISHING

Using Kindle Direct Publishing, you can upload books to be distributed through Amazon to tablets and other mobile devices. You will upload your cover separately. It should be either a JEPG or a TIFF file (RGB color) with a minimum of 625 pixels on the shortest side and 1000 pixels on the longest side. For best quality, your image should be 1563 pixels on the shortest side and 2500 pixels on the longest side.

You have two choices of royalties: 35% and 70%. The standard royalty for KDP is 35%. To qualify for the 70% royalty option, books must satisfy the following set of requirements:

- The list price must be between $2.99 and $9.99.

- This list price must be at least 20 percent below the lowest physical list price for the physical book.

- Titles must be made available for sale in all geographies for which the author or publisher has rights.

- The title will be included in a broad set of features

SEND TO KINDLE APP

If you'd like to circumvent KDP entirely, you can encourage your readers to use the free Send to Kindle app (available for Mac and PC) to get your PDFs onto their tablets. It's easy-peasy for them to download your MOBI file and then, with a simple drag-and-drop function, move it to their Kindle, iPhone, etc. It can be downloaded at **Amazon.com/gp/sendtokindle**.

in the Kindle Store, such as text-to-speech. This list of features will grow over time.

All Kindle Direct Publishing titles are enrolled in lending by default. The Kindle Book Lending feature allows users to lend digital books they have purchased through the Kindle Store to their friends and family. For titles in the 35% royalty option, you may choose to opt out of lending by deselecting the checkbox under Kindle Book Lending in the Rights and Pricing section of the title upload/edit process, but you may not choose to opt out a title if you have chosen to include the book in the lending program of another sales or distribution channel.

NOOK PRESS

Although the Nook is a distant third place behind the Kindle and iPad, it would be a mistake to completely disregard this tablet offered by Barnes & Noble. The Nook's preferred file format is ePub.

EPUB FILE FORMAT

You can upload your ePub-formatted document to Nook through Nook Press (nookpress.com) — an online, self-service portal for uploading books and tracking sales. You will need to register a Barnes & Noble account to do so. InDesign users, you can select the following: **File -> Export** (EPUB will be one of the selections near the bottom of the dialog box).

You will upload a cover image separately. This will be either a JPEG or a PNG file (RGB color) that is at least 1400 pixels at its shortest dimension. Nook Press will not access a file size greater than 2MB for the cover.

Once you've uploaded your ePub file to NookPress, you can click Preview Nook Book, which is under the Manuscript tab. Alternately, you can download **ePubCheck** from Google to test your file. Mind you, this isn't exactly a user-friendly app like the Kindle Previewer. You must be able to run java from the command-line and be familiar with command-line tools to use this effectively. If you so choose, you can also use the following services to help create ePubs:

- Aptara
- CodeMantra
- Innodata Isogen
- Jouve
- LibreDigital

TERMS AND CONDITIONS

Among the requirements:

- Nook Press is not exclusive. You can sell your digital title elsewhere.

- Nook Press requires a U.S. bank account, U.S. credit card and a U.S. tax ID that are *all* tied to a U.S. address. The content will be offered for sale in the U.S.

- No hardcore porn
- No advertising

- No hyperlinks
- No e-mail addresses
- No requests for action
- No contact information for the author or publisher

Pricing and payment will break down as follows:

- Publisher will set a list price for each e-book between $0.99 and $199.99.

- Publisher will be paid a royalty off the list price according to the following:

 - **For e-books with a list price at or between $2.99 and $9.99:** 65% of the list price.

 - **For e-books with a list price at or below $2.98 or at or greater than $10.00 (but not more than $199.99 and not less than $0.99):** 40% of the list price.

- Publisher will, at all times, ensure that the e-book list price:

 - Is no greater than the e-book's list price any place else.

 - Is no greater than the e-book's print edition (if applicable).

 - Complies with the minimum and maximum pricing policy.

Nook Press offers the ability to share e-books with friends through a feature called "LendMe." Customers can share LendMe-eligible e-books once, for up to 14 days. Customers can send a lend offer and a personal message about the e-book they are offering to any friend's email address. The lend offer is available for seven days and can be accepted or declined on a Nook or online.

Recipients can easily download the book to their Nook e-book reader or on a computing or mobile device enabled with free Nook e-reading software. While the e-book is with the recipient, the customer who shared the title will not have access to it. All e-books offered via Nook Press will be eligible for sharing through the LendMe program and noted with the LendMe icon.

COMIC-BOOK READER FILES

There are a number of comic-book reader apps available to facilitate reading comics on smartphones and tablets. If you'd like to prepare your work to be accessed through these reader apps, the primary file types to be aware of are CBZ and CBR.

CBZ

CBZ is a folder (containing comic images numbered sequentially) saved as a .zip file, then renamed to .cbz (replacing .zip). Make a .zip of the folder. If you're on a Mac, use the Compress feature: Click the folder, then go to **File -> Compress**. If you're on Windows, you may need to install a special utility like Winzip. To create the .cbz file, simply change the .zip extension to .cbz.

CBR

CBR is a .rar file renamed to .cbr. There are a bunch of programs designed for reading a CBR. But basically it's just an archived folder with all the images (usually JPEGs) in them.

- Put your JPEGs (numbered sequentially) into a folder.

- If you want to create a .cbr file, you need to use RAR compression when you compress the folder. Windows users can do this through WinZip, and Mac Users can use something like SimplyRAR.

- You can now open this file with a digital comic-book reader.

CALIBRE

Calibre, a free app from Centresource Interactive Agency, is intended to allow users to process the files in their e-book library so they can be uploaded to any number of readers/tablets the user might have. So if they have an entire selection of ePub-formatted books that they'd like to read on their new Kindle Fire, it's a small matter of using Calibre to convert the ePub into a Kindle-friendly MOBI file. Of course, that means it's tailor-made for folks like us who want to offer our digital-download publications to users who may own a wide variety of tablets.

Calibre is also outfitted with a number of archiving features — like entering author name/publisher information — that are also very useful for webcartoonists. And you can easily use the software to create a cover for your e-book.

Best of all, Calibre offers preview mode so you can test the files that you've created. Unfortunately, there doesn't seem to be a tool that allows users to switch from vertical to horizontal viewing, but judging from my tests with the Kindle Fire and the Nook Color, the preview is a very accurate representation of the image quality and reading experience.

TRACKING DOWNLOADS

For quite a while, the working title of this book was *I Was Dumb So You Don't Have To Be.* Here's what happened. I offered a recent story line to my readers as a digital download (PDF and MOBI versions) to test the waters for an idea I've been knocking around in my head.

I rushed to my Web stats the morning after I launched the project, eagerly looking for the section in which I could find stats on the downloads of those two files — only to find that no such section exists. No worries, that's what Google Analytics is for, right? Nope. It turns out that you must do a little forethought if you want to track the downloads of a certain type of file.

When you're coding the hyperlink to the file that you'd like to track, you must add a little java-script code to it. This tells Google Analytics to count the download as a pageview. Here's the code. Please note that you'll want to replace the parts I bolded with code that actually applies to your own file.

You can check your Top Content report 24-48 hours after the updated tracking code has been executed. You should be able to see the assigned page name in your report.

THE MONTHLY PRE-RELEASE DIGITAL DOWNLOAD

In the summer of 2012, I started a digital-download experiment that has worked out very well for me. I built up a five-week buffer for my daily comic strip, *Evil Inc*. Then, at the beginning of each month, I offered the entire upcoming month's comics as a $3 digital download — available in both PDF and MOBI formats. Readers were welcome to read them for free on the Web site as they updated, one day at a time, or they could buy the download and read the entire month of comics on their digital devices.

THE PRICE

Let's assume (for the sake of argument) that the typical *Evil Inc* reader comes to the site every day, providing me with 30 pageviews. Multiplied by the number of ads on the site (four — one leaderboard, one skyscraper, one rail, one square), that's 120 ad impressions. The CPM (cost per thousand) for each of my ads is more than a dollar. Even if each reader shares the download with several friends, I have a lot of pageviews to forfeit before I lose Dollar One.

THE DOWNLOADS

I've made my downloads available in the file formats that cover the two dominant tablets on the market — iPad and Kindle Fire. PDFs are fairly ubiquitous, so I'm counting on users of other tablets to be able to access PDFs — which I've made available in a hi-res (11 MB) and a low-res (4 MB) version.

The MOBI files work perfectly on the Kindle Fire I tested them on. I sold them on Amazon.com through Kindle Direct Publishing (KDP), and I sold them directly to my readers on my Web site (using the Save to Kindle app described a few pages ago).

I present my monthly pre-release to my readers in the form of a monthly digital comic book.

THE PROCESS

This can be handled the same as using Paypal to give free wallpaper to people who make donations (Chapter 12). After the sale is complete, PayPal is directed to send users to a predetermined page where they may download their files. However, sites like Gumroad.com and SendOwl.com are great tools for facilitating online sales of downloads, and they boast impressive features like the ability to handle subscriptions and generate discount codes.

MAILING LIST

Unless you use an app to establish a subscription, some readers will fall out of the habit of coming to the site every day, and as a result, they'll forget to come back for the next month's comics (and eventually forget about the comic entirely). I'm trying to combat that by offering to place users onto a monthly mailing list that will send them an e-mail when each new download is ready. (The process is explained in Chapter 10.)

A solicitation to opt into the mailing list can be found prominently on each month's download page. I also have a handy sign-up list on my table during conventions. And each month's e-mail features instructions on opting out of the mailing list if the reader so chooses.

Panel 1: SO THAT'S MY DILEMMA... THE VICTOR GETS ONE WISH FROM AN OMNIPOTENT BEING.

OBVIOUSLY, I CAN'T LET THE HEROES WIN, BUT I ALSO HAVE TO BE CAREFUL TO PICK A POTENTIAL VILLAIN WINNER.

Panel 2: IT HAS TO BE SOMEONE STRONG ENOUGH TO BEAT THE HEROES, YET SOMEONE I CAN MANIPULATE IF NEEDED.

Panel 3: WHAT ABOUT KILL-BOT 3000? WE CAN *PRE-PROGRAM* HIS WISH..

KILL-BOT GOT AN UPGRADE. HE'S GONE COMPLETELY DIGITAL.

Panel 4: ARGH! THE DANGED THING BIT ME!

KILL. ALL. HU-MANS!

SPONSORED DOWNLOAD

There are a few possible variations to this plan. For example, one month, I acquired a sponsor, placed an ad for his product on the last page of the download, and allowed the files to be downloaded for free. This could work in my favor two ways. Beyond getting paid upfront for that month's comic, the free download might spur sales of the other for-pay downloads.

Be careful, though. If you include an ad in your comic, it may prevent you from offering it through KDP and similar outlets. Sponsored downloads would likely have to be limited to direct-download from your site.

DIGITAL COMIC SHOPS

As I expanded my digital-download operation, I decided to try to reach non-*Evil Inc* readers by offering the monthly download off site. Of course, I had already dipped my toe into these waters by using KDP, but I wanted to see if it would be useful to expand further — in a way, mimicking the business model of an independent comic publisher approaching brick-and-mortar comic shops.

COMIXOLOGY

Comixology.com is the 400-pound gorilla on the digital-comics landscape today. The good news is that it has developed a dedicated base of comics-buying users. The bad news is that now you're in direct competition with Marvel, DC, Dark Horse and other large publishers, and it's going to be very easy to get lost in the mix. They have a special portal for independent cartoonists called Comixology Submit (submit.comixology.com).

You'll receive 50% of the net sale of your title (after they pay their mobile distributors their standard fees). If your title is sold through their Web site, you will receive 50% of the gross sale after credit-card fees are taken out.

DRIVE-THRU COMICS

I also signed with Drive-Thru Comics (drivethrucomics.com). Why Drive-Thru? Simple. It has porn. I really don't care how you feel about adult material. This is business. *Fifty Shades of Grey* has proved one thing beyond a shadow of a doubt: People are using the anonymity of the e-reader to read all that trashy stuff they'd be too ashamed to be seen with otherwise. The comics-buying audience is no different. (Heck, they're probably the same — only more so).

WHAT'S IN A NAME?

When I first started offering my comics in a monthly preview digital-download, I simply named them according to month when I distributed them through outlets such as KDP and DriveThruComics. For example, in September, I offered "Evil Inc monthly (Sept. 2012)."

However, I've recently seen the wisdom of naming the download according to topic. For example, the following month, I titled my download: "Evil Inc: The Real Housewives of Transylvania (Oct. 2012)."

The title reflected the main storyline found in the download. And, to people who may not have been familiar with the comic, it was a much better enticement to give it a try. Finally, I'm confident that it popped up in a lot more searches than the previous downloads did, since there were more keywords (like "housewives" and "Transylvania") that were likely to be tagged.

BACK ISSUES

Believe it or not, I've seen a healthy business in back issues.

It's amazing, but even when readers know that they can get all of the archives for free on my Web site, my experience has been that some people like that comics-on-tablet reading experience so much, they're willing to pay to download back issues.

They like the ad-free, lightning-fast, large-format reading experience that much.

So it's a great idea to make the links available to your previous issues (or offerings) every time you offer a new digital download — no matter how you're selling them.

So when I noticed that Drive-Thru was an easy source for adult comics, I knew right there that it would have the ability to generate good traffic. Yet it's small enough that a self-publisher isn't going to get lost in the shuffle. Furthermore, I'm reasoning that this is exactly the kind of comics-buyer who would be more apt to sample offerings outside of the Marvel/DC publishing spheres.

DriveThru pays out 60% of the gross sale for downloadable content.

PAGE-COUNT DRIVES SALES

Asking $3 to download an eight-page e-book is somewhat daunting. But a 23-page download? Done deal. For me, that meant including a new feature in each digital download called "Tales from the *Evil Inc* archive." In some cases, this was a multiweek story line from my archive. In July, in honor of Comic Con, I collected a group of comic-convention-inspired story lines. Last month, since I was launching a new graphic novel, the extra content came in the form of a two-chapter preview.

The point is this: Your archive is a powerful ally in driving up pages in an e-book. And pages tend to be a driving force in sales.

REPACKAGE ARCHIVE CONTENT

I got this idea when I was prepping the comics for October. I have a nice Halloween story line, and thought about how I'd market that monthly comic on my site. Then it hit me that it would be *extra* cool to group all of the Halloween-themed comics I've done over my 12 years in comics into a standalone e-book offering.

So, along with the *Evil Inc* digital download for October, I produced a second download for October: "Tales from the *Evil Inc* Archive: Halloween Special." It included all of the spookiest *Evil Inc* stories — plus, Halloween arcs from my other comic projects, like *Greystone Inn* and *Phables*.

It's a great way to introduce my work to someone who might buy it as cool Halloween reading. It's also a great thing to offer longtime readers who'd like all of that material grouped together. And best of all — aside from a few hours spent digging some of the strips out of storage drives — it's very little extra work for me.

And after Halloween, there's Christmas. But don't stop at seasonal themes. Consider other themes — like all of your strips about World of Warcraft for a special WoW edition of your comic. Or all of the relationship gags for a special e-book about couples. Look through your comic for themes. I'll bet you can find a marketing angle for them.

DIGITAL-DOWNLOAD APPS

When I started offering digital downloads of the upcoming month's worth of comic strips for Evil Inc, I handled it entirely through Paypal. I enabled micropayments on PayPal, and put up "Buy It Now" buttons that accepted the payment and then deposited the user to a page that I had set up to facilitate the download. Piracy-proof, it wasn't. But that being said, I haven't seen any significant signs of piracy.

GUMROAD

But I wanted to start experimenting with a little more efficient way of handling the transaction, and I found Gumroad (Gumroad .com) through the endorsement of a respected colleague.

Gumroad is easy. You upload a file, upload a cover image and provide some information ... and it creates a bit of code you use on your site to create a payment widget. The widget is quite slick, opening up a payment portal directly on your site. Users enter their credit-card information, and they're e-mailed a download link that expires after the first use.

Gumroad charges a flat 25¢ per transaction, plus 5% of the sale.

That's 20-cents higher than PayPal's micropayment pricing (5¢ plus 5%), but in return you get protection from piracy and a sleek payment experience.

GUMROAD VS. SENDOWL

Both of these apps enable you to sell digital downloads directly to your readers. I've used both, and I like each of them. Here's how they line up against each other

Gumroad	Feature	SendOwl
25¢ per transaction, plus 5% of the sale	Your cost	$9-$39 per month
✓	They host file	✓
✓	You host file	✓
✓	Pay-what-you-want option	✗
✓	Offer subscription	✓
✓	$0 pricing	✓
✗	Create discount codes	✓
✗	Bundle products	✓
✗	Create your own affiliate system	✓
✓	PDF stamping	✓
✓	Alert customers of updated file	✓

✓ YES ✗ NO

SENDOWL

I left Gumroad for SendOwl (SendOwl.com) for one reason: The latter offered subscriptions (Gumroad didn't at the time). This was something I desperately wanted for my monthly comic. Send-Owl also offers a cadre of features that are truly impressive. You can create discount codes, bundle several products (in order to offer them for sale as a unit) and even create your own affiliate system to enable others to sell your merchandise on their sites.

SendOwl's shopping-cart setup was a little nicer, in my opinion, as well. It facilitated multiple purchases in a clean, easy manner.

SendOwl charges a flat, monthly fee at several tiers. $9 per month gets you the basic plan, which limits you to 10 products. At $15 per month, you can have 30 products (and more features). The full line of features (including subscriptions) is available at $24 (100 products) and $39 (250 products).

FINDING THE RIGHT PRICE

I started with an almost arbitrary pricing system, introducing the monthly download at $1.50, and then raising it to $3. When I started using Amazon's KDP to offer a Kindle-formatted MOBI file to users through Amazon.com, I got locked into using either $2.99 (with a 70% royalty split) or $1.99 (with a 30% royalty split). I went with the former.

Special thanks to Kickstarter supporters Steven Dengler and Ash Vickers (Megacynics.com)

When Amazon released a free "Send to Kindle" app, it became less important for me to release the downloads through KDP.

Using Gumroad (and then SendOwl) soon replaced my DIY PayPal delivery system (a simple redirect on completion of payment). It was a smoother experience, offered more analytics and reduced potential piracy. Free from Amazon's pricing constraints, I was, once again, in search of the right price.

FREE/FAIR PRICING

Gumroad offers a "Pay a Fair Price" option, by which you can set a floor-level price, but users can pay more if they desire. So I experimented by lowering the price to 99¢ with the Fair Price option. The number of downloads increased markedly — and so did revenue, as many people *voluntarily paid more* than 99¢ for the download.

The next step came naturally. If downloads increased as the price went down, and if many of my readers happily paid a little extra for the product, then offering the download as a free download with a Pay a Fair Price option has some interesting possibilities.

However, Gumroad charges a flat fee per download, so a free download isn't really *free* on my end. And besides, what happens if everybody chooses the free option? My sales go out the window, I have nothing to show for my trouble and I'm staring at a following month in which I've set a user expectation that I can't fulfill.

SPONSORED DOWNLOAD

So I tweeted that I was looking for an advertiser for the coming month's comic. I sold it at a price that would more than cover any lost revenue from the free pricing. If all my readers chose the option of a free download, I'd still stand to make more than I had in previous months (unless the response was far greater than I had estimated). Once the advertiser was secured, I was able to release the free/fair download.

I was flabbergasted. The response was far lower than any previous month since I had started. Only one user chose to download the comic for free, and a couple of readers voluntarily paid $5-$10 for the download. This led to a few thoughts:

- While the occasional $5-$10 voluntary payment is nice, that's not going to happen every week, realistically. Sooner or later, if that $10 user becomes a repeat customer, the Law of Diminishing Returns is going to dictate that the voluntary price she pays will drop.

- I'm wondering if the average user is clear on the fact that getting the comic for free is an actual option.

- This is problematic because the only way I'll be able to keep advertisers will be to post impressive download statistics. And that doesn't seem to be possible.

THE 99-CENT 'SWEET SPOT'

I returned to the 99¢ price the following month, and that has become the default price for the digital comics I offer directly to my readers on my site. This, of course, is completely separate from the comic's performance on sites like Amazon and DriveThruComics. The lowest I can go on those sites is $1.99 and 50¢, respectively.

SELLING A DIGITAL DOWNLOAD AT A COMIC CONVENTION

Webcomics.com member Tim Gibson (mothcity.com) shared an excellent technique for selling downloadable content at comic conventions. He uses SendOwl to generate 100% discount codes for each download he plans to offer. He prints the cover of the download on card stock and includes the download code, along with the URL for the download itself, on the back.

When convention-goers purchase the card, they can download the digital comic for "free."

I tested this out at Philadelphia Comic Con in 2013. The entire week leading up to the convention, I was scrambling to get as many of these printed as I could before my printer ran out of ink. I was grinding my teeth over not leaving myself enough time (or ink) to print up cards for the entire 14-issue run. I wanted to put them on a spinner rack. I had *big plans*, I tell you!

And I sold One. Lousy. Card.

I couldn't *give* them away.

WISDOM FROM A MUSICIAN

During the convention, I was talking to a musician, and the topic came up (as he politely refused my pitch to drop a dollar on one of the download cards). And he said something very enlightening.

See, his band had used Dropcards.com to do something very similar. I asked how people responded to them. He told me that they gave *tons* of cards away.

But almost nobody actually downloaded the music.

"How can this be?" I asked.

"I asked one of my fans the same thing," he told me, "and that guy put it like this ...

> 'You're almost asking me to go on a *quest*! I have to go to my computer. Then I have to type in a long Web address. Then I have to select my music ... enter another long code ... download it to my machine — and *then* I have to get it to my device.
>
> I don't wanna do all that. I just wanna listen to music!'"

Ugh.

We've really taken instant gratification to a new level of *instant*.

Our readers — I'm thinking — are looking at these download cards much the same way. It's too much work for too little payoff.

Am I giving up on digital downloads at conventions? Not entirely.

But am I putting them at such a high priority in prepping my next convention? Definitely not.

Comic conventions

I wrote the chapter on Comic Conventions for the *How To Make Webcomics* book. It kicked off with the illustration below. It's me as a carnival barker, standing on my table. And the chapter itself was as enthusiastic as the caricature. I eagerly encouraged cartoonists to book themselves a table at the nearest con, set up a banner and begin promoting their work.

And I'm *still* a big fan of comic conventions.

But I've come to a new place in my philosophy toward them. I don't think you should be exhibiting at a con unless you're confident you're going to turn a profit.

If you think you're ready, brace yourself for a *lot* of work.

IS THIS A GOOD TIME TO 'CON'?

Conventions can certainly be used to promote new comics, but, let's face it, there are dozens of more efficient ways to promote your new comic that don't cost half as much. From outright advertising to viral marketing, Twitter, Facebook, etc. — you have plenty of ways to reach new readers that don't involve sinking a few hundred bucks into a table, hotel and travel.

Flyers and handouts are great — and they're a substantial part of an effective booth strategy — but the overall readership-conversion on those things is tiny. And unless you're turning a fair profit on the show, it's just not worth the expense for the promotion alone.

Of course, if you can mitigate these expenses — and if you have merchandise that you're ready to sell — I think conventions are still a strong part of a webcomics business plan.

In short, if you consider yourself a beginner, skip this chapter and focus on your comic.

IS IT THE RIGHT CON FOR YOU?

Beyond asking if you're in the right place to begin exhibiting at conventions, you should also be asking whether the convention itself is in the right place.

The health of a convention is largely a function of the local economy of the host city.

Unless we're talking about a show with international pull like Comic-Con International (in San Diego) or New York Comic Con, conventions pull attendees from the local area of the host city. And if the local economy is strong, you're more likely to have attendees with money to spend on your merchandise. If not, you're liable to spend much of the day greeting readers who "just want to say thanks for the free comic."

I would encourage you to research the economic health of the city you're considering exhibiting in. As you do your own research, I would encourage you to check out the Bureau of Economic Analysis Web site (bea.gov) — particularly its regional section and especially its interactive regional maps page.

It wouldn't hurt to Google the name of the city you're considering along with key words like the current year, "economic" and "forecast".

And finally, ask around. The best advice you can get is from someone who has been there.

WHAT'S YOUR CON OBJECTIVE?

There are two main reasons to attend a con: to sell or to promote. Of course, if you're going to sell, you can promote, too. But if you're going to promote, you shouldn't be distracted by trying to sell.

How do you decide? You don't. Your situation decides for you. You must honestly judge where you stand with your webcomic, and then you decide which option would benefit your comic more.

Look at it this way, exhibiting at a convention is like renting real estate. You sign a lease for a finite amount of hours in exchange for your hard-earned cash. What is the best use of that space during those hours? If you have a smaller readership and little merchandise stocked up, it sounds as if you'd be better focused on promoting.

Here's another dead giveaway: If you have to ask what you should be selling, you should probably be promoting. You'll know that you're ready to focus on selling when you have a basement full of merchandise that you need to sell and you're wondering how to display a range of price points on your table to effectively move your stock.

GOING TO A CON TO SELL

If you have something to sell, you have to be reasonably sure you'll at least break even. Otherwise, you have to weigh whether this convention appearance is worth the time, money and effort.

You have to have merchandise that you honestly believe people want and a large enough readership to support your appearance.

If not, you have to take a long look in the mirror and ask whether your money is better spent elsewhere.

If you have quality merchandise — say, professionally printed books — then you can present a table with a nice variety of price points: buttons for a dollar, T-shirts in the $15-20 range, original art for $50-plus, sketches for $10 and up, etc.

But if you find yourself trying to get merchandise out just so you can attend a convention, you're putting the cart before the horse.

GOING TO A CON TO PROMOTE

Of course, you can always attend a convention to promote your work. But you have to be advised that there are tons of better ways to spend that money. Even a banner ad has a better return on investment. Nobody can click an Artist's Alley table and go to your site.

You can attend a convention to promote and hand out flyers and free mini-comics and all sorts of stuff. And a percentage of people who receive these things will actually find your site eventually.

But in this case, your primary reason for being there is to promote — not to sell. Your money (and mental effort) should be going into spreading the word on your comic. Splitting your efforts between the two is only going dilute that effort (and waste your money).

So ...why are you going? To promote or to sell?

AND NOW A NOTE FROM 2001

The advice above comes from a guy who has been attending several conventions a year for more than 10 years. I'm pretty confident in its veracity. And if I had heard it in 2001, I would have had a list of "yeah, buts" a mile long. I would have been dead wrong, but I would have insisted I knew better, too.

CON CHECKLIST

In *How to Make Webcomics*, we suggested keeping many of the items you use at a con in one container — a convention tool kit. Here's an updated list:

☐ Credit-card reader

☐ S-hooks

☐ Zip ties

☐ Tape (duct, masking and Scotch)

☐ Safety pins

☐ Scissors

☐ Ruler or tape measure

☐ String or dental floss

☐ Drawing tools (including writing pens and Sharpie markers)

- ☐ Paper
- ☐ Eraser
- ☐ Bandages
- ☐ Facial tissue
- ☐ Breath freshener
- ☐ Hand sanitizer
- ☐ Emergency cash
- ☐ Calculator
- ☐ Aspirin / pain reliever / emergency meds
- ☐ Extra business cards
- ☐ CD/USB drive of promo samples, logos, press kit, etc. — in case you need to print something on the fly
- ☐ Nonperishable snacks

I suggest a sturdy, durable box — perhaps a fishing tackle box — to contain this. The benefit of the tackle box would be, obviously, that you could keep many of the smaller items organized.

If you're interested in what Penny Arcade brings to a show, Robert Khoo shared their checklist on Webcomics.com:

- ☐ Trusses for display
- ☐ Banners for truss
- ☐ Shelving
- ☐ Inventory
- ☐ Credit-card machines
- ☐ Power
- ☐ Phone line
- ☐ Line splitter
- ☐ Paper rolls
- ☐ Change (see sidebar)
- ☐ Sales permit/paperwork
- ☐ Customer bags
- ☐ Calculator
- ☐ Pens
- ☐ Clipboards
- ☐ Power strip
- ☐ Nylon ties
- ☐ Pricing stands
- ☐ Pricing print-outs

BOOK STANDS

Everything in your booth display should be vertical, and that includes the merchandise on your table. Books lying flat on a table aren't visible to the passers-by. Use plate stands (you can find them online or at any craft store) to stand your books upright on your table so that cool cover you designed can work its magic.

GOT CHANGE FOR A TWENTY?

Mr. Khoo suggests estimating the amount of sales you will make during the weekend, and bringing 3% of that in $5s and $1s. Keep in mind that *Penny Arcade* features pricing very focused on $5 units, so the team very rarely uses $1s. For folks who don't do this, 4-5% could be a consideration.

I have one more thing I'd like to suggest you include in yours — especially if you're in Artists' Alley.

A bike chain.

I don't know why this happens, but I've yet to exhibit in Artists' Alley and end with the same number of chairs that I started with. Sometime in the night, some jerk decides to grab a few extra chairs — and they must think Artists' Alley is the perfect place to go hunting.

It has happened to me consistently enough that I'm going to start bringing a bike chain with me so I can lock up my chairs at the end of the night.

Speaking of security, if people are taking chairs, who knows what else they're taking, so be sure that the only stuff you're leaving behind at the end of the day is stuff that you wouldn't mind losing. Stashing money and original art at your table overnight — even well-hidden — is taking a risk.

- ☐ Sales-ticker sheets
- ☐ Rubber bands
- ☐ Tape and tape guns
- ☐ Stretch wrap
- ☐ Shirt-folders
- ☐ Order services
- ☐ Freight arrangements
- ☐ Hotel information (including address, phone and confirmation numbers)
- ☐ Flights information (including times, gate information and confirmation numbers)
- ☐ Per-diem cash
- ☐ Personal effects (toiletries, clothes, etc.)
- ☐ Inventory management

HAND TRUCK

This is not going to be something you can easily use on a convention trip that involves air travel, but for any cons that are drivable, a hand truck is worth its weight in gold. Here's what to look for in a good one:

Payload. Don't buy a wussified plastic one that's basically a milk crate with wheels and a handle. You're gonna be hauling books and other merchandise. You need a workhorse. A box of my books can be about 35 pounds, and I can get four or five of them on the two-wheel version of the cart. I can get 10 or 11 on the four-wheeler. That's upward of 350 pounds.

Convertible. It coverts from a two-wheeler to a four wheeler. This gives you greater flexibility in what you're able to haul. Also, some convention centers have rules about what you're allowed to haul on your own (without the help of official, expensive convention labor). Often, these rules are focused on the number of wheels on your hand truck. Two wheels = good. Four wheels = bad. I've often hauled a truckload from the parking garage to the front door, unpacked half of it there to be watched over by a friend, and carted what I could the rest of the way on two wheels. Then I went back for the rest.

Size. This is going to be taken along on a driving con, so make sure you can fit it in your vehicle and still have room left over for your actual merchandise — and anything (or anyone) else you're planning to take.

Weight. Take note of the actual weight of the hand truck itself. Is this something you're able to swing into your vehicle single-handedly if need be?

Straps. If your unit doesn't come with straps, stop by the hardware store and pick up some bungee cords while you're thinking about it. No one likes to have a couple hundred pounds of your brilliant work on their big toe.

If your exhibit doesn't involve as much heavy-hauling, there are several other options, including collapsible grocery carts and wheeled crates.

GETTING A GUEST INVITE

Convention promoters often invite certain comics professionals to attend their shows for free. They promote the pros' attendance to help drive attendees to the show. If you can bring people through the door as a creator, it's worth it from the promoter's viewpoint to give you free space to exhibit.

So, what if you're not getting invited?

Ask for an invitation.

I think the biggest stumbling block in getting a guest invitation is the phrase "guest invitation." Both of those words, *guest* and *invitation,* imply a social event. It's like asking to be invited to party — which is impolite. But this isn't a social event — it's business. And a guest invitation is, simply, *having certain show expenses covered in return for being able to help promote the convention.* And with that in mind, it's perfectly acceptable to e-mail a convention promoter and inquire about the possibility of getting invited to their show as a guest.

As you're writing this request, keep in mind the exchange that's being implied: You're worth free table space only if you can offer the ability to help bring people to the convention. You can do this in two ways: (a) Your presence at the show is going to encourage fans to attend and (b) Your ability to promote the show from your site (including both the blog and banner ads) and social media will help spread the word about the show to a large group of readers.

So, to the right you see how a guest-invitation request might look if I were writing it.

If the promoter says no, accept it with the understanding that this is a business decision — not a personal judgment of you as a cartoonist. If he or she says yes, it's likely to be just that:

> Dear Brad,
>
> That sounds great!
>
> — Joe Promoter

And here's where your ability to be a good businessperson comes into play, because this ambiguous "yes" hasn't really confirmed all of the requirements on your side. Will Joe be booking a hotel room? If so, is it a private room or does he expect you to occupy a "crash room" with a dozen strangers? Is he going to book a flight (or rental car, etc.), or is he going to reimburse you (or neither)? And what are the dimensions of the booth (and does it include a table and chair)?

These details have to be agreed upon before the promoter has your permission to use your name/comic to promote the show, and you have to make that clear.

> Dear sir or ma'am,
>
> I'd like to ask about the possibility of being invited to your convention as a guest.
>
> My comic, Evil Inc (hyperlinked to the site), is about super-villains who have formed a corporation, and it traffics about XXX in daily pageviews and ZZZ in daily unique visitors.
>
> In return for a table plus hotel- and travel-expenses, I can offer XX daily pageviews in advertising promoting your show between the date of our agreement and the show itself.
>
> I will also be promoting the show in my comic's blog as well as my Twitter page (XXX followers) and my Facebook Fan Page (XXX members).
>
> Thank you for your time and consideration.
>
> Sincerely,
>
> Brad Guigar

©ECCC Corp. **Tales From The Con,** courtesy of Emerald City Comicon (emeraldcitycomicon.com), is illustrated by Chris Giarrusso and written by Brad Guigar

Your reply should be polite, but direct.

> *Dear Joe,*
>
> *I'm excited about attending your show! I've heard a lot of great things about it.*
>
> *Before I can confirm my appearance, I need to go over a few details:*
>
> *Will you be booking a private room, and if so, at which hotel?*
>
> *What information do you need to book my flight — or is it easier for you to reimburse me?*
>
> *What are the booth dimensions? Is it fully furnished with table/chairs?*
>
> *I can't wait to share this appearance with my readers. Please send me any promotional material I can use to help spread the word about the show.*

And that's where the negotiation begins. You may have to be prepared to do some extra work for the show — like participating in a panel discussion, for example. He may balk at certain expenses. He may actually offer some benefits that you hadn't considered. It's a back-and-forth that is going to come down to this:

- Are you worth the money the show is spending on your attendance?

- Is the promoter they offering you enough to make this show worth your time?

It's not a good guest invite unless both of these criteria are met. Once you come to an agreement, you can start promoting the show with gusto. Remember, your job is to drive people to buy tickets, and the better you do your job, the more likely the show is going to have you back next year. That means beyond the blogs and tweets and house ads, it's a great idea to offer convention-special merchandise or deals.

In most cases, believe it or not, guest invitations are handled with a handshake. A few e-mails back and forth, and before you know it, you're on a plane. However, I know several webcartoonists who have drafted contracts that delineate the full extent of the expectations — on both sides — that must be signed before any official announcement is made. That's not only fair, it's the smarter route.

WHAT'S EXPECTED FROM A GUEST?

So, you got your invitation. Now what? Simply put yourself in the shoes of the people (or company) that are spending money on your appearance at their show.

They succeed when they:

1. Sell tickets.
2. Sell exhibitor space.
3. Manage their expenses so that there is profit left over from 1. and 2.

Your responsibility as a guest is to help your host succeed. Here's how:

PROMOTION

This is the most important thing you can do as an invited guest. When you promote the show, you're helping with 1. and 3. You're helping to sell tickets by encouraging your readers to buy admission to the show to see you. And in so doing, you're saving the convention money on promotion.

You should start by entering a house ad into the rotation of ads on your site. It should be big — leaderboard-size or comparable — and it should run on your site one or two months before showtime. If you're running only Project Wonderful, now is the time to establish a minimum bid and use this con-promotion ad as your default (as we discussed in Chapter 9).

It's also a good idea to blog about it a few times, talking about your excitement for the show, what you'll be bringing, any merchandise that's exclusive or special to the show, etc.

And finally, you should be doing regular promotion on Twitter and/or Facebook.

PARTICIPATE IN PROGRAMMING

I make it clear that, unless I'm an invited guest, I don't typically participate in panels. Any time spent away from my booth is time that I'm not making money, and making money is the primary reason I attend a convention. So my panel-participation is a commodity that I use to barter guest benefits. If I'm an invited guest, I'll happily participate in a show's programming. If not, I'm quite content to spend the weekend behind my booth.

As an invited guest, it's good form to offer to participate in as many relevant panels as you can justify. You don't have to go overboard — one or two would be nice — but programming is also a big part of many conventions, and your participation will be welcomed.

Don't wait for the promoters to come to you. It's perfectly reasonable to dash off a quick e-mail offering participation in specific panels and even making suggestions for new panel topics that you can moderate.

The worst that can happen is they say no and you have extra time at your table to sell merchandise and greet readers. The best that can happen is that you can build such a favorable relationship with the promoters that inviting you back next year is a foregone conclusion.

BE AN AMBASSADOR FOR THE SHOW

No one is asking you to say things that you don't believe, but if you are being invited to the convention as a guest, the very least you can do is help

HOW TO FART BUTTERFLIES

You'd be surprised how attitude is linked to success. If you look like you're having a great time, people are going to gravitate to you.

I was at a convention one year when a convention veteran took a moment to share some priceless advice with a newer exhibitor who was having a rough weekend.

The great Phil Foglio (Girlgeniusonline .com) walked up to a colleague of mine at a comic convention.

"How ya doin'?" he asked.

"Feh," said the cartoonist, "my feet hurt like hell, I'm not selling as well as I'd hoped, and I feel like I'm coming down with a cold."

"No," said Foglio, in what could only be called a fatherly tone. "These people," he gestured across the convention floor, "they want to know that you're having the time of your life and that when you fart, butterflies come out. It's why they're here. And it's what you owe them."

And every darned time I ever felt a little tired, a little sick or a little defeated at a convention, Phil's voice piped up in my head.

And I fart butterflies.

the show present its best face to the attendees during the convention. Accentuate the positive, and try to present any criticism in a polite, helpful way — especially when talking to attendees.

DONATE ART

If the convention is printing an art book to sell on the show floor or if it's having an auction, it would be a good idea to participate. You don't have to give away your most prized art, but you could certainly create something to help the promoters with their cause.

MODERATING A PANEL DISCUSSION

A comic-convention panel can be an excellent opportunity to get people excited about your comic, but unless you do a good job of presenting on the panel, you're going to wind up boring people. And no one is going to check out your work after you've bored them silly for an hour.

We've all been to the ubiquitous panel in which five cartoonists take turns answering the same question over and over again. They inevitably end up repeating each other's points, constantly flogging their own work, and the result is a droning mess.

HERE'S THE SECRET TO A GOOD PANEL DISCUSSION: IT'S NOT WHAT YOU TALK ABOUT; IT'S HOW YOU TALK ABOUT IT

The key to the whole operation is the moderator. As the moderator, it's your responsibility to engender a comfortable, informal atmosphere — even if your panelists just met on the stage. Add to this challenge the fact that many cartoonists are not very good public speakers, and you've got your work cut out for you.

A little preshow prep is crucial. Come up with any theme for your panel: the business of webcomics, marketing your webcomics, creating a webcomic, etc. A list of 6-10 questions that fit this theme will do nicely. Take the time to get to know your panelists before the panel. Google them. Read their work. Take notes. Talk to them during the convention.

At the start of the panel, here's what you do: You have your list. First, introduce your panelists and give the obligatory promotion (Web sites, titles, projects, etc.). Get the promotion out of the way so your panelists can focus on the topics to be discussed.

Now, pitch the first question, and direct it to *one* of the panelists. Listen to the response. When she's done, point to another panelist and say, "Panelist Two, you've had some experience with this ... how did it affect you?" or something like that. Maybe it's: "Panelist Three ... your approach is in direct opposition to this, can you discuss that?"

LISTEN TO THE RESPONSE

From here on out, you're the conductor — but not the controller. You're in charge of directing the conversation and making sure the panelists who want to weigh in on a topic get their opportunity, but if your panelists spontaneously jump in and get involved in a back-and-forth — that's interesting! Let it go. Let it go for as long as it remains interesting. If your panelists are actively engaging in the topic, your job is simple: You stay out of it except to make sure that all of the panelists are getting a chance to talk if they seem to have something to say.

NOT EVERY PANELIST HAS TO SPEAK ON EVERY TOPIC

There will be some panelists who do not speak on the first topic. Try to bring them in on a subsequent topic. And so on. At the end, if you've moderated well, everyone will have spoken the same amount, but not everyone will have addressed every single topic. Remember that list of 6-10 questions? They are your last resort. They're your safety net.

The discussion should develop organically from that first question. But if the discussion dies down, you pitch another question exactly as you kicked off the panel — by directing it to a specific member of the panel (not the same one, though).

If no one jumps in to respond after that, you prod one of the others to do so based on what you know about him/her. If you know your ingredients well enough, you should be able to concoct a wonderful stew of ideas and stories. You should feel free to jump in when it's appropriate with a comment or story of your own, but you've got a bigger role to play, so don't allow yourself to get distracted.

KEEP AN EYE ON THE CLOCK

If you wish to have an audience Q&A, make sure you leave enough time for it. When that time comes, take control of the discussion and introduce Q&A time. This is crucial: When the audience member asks his/her question, repeat it into the microphone. If necessary, pitch it to a specific panelist. If necessary, direct a response from another — just as you did with the discussion questions. And, as always, if an interesting discussion breaks out, stay out of the way.

THE AUDIENCE DOES NOT SPEAK

Do not let audience members get involved with the discussion. They can ask a question and suggest a follow-up (both at the same time), but after that, they sit and are out of the discussion. Why? Audience members aren't mic'ed. No one else can hear them. It's a death sentence for everybody else if they try to get involved.

If they do want to ask follow-ups or get involved in the discussion, you simply — and politely — interrupt and say, "Since we have a limited amount of time, I'm afraid we can't discuss this topic as deeply as it deserves, but all of our panelists will be available directly after the discussion and will be happy to talk to anyone individually about any of these topics." Smile. Move on. Quick.

CLOSURE

At the end, bring it to a close. Leave time to reintroduce each of the panelists along with a short plug for their comics and information about where they can be found on the convention floor after the discussion. If you've done your job, the audience will not only hang through the entire time, but many of them will need to find out more about you and the other panelists. And you can't ask for better promotion than that.

THE CON PITCH

As you're standing at your table, you're going to attract some people who are unfamiliar with your comic, and you're going to have to explain it to them — in a quick, entertaining, meaningful way. I think the key to a good con pitch is to think like a reader — not like a creator.

CHOOSE YOUR WORDS CAREFULLY

For example, when we talk about comics, we use words like the following:

slice-of-life	single-panel	meta
long-form	geek humor	sprite

These words don't carry the same weight with our intended audience as they do among us. We use those words and phrases to communicate thoughts on a certain level, but our readers ... they just want to be entertained. *No reader* describes himself as a devotee of slice-of-life family comedies.

To write a good elevator pitch, you have to first understand who your audience (intended and/or actual audience) is. Getting into the mind-set of your readers allows you to use the words that have special meaning to that community. And one of those words might be one of the words listed above for your audience. But it's probably not.

KEEP IT SHORT

Two sentences. Tops. The best pitch is one sentence. And a short one at that. Editing a pitch means being absolutely brutal. Every word that doesn't help deliver significant meaning is actually blocking the meaning.

USE 'MASH-UPS' WITH CARE

"It's like the 'Addams Family' meets 'Lost in Space.'" We hear these kinds of pitches used all the time when people describe ideas for movies and television. And, to be sure, if the mash-up is chosen accurately, you can build off the concepts carried by each component to communicate your idea. But beware, every once in a while, you'll meet someone who didn't like "Lost in Space." And they'll carry over that dislike to your work.

MAKE IT POWERFUL

Use active, expressive words. You're trying to generate a little interest here. Your vocabulary should reflect that.

PRACTICE

Once you've honed your pitch on paper, start repeating it. Memorize it. Rehearse it. The more you say it, the more you're going to erode the corners off it, wearing away extraneous words and phrases. It's also a great way to lock it into your subconscious, where your brain can continue to work to improve it.

BOOTH ETIQUETTE

There are a few points of booth etiquette that you should be aware of as you're exhibiting at a convention.

No poaching: You may never — *ever* — address an attendee while he or she is speaking to another exhibitor. Interrupting a discussion between an attendee and an exhibitor is unforgivable.

No blocking: It's important to get as much vertical display space as possible. Placing a tall banner stand behind your chair is perfectly fair. And so is erecting a display that stands above your table. But when you start blocking your neighbors' ability to see down the walkway, you're treading on dangerous turf. If you have this kind of setup, you should ask your neighbor's permission — and be prepared to improvise if he says he'd rather not be blocked by your display.

Stay behind the table: You might think that standing in front of your table, handling out flyers and barking for your table, is a great idea, but I guarantee your neighbors don't. You're disrupting the traffic flow, and you're probably causing more than a few people to rethink how badly they want to walk down your aisle. Stay behind the table, where you belong.

BOOTH BARNACLES

Yes, I coined the term in 2002. Consider it my linguistic gift to webcomics.

Booth Barnacle (*barnaclous blahblahblahblus*): A fan who stands in front of your booth for way too long. Sometimes they've bought some merchandise, and sometimes they won't buy a thing. Sometimes they're talking incessantly, and other times they're just ... standing there. But they're making it impossible for you to do what you came to the convention to do.

I know what you're thinking: Clearly, these are the wizened musings of an aging comics curmudgeon. The poor, old fellow has had one too many exhibitor badges slung around his veiny neck, and he's finally hardened to the loving fan interaction that once brought him to webcomics.

First of all ... ouch.

Secondly, it's not that I have allowed myself to devalue the worth of a fan who thinks enough of me that — out of all the things he could be doing at this convention — he can only imagine standing there talking to me. Believe me. I have a keen awareness of the importance of superfans — and I know how they can propel a comic's success.

But facts are facts. Total up your hotel costs, travel, booth costs and the cost to ship your merchandise to the convention. And then divide that amount by the number of hours the show is open. That's your hourly con rent. You have to average that amount — every hour — to turn a profit at the

©ECCC Corp. **Tales From The Con,** courtesy of Emerald City Comicon (emeraldcitycomicon.com), is illustrated by Chris Giarrusso and written by Brad Guigar

convention. And if you're not selling, you need to justify that rent with promotion, and that means handing out flyers and making elevator pitches.

All of this is impossible, however, when you incur a booth barnacle. You must be able to politely, kindly and efficiently draw the interaction to a close when it threatens to take too much of the time that you're renting. And that's much easier said than done. Here are a few pointers.

GIVE THEM THE WAVE

I will sometimes hand out flyers right around the person. This has two effects. First, usually the person has to step aside slightly to avoid my poking him in the ribs (not that I would … not *hard*). Second, it increases the chances that someone else will step up and allow you to turn your attention away.

Drawback: On more than one occasion, I have ended up with two barnacles this way.

(HAND)SHAKE 'EM OFF

Spontaneously reach out and shake their hand and say, "Thanks again for coming out. I really enjoyed talking to you."

I've become convinced that barnacling is, more often than not, the result of not being able to recognize closure in a personal interaction. It's like that guy who stays at the party long after the other guests have left. The party is over, but this guy hasn't picked up on the fact that his hosts are clearing dishes and changing into their pajamas.

So I try to incorporate as many familiar end-of-meeting phrases and actions as possible into the situation. Handshakes work well, and so do phrases like: "Thanks for coming out. I really enjoyed (past tense) talking to you."

Sometimes, in my phrasing, I'll make the assumption that they are leaving: "Thanks for stopping by. Do try to stop back sometime before the end of the show."

Drawback: Often, they do.

'I DON'T WANT TO BE A BARNACLE …'

Ah, the self-aware barnacle. You'd be surprised how many convention-goers know the term "booth barnacle." And they know that they're doing it as it's happening. They'll step to the side and politely chat away (or worse … stare …) as you try to adjust to performing for an audience of one.

I'll be honest. As long as they're not blocking the table, I really don't have a problem with this sort of fan. If it seems to go on for too long, I try a few of the "closure cues" mentioned previously.

Drawback: They might just stand there all day — or worse yet, try to engage the other people to walk up to the booth.

THE BACK-TO-THE-BOOTH BARNACLE

This one is infuriating. He's not a fan — heck he doesn't know you from Adam. But he's decided that your booth-front is an excellent spot to wait for his friend who's standing in line to see Jim Lee (and that's a long line).

This is one of those times when you just have to come right out and say it. This usually goes best if you suggest a suitable alternate waiting place and level with the guy.

"Excuse me, but would you mind moving off to the side somewhat? I'm afraid you're blocking my ability to do business here."

Yup. I say "do business." It kinda jerky, but it reinforces that I'm not standing there for fun.

Drawback: Sometimes they indicate that you are, in fact, a jerk. *Shrug* But they usually say it over their shoulder as they stomp away, so you're a jerk who is back in business.

THE BLOCKADE

At this point, it's useful to mention a kind of barnacle that actually isn't a barnacle at all. These people block your booth while waiting in line for the cartoonist exhibiting in the booth next door.

First of all, let's make this clear. If any of you are ever in the situation in which you're drawing a crowd that inhibits your neighbors, con etiquette demands you take reasonable steps to mitigate the effect it's having. That means line maintenance — directing your fans to queue up in such a way that they're not blocking others. This might mean doubling the line back on itself or directing the line around a corner that isn't serving as active booth space or asking the convention staff for assistance.

However, not everyone follows con etiquette. So, in the course of exhibiting, you will occasionally find yourself hemmed in by a lineup of someone else's fans.

You have to measure your response carefully.

If this is a reasonable line — and if I see that it's going to move in a short amount of time — I start handing them flyers. "Would you like something to read while you're waiting in line?"

Heck, I've been known to start elevator-pitching people as they're standing there.

However, if it's a long line and you can see that you're going to be affected by it for a while, you have two options.

Politely — and in a friendly, nonconfrontational way — ask the person in the other booth if there isn't something he can do about the situation. Scope it out beforehand and be prepared to make suggestions. For example, if there's another way to queue up that doesn't block your booth (or someone else's), then be prepared to suggest it. It's unfair, however, to interrupt someone's fan interaction and ask him to solve a "problem" that he's probably delighted to have. So you're going to have to offer a solution — one that benefits everyone involved.

If that's not possible, you have to get the convention staff involved. They might be able to help the person manage the line. Or they might be able to direct it in a way that can benefit everyone involved.

But remember, this is touchy territory to tread. You can easily come off as looking jealous of another person's success. This takes a little finesse. And a little smile.

THE BOTTOM LINE: SMILE

You're a cartoonist, so you ought to understand that it's all in the presentation. Any of the approaches I mentioned above can be disastrous if you try to pull them off in a surly or aggressive manner. You gotta remember ... except for that last lot, these are some of the people you've worked very, very hard to win over. It would be foolish to lose them over something like this.

So smile. Shake hands. Place a hand on a shoulder in a friendly way.

If you handle the barnacle with kindness, it won't be "goodbye." It will be "until we meet again."

And, yes, that's a good thing.

TAKE A PHOTO

Here's some advice that I got from Bill Barnes (Unshelved.com).

When you're exhibiting at a comic convention, don't pass up an excellent opportunity for community building: Bring your camera. Photos of your convention appearance make for nice bonus content for your readers, but more importantly, you should be taking photos of people who bought your merchandise standing proudly with their newly gotten gains.

This has a powerful psychological influence on your readers. We react strongly to seeing other people's faces. We might find some of them attractive. We might feel we have something in common with some of them. We might notice something in the photo that reminds us of something or someone we like.

There are all sorts of connections that are made in that split second — many of which are very positive. And, there amid it all, is your book — nicely associated into the mental exchange: Hey, that guy has a Bizarro shirt. I like Bizarro! Maybe I'd like the book! She's attractive! And she bought a book. Desirable people buy this book!

Before you roll your eyes, hang with me. Obviously, no one actually thinks these things. But the subconscious benefits are *real*.

So keep your camera right by your cash box, so it doesn't become forgotten in the heat of the moment. Before you click, keep a few tips in mind:

- Ask permission first.
- Let them know you'll be posting this on your site.
- Accept "No" as an answer.
- *Never* photograph other people's kids unless you're certain they're OK with it — and after you've explained that this will be on your site.
- If you identify the readers at all, I favor using a first-name-only attribution.

When you return from the convention, post the photos along with any anecdotes or stories that involve your positive interactions with your readers. It's a great way to build your community — and it's a reward to those supportive fans who come to your site and get greeted by your singling them out as special that day.

FREE SKETCHES?

One of the most passionate debates in comic-convention exhibition is whether to charge for sketches. There are two major camps.

VERNE BLANSTON ARTIST OF DEATH WOLF

Convention Sketches

Black & White -- $20

Color -- $40

SARA FERNE ARTIST OF WIZARD OF MARS

Convention Sketches

Headshots $10

Full Figure - $20

Complete Scene - $40

BUDDY COPPERDALE JR. WRITER OF DOOM TROLLY

Convention Writing

Short -- $10 Dialogue

Full ---- $20 Paragraph

Short Story -- $40

ROBER SMITH ARTIST OF ROBO-C

Co Sk

Fu Fig

Bla WI Co

IT DIDN'T WORK.

One says that the cartoonist should charge for sketches at conventions. Period. You're there to make money, after all, and this is an important source of revenue. And, truly, most of your fans are only too happy to pay a small fee to get a personalized piece of original art.

In the other camp are those who insist that free sketches are an easy way to thank your fans for their support. Moreover, asking for money for these sketches is an insult to a fan who already paid to get in the doors to see you at a convention.

So, who's right? Both are. Prominently post a price list on your table that includes sketch prices (including a free option). You should offer price breakdowns — in other words, you'll do a foreground sketch for $XX or a full scene (foreground-plus-background) for $YY.

If you haven't done this before, you may be surprised how many people are eager to *buy* sketches. Many convention-goers will bring books for you to sketch in, but some won't, so be sure to bring along some good-quality illustration board.

Meanwhile, practice a handful of simple character sketches that you can execute in under a minute each. These are the sketches you'll offer to anyone who asks for a free sketch. You might even consider these sketches — or somewhat more developed versions thereof — for inside the books you sell at the booth. But you have to be able to do these free sketches quickly.

Any amount of time you spend with your head down at the table is time that you're *not* doing what you came to do — interacting with fans, selling merchandise and promoting the comic to new readers. You can't afford to get too wrapped up in these sketches.

Done right, this system can be used quite deftly to help ensure a profitable convention. Often, a free sketch can be used to drive a sale. For example, you can offer a free sketch to a person who is waveringly considering buying one of your books. And you can slow down your tempo on a free sketch and encourage a potential customer to leaf through one of your books. If you think he or she might possibly buy a book, you can facilitate some quality time with your merchandise as he or she waits for you to complete the sketch.

ASHCANS

Comic conventions have a wonderful tradition of offering "ashcans." This is a small, photocopied booklet that serves as a sample of the cartoonist's work.

Go to one of the printing companies that offer self-printing (the local copy shop is a great place

to start your search) and print 50-100 copies of an eight-page-long book featuring some of your best strips — or maybe one of your best story arcs. Make sure contact information such as your comic's URL appears prominently. This is, after all, a sales tool. Put them on the table and offer them for free. People love free samples. If they like it, they will reread it and want more, which will lead them to your site. As with all freebies, the payoff comes when people get hooked by the sample and return — either to your site or to your table to pick up some merchandise.

LOSS LEADERS

When your local grocery store offers an item — say, a loaf of bread — at an extra-low price, that item is being used as a loss leader. A loss leader is an item that is sold for little or no profit (even, literally, at a loss) for one reason and one reason only: to encourage you to walk into the store. Because, the grocer knows that once you walk into the store, you're not only going to buy bread, you're also going to probably buy milk, eggs and maybe even those little cookies with the chessmen on them.

When the total sale is rung up, the grocer has made a tidy little profit. All because he was willing to take a loss on one of the items. And you can, too.

One of the best things you can feature in your store is a small, inexpensive item that you can use to drive people to your store.

For example, last year, I offered a set of three buttons. The buttons cost me about 50 cents apiece to have manufactured, and I offered to sell all three for $3. It was a decent profit, but certainly nothing that was going to make or break my year.

But where the buttons really came in handy was when I offered to include all three buttons for free with the order of any book from my store. Orders jumped instantly. People were willing to place an order that they most likely wouldn't have placed otherwise — and all because I was willing to include free merchandise that set me back all of a buck-fifty.

In the end, I was able to spur sales at my store and make my readers happy — all at the same time.

Hardly a loss.

TRACKING INVENTORY

Keeping track of your sales during a convention appearance is important for several reasons. First, you need to track sales in order to accurately account for sales taxes and income taxes. Secondly, it's important to track which items are selling better than others as you decide on what types of items

to offer in the future. Third, it's always helpful when planning how much of each item to ship to a convention. And finally, if you buy books in bulk and claim them as inventory on your income taxes, you'll need these numbers when you get home to adjust your count.

With all of these reasons, you'd think there would be a better way to track sales, but as you go from booth to booth, you see two derivations of the same system. The first is a chart artists keep behind the table and mark on to record each sale. If they remember to.

The second, less-visible, method is to simply count the items before the show and count them after the show, subtracting to find the difference. Pretty unassuming, isn't it?

Trust me, I've brainstormed other methods. I bought a bar-code scanner, thinking I'd scan every item as it was sold so it could be entered into a spreadsheet. I figured out how to print special bar codes for items that didn't already have one. I even considered getting a second hand cashier's money drawer that would force me to enter the transaction before allowing me to open the drawer.

But the system was too bulky and clumsy to be practical. Let's face it, if you're lucky enough to have a few people standing in line at your table, the last thing you want to do is try their patience by futzing around with money.

Fortunately, the Running Hash Mark system and the Before and After Count system — as primitive as they may be — are actually pretty quick. And that gives them a serious edge.

I incorporate both into my shows. The hardest part is sticking to them. To help keep me on track, I stick a note in my money box reminding me to record the sales. And at the end of the show, no matter how tired I am, I force myself to spend a few extra minutes counting my merchandise.

I record this data directly into the same sketchbook I use to brainstorm my daily comic. It goes everywhere with me — especially conventions. And as such I know it will be there when I'm prepping or tearing down a booth, and it will be there when I'm planning my next show.

On the same sketchbook page(s) I devote to inventory, I also jot down expenses (like lunches, dinners, taxis, etc.) before I forget about them. Yes, I keep the receipts, but I want this information all in one place for future reference. And I keep general notes — like the show traffic, whether I think the show is being run well, etc.

When I get home — and after I've given myself a day to recover — I start crunching numbers and comparing notes. I determine whether I sold more at the show than I spent overall. I track what I took to the convention and how much I sold. And I write my overall feeling about the event.

It's a tremendous resource later on as you're working on taxes or determining whether to make a return appearance at a convention.

SALES TAX

Something happened at Comic-Con in 2009 that really made my eyes pop open. And it had nothing to do with cosplayers. A representative from the California State Board of Equalization dropped by our booth and asked to see our sales-tax documentation. And then he started asking some very direct questions about how much merchandise we had brought, how much we sold last year, how many years we had been exhibiting in San Diego and so on. I have no doubt about what would have happened if we didn't have our documents in order.

When I was visited earlier that same year by a tax representative in Connecticut while exhibiting at a comic convention there, I knew it was the beginning. And, to be honest, I'm surprised it hadn't happened sooner in San Diego. And it's coming to a con near you.

The days of showing up to a comic convention without having the proper sales-tax documentation

are coming to an end. In a time when state budgets are stretched to the limits, many governments have clearly decided to start raiding the sofa cushions for change. And, to be fair, in some instances it's much more than pocket money we're talking about. Especially when you add up all of Artists' Alley, then all of the comic convention, and then all of the convention that sets up the next week.

So it's something to get used to. It's going to mean combing the state's Web site (a daunting task in most cases) and/or placing a phone call to the proper state agency. For states such as Illinois, you might be able to file a one-time-only special-event sales tax. In New York, you can limit your sales-tax license to the days of the convention you're attending. In other cases, you may be required to stay on top of your newfound license and file quarterly returns even though you've made no revenue in that state for several months.

Don't kid yourself. Insisting that you're handing out free merchandise in return for "donations" simply isn't going to hold water. If there's money involved during an exchange of goods, the state is going to want its cut.

You're going to need to register *before* attending a convention. The alternative is showing up to a convention without the proper documentation and — if you get caught — being prevented from selling all weekend and/or facing a stiff fine.

MERCHANT SERVICES

A merchant-services account is a method of accepting credit cards for business transactions. PayPal is a merchant-service provider that you're probably already using. It facilitates transactions and claims a percentage in the process. Your bank probably offers merchant services, as well.

When considering which is right for you, be sure to consider some of the following:

WHICH CARD READER IS BEST FOR ME?

You actually have several choices. You could use a manual-imprint machine (commonly referred to as a "knuckle-buster"), an electric credit-card reader, an iPhone attachment (like Square, which we'll be discussing in depth shortly), or any number of other workarounds (like using PayPal on a laptop computer).

CONVENTION COSTS

Using a credit-card reader incurs other costs while you're at a convention. If you have a card reader that uses a phone line, you will need to arrange for a phone line at the convention. This can be expensive — and if you're in Artists' Alley, it might be impossible. If your card reader uses cell-phone technology to send a signal that completes the transaction, you'll pay a monthly fee there. Wi-Fi? You might wind up paying to access the convention center's Wi-Fi signal.

RISK

Using the manual-imprint machine involves a certain amount of risk. There's no way to know for sure if the credit card is valid until you upload the data, and that usually happens long after the convention floor is closed. Also, many cards are now being issued without the raised numbering, which will make these cards impossible to imprint.

Similarly, many people use their electric card readers without the cell/Wi-Fi/phone hookup. In those cases, the machine, essentially, becomes a fancy manual-imprint machine because the data gets uploaded after the show floor is closed (for example, back in your hotel room).

If you get handed a bad credit card, you have no way of knowing until it's too late. To eliminate this risk, you'll want to be able to verify the credit cards on the spot. However, that brings the cell/Wi-Fi/phone technology back in, and that means a higher initial cost.

PERCENTAGE

Every merchant-service account takes a percentage of every credit-card transaction. Some of them are staggered according to how the transaction transpired. For example, you might be charged a higher rate for using a manual-imprint machine than an electric swiper.

FLAT FEE

Some merchant services charge a flat monthly service fee on top of any transaction charges they may levy.

DISUSE PENALTY

Some merchant services charge a fee ($25-$30 or so) if you fail to use your account for a credit-card transaction during the month. For people like us who may only use their credit-card readers during conventions, this is a significant penalty to be aware of.

Ask your provider of they allow you to pre-establish months in which you will not be using the service. You may be able to have your system shut off during these months. Of course, that will mean that if a convention pops up in one of your "off" months, you will not be able to take credit-card transactions.

READ THE FINE PRINT

Most merchant service accounts require a commitment (three years or so). You might get tempted by a new merchant service provider that offers free equipment after having signed up with a competitor. If you're not at the end of your commitment, you'll have to pay the penalty for leaving the contract early. Remember that disuse penalty? It's usually that amount for every month left on the contract.

SMARTPHONE SWIPERS

If you already have a merchant account, adding a swiper to your iPhone may incur an additional monthly charge for its use. Again, this charge is levied whether you're using the swiper or not.

Some swipers may deduct an additional percentage per transaction as well. This is on top of the percentage that your merchant-services provider takes per transaction.

Sometimes — especially in those huge, old, concrete convention centers — it's impossible to get a clear Wi-Fi signal. Completing a 3G transaction has also proved difficult — especially at large conventions where the competition for bandwidth is fierce. Batteries die, and sometimes electronic devices just fail to cooperate.

©ECCC Corp. **Tales From The Con,** courtesy of Emerald City Comicon (emeraldcitycomicon.com), is illustrated by Chris Giarrusso and written by Brad Guigar

And there's nothing worse than being in one of those situations and facing someone who wants to buy a stack of your merchandise who can only use a credit card for the transaction.

MANUAL-IMPRINT MACHINES – PROS AND CONS

I always have a back-up manual-imprint machine handy. However, you need to know:

- Manual-imprint devices often register higher merchant-services fees, depending on your provider.

- The device does not capture the invisible data a credit-card reader captures to help the merchant-service provider verify the identity of the credit-card owner. If that information is not collected, your provider might levy still more fees on the transaction. The other option is to ask the buyer for this information outright (for my provider, it's the number of their house address and the ZIP code the credit-card bill is mailed to).

- Sometimes you don't get a clear imprint, and you don't realize that one of the numbers could be a 6 or an 8 (or maybe a 3) until it's much too late. After the convention is over, you will have a stack of receipts to manually upload to your merchant-services provider for processing. If you don't do this in a timely manner, you take the risk of buyers not recognizing the charge on their bill and calling their credit-card company, worried about credit-card fraud.

For all of these reasons, I use my manual imprinter only as a backup for when my iPhone-enabled reader doesn't work. And when I do, I usually go one extra step, just to make sure: I ask the buyers, if they're comfortable doing so, to provide their phone number so I can contact them in case anything goes wrong. There's only one thing worse than missing a sale, and that's giving merchandise away for free.

SQUARE VS. MERCHANT SERVICES

"Merchant services" is the term that banks apply to any equipment or process used to facilitate credit-card transactions. Square (Squareup.com), a mobile-phone-based credit-card processing app, is perfectly suited to the needs of a webcartoonist exhibiting at conventions. The per-transaction fees are perfectly reasonable, there are no monthly fees and there's no long-term commitment. I've been a fan of Square for a while — but that's mainly because I've made such poor decisions in merchant services in the past. Given my personal experience, here's a quick compare-and-contrast:

STATEMENT FEE

Merchant-service providers charge you to compile your monthly data and send it to you.

Merchant services: $9-12 per month. **Square:** Zero.

MONTHLY MINIMUM

This is the lowest amount of sales you are allowed to carry each month. If you don't meet the minimum, that amount is charged to you. Some merchant-service providers allow you to make certain months "dark" — in other words, if you're not doing business in these months, and if you've made them dark, then you won't be charged a monthly minimum during those periods. Which is great if you remember to do stuff like that.

Merchant services: $15-30 per month. **Square:** Zero.

EQUIPMENT

If you're going to be handling credit-card transactions, you'll need a reader. My VeriFone card reader that attached to my iPhone was $160. When I was pricing readers through a wholesale store, I recall them being between $500 and $700 — depending on whether they used a phone line or Wi-Fi. Keep in mind, if you want to enact real-time transactions, this means you'll need to pay for a phone line at the convention center or purchase Wi-Fi access. Or you could swipe cards all day, upload them back at the hotel and hope that no one slipped you a bad card.

Square will send you the dongle for free. It fits into the headphone jack so if you upgrade your iPhone, you don't have to worry about your reader becoming obsolete (which is exactly what happened with my $160 VeriFone reader).

COMMITMENT

Several merchant-service providers require a service commitment. One of my providers required three years, and another insisted on two. If you try to get out early, they generally charge you your monthly minimum fee for every month left on the contract.

Square has no commitment contract or fee.

CHARGES

Whew. This is where it gets hard. I kept all of my paperwork from all of my merchant-service providers, and I am downright reticent to tell you what the transaction fees were because they weren't clearly spelled out anywhere!

One provider gave me a page full of percentages, divided with categories like Qualified Discount Rates (1.79%), Mid-Qualified Discount Rates (2.49%) and Non-Qualified Discount Rates (3.49%). Since the categories are determined by sales volume, I believe I was paying about 3.49% for that particular vendor.

And those rates don't include the flat per-transaction fees that many providers charge (19¢ for that same provider).

I'll be completely honest here, I had planned to do a side-by-side comparison of every merchant-service provider I had worked with to show how Square stacks up. I abandoned the format in favor of the one you've just read because it was impossible to navigate all of the mounds of paperwork I had saved. I couldn't find what I was paying in transaction fees for many of them — not reliably. I found the above with a quick Google search, and it's helpful, but nothing beats clear, transparent wording that's prominently displayed on a vendor's site ...

Square: 2.75% per transaction. If you enter credit-card numbers manually, it costs 3.5% + 15¢ per transaction.

LET'S TOTAL IT UP...

No monthly statement fee, no monthly minimums, free equipment that won't easily go obsolete, no commitment and a downright competitive transaction fee (with no flat charges in most cases).

It's a pretty square deal.

BOOTH DISPLAYS

The standard booth display has several components: a tall banner behind the cartoonist's chair, signage on the table and sometimes signage over the table. The merchandise is displayed on the table, leaving a little room for the cartoonist to sketch and sign merchandise.

The key to booth design is to get your message up high. Aisles at comic conventions are worse than rows of slot machines in Las Vegas. They're filled with clashing colors, blinking lights and jarring sounds. That's what you have to compete against.

On the next couple of pages are a few tried-and-true booth displays. Feel free to take some components from one and add them to another to address the specific needs of your exhibit.

THE RETRACTABLE BANNER STAND

The retractable banner stand is the most useful part of your booth display. It gets your message up high, and it provides a backdrop for your entire display. Plus, when you're done for the weekend, it retracts, window-shade-style, into a small unit that can easily be carried or shipped home.

Designing a banner is very much like designing an ad (which is discussed in the Chapter 10). In short, it's helpful to center on one message, and craft the words and text to deliver that message. The top of the banner is prime real estate — being the most visible part of the banner — and that's where the title of your comic goes. Under that, you can put any phrases, taglines or slogans that help deliver your message. The visual should be compelling, strong and interesting.

MAKING A PVC BANNER STAND

PVC pipe is cheap, it's easy to cut and it can be used to make all sorts of sturdy convention displays. One of the most popular is the ubiquitous PVC banner stand. Here is a simple guide.

Start by buying some PVC pipe, a few connectors and a PVC cutter. The 3/4-inch pipe should be large enough to support the weight of a banner without being too clumsy to carry. Your local home-improvement store probably stocks them in 10-foot lengths. Two of these should be plenty.

To keep setup and tear-down easy, I'd recommend cutting the pipe into standard lengths so you're not trying to remember which piece goes where. In the illustration, all of the straight pipes are the same length except the foot pipes, which are a few inches shorter.

USING SQUARE WHEN YOU'RE OFF-GRID

Square's big advantage — being able to enact a real-time credit-card transaction using a cell-phone or Wi-Fi signal — is also a huge disadvantage if you're unable to get a clear cell signal (and unwilling, like me, to pay for the Wi-Fi service). Despite the fact that many convention centers are huge, concrete behemoths containing thousands of fanboys and fangirls running around with their smart devices, sucking up bandwidth, this problem actually surfaces less often than you'd expect. But it does happen.

I wrote Square asking for a solution. I want to be able to collect the credit-card transaction and embargo it until I am able to get a clear cell signal, and then upload all of the held transactions at that time. I was offered this alternative.

The Square representative said that I could collect the credit-card information (number, expiration, CVV number, ZIP code), and then manually enter the data and upload the transaction later on — once I was able to get a clear cell signal.

HERE'S HOW

• Open the app on your phone by tapping the Square icon.

• Input an amount and an item description for your payment. If you have an iPad, you can choose a premade item from your Item Library by swiping the keypad to the left.

• Tap the Dollar Sign button at the upper right ("Charge" on Android).

• Select the "Card" option.

• You'll be prompted to enter in the card number, expiration, CVV and the billing address ZIP code of the buyer. All of this information is required in order to process a payment.

• If the numbers turn red, that means the card information you entered was invalid or the card was declined. Usually this is due to a simple typo, so make sure you input the numbers carefully.

• Tap "Authorize" after you've entered all the required information.

• Once you see the signature screen, write either "Internet Order" or "Phone Auth" on the signature screen to confirm this was not a card-present payment.

If you are making a phone, mail or Internet order in which the buyer is not present, please follow these recommendations:

• Tap "Continue" and input the customer's phone number or e-mail address to deliver a receipt.

• You'll see the final Thank You screen after the payment is completed. You're finished!

When entering a transaction in which the card owner is not present, Square suggests the following:

• Verify the identity of your buyer.

• Keep signatures on file for all cards.

• Provide receipts to your clients for all payments.

• Enter detailed descriptions for each payment.

• Enter valid CVV, expiration date and ZIP code information (buyer's billing ZIP code).

• Store any tracking information with proof of delivery.

• Write either "Internet Order" or "Phone Auth" on the signature screen to confirm this was not a card-present payment.

HIGHER RATE

When you key-in credit-card information rather than use the card reader, the fee is slightly higher (3.5% + 15¢ vs 2.75%.) This is due to the greater risk involved with manually entered payments, as the card and buyer do not have to be present for this type of payment to occur.

To determine the length of the straight ("structural") pipes, determine the height you want the overall stand to be and divide by four — leaving about an inch or so for each connector. For a 7-foot display with five connectors, divide 6'6" (yes, I'm ballparking) and you'll need 19.5-inch structural pipes.

For the basic setup shown, you're going to need:

- 10 structural pipes
- 4 foot pipes (about 1 foot long apiece)
- 2 elbow joints
- 4 connector joints
- 4 T-joints

Use a poster hanger to attach the banner to the stand with a nail driven through the center of the top crossbar.

The wonderful thing about this setup is that it can be assembled and disassembled very easily. The parts can be thrown into a duffle bag for easy transportation. And the total cost is so cheap that replacing a damaged or lost piece is a negligible concern.

And, once you get the hang of the basics, it's a small matter to start experimenting with different connectors and structures to expand the display (as seen on the right). Just be sure to give it plenty of cross-support and footing as you expand. These things are only good when they're vertical.

TABLE DRAPE

Although it's certainly not a vertical element, a table drape helps to bring a cohesive look to your booth display. I think that not only increases the professionalism of your booth, it also helps it to stand out among the other displays that offer a more jumbled visual presentation.

I bought a table covering big enough to cover 8 feet of table (I fold a foot under on either side for a six-foot display). I printed a horizontal banner (again, mine's six feet wide to accommodate both 6- and 8-foot displays).

At my first convention with the new drape, I centered the

BOOTH BASICS

Horizontal banner. Remember to get grommets punched into your banner so you can hang it up with S-hooks. It's a good idea to have them punched at the corners and in the middle for extra support.

Wire magazine rack. You can buy these online. Be sure to get one that folds down flat for easy transport.

Stackable crates. These are great for displaying prints and other merchandise. With the open side facing you, fill the crate with your stock and hang a sample on the side facing con traffic.

Vertical banner stand. Consider buying two or more of these as a cheap, attractive backdrop when you exhibit in Artists' Alley.

Overhead PVC display. See the next page for step-by-step instructions on creating a clamp to anchor this to your table.

Table drape with horizontal banner. Use adhesive Velcro strips to pre-position the banner on the drape. This makes setup and tear-down a breeze.

C-CLAMP ANCHOR

Here's a great tip for anchoring an overhead PVC display to your table that I picked up from Amber Davis at Philadelphia Comic Con in 2012.

Her husband drilled two holes into a C-clamp that corresponded to two holes in a section of PVC pipe.

Using a bolt, a couple of washers and a nut, he could secure the pipe to the C-clamp.

The C-clamp then is attached to the table (see illustration above).

This is done on the other side of the table as well, forming two legs.

The rest of the rig is created by simply using an elbow joint and a third section of PVC pipe to connect the two legs at the top.

The resulting display was sturdy enough to hold aloft an 8-foot-wide vinyl banner.

drape on the table, and, affixed three adhesive Velcro strips along the edge of the table in the middle.

Then, I affixed the opposing strips of adhesive Velcro along the top edge of the back of the banner. I positioned these by holding the banner up to the Velcro on the drape and eyeballing it.

Now that the Velcro is in place, I am able to affix my banner to the center of my drape during setup and take it down during tear-down in the blink of an eye — never wondering if it's centered. Plus, since it's permanently stuck to the two components, I never find myself unable to do setup because I forgot tape or hooks or pins.

GET FLYERED UP!

A flyer is a single sheet that you have printed (sometimes front-and-back) with samples of your work. You can hand these out at your booth and you can leave a stack at the convention's freebie table.

Spend a little time selecting your samples. This should be your strongest work, certainly, but it should also be the work that has the broadest appeal — and requires little or no backstory to enjoy. Narrow down your selections to a small group, and then show it to a large group of test subjects (family, friends, etc.). Ask them to tell you which ones are their favorites.

Along with your sample strips, include the title of your comic and the URL. I would advocate placing the URL in two or three places on the same page — to increase the likelihood that it will be found.

Finally, along with any closely edited promotional text, consider including a map to your booth location on the convention floor. Conventions usually publicize their floorplan before a show. Find out where yours will be, and include it on the flyer. Even if you're giving out only the booth number, this is an excellent way to make sure that an attendee who grabs a flyer and walks away can find you after those samples grab him — or someone else in his group that he shows the flyer to.

Flyers can be made incredibly cheaply. You might find that the best deals can be made with a local print shop. Otherwise, there are several online companies that can do the job well. Both Overnight Prints and Boss Logo do high-quality flyers, business cards, postcards and bookmarks.

BUSINESS CARDS

Everyone understands the importance of business cards. They're a convenient way to exchange contact information as you're networking — whether at a convention or in the normal course of day-to-day business.

Business cards are a lot like banner ads. The ones that work best feature one simple visual and very thoughtfully edited text.

The visual, usually, will be the logo of your comic. Alternatively, it could be an iconic character from your comic. I'd really suggest not trying to fit both.

FLYER CONTENT

Consider putting a map to your booth on your flyer. You'd be surprised how many people read the flyer hours after it's handed to them, become interested and then can't find the booth again.

Dave Kellett, in a Webcomics Weekly episode, once shared that he splits his flyer content: general-audience gags on one side and pop-culture/geek humor on the other. That way he can fine-tune his flyer's pitch by deciding which side of the flyer would match best with his impression of the person he's handing it to.

Information to include:

- Name

- Title of your comic (if it isn't clearly represented by a logo)

- Web site

- E-mail address

- Tagline (maybe — if it's really good)

Information I'd think twice about:

- Home address (If you use a P.O. Box, feel free ... but ask yourself who is going to use it and for what.)

- Phone number (Do you really want a few hundred cards with your phone number floating around? This goes for your home address, too.)

- Twitter/Facebook info (Who is really going to use this information?)

- IM address (See above.)

A business card is the epitome of clear communication. You're handing these out to business contacts — not to friends and family. So the message you send should be one of business: If you want to do business, this is how to contact me. And don't obfuscate the message by clouding it with a bunch of tangential stuff like your Twitter feed.

If the nature of the business contact is such that a phone number is required, you can always write it down on the back of the card, but I really don't want every person who has my business card to be able to call me at home. That's a privilege I'll grant you with a ballpoint pen.

BUSINESS-CARD ETIQUETTE

While we're on the topic, let's discuss some proper behavior around business cards.

Don't offer your card unless one of two things happens: you're asked for it or if you're discussing business and the topic of contact arises. Never offer a business card cold: "Hi, I'm Jimmy. I do a comic. Here's my business card."

Don't ask for a card unless you're discussing business and the topic of contact arises. It's creepy.

Don't assume that your giving a card obligates the other person to do likewise. Again, unless you're discussing a business arrangement that requests further contact, you're not entitled to a business card.

QR CODES

A QR code is a specific matrix bar code (or two-dimensional code), readable by dedicated QR bar code readers and camera phones. The code consists of black modules arranged in a square pattern on a white background.

What makes these little babies cool is that you can embed all sorts of information into a QR code, including text, phone numbers, SMS messages and URLs.

And that means you can deliver your Web site's URL to an interested party through the party's smartphone, tablet or other mobile device.

You can use any number of free apps to generate a QR code. (The QR code to the right points to my *Evil Inc* Web site.) This has a ton of interesting uses — on flyers and at the booth.

- Print a single QR code that delivers your Web site's URL to your table at a convention. This replaces the handing-out of flyers entirely for people who have the capacity to read QR codes.

- You can feature a special smartphone-friendly preview of your comic and allow people to access it through a QR code displayed at your table.

- A QR code could be used to deliver a special incentive to people who purchase items at your table. (Just have the URLs printed out on a few slips of paper for non-QR-capable people who want to access the same bonus with their purchases.)

- You and a few friends who are exhibiting at the same convention could use QR codes to develop a game for people to play as they move from table to table.

- A QR code could point to a special page with items from your store that will be discounted for a limited time. Anyone who purchases items at your table can get access to the code to buy more stuff later at a discount.

I'm not saying that it's time to eliminate traditional promotional measures like flyers. After all, not everybody has a device that can read a QR code. But the time is now to start working on how to use this feature to your best advantage.

MEDIA KIT

A media kit is a folder that contains information about you and your comic, along with samples of your work, recent press releases and other promotional material. It is handed to members of the media to enable (or encourage) them to cover your work in their publications. In short, a media kit is, as the name implies, the building blocks to the story that you want the world to know. In preparing the media kit, you are giving the journalist everything she needs to tell the story that you want to have told. Here are a few things you might like to consider including in yours:

Cover letter. The cover letter should read similar to how you'd like the introduction to go. It should lead with your personal background, a synopsis of your comic and a brief overview of your

online business (including milestones such as first book, awards and any Web-traffic benchmarks).

Statistics. One page should be devoted to stats about your Web traffic. Pageviews, unique visitors ... whichever is more dramatic. Perhaps both. The accompanying text should emphasize things such as growth and staying power. Find the positives and emphasize them.

Free book. If you can spare a free book, include it as a sample of your work. Journalists love swag.

Free sample. Select a story arc that you really feel is definitive of your comic, print it separately and submit it as a sample story line. This will give the journalist an opportunity to get a quick feel for what you're all about. It also allows you to control his or her first impression of your work by directing the initial exposure. These few pages can actually be more powerful than an entire free book. At the bottom of the sample, include a URL to the place on your Web site where one can learn more about your comic and its characters.

Awards. A separate page for awards, honors, reviews and quotes.

Photo. You need to provide a head shot. Even if the journalist you're speaking to works for the radio, chances are there's a Web site involved. Having a head shot ready increases the chances that you'll get better play. Upload a hi-res photo (300 ppi) of yourself to your server and provide a URL.

Digital samples. Although the Web editors are certainly free to swipe what they want from your site, they'll always pull the blandest stuff and disappoint you. Preselect two or three standouts, upload them to your server and provide links to them. If you want to be prepared for print coverage, make sure these samples are high-resolution (300 PPI for color or grayscale, 600 PPI lineart).

Press release. Include your most recent press release (discussed in Chapter 10).

Business card. This is not a necessity, but it's always nice to have.

Skip the CD. Years ago, it was fashionable to include a CD with the promo folder. You're a webcartoonist. You have a Web site full of material. Bag the CD.

At the top of every page (excluding the press release) should be your comic's logo and your full contact information: name, address, phone, cell, e-mail, Web site. At the bottom of every page, in a single line, repeat the information (without the logo).

Collect all of this in a pocket folder. This is a blank folder with pockets to hold all of your papers inside. Some types of pocket folder have die cuts on the pockets to hold business cards. If you purchase this style of folder, make sure you have attractive business cards to insert.

If you have the means, you may choose to brand the cover of the folder with your comic's logo. You can easily buy special inkjet-printer paper that enables you to print stickers. This is a low-cost way to quickly identify your folder so it's harder for the journalist to lose amid his other acquisitions.

I recommend keeping your media kits under the table in close proximity. Learn to spot the press credentials the convention you're attending, and when you spot one, have a media kit ready in case you need it. That being said, I rarely carry more than 10 promo folders. There are seldom more than 10 journalists at any convention to whom I find it necessary to give a complete media kit. I tend to save my media kits for opportunities for maximum exposure.

Don't hope for good press. Make it happen. The media kit is an easy-reference guide to the story that you want to be told about your work. Make sure it's well organized, complete and positive. And when that story or report does run, don't hesitate to follow-up with a polite thank-you note. As you grow your business, you'll be glad you cultivated media contacts along the way.

GO GREYHOUND!

The only thing worse than having too much merchandise at a convention is having *too little*. If this happens to you — and if you're not too far from home — you could have a friend or family member put a box of merchandise on a Greyhound bus!

Seriously.

Greyhound will accept packages, and it's much cheaper than overnight delivery by any of the standard parcel carriers. Go to the bus station and pick up your package.

It's beautifully simple and efficient. I ran out of copies of one of my books at New York Comic Con in 2011.

My wife in Philadelphia had replacements at the Port Authority Bus Terminal (a short walk from the Javits Center) within three hours.

It cost us about 30 bucks.

SHIPPING MERCHANDISE TO THE CON

Obviously, for comic-convention travel, luggage fees are going to take a serious bite out of your bottom line. Remember, you do have the option to ship your merchandise (and other stuff, like clothes, toiletries, etc.) instead of trying to lug it on the plane.

This is going to require a little planning. First of all, you're going to want to ship plenty of time in advance of the show — so you can confirm the arrival (or make alternate plans in the event that the shipment is late or lost). Secondly, if you ship to the hotel, call in advance and find out if there are any fees levied by the hotel for accepting/storing packages. One hotel charged me so much I asked the front desk if they had given my boxes a private room! Finally, take into account the unit cost of your merchandise before getting zapped by luggage fees on your return flight. I have actually been in situations in which it was cheaper to throw a handful of books into the trash rather than pay what the airline was asking to ship them home.

SHIPPING TIPS

Ship your books to your hotel. If you're staying at a hotel, ship them there. Call first and make sure there's no charge for holding the boxes or if there is any special protocol you need to be aware of. In the address, write your name and "Hotel guest: check-in date through checkout date." If you're able to ship 4-6 weeks out, you can save a ton of money shipping books Media Mail. Be careful, though: Media Mail shipments can contain only books — nothing else. Remember, when it's time to get your books at the hotel, tip the bell captain well: (1) It's the right thing to do and (2) he'll take good care of you all weekend long. I suggest between $2 and $5 per box.

Know the airline's luggage regulations. You might try to pack your merchandise in your luggage and check it at the airport. But airlines are becoming downright predatory when it comes to luggage. Some have weight restrictions and others have limits on the number of things you can claim as luggage. In both cases, going over their limit will cost you serious money. Take a few minutes and understand the rules before you get to the airport. It might be less expensive to ship your stuff separately beforehand.

Phone a friend. If you have a reliable friend, you may consider shipping the boxes to her house and have her meet you at the convention. Be sure to get her a badge in return for the favor. Furthermore, if you have a friend who lives near a city in which you annually attend a convention, perhaps you can work out a deal in which you can make a one-time shipment of a lot of boxes, which the friend then agrees to store in a safe place. Then, every time you prepare for a show in that area, you contact the friend with the details and arrange a way to get the merchandise to the convention.

Freeman. Chances are, you're not going to ship directly to the convention center during your first several convention appearances, but if you do, you're likely to be dealing with a company called Freeman. Here's my only tip on Freeman: They charge per CWT — which means they charge

in 100-pound increments. So if you ship a 101-pound box, they will charge you as if you had sent them a 200-pound package. You'll want to pack carefully.

Getting home. No one wants to lug merchandise home. Chances are, you have a plane to catch, and you have no idea how to find the nearest Post Office or UPS center if you had the time. Most convention centers have a FedEx on site, but that can get awfully expensive. Your hotel might offer a shipping service, but it's bound to be expensive. Still, asking about it upon check-in wouldn't be a horrible waste of time. And asking the concierge about the nearest shipping place might be helpful, too. There are no easy answers here. Your choices are to sell as much as you can at a slashed price in the final hours of the convention*, ditch some of the merchandise after the convention closes, find another ~~gullible~~ helpful friend who can store and/or ship them back to you later, or find a way to ship them before your flight leaves.

** Some exhibitors drop their prices in the closing hours of the convention. I don't like the practice for several reasons. First, it punishes the fans who came to support you earlier. They paid more than the person who bought your book on a whim while exiting the show floor. And that's not a way to reward dedicated readers. Secondly, you'll train people to hold off on their purchases until the last hour of the last day — and that's bad news for you as you struggle to fit an entire convention's worth of reduced-price sales into a very short period of time.*

DON'T SHIP IT HOME – SELL IT!

By Saturday night, I know how the rest of the convention is going to play out. Very rarely will I sell more of any given title on Sunday than I did on Saturday. So, I know roughly how many books I can expect to sell Sunday — and, therefore, how much I'm going to have on my hands after the show closes. If it's a lot, I arrive at the convention early Sunday and make the rounds to the retailers that are exhibiting at the show, offering to sell them the books at 50-70% off the cover price. It's a nice deal for them. And it's a win-win for me because if I do sell out that day, I know where I can send a fan to get the book he's looking for.

GETTING THERE IS HALF THE FUN

If you're smart, you'll begin to think about your summer conventions during the preceding winter. The further out you begin booking your travel accommodations, the better your chances at finding good rates. Here are a couple of surprising tips.

FINDING THE BEST AIRFARE

Clear your Web browser's cookies before searching for airfare. Some online airfare sellers use those cookies to manipulate their site into giving you a higher price once they see you're interested in travel. More innocently, cookies could cause your browser to return the same results from an earlier search for the same destination, meaning that you may be missing out on newer, cheaper fares.

DRIVING CAR-RENTAL PRICES DOWN

Car-rental prices have risen over the last few years. But did you know that many automobile dealerships rent their cars? They often rent for lower rates than the car-rental places.

BAGGAGE GUIDELINES

Updated as of February 2013, here is the list of baggage fees being charged by major American airlines (excluding special programs or privileges) for travel within the United States. All of the below restrict luggage to a maximum of 62 linear inches* and 50 lbs. (except Spirit, which draws the line at 40 lbs.).

Airline	Carry-on	1st	2nd	Extra	Overweight	Over-size
AirTran	$0	$25	$35	$75	$75	$75
Alaska Airlines	$0	$20	$20	$50	$50	$50-75
American Airlines	$0	$25	$35	$150	$100-200	$200
Delta	$0	$25	$35	$125-200	$90-175	$175
Southwest	$0	$0	$0	$75	$75	$75
Spirit Airlines	$35	$30	$40	$85	$25, 50, 100	$100-150
United Airlines	$0	$25	$35	$100	$100-200	$100
US Airways	$0	$25	$35	$125-200	$90-175	$175
Virgin America	$0	$25	$25	$25	$50-100	$50

Size is calculated by adding height, width and depth.

NOTES:

Alaska Airlines: Allows *three* checked bags before applying extra-bag fees.

American Airlines: Overweight charges are $100 for 50-70 lbs.; $200 for more than 70 lbs.

Delta: Third bag is $125 and any bags after that are $200 each (no more than 10). No bags over 80 inches. Overweight breakdown is $90 for 51-70 lbs., and $176 for heavier than 70 lbs.

Southwest: Anything over 100 lbs. gets shipped as air cargo.

Spirit: You can bring one free item aboard (per seat purchased) as long as it is small (purse, small

backpack, briefcase, etc.). Dimensions may not exceed 16x14 x12 inches. Higher rates apply if you don't pay for your checked luggage when you originally book the flight. Overweight: $25 for 41-50 lbs., $50 for 51-70 lbs., and $100 for 71-99 lbs. Oversize: $100 for 63 inches; $150 for more than 80 inches.

United: The figures in the chart are estimates. Use United's baggage calculator (at United.com) to determine the charges that will apply to your flight. Overweight: $100 for 51-70 lbs.; $200 for over 71-100 lbs. Oversize: $100 for 61-115 inches.

US Airways: Third bag is $125, four to nine bags are $200 each. Overweight is $90 for 51-70 lbs.; $175 for 71-100 lbs.

Virgin America: Overweight is $50 for 51-70 lbs.; $100 for 71-100 lbs. Oversize is $50 for over 62 inches.

THANK YOU!

I'd like to extend a heartfelt thank-you to everyone who supported the Kickstarter campaign to fund this book, including the following ...

- Andrew Wilson
- Steven M. Jones
- Scott Donald (ScottDonald.co.uk)
- Santosh Oommen (santoshoommen.com)
- Gwendolyn Patton (Quarktime.net)
- Rob Chambers (Meatshield.net.)
- Charlie Hawkins (alteredconfusion.com)
- Brittany Shepard
- Zac Rorberg
- Jeremy Grant Seip
- Mark Miller
- Darrel Troxel (ThatComicThing.com)
- Doug Magruder (Cartoondoug.com)
- Christian Lindke (Advanceddungeonsandparenting.com)
- Py (Rolytic.tumblr.com)
- Christopher J Foster
- Rich Coy (Richcoy.com)
- Mike Wytrykus (Mikewytrykus.com)
- Tim Hengeveld (TimHengeveld.com)
- Bob McGinnis
- Sami Beese (stgd.de)
- JG Heithcock
- Jose Alfredo Villalobos
- Kalisa Lessnau
- Ben Scarbeau
- Brookes Eggleston (Tribaldroid.com)
- RKTOKOMAK
- Suzanne C. Compton
- John Bogenschutz (Tonedeafcomics.com)
- Brian D. Sheaffer
- Neal Byles (wtbcomic.com)
- Chris Cameron (Oium.com)
- The Mugshotz Art Studio (Mugshotzonline.com)
- Stan! (Stannex.com)
- Michael A. Swanigan
- Ken Franklin, PhilGAMEthropist
- Robert Kac
- Mike Larson (Creativefloret.com)
- Gareth-Michael Skarka (Intothefarwest.com)
- Alex Heberling (Alexheberling.com)
- Eric Holm (Voldare.com)
- Scott Bachmann (Scottcomics.com)
- Matthew Kuhn
- Aaron Benjamin Carter
- Michael Jensen
- Tim & Natalie Cox (Lego@ukbricks.com)
- Ben Pooped (Poopoffice.com)
- Joe Abboreno (Crackpotuglies.com)
- Scott "Tiki" Turriaga
- Mike Craft (Radcomic.com)
- Dawn Oshima

- Amber Padilla-Argiris (Candymistakes.com)
- Meaghan Carter (Megacarter.com/takeoff)
- Trent Thompson
- Ronald R. Richter
- JD Hood
- Alex Moore
- Steven Kunz (Bleedinginkcomics.com)
- Keenspot (Keenspot.com)
- John S. Klinge
- AlexandreK
- James Watson
- Rick K. Hughes (Wintersuns.com)
- Josh Way (Joshway.com)
- Dr. James
- Perry Alter (Tamacomic.com)
- David Kirlin (Altsad.net)
- Ian Ng
- Alex White
- Jeff & Dianna Smith
- Derek Groothuis
- Edward "Ted" Helmers (Tedwrd.com)
- Guilded Age (Guildedage.net)
- Mark Liebrecht (GeekNewsWeekly.com)
- Michael DeMoss (Michaeldemoss.com)
- Stephen Rognlie
- Jason T. Roberson
- Kurt Sasso (Tgtmedia.com)
- Dave Costella (Dcdigitalimagery.smugmug.com)
- Johnny Nguyen (Finncomics.com)
- Tommy Lewis
- How-Hing Pau
- Alex G. Stamoulis
- Scott McEvoy
 Stephen Ray
- Aaron Griffith (Signaltonoise.fm)
- Michael H. Payne (Pandora.xepher.net/daily)
- Thomas W. Horner (Thomasofseattle.deviantart.com)
- Rylan Hilman
- Nicole J. Toews
- Jim Sigler
- @brainwise
- John Baird (Ccproject.comicgenesis.com)
- Tom Briscoe (Hatecats.com)
- Kevin McGoldrick
- Mark Stickley (Markstickley.co.uk)
- Sarah Frisk (Tavern-wenches.com)
- Roberto De Almeida (Dealmeida.net)
- Nick Grugin (@nscottg)
- Andy Lundell (AndyLundell.com)
- Allen Nussbaumer
- Dejan Krstevski
- Leo Depsky
- Alisha Jade (Ajadeart.com)

- Donnovan Knight (Donnovanknight.com)
- David Wagaman
- Ray Michels
- Eric Snell (Champions-call.com)
- Antonio N Porras
- Bodie Hartley (Bodiehartley.com)
- Ian A. Castruita (Unfedartist.com)
- Sarah Thomas (Sarzcoo.deviantart.com)
- Nick Etherton (Nicketherton.com)
- Britt Treichel (Akaemmybelle.tumblr.com)
- Ted Atkinson
- Jesse D. Guiher (Tigertailart.com)
- Ashley Lehane (AshleyLehane.com)
- David Goldstein
- Rafael Mejia (Nocturnalpixel.com)
- Jean Frost
- Kraig Kyer (Kraigkyer.wordpress.com)
- Chris Tihor (Ironiciconicstudios.com)
- Dave Wells
- Carrie Ann Favela (Chicagoforce.org)
- Greg Cespedes
- Reese Mills
- Ian Salsbery
- Dre Alvarez (Nerdnumbers.com)
- Daniel Schaefer
- Aaron P. Churchill
- Doug Gray
- Norm Walsh
- Ron (RonO) Oakes (Ron-oakes.us)
- Gene Kelly (Rocketbot.com)
- J2koffline (@J2koffline)
- Kamar M. Bratko
- Scott Vandehey (Spaceninja.com)
- Devon Teneycke
- Corey Scott (Baujahr.dontaskcomics.com)
- Shari Chankhamma (Sharii.com)
- Nick May
- Tom Deylen (Mixednutscomic.com)
- Dave Windett (Davewindett.com)
- Jenna Zamie (Jetmode.title-pending.com)
- Jan Jaap Sandee (Jjsandee.com)
- Logan 'Logie' James (Logiejames.com)
- J. Alexander Chiara
- Lee Sheppard (Leesheppard.com)
- A.J.Mashburn
- K Smith
- Ryan North (Qwantz.com)
- Patrick Rennie (Patrickrennie.com)
- Chris Fong
- James Sisti (Sidecarcomic.com)
- Marjorie Rishel (Lepusstudios.com)
- Thomas Sausen (EikaUndHannibal.de)
- Ed Kowalczewski
- Michael Farren
- Daniel Purcell

- Wayne Bourque (Waynebourque.com)
- Jeffrey Allan Boman (Jabwriter.com)
- David Whitten (Worldvista.org)
- Mark Smit
- Stephen Crawford
- Jacob Fehr (Kissingcoupleofgp.blogspot.com)
- Lee Wark
- Laurie Stevens (Mixedmetaphorscomic.tumblr.com)
- Jamie Townsend (Modestcomics.com)
- Joyce Ann Martin (Inkgizmo.com)
- Lance T Hildebrand (Forgottentale.com)
- Stephen "Switt!" Wittmaak (theSwitt.com)
- A.J. Murphy
- Brandt Forrest
- Nath Kai
- Paul Justin Hollingsworth (Destroyedbyrobots.com)
- Micah Addison Salyer
- Kam & Thom Pratt
- Tomas Orti
- Logan Swift
- John-Thomas Foster (Gamerdoodles.com)
- Jason Norman
- Jostein Fyllingen (Invisiblepaperclip.com)
- Kevin Yong
- Jarrod Lombardo
- Johnny Glynn (@johnnyglynn)
- Eric Royal (Royallyeric.com)
- Jon Delmendo (Halfbrown.com)
- Cory Casoni
- Randy Belcher
- Eric Hamilton
- C.M. Ridge (goblinboycomics.com)
- Michael Krzak
- Jennie Breeden (Thedevilspanties.com)
- Kevin Souders
- Scott H Mitchell (Readysoupcomic.com)
- Eric Schroetlin
- Lindsay Hornsby (Fizzlebit.com)
- Joseph Burke
- Cassandra Dart
- Eric E. Torres
- Mark Davis
- Ray Burke, aka "Masked Ray"
- PJ Knepp (EpicMoonBase.com)
- Joseph A. L. Quander III
- Ben Siepser
- Gurinder (Gary) Kullar (Pigminted.tumblr.com)
- Jonathan Murdock (Dungeonhordes.com)
- Adam P Bebko
- Robert Wertz (Kittyscats.com)
- Sacha Ravenda (Ravendasketch.blogspot.ca)
- Alex Le
- Karine Charlebois (Kkantharasloft.net)
- Jon Hughes Tpiaa.com)
- Adam J. Monetta (Luckyblawg.blogspot.com)
- T.J. Sciorrotta (Geeko-system.com)
- Aleister Gilgrim (GlamSnot.com)
- Clint Hollingsworth (Wanderingones.com)
- Jason F. Broadley
- 'Mad Jay'
- Josh Bruce (Inkbyte.net)
- Charlie Pfaff
- Scott Hewitt
- Joey Rouleau
- Caanan Corey
- Joosus
- Chris Josephes
- Chris Watkins (OdoriPark.com)
- Chad Shepherd
- Billy B Burson III
- Jamie Erwine
- Rebecca and James Hicks (Little-vampires.com)
- Arya Rose Clarke
- David Drake Hunter
- David Kusiak
- Taylor Hall (Imaginatecomic.com)
- K.J. Wortendyke Jr. (Kitandkaboodleonline.com)
- Rowland Gwynne
- Ash Vickers and Steven Dengler (MegaCynics.com)
- David Birch (Socksandpuppets.com)
- Gar Molloy (Nekothekitty.net)
- Natalia and Keith Smiley
- David "Wolf" Mc
- Rachael Hixon (Tangentartists.com)
- Thomas Baehr (Penguinsforfree.com)
- Dave Sigley
- Todd Schumacher (Todd-schumacher.com)
- Chris Rose (@zenbubble) & Kit Fox (@xombiekitty)
- Rikke Lindskov Loft (Gwennafran.com)
- Alex Ray
- Kimberly Marsing
- Kira Parker (Seriouslesbian.com)
- Myles C. Allen (Pointsofexperience.com)
- Daniel Head
- Eric Stratte (CGwabbit.com)
- Victor Johansson
- Chris Hanel (ChrisHanel.com)
- Audie Norman
- Rachel M. Brown
- Ben Heaton (Requestcomics.com)
- Gareth Pitchford
- Amy Gardner (@amysophie)
- Najm Haq (About.me/Najm)
- Alexandra Z.
- Drew J Cass (Shardsofparadigm.com)
- Debbie Hutt
- Robert Houghton
- Jason A. Barros
- Matt Snelgrove
- Cameron Davis (Gazunta.com)
- Vincent LoGreco (Ohnocomics.com)
- Adam Huber
- Troy Dye (FracturedEntertainment.com)
- Valentino Casimir Roman
- John Hergenroeder
- Kristian Nygård (Optipess.com)
- Jeffery Stevenson (Brat-halla.com)
- Ruben R. Puentedura (Hippasus.com/rrpweblog)
- Marc Streeter (Actionmanadam.com)
- Amy MacLeod
- Wesley Perrett
- John Sanford (Chippyandloopus.com)
- James Gresham
- Dean J Lovett
- Anthony R Wheatley
- Keith R. Martin
- Ron.Mansolino.com
- Dylan Boyle
- Erik Lagnebäck
- Gabe Miller
- Joe McGlone (Aliencomix.com)
- Alison Pilorz (Alisonpilorzart.com)
- Peggy Wolohan von Burkleo (Samhainnight.com)
- Melony Chitwood (Melonychitwood.com)
- Michael Takanori Noma
- Patrick Jasina (Talesofsaia.com)
- Colin David Gibson
- Griphin India Pvt. Ltd. (Griphin.com)
- Robert E Kemp
- Jared Koon (Jaredkoon.com)
- Patrick Taylor
- Carrie Potter (Junipercomic.com)
- Ryan Fisher (Sometimeaftercomic.com)
- Jose Acevedo (Childish-behavior.com)
- Eric Lobdell
- Ville Kaipila
- Ray Bishop
- Robert Weldon
- Matthew Lim (Lessthanurban.com)
- American Ninth Art Studios LLC
- Dave Robles (Rareearthcomics.com)
- Jason Thomas (Freedrawingsfortotalstrangers.com)
- David Ketcherside (Purposelessplay.com)
- Somnigram
- Tara, Jeffrey, and Jonah Skolnik
- Peter Kempson (Ubiquitous-singularity.com)
- Iain Davidson (WargamingResources.info)
- Nicholas Barone (WeeklyGamingRecap.com)
- Jamie Isfeld